W9-ABA-178

# DAVID BUSCH'S
# QUICK SNAP GUIDE
# TO PHOTO GEAR

David D. Busch | Dan Simon

**Course Technology PTR**
*A part of Cengage Learning*

COURSE TECHNOLOGY
CENGAGE Learning™

Australia, Brazil, Japan, Korea, Mexico, Singapore, Spain, United Kingdom, United States

# COURSE TECHNOLOGY
## CENGAGE Learning™

**David Busch's Quick Snap Guide to Photo Gear**
David D. Busch, Dan Simon

**Publisher and General Manager, Course Technology PTR:**
Stacy L. Hiquet

**Associate Director of Marketing:**
Sarah Panella

**Manager of Editorial Services:**
Heather Talbot

**Marketing Manager:**
Jordan Casey

**Executive Editor:**
Kevin Harreld

**Project Editor:**
Jenny Davidson

**Technical Reviewer:**
Michael D. Sullivan

**PTR Editorial Services Coordinator:**
Jen Blaney

**Interior Layout Tech:**
Bill Hartman

**Cover Designer:**
Mike Tanamachi

**Indexer:**
Katherine Stimson

**Proofreader:**
Sara Gullion

© 2010 David D. Busch

ALL RIGHTS RESERVED. No part of this work covered by the copyright herein may be reproduced, transmitted, stored, or used in any form or by any means graphic, electronic, or mechanical, including but not limited to photocopying, recording, scanning, digitizing, taping, Web distribution, information networks, or information storage and retrieval systems, except as permitted under Section 107 or 108 of the 1976 United States Copyright Act, without the prior written permission of the publisher.

For product information and technology assistance, contact us at
**Cengage Learning Customer & Sales Support, 1-800-354-9706**

For permission to use material from this text or product, submit all requests online at **cengage.com/permissions**. Further permissions questions can be e-mailed to **permissionrequest@cengage.com**.

All trademarks are the property of their respective owners.

Library of Congress Control Number: 2007906523

ISBN-13: 978-1-59863-454-9

ISBN-10: 1-59863-454-2

**Course Technology, a part of Cengage Learning**
20 Channel Center Street
Boston, MA 02210
USA

Cengage Learning is a leading provider of customized learning solutions with office locations around the globe, including Singapore, the United Kingdom, Australia, Mexico, Brazil, and Japan. Locate your local office at: **international.cengage.com/region**.

Cengage Learning products are represented in Canada by Nelson Education, Ltd.

For your lifelong learning solutions, visit **courseptr.com**.

Visit our corporate Web site at **cengage.com**.

Printed in the United States of America
1 2 3 4 5 6 7 11 10 09

*Dedicated to my wife, Lisa,*

*who, as always, is the most important person*

*in my life and the one thing I can't do without.*

*—Dan Simon*

# Acknowledgments

Once again thanks to the folks at Course Technology PTR, who have pioneered publishing digital imaging books in full color at a price anyone can afford. Special thanks to executive editor Kevin Harreld, who always gives me the freedom to let my imagination run free with a topic, as well as my veteran production team including project editor Jenny Davidson, and technical editor Mike Sullivan. Also thanks to Mike Tanamachi, cover designer, Bill Hartman, layout, and our agents at Waterside Productions, who have the amazing ability to keep both publishers and authors happy.

I would also like to thank Longwood Gardens (near Wilmington, Delaware) for letting me shoot there. The staff at Longwood has always been very helpful with my projects and the gardens are a great place for photography. And special thanks to the people who modeled for this book: Eric Fisher, co-author Dan Simon's wife Lisa, A. Thomas Roberts, Heather Malikowski, and Sarah Dunn. Stephen Kerr was nice enough to help us out with the Digiscoping section of the book. The photo made through the Digiscope was his. You can see more of his images at http://home.att.net/~hsk3/index.htm.

The following manufacturers have contributed evaluation units or photographs to help us produce a more complete work. You can find links to websites where you can find more information about their products at www.dslrguides.com/photogear.

**Hoodman Corporation:** Memory cards/readers, right-angle finder, loupe, LCD screens, hoodstrap

**Lowepro USA:** Camera armor and belt packs

**Argraph Corporation:** Marumai, Qpcard, Flotone

**HonPhoto Professional:** Light modifiers

**Saxon PC:** Grids for shoe mount flashes

**Black Rapid:** RS4 camera strap

**UPstrap, Inc.:** Camera straps and LCD Exposure Cloth

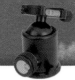

**Think Tank Photo:** Belt pack, pixel pocket rocket mini, and photos

**Trek-Tech:** Trek Pod, beanbag, tabletop tripod, dSLR Optera Pro 460

**Omega Satter:** Cokin filters

**Satechi:** Power grip, intervalometers, camera remote

**Presslite:** VerteX

**Harbor Digital Designs:** Ultimate Light Box

**LensPen:** SensorKlear kit

**The pod Industries:** Two pods

**Lensbaby, L.L.C:** Composer

**Expodisc:** Expodisc

**Camera Armor:** Camera skin

**Delkin Devices:** LCD viewer shades

**Gisteq Corp.:** Geotagger gps

**Zoot Snoot:** Zoot Snoot

**Mumford Micro Systems:** Time Machine

Supplying photographs were: Jobo AG USA; Kirk Enterprises; MacGroup; Ikelite Underwater Systems; L.L. Rue; Meiji Techo; Tabletop Studio LLC; Campus Camera and Imaging

# About the Authors

With more than a million books in print, **David D. Busch** is one of the best-selling authors of books on digital photography and imaging technology, and the originator of popular series like *David Busch's Pro Secrets* and *David Busch's Quick Snap Guides*. He has written nine hugely successful guidebooks for Nikon digital SLR models, and six additional user guides for other camera models, as well as many popular books devoted to dSLRs, including *Mastering Digital SLR Photography, Second Edition* and *Digital SLR Pro Secrets*. As a roving photojournalist for more than 20 years, he illustrated his books, magazine articles, and newspaper reports with award-winning images. He's operated his own commercial studio, suffocated in formal dress while shooting weddings-for-hire, and shot sports for a daily newspaper and upstate New York college. His photos have been published in magazines as diverse as *Scientific American* and *Petersen's PhotoGraphic*, and his articles have appeared in *Popular Photography & Imaging, The Rangefinder, The Professional Photographer*, and hundreds of other publications. He's also reviewed dozens of digital cameras for CNet and *Computer Shopper*.

When About.com named its top five books on Beginning Digital Photography, debuting at the #1 and #2 slots were Busch's *Digital Photography All-In-One Desk Reference for Dummies* and *Mastering Digital Photography*. During the past year, he's had as many as five of his books listed in the Top 20 of Amazon.com's Digital Photography Bestseller list—simultaneously! Busch's 100-plus other books published since 1983 include bestsellers like *David Busch's Quick Snap Guide to Using Digital SLR Lenses*. He is a member of the Cleveland Photographic Society, which has been in continuous operation since 1887, and can be located at www.clevelandphoto.org.

**Dan Simon** is an adjunct professor in the Culture and Communications Department at the College of Arts and Sciences at Drexel University. He teaches courses on a wide variety of topics including online journalism, fundamentals of journalism, public relations, public speaking, desktop publishing, business and technical communications, and communication theory. He has also taught courses in camera techniques and digital photography for East Stroudsburg University and desktop publishing for Gloucester County College.

Dan also has more than 30 years of experience as a writer and photographer. He is currently working on a doctorate in culture and communication at Drexel University. His published works include the *Digital Photography Bible Desktop Edition* (John Wiley and Sons Publishing), *Digital Photography All-in-One*, (Wiley), and *Digital Photos, Movies, & Music Gigabook for Dummies* (Wiley). He is also a regular contributor to the *Growing Edge Magazine* (hydroponics) and *Pennsylvania Magazine* (regional, travel).

He began his career as a Navy journalist with assignments aboard several ships, and in Norfolk, Virginia, Dededo, Guam, and McMurdo Station, Antarctica. He has traveled to all seven continents and photographed many of America's scenic and wild places. Dan also serves as a guest lecturer for Norwegian Cruise Line, the Delta Queen Steamboat Company, and Royal Caribbean International.

# Contents

# Preface

You've mastered your digital SLR (mostly), used it to create a few thousand photographic master-pieces, and now you want to expand your repertoire with some useful gadgets and accessories that will help you explore whole new types of photography. For instance, tripods can help you investigate the world of long exposures and long lenses; filters can add special effects—in your camera—that are impossible to achieve in an image editor; underwater photography can take your images to new depths.

But, to select the best gear for the job, you need to know a lot more than you'll find in typical accessory and equipment "buying guides." Learn why it's a good idea to purchase your tripod legs and mounting head separately. Discover the five things you *must* know before you choose accessory lighting equipment. Save money on filters by using the Cokin system—the savvy photographer's tool for buying one set of attachments that will work with every lens you own.

This book will give you a quick introduction to the wonderful world of photography gadgets and gear, cutting through the confusion to provide the basics to understand exactly what you need and how to select the best products for the kind of photography that you want to do. The most important facts and criteria for each type of product are presented on facing pages, with illustrations, so you can thumb through and locate the advice you're looking for quickly.

I'm not going to tell you everything there is to know about using each piece of photo gear; I'm going to tell you just what you need to get started using these useful gadgets to take compelling photos that will amaze your friends, family, colleagues—and yourself. And, along the way, you may discover a few priceless tools that you didn't even know existed.

# Introduction

This is the sixth book in my *Quick Snap* guidebook series, each of which takes a single puzzling area of digital photography and condenses the key concepts into a few pages that explain everything in easy-to-absorb bullet points, some essential text that summarizes just what you absolutely need to know, and is clearly illustrated with a few compelling photographs. Previous books in this series have dealt with point-and-shoot and digital SLR cameras, photographic lighting, and the selection and use of interchangeable lenses. This one is devoted entirely to the mysteries of those wonderful gadgets that can help expand our repertoire of techniques and perspectives.

Like all my *Quick Snap* guides, this book is aimed at photographers who may be new to SLRs, new to digital SLRs, or, simply, new to particular kinds of tools and equipment, and are overwhelmed by their options while underwhelmed by the explanations they receive in most of the photography books available. The most comprehensive guidebooks try to cover too much material. You're lost in page after page of background and descriptions, most of which you're not really interested in. Books of that type are great if you already know what you don't know, and you can find an answer somewhere using voluminous tables of contents or lengthy indexes.

This book is designed for those who'd rather browse their way through a catalog of tools, ideas, and techniques, arranged in a browseable layout. You can thumb through and find the exact information you need quickly. All the most common—and many uncommon—types of photo gear are presented within two-page and four-page spreads, so all the explanations and the illustrations that illuminate them are there for easy access. This book should solve many of your problems with a minimum amount of fuss and frustration.

# Who Are We?

Everything in this book is the result of years of experience in using a vast array of photo gear by the co-authors, David Busch and Dan Simon. Both of us are inveterate gadget freaks, dating back to the film era when designing and building your own tools was a basic part of the creative fun. David, for example, worked with an aerospace engineer some years ago to design a cigar-sized motor drive battery pack that freed the sports photographer from the bulky power sources of the day. He also wrote many "Nuts & Bolts" articles for a leading photography magazine on gadgets he developed. Dan, too, has amassed quite a collection of purchased gear to complement the assortment of tools he built for his own use. Thankfully, cobbling together your own stuff is less essential these days, because you can purchase better-designed and more versatile gear for most applications, as described in this book, at much less than the cost of rolling your own.

Between the two of us, we've had a total of more than 2,000 articles in magazines like *Popular Photography & Imaging*, *Petersen's PhotoGraphic*, plus *The Rangefinder*, *Professional Photographer*, and dozens of other photographic publications. But, first, and foremost, we've both spent most of our time as photojournalists and photographers and have made our livings in the field. Dan's visited all seven continents, and, while my world travels are a bit more limited, I love to roam around and, in fact, took off right in the middle of writing this book to spend a week in Prague, photographing one of the most beautiful cities in Europe.

Collectively, we've worked as a sports photographer for an Ohio newspaper and for an upstate New York college, operated our own commercial studio and photo lab, cranked out product shots on demand and then printed a few hundred glossy 8 × 10s on a tight deadline for a press kit. We've served as a photo-posing instructor for a modeling agency; people have actually paid us to shoot their weddings and immortalize them with portraits; and the US Navy has entrusted a modest portion of the photographic component of our nation's defense to us. Like you, we love photography for its own merits, and view technology and photo gear as just additional tools to help us get the images we see in our mind's eye.

But, enough of the editorial "we" and "I." For the rest of this book, I'm not going to differentiate which advice comes from David and which derives from Dan's experience, as who did what is not as important as the information we have for you. If you want to know more, check out the web page at www.dslrguides.com/photogear, where you'll find links to the key vendors who offer the equipment and accessories described in this book. Some URLs will take you to the manufacturers' sites themselves, but I've also tried to assemble some links where you can purchase stuff directly from reliable sources.

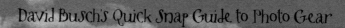

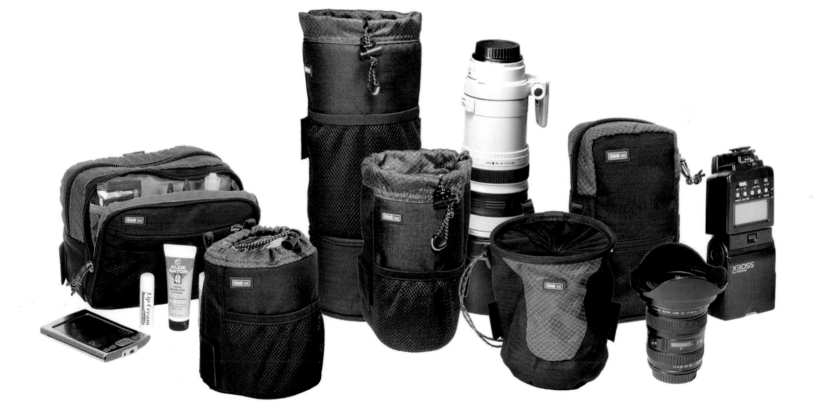

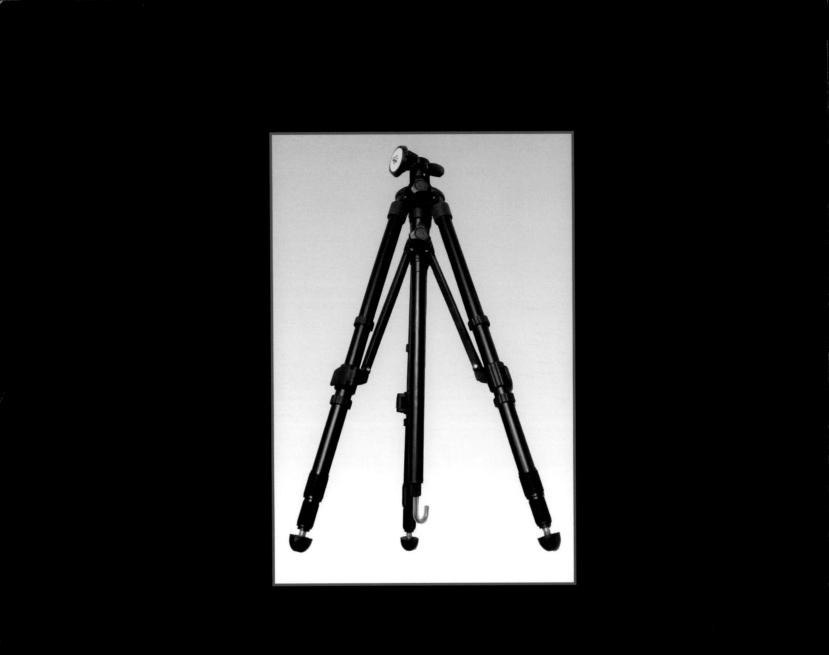

# 1 Tripods and Other Camera Supports

Tripods and other mounts support your camera and lens as you take a photograph, allowing you to get in the picture, making it easy to lock carefully selected compositions in place, and helping to prevent sharpness-robbing camera motion as the picture is taken. Unfortunately, the difference between a good tripod and a bad one is huge—even though the cost difference may be small. The Cleveland Photographic Society's renowned School of Photography—which has been conducting classes for more than 80 years—devotes much of an entire session to reasons why students should avoid making the "$49-tripod-mistake."

A well-constructed tripod is strong enough to bear your camera's weight, sturdy enough to withstand abuse, and easy enough to use that it can be set up and deployed quickly. Cheap tripods fail on all these accounts. So how can the camera enthusiast looking to raise his or her game make sure they're purchasing the right kind of tripod, one that best meets their needs?

This chapter will show you some of the key applications for tripods and other supports, what features you need to look for when choosing a tripod, monopod, or other tool, and how to select the right combination that will suit your shooting needs and style. Although I'll mention a few brand names here and there, the emphasis here will be on features, rather than vendors.

# Why a Tripod?

A large percentage of the photographs you see in my books were taken with the camera mounted on a tripod. That's not to say that I use a tripod for the majority of my images—just that, of all the pictures I take, the ones that are good enough to put in a book seem to have been taken, disproportionately, with a tripod. Unless you're shooting fashion or, particularly, shooting sports (where monopods are often a better choice, because tripods can be a distraction, take up too much space, or even be dangerous), many types of excellent images can be made even better by the steadiness that a tripod provides.

Indeed, of all the things that help photographers produce great photographs, use of tripods is not only one of the most important, but is also the most neglected. Novice photographers frequently underestimate the importance of camera steadiness and its effect on image sharpness. You may *think* you can take landscape photographs in the waning light of dusk with a wide-angle lens setting handheld at 1/30th second, but you'd probably be shocked to see how much sharper the same shot is at 1/125th second.

A good tripod is a vital ingredient in this task. While it's true that lugging a heavy tripod around makes your camera outfit that much heavier and your life a little more complicated, it is also true that a good solid tripod will help you improve the quality of your photographs. Tripods give you a chance to make sure that your camera is properly positioned and level and also help you make sure your composition is spot on.

The enhanced stability a tripod offers also provides you with the opportunity for improved creativity. With a good tripod exposures of 30 seconds or longer are possible. This means that you can produce some stunning effects and solve some normally unsolvable problems. Turn the local creek into a mystical field of spun glass. Eliminate cars and pedestrians from roadways and sidewalks. Create razor sharp landscape photos with amazing depth-of-field. A good tripod is your ticket to admission for a whole new world of photography.

There are four main uses for a camera support.

◆ **Steady the camera during long exposures.** A tripod or monopod can improve sharpness for any exposure longer than 1/60th second, and is essential when exposing for more than one second, as shown in Figure 1.1. I'll expand on this topic later in the chapter.

◆ **Reduce vibration when shooting with longer focal lengths.** Telephoto lenses magnify camera shake, so that even a little vibration is multiplied. Front-heavy lenses can make the tendency to jiggle the camera even worse. Even if your camera has vibration reduction/image stabilization/anti-shake built into the body or you have a similar feature in a lens, a tripod or monopod can often do a better job.

◆ **Increase sharpness during close-ups.** Shooting up close has the same effect as working with a telephoto lens—any vibrations are magnified. In addition, as the camera moves, your carefully calculated focus point shifts. A tripod reduces the effect of camera shake, and helps keep your focus point where it belongs.

◆ **Lock in your composition.** You can be sure that when Ansel Adams was creating his most memorable compositions, he used a tripod to lock in the arrangement long before he snapped the shutter. You can do the same.

◆ **Let you get in the picture.**
With the camera on a tripod or other steadying support, you can trip the self-timer and run and get in the photo yourself.

◆ **Provide a base for panoramic photos.** Shooting a wide-screen panorama calls for the ability to swivel the camera through an arc of overlapping photos. You can do this handheld, of course, and image editing tools like Adobe's PhotoMerge (found in Photoshop and Elements) actually do a good job of reorienting your panorama set as they are stitched together. But for the best results, using a tripod with a panorama head (discussed later in this chapter) can't be beat.

◆ **Allow repeated exposures for bracketing/High Dynamic Range (HDR).** HDR photography is all the rage right now, allowing shooters to take several pictures at different exposures, and then merge them together into a single shot with greater detail in highlights, shadows, and everything in between. This technique works best if all the exposures are made with the camera locked down on a tripod.

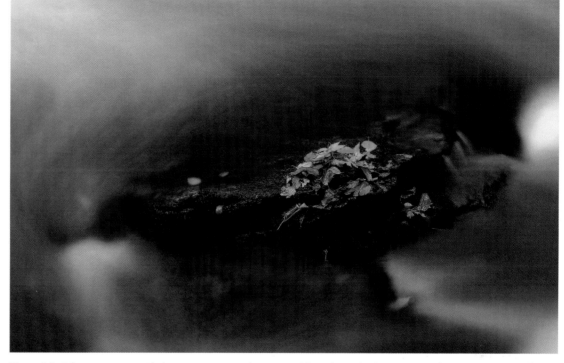

**Figure 1.1** A long exposure with the camera mounted on a tripod kept the rocks sharp even as the moving water took on a silky look.

# Essential Tripod Features

The biggest mistake first-time tripod buyers make is to buy the wrong one. That wastes your money and time, and you'll probably lose more than a few pictures when your inadequate tripod isn't up to the task. That big, impressive, $49.95 aluminum tripod you saw at the megamart certainly looks like a good deal. It comes with leg braces and a nifty two-way tilting head. Unfortunately, in this case those leg braces are there because that poorly designed tripod would probably sway like a reed without them (most quality tripods have legs that are stiff enough that they don't need special bracing). That pan-and-tilt head is slow to use and doesn't offer the flexibility you need to orient your camera quickly and precisely. After toting your bargain tripod around for a while, you'll find that its "lightweight" aluminum construction makes it, compared to better quality units, as easy to carry around as a boat anchor.

Save your $49.95 and apply the money to a good-quality tripod that can, potentially, last a lifetime. A basic tripod has certain features, shown in Figure 1.2. I'll explain them in more detail in later sections. These include:

◆ **Mounting platform.** Some sort of head that attaches to your camera is needed. The available styles including tilting heads, or, commonly, a rotating *ball head* like the one shown in Figure 1.2. Inexpensive tripods may include a non-removable head. More expensive models are sold as tripod legs, with a platform where you can attach the type of head you prefer.

◆ **Locking legs.** The legs extend to provide additional height, and can come in two, three, four, or more extension sections, with a locking mechanism to fix their length at the desired height.

◆ **Leg braces.** As I noted, these are found on some tripods to provide more rigidity. They are very common on cheap tripods, because the spindly legs on those models absolutely need bracing. But braces aren't worthless—they can be found on some more expensive tripods, too, adding to their stability.

◆ **Rubber feet.** Most tripod legs end with soft rubber feet, which can rest on many types of surfaces without damaging them. With some tripods, the rubber feet can be removed or replaced with spikes suitable for implanting in the earth or other surfaces. Others have soft feet that convert to spikes by rotating them.

◆ **Center column.** The center column is a pole that can be extended to provide additional height. Some center columns can be reversed to point the camera downward, or tilted sideways.

◆ **Anchoring hook.** The hook is often used to support an extra weight (your camera bag will do), adding some additional solidity to a tripod.

The secret to finding a tripod you can live with is to consider all the features you must have, add in some that you'd really like to have, and buy a tripod that offers those capabilities at a reasonable price. This section will get you started, with an overview of essential tripod features. I'll explain the most important considerations in more detail later in the chapter, along with some tripod alternatives, ranging from monopods to Gorillapods, clamps, and beanbags.

◆ **Cost.** What can you afford? Your budget is the first place to start, as the amount of money you have to spend on your tripod will affect the features you'll be able to expect to have. Decent tripods can cost $100 to $500 (or more). (See the "What Your Money Buys" sidebar for a comparison.) Tripods come in different configurations and are made from different materials, as described next.

◆ **Capacity.** One of the specifications that vendors list for their tripods is *load capacity*. This is the amount of weight *with lens mounted* that the tripod can reasonably be expected to support without the legs bowing or bending. Load capacities vary from a few pounds to about 22 pounds, and on up to 44 pounds or more (they're often designed with capacities measured in kilograms, which is where these odd numbers come from). If you use a heavy camera and/or long lenses (say, for wildlife photography or birding) you need to take that into account

and choose a tripod that can support your gear reliably.

◆ **Maximum height.** This is the height at which the tripod will place the camera, generally measured without the center column (if present) extended. You'll want a tripod that can bring the camera at least up to eye-level (although, ironically, for many types of photography, eye-level can be the *worst* and least imaginative position for your

camera). Most tripods will have a maximum height of 50 to 60 inches or a little more. I own one older studio tripod that extends to nearly seven feet, and I need a step-stool to look through the camera—which is why this one is used only in the studio these days.

◆ **Minimum height.** Tripod specs also show the minimum height they can be set at, which is useful for photographing plant life and other

subjects that are low to the ground. This height isn't necessarily the height of the tripod when the legs are completely collapsed—many models allow folding the legs out at an extreme angle to take the tripod head down to within a few inches of the ground. Or, you may be able to reverse the center column and mount your camera upside down to get very low.

◆ **Folded length.** The length of the tripod when all the legs are collapsed can be important when traveling. This size parameter is often a compromise between compactness, sturdiness, and cost. Three-section tripods tend to be a little cheaper, a little more solid, and collapse to a larger size than their four-section kin. A four-section tripod will collapse down to a smaller height (making it a better choice for travel and backpacking) but may be a bit more expensive and slightly less sturdy. The extra section also means the tripod may take longer to set up, and slightly increases the chance of breakdown since there's one more part to malfunction.

◆ **Materials/weight.** The material a tripod is made of goes hand-in-hand with its weight. Some materials, such as carbon-fiber, basalt, and titanium provide less weight to

carry around, but can cost considerably more. A few tripods use a combination of different materials.

◆ **Tripod head.** Very cheap tripods tend to be furnished with a built-in, fixed head. Better quality models are purchased only as a set of legs, with the head bought separately. Buying the head separately gives you more ways to tailor the device to meet your exact needs. It also means making a decision can get that much more complicated. I'll explain how to choose a tripod head later in this chapter.

◆ **Available accessories.** You may want to consider the accessory and expansion options available for your tripod. The ability to substitute the stock center column with a short column, or no column at all can be useful. Perhaps you want "spike" leg tips that dig into loose ground to steady the tripod. Some models have net-like "trays" that can be suspended between the legs to hold extra gear, or, perhaps, a few rocks to create a little ground-hugging weight. If you're shooting indoors on a smooth floor, a dolly may be useful for moving the tripod around. The better tripod brands offer lots of accessories that everyone may not need, but which can be indispensable when you must have them.

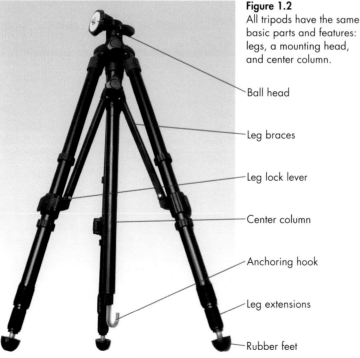

**Figure 1.2**
All tripods have the same basic parts and features: legs, a mounting head, and center column.

Ball head

Leg braces

Leg lock lever

Center column

Anchoring hook

Leg extensions

Rubber feet

# Materials

Tripod legs, purchased without an attached head, come in a variety of materials. The most common are aluminum and carbon-fiber, but alternatives are also available in basalt, titanium, and, believe it or not, wood (which are still available from precision manufacturers like Berlebach). Your choice of material will probably be determined by how much weight you can tolerate, and how much you are willing to pay. Aluminum tripods are the least expensive, but also are the heaviest, while those made from more exotic materials, like multi-layer carbon-fiber, may have half the weight, and cost two or three times as much. Here's a quick summary of the types of materials from which to choose.

## Aluminum

Aluminum is the most common material choice for tripods and it's a good one. Aluminum tripods tend to cost less, offer good to great strength, and are durable and safe. They can range in weight from light to heavy. There is also a huge range of choices available. On the downside, aluminum gets icy in cold weather and aluminum is also heavier when compared to materials such as carbon-fiber when tripods of equal strength are compared. Aluminum tripods cost about half the price of carbon-fiber tripods though.

If you need a strong tripod that doesn't cost a lot of money and you're either not planning on carrying it long distances or weightlifting is another one of your hobbies, an aluminum tripod can be a good choice for you. Aluminum tripods do take a little longer to quiet down their vibrations, so you might have to wait a little longer before tripping the

shutter than if you were using a wooden tripod, but the difference isn't all that significant.

## Carbon Fiber

This is one of those "space-age" materials that's lightweight, sexy, and expensive, but if you're a backpacking photographer who plans on taking your tripod into the backcountry, this is the tripod for you. Significantly lighter than wood or aluminum, carbon-fiber

is stronger than wood or aluminum and warmer in cold weather than aluminum. You can tell carbon-fiber tripods by the characteristic texture of the tubing, shown in Figure 1.3.

One word of warning though, carbon-fiber tripods can break and when they do, the shards can be really sharp and dangerous. Still, I've lugged mine over hill and dale for years now and it's been a pleasure to use. As I

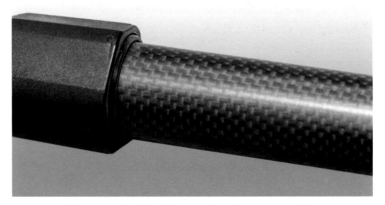

**Figure 1.3** The texture of carbon-fiber tripods is characteristic of this very strong, very light material.

mentioned earlier, I have a bigger, heavier aluminum model, but I only trot that out when I'm driving to a shoot and unloading the car right at the shooting location. If I have to carry my tripod at all, I reach for the carbon-fiber model. On icy days (which photograph really well) the carbon-fiber doesn't get quite as cold either (a big deal when you've been frostbitten like I have).

## WHAT YOUR MONEY BUYS

I have three sets of tripod legs that I use regularly, priced in the $100, $300, and $550 neighborhoods. The $100 model is a sturdy three-section aluminum model from one of the major vendors. It's heavy and not pleasant to carry, but I keep it in a bag in the trunk of my car (along with a monopod) so I'll always have a reliable camera support with me as I'm driving around. The $300 tripod is a four-section carbon-fiber model from the same vendor. It's just as strong, but weighs less than half as much and is more compact. I use this one in the studio and take it with me when I know I'm going to need a tripod, because it provides the best compromise between weight and sturdiness in the field. My $550 model is actually the least used of the three. It's the famous Gitzo Traveler GT-1541, a four-section carbon-fiber tripod that's prized for its light weight, strength, and portability. I use it when traveling by air. It actually fits inside my 22-inch rolling carry-on bag, as it collapses to about 16 inches and weighs just two pounds. Yet, extended, it's virtually as rigid as any tripod I've ever used. So, why isn't the Traveler my main tripod? Unlike my other models, it takes much longer to set up and has a maximum height of only 53 inches. When I'm working fast and need more height, and don't mind some extra size/weight, my other tripods do a better job. With the Traveler, a lot of that $550 goes into making the tripod more transportable—and for someone like me who never checks luggage, and who frequently hikes into the boonies with a backpack, it's worth every penny. In addition to Gitzo, the most widely known and respected tripods come from vendors like Manfrotto, Giottos, Linhof, and a few second-tier manufacturers such as Induro/Benro, Benbo, and Slik.

## Titanium/Magnesium

Tripods made from these materials are extra strong and extra expensive. Not as brittle as a carbon-fiber tripod, these alternatives weigh a bit more and stand up to a lot of abuse.

## Basalt

This is a relatively new material for tripod construction and there are very few options available. Basalt is made from volcanic rock, which is crushed, melted down and mixed with other materials. It's then drawn into fibers that are eventually formed into the tripod components. Basalt is strong and lightweight (comparable to carbon-fiber). Manufacturers also say it is a more environmentally friendly material than others typically used to make tripods. Because it's so new and there are so few choices are available, basalt tripods will likely be on the high end of the price scale.

## Wood

Wood tripods, although uncommon, can still be found. Heavier than carbon-fiber and perhaps not quite as strong or invincible as aluminum, wood is still a wonderful material for a tripod. Natural, elegant, and warmer in cold weather than any other material, wooden tripods are usually designed for massive weight loads (you often see them supporting 8 × 10 view cameras or other larger format beasts). Wood tripods also transmit less vibration than tripods built from other materials (an important consideration for long exposures). Price wise, a high-quality wood tripod may be a little more expensive than a carbon-fiber job, but the difference usually isn't as much as you might think. Wood is an environmentally friendly choice too.

# Construction Concerns

When selecting a tripod, pay attention to how the unit is constructed, as how the tripod is made can affect usability and durability. If, as you should, you're buying a tripod without a head, your construction concerns will deal primarily with the legs: how they are made and how they are used. Here are some of the main points to keep in mind:

## Center Column Choices

Most tripods come with a standard center column that's several feet in length so you can extend it when you need extra height. As a rule of thumb, you should *avoid* using the center column when possible, because when the camera is elevated in this way there is a greater chance of vibration and movement. You should, instead, set the legs to the height you need, and then raise or lower the center column only as required to get the exact height you want. If you use the center column only for plus/minus an inch or two, so much the better.

Occasionally a tripod will come with both a short and a long center column, but more often than not you'll need to buy the short one as an extra item. As I mentioned earlier, many tripods let you position the legs extremely low to the ground. In order for this to be effective you need a short center column to get your camera as low as possible. Alternatively, some tripods are furnished with an adapter that allows using the legs with no center column at all; the camera or head fastens directly to the top of the legs, which makes it possible to flatten the legs out so the camera is only an inch or two from the ground.

A few models let you remove the center column and use it as a monopod, which adds versatility without increasing the number of things you must carry around. The only other choice you're likely to make in regards to your center column is whether the column moves freely, or has a gear mechanism that raises or lowers it in increments. A so-called "rapid" free-moving column (see Figure 1.4) can be faster to use, but makes it more difficult to reproduce a particular height setting, while a geared column simplifies raising or lowering the camera a little at a time.

## Leg Deployment

How do you extend and collapse the legs? Generally tripod legs are released one of two ways, either by un-tightening knurled rings at each section or by flipping locking levers at each

**Figure 1.4** A rapid, free-moving center column is fast to use, but less precise.

> ### STEADY AS SHE GOES
>
> However, at times you really must use the full length of the center column because the tripod itself simply isn't tall enough. This might be a perfect opportunity to hang a weight from the hook at the bottom of the center column offered on many models. (I use a mesh bag of the type that holds oranges, because it can be filled with rocks, then emptied and compacted down to fit in a pocket.) The extra weight will tend to steady the center column and tripod.

section. I've worked with both, and I prefer the knurled rings. With practice you can tighten and un-tighten them very quickly and easily. While it might seem like levers would be faster and easier (and sometimes they are) they can also be set too tight and be painful to release or lock. I've even used a tripod in the $100 range that had levers that could crack and break if squeezed shut when the locking mechanism was not lined up properly. My advice is to try each style and figure out your own preference.

Keep in mind that as the number of sections increase, the ease with which you extend and collapse the legs grows in importance. A three-section tripod with a particular type of locking system may be much faster to deploy than one with four (or even five) sections and the exact same system.

## Feet

Most tripod legs come with a combination spiked/rubber stubbed feet. You spin the rubber stubs in one direction to expose the spikes and then in the other to hide them again (see Figure 1.5). The idea is that the spikes give better purchase in dirt and sand, while the stubs protect wooden and tile floors and other surfaces that might be scratched by the spikes. Consider the type of photography you do to determine whether you need this feature. Some vendors offer add-on spikes that can be purchased if you later discover you need this capability.

**Figure 1.5** Spiked feet can grip loose surfaces like dirt or sand.

## Leg Range of Motion

Many tripods are capable of locking the legs into a standard position for use on level ground, but can also be further unlocked so one or more legs can be raised up at a right angle to the tripod head. *Independent* leg movement is a definite plus. It is helpful on uneven ground or in cramped quarters where you might have to get creative to position your camera. I was shooting a bike race once and set my tripod up in my car with my camera triggered by a cable release. I could pace riders, shooting at a slow shutter speed and get a sharp rider and blurred background showing the rider's speed. It was only because the tripod legs could be deployed at crazy angles letting me position two legs on the floor and one on the car seat that I was able to work that way.

More recently, I was taking pictures at the edge of the Virgin River in Zion National Park. The shore area where I set up was very narrow, so I adjusted two legs to rest in the sand at the edge of the water, while the third leg was shortened and angled out so that it rested on the bank two feet farther away (and two feet higher).

## Leg Wraps

One other useful consideration for your tripod is a set of foam leg wraps. Some come with them permanently attached. These slide over your tripod legs and make the tripod much more comfortable to carry on your shoulder or back of your neck (some photographers carry their tripod by positioning it on the back of their neck and shoulders and draping their arms over and around the tripod. It's effective, but can be uncomfortable without leg wraps).

**Figure 1.6** Leg wraps make carrying a tripod more comfortable.

# Tripod Heads

The tripod head holds your camera, and allows adjusting its position once the legs have been extended and fixed in place. You'd think any old head for your tripod legs would do. In fact, you'd think it would be easier just to purchase a complete tripod and not have to worry about the whole issue. Well, it *would* be easier, but it wouldn't necessarily be better. In fact, if you buy one of those $49.95 specials with a fixed tripod head, you're losing a great deal of flexibility.

Purchasing the head that best suits your needs is the second most important decision you can make when it comes to camera support—or perhaps even the first, as you can get by with legs that are too heavy or slow to set up, but most of your picture taking adjustments once you've set up come from fiddling with the tripod head.

Tripod heads help you get your camera oriented the way that works best for your photograph. For some types of shooting, positioning is no big deal, but for others, the right head can mean the difference between getting the shot and not getting it. Let's take a look at some of the choices available and their strengths and weaknesses. Here are some basics on the type of heads you can choose.

◆ **Three-position heads.** This is a simple head that lets you control the camera's position on X-, Y-, and Z-axes. You have three separate locks to unlock and three separate movements to make, but you gain very specific control over how your camera is positioned. Some very nice things about the three position head are its low cost, small size, and relatively light weight. The big drawback is that it can be a slow process to try to get the head and camera positioned exactly the way you want. Fail to tighten one of the knobs properly and your camera tilts unexpectedly too.

◆ **Video heads.** Video-style heads are really designed for video cameras (d'oh) but some photographers like them for still cameras too. A video head features a longish handle that twists to loosen or tighten the head. Loosen the head and swing the camera around and pan and tilt it while a separate control lets you swing the camera from horizontal to vertical. It's not a bad system, although sometimes the handle gets in your way when you're trying to look through the viewfinder. There's a difference though between a video *style* head designed for still cameras versus a true heavy-duty video head made just for video. These heads won't orient your camera vertically the way a still camera capable video head will. Another version of these heads is known as "fluid" heads. This variant uses a liquid to create a damping effect that smoothes out its movements. This feature is more important for video than stills, but if you shoot both, it's worth considering. Fluid heads can get pretty expensive, but there are some inexpensive ones that work well too.

## HEADS FOR MONOPODS

Any of the heads you can buy for a tripod can generally be purchased for and mounted on a monopod as well, although monopod heads are often smaller and lighter because they don't need to support the camera and lens entirely on their own—you're there holding the combo.

However, I suggest you try working with your monopod for a while before you invest in a head for it. You may not need one. A monopod can be easily tilted at an angle to re-aim a camera, and rotated to change the orientation. Some models have an optional wide swing foot that makes this even easier. I even tilt the monopod and brace it against a wall or other support when shooting vertical images. However, I'll grant you that a ball head does make a monopod easier to use for vertical shots, and a simple up/down swivel head can come in useful when photographing subjects that are much higher or lower than a horizontal vantage point (hot air balloons and mushrooms come to mind).

◆ **Pan/tilt heads.** Pan and tilt heads (see Figure 1.7) are inexpensive and flexible choices for the photographer on a budget. They offer separate handles for pan, tilt, and swing movements unlike the video head, which combines all of these in one control. While that may sound like more work, it does come in handy when precision is required because you can set each type of movement in turn, then worry about the movement. When you're working with a video-style head it can be hard to get all the swings and tilts dead on without a lot of fussing. Some photographers love the control they provide while others find these frustrating.

◆ **Ball heads.** These ball-and-socket mounts (see Figure 1.8) are the heads that most advanced photographers prefer. They are available in pistol-grip type configurations, plus the standard ball head, as described in the next section.

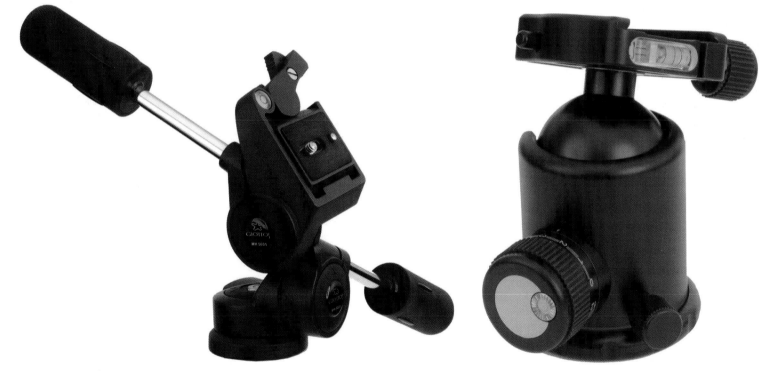

**Figure 1.7** Pan/tilt heads are the simplest and least expensive type of tripod head.

**Figure 1.8** Ball heads provide a great range of movement.

11

# Ball and Gimbal Heads

My personal favorite, the ball head, and a related device, the Gimbal head, let you rapidly position your camera with comparative ease. Twist a knob with one hand and swing your camera into position with the other. Get it set just right, and twist the knob in the other direction and your camera's locked in.

The problem is that a good ball head usually isn't cheap and a cheap ball head usually isn't good. If you're putting a lightweight point-and-shoot or dSLR on it you might get away with an inexpensive ball head, but for heavier cameras or camera and big lens combos, it will cause you lots of frustration. Trust me on this one, if you're looking to use a heavy camera and large lenses and want to use a ball head, make sure you buy a good one.

A decent ball head may easily cost as much as your tripod legs, and, at such prices, will be a wise purchase.

I own and use five different ball heads. One is an expensive jewel of a ball head made by Arca-Swiss, which more or less sets the bar (high) for these devices. It's priced at more than $300, and I generally use it only in the studio. Two others are sturdy but inexpensive models from Induro (also sold under the Benro name), which cost between $100-$200 and are suitable for light-duty use, despite a couple quirks (if you loosen the wrong knob—say, mistaking the knob that sets the friction placed on the ball for the one that locks it down—the knob can fall out and be tricky to re-insert). My current favorites are two Korean models with the unlikely name Photo Clam. I have one heavy-duty

Photo Clam that's every bit the equal of my pricy Arca-Swiss in features and precision, and a smaller one that's a perfect fit for my tiny Gitzo Traveler tripod. (You can find out more about these heads at www.reallybigcameras.com.) I also have used and highly recommend ball heads from Kirk Photo, Really Right Stuff, and Markins.

Although pistol-grip ball heads, like those available from Bogen/Manfrotto, are popular, the ball mounts found on these are generally smaller than those found on a traditional ball head, which I prefer for their extra solidity. A good ball head supports your camera solidly, allowing the tripod to do its job of eliminating and damping any sharpness-robbing vibration. It should be fast to operate, with controls that are intuitive to use, because framing your image should be

instinctive, and not a chore. Here are some things to consider when choosing a ball head.

◆ **Select the right size for the job.** You want a ball head that's compact and light in weight, but which is rated for the load you'll be asking it to support. The diameter of the ball itself determines the size of the surface that will be available to support the weight of your camera and lens. My most-used head, for example, has a 48mm (1.89 inch) ball, which is in the middle of the (33mm to 74mm; 1.3 to 2.9 inch) range. It can support up to 110 pounds, which is enough for medium-format shooting with a heavy lens, and plenty for the sports photography I do with a Nikon D3 and long telephoto lens. Yet, this head weighs less than 20 ounces, so it doesn't add a lot of heft to my kit. You might find other models more suitable for your work, particularly if you're backpacking or using a very light camera/lens combination. My smaller, 33mm ball head weighs just 11 ounces, but can support up to 66 pounds.

◆ **Easy friction adjustment.** The key to fast operation of a ball head is the ability to adjust the amount of "drag" on the ball head, or its tightness. When you unscrew the main tightening knob, the ball head should pivot readily to the new position without a lot of effort, yet not so easily that gravity flips the camera all the way down. Different camera/lens combinations have different weights, so the amount of tension on the ball head needs to be adjustable.

My favorite ball heads have the friction adjustment in the main knob that includes an indicator scale, with a thumb-twist dial embedded in the knob's face to allow you to quickly set minimum friction. (See Figure 1.9.) I prefer this to the dual-knob setup some of my other ball heads have. Although units having a second knob make the friction knob smaller, it's easy to get mixed up when working fast, and change the tension when you meant to lock or release the ball head. That means you have to reset the friction setting before you can proceed. The drag adjustment stays set for a full shooting session, and I don't have to fuss with it until I switch to a heaver/lighter camera and lens combination.

◆ **Camera lock and Arca-Swiss-type mount.** The Photo Clam models come with an easy push-button lock that engages a slot in the camera plate, so you can't accidentally drop your camera should you turn the plate release knob unintentionally, or are not holding the camera solidly when you remove it from the ball head. The availability of safety measures like this are one reason why I prefer the Arca-Swiss-type quick release mounting system over the Bogen/Manfrotto design's lever-type lock. It just seems safer to me.

◆ **Panorama swivel.** Don't buy a ball head that doesn't have a panorama adjustment that allows you to rotate the camera horizontally. Degree markings on a pan swivel let you rotate a specific number of degrees so you can overlap images for a real panorama shot (for best results, rotate around the optical center of the lens, not the camera's tripod mount; there are special adapters you can use for that, if necessary). If you're not shooting an actual panorama, the swivel makes it easy to change the camera's view smoothly without unlocking and adjusting the ball. Once you've made the adjustment, you can fix the position using a locking knob (see Figure 1.9).

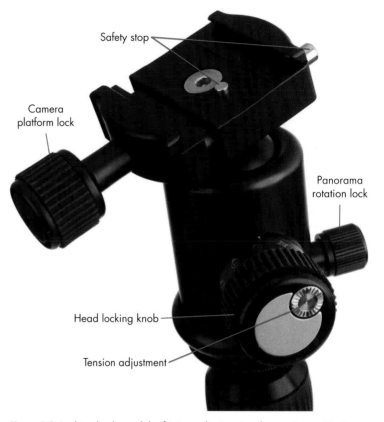

Safety stop

Camera platform lock

Panorama rotation lock

Head locking knob

Tension adjustment

**Figure 1.9** Locking knobs and the friction adjustment make precise positioning easy.

◆ **Bubble level.** A pair of large, easy-to-read bubble levels help you straighten the camera horizontally and vertically, even if the tripod is mounted on uneven terrain. (See Figure 1.10.)

◆ **Drop slot.** This is a slot, shown in Figure 1.10, that accepts the ball head stem, allowing it to pivot the camera into a vertical orientation. I prefer a single drop slot over the dual notches offered with some other ball heads. When I want to tilt the camera into a vertical orientation, or shoot straight down, there's one less decision to make. I just pivot the upper half of the ball head into the slot, lock, and shoot. If the camera is pointing the wrong way, I loosen the panorama locking knob (described earlier), and rotate the camera to suit.

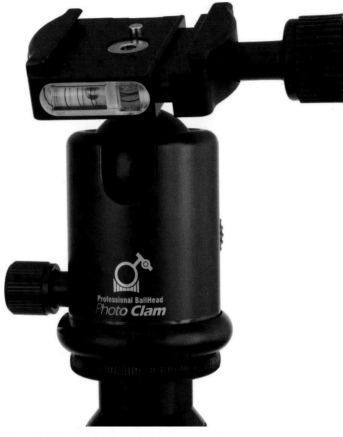

**Figure 1.10** Bubble levels and other amenities allow more accurate positioning of a ball head.

I can't emphasize enough that you should avoid the temptation to skimp and get a cheap ball head because it looks like it can do the job—don't. Ball heads that are "almost good enough" are like a pebble in your shoe on a long walk. Sure, it's a small pebble, how much pain can it cause? Well, the problem with a ball head that's almost good enough combined with a big telephoto is that it can drive you just as nuts as that pebble. The problem is known as "creep." Go to position your lens to compose the shot, tighten the ball head, and oops! The lens drops an inch or two, not enough to risk your precious glass, but enough to ruin your composition. You end up playing a guessing game trying to position the lens to where you think it needs to be and then hoping it falls into the right place as you frantically tighten. Quality ball heads lock into position like my cat in front of his dinner plate, nothing gives!

## Gimbal Heads

Rolling in money? Spend most of your photographic time wielding big lenses trying to capture birds in flight? A Gimbal head could be the choice for you. Gimbal heads (shown with a lens mounted on a film camera in Figure 1.11) call for complicated and precise alignment of camera, lens, and head, but pay off with incredible balance and control of what is usually a heavy and cumbersome pair. A properly balanced 600mm f/4 monster lens on a big, bulky pro dSLR can be rapidly swung to follow a fast moving target with very little effort. While it's possible to find a smaller version that can manage up to a 300 f/2.8, if you need to work with anything bigger, expect to spend upwards of $500 for one.

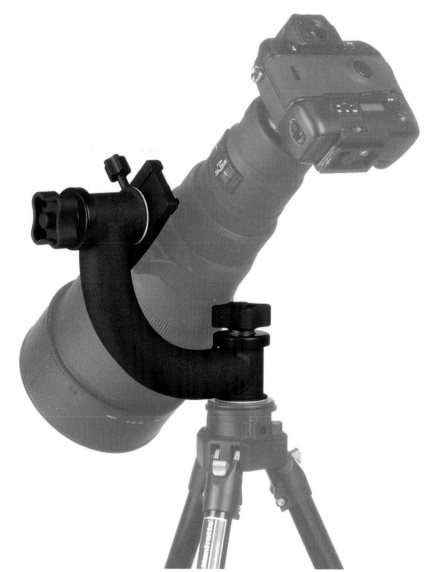

**Figure 1.11**
A Gimbal head is particularly useful with very large, heavy equipment.

# Quick Release Systems

Pro football quarterbacks aren't the only ones who need quick releases; photographers who change lenses often and shoot from tripods and monopods do too. It's not a real big deal if all you're using are wide-angle lenses, but if you're regularly switching between telephoto lenses, a quick release system is a good idea. It's also handy if you're going to be switching between cameras (such as when spouses are taking turns using the same tripod).

The idea behind a quick release system is that you have one part that attaches to your tripod head and then another that mounts on the tripod foot of the telephoto lens or zoom, or underneath your camera. This way, rather than unscrewing your lens or camera from the tripod head, you just push a button and pull your camera and lens off the tripod. Swap lenses and so long as the new lens has the right adapter plate, pop your camera back on the

tripod. Trust me, it's much faster this way.

There are a fair number of choices out there, but one of the most popular is the Bogen/Manfrotto quick release system, which works well with the Manfrotto pistol-grip ball heads as well as pan-and-tilt and other smaller camera mounts. This system includes two parts: a tripod platform, which you can see at left in Figure 1.12, and a camera plate, shown at right in the

figure. You can view the two parts mated together in Figure 1.7 in the "Tripod Heads" section.

For heavy-duty and pro use, the most popular quick release equipment uses the Arca-Swiss compatible system used by higher-end ball heads. You'll find proprietary quick release systems available for specific tripod models, too, and even the Gorillapod (described later) comes with its own quick release mechanism.

Quick release systems come in several different parts. These include:

- **Tripod platform.** This component fastens to the top of your tripod legs or head, and accepts the other half of the quick release system. Many ball heads come with the tripod platform permanently attached. That means you don't have an extra piece to come loose, but also that you're locked into that type of quick release system for that particular tripod. Usually, it also means you must use the same quick release system with all the tripods you own, because your cameras will have the matching plate attached. This platform may have bubble levels included, a locking knob, and, often, a camera lock mechanism that keeps your camera from sliding out of or off the tripod platform. If your tripod mount does not have either (usually) a Bogen/Manfrotto or Arca-Swiss-style platform, you'll need to buy one. (See Figure 1.13.)

- **Camera plate.** This component attaches to the bottom of your camera, and mates with the tripod platform, allowing you to quickly attach and detach your camera

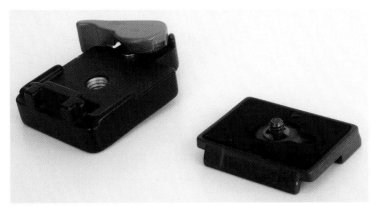

**Figure 1.12** The Bogen/Manfrotto quick release system is a lower-cost alternative.

from the tripod. Some vendors, such as Kirk Photo and Really Right Stuff, go to the trouble to machine custom-fit plates that fit snugly on the bottom of each and every digital SLR made. Some camera plates, called L-plates, have two sets of mounting grooves—one on the bottom of the camera for positioning the camera on the tripod in horizontal orientation, and a second set on the side of the L-shaped plate for positioning the camera in vertical orientation.

◆ **Lens collar shoe.** Longer lenses have a collar around their diameter with a threaded tripod shoe. It's usually wiser to support a camera with a telephoto lens by the tripod collar, rather than by attaching the camera directly to the tripod (which places all the weight of the heavy lens on the camera body's lens mount). A plate similar to a camera plate can be attached to the lens collar. Some vendors make

**Figure 1.13** Mounting plates attach to your camera and snap onto the quick release platform.

plates that are sized for specific lenses, but a general-purpose plate can be used as well. Lens collars are especially useful when using monopods, because you can loosen the collar lock and rotate the lens/camera to switch from horizontal to vertical orientation (or anything in between).

◆ **Replacement lens collars/ shoes.** A few of the most popular lenses can be fitted with an entire replacement lens collar with an Arca-Swiss-compatible shoe tripod plate. Alternatively, you can purchase only a replacement shoe with built-in tripod plate. These replacements make the attachment to the tripod more solid and, in the case of some lenses, improve steadiness that was lacking in the original lens collar/shoe. One particular Nikon lens, for example, is noted for its "flexing" tripod shoe, making the third-party replacement component almost mandatory. (See Figure 1.14.)

## Quick Release Considerations

When choosing a quick release system, don't skimp, particularly if you have heavy lenses. One of the things to look for is an adapter plate that is designed to lock the lens or camera in solidly.

**Figure 1.14** Replacement tripod collar shoes are available for some lenses.

This means most good systems offer some kind of rectangular tongue-and-groove connection that ensures the lens won't wiggle or spin. There are only one or two round designs that work well at all. Here are some considerations to keep in mind:

◆ **Do you need a quick release system?** If you don't mount your camera on a tripod or change lenses frequently, you can probably get away with tediously fastening the lens or camera to the tripod, and then loosening it when finished shooting or changing lenses. But, personally, I wouldn't want to work any other way. The only drawback is the expense.

◆ **Can you afford the investment?** For maximum convenience, you'll want one camera plate on every camera and longer lens you own, and one tripod platform on every tripod. The pro-style plates for cameras and lenses can cost $60-$180 each, and tripod platforms can be about $80 each (or free if they are built into your ball head). That's not a punishing investment for someone with one or two cameras, and one or two long lenses. In my case, though, I had to shell out for camera plates for six cameras, three lens plates, and two platforms for monopods that I use without ball heads. Ouch!

◆ **Which style to get?** If you like a pistol-grip ball head, the Bogen/ Manfrotto system makes sense. If you want the ultimate in solidity, the Arca-Swiss quick release system is better. Should you have an odd-ball tripod with its own quick release system, you'll be limited in the choices (such as lens mount shoes) you can use. While I have the Arca-Swiss quick release system on virtually all my cameras, various family members have their own tripods and preferences. One uses a Bogen/Manfrotto system (see Figure 1.12) on her Nikon D90, while the other prefers a Gorillapod for her Nikon D60.

# Monopods

Sometimes you don't need three legs. Sometimes one is just enough. Monopods offer at least some stability (particularly if they're used properly) and also help take the weight of a heavy camera and lens combination off your neck and put it where it belongs, on a solid, extendable rod that can double as a walking stick or flash stand in a pinch (more on that later). They're also handy for extending your camera up over crowds or for providing bird's or bug's eye views thanks to your camera's self-timer. You can also mount a remote flash on a monopod and use it for some nice off-camera directional light (more on this idea in Chapter 9 of this book).

Bear in mind, a monopod isn't a tripod "lite." Whereas a good tripod can open you up to the world of 30-second exposures, even the best monopod isn't going to give you much more than an extra stop or two's worth of shutter speed gain. That telephoto shot that displays camera motion with a 1/500th second shutter speed may be as sharp, when using a monopod, as if you used a 1/1000th or 1/2000th second exposure.

Monopods are handy because they carry the weight of your rig (see Figure 1.15) and make your life easier. They are particularly useful when shooting sports with long lenses, because in such situations, a bulky tripod can be impractical or, as I mentioned earlier, even dangerous to you and the players.

There are a wide variety of monopods on the market. Some of them are cheap, but good, solid and heavy pieces of equipment. Some of them are just cheap. It is possible to find a useable aluminum monopod for $30 or so. If you're willing to spend more, you can upgrade to a much better unit. I keep a monopod in the trunk of each of my cars at all times, in a duffel bag that also contains a tripod and a few reflectors. My "main" vehicle stores a sturdy carbon-fiber monopod, while a serviceable aluminum monopod from the same manufacturer resides in my alternate vehicle. Here are some things to consider.

◆ **Material.** While aluminum is good, carbon-fiber is lighter and doesn't get as cold during the winter. On the other hand, an aluminum monopod isn't *that* heavy and gloves aren't *that* expensive. Carbon-fiber monopods aren't cheap. You might find aluminum monopods preferable because of

balance issues. A super light carbon-fiber monopod with a big heavy telephoto mounted on it has a strange balance you might not like.

◆ **Versatility.** There are a few aluminum monopods on the market that offer a bottom section that unscrews to reveal short legs that fall into position when the bottom is screwed back in. Others offer these as an accessory. Once these little legs are deployed, they help hold the monopod up for you. While they're nowhere near tripod-like, they can steady the monopod enough to make your life easier in certain situations. They also make it possible to walk away from your camera and lens while your rig is still being held vertical by the monopod (don't try this on a windy day). Another advantage to this support is that you can turn your monopod into a handy light stand by mounting a remote flash on it.

◆ **Variations.** If you're any kind of a hiker, you've probably seen ads for trekking poles or hiking sticks that have a knob that unscrews off the top to provide a place to mount your camera. These things work

okay if you use the proper mono-pod technique, and if you're on a long hike or backpacking trip, lightening your load as much as possible is a good idea. If you do a lot of hiking photography and like hiking with a hiking stick, these trekking pole/monopod combos are worth trying.

◆ **Techniques.** There's more to using a monopod properly than just mounting a camera on it and planting it on the ground. To get the best possible results, it's neces-sary to maximize your monopod technique. For a right-handed pho-tographer, brace the monopod against your body with the back of the camera pressed against your forehead. Then bring your forward foot (your left one) back against the foot of the monopod at a right angle while positioning your left knee against the opposite side of the monopod. Use your left hand to push the monopod and camera against your forehead. This way you're using your body, foot, leg, hand, and forehead to keep the camera and monopod as steady as possible. It's a little different if you're using a long lens on the monopod mounted at the lens' tri-pod collar, but the idea is still the same.

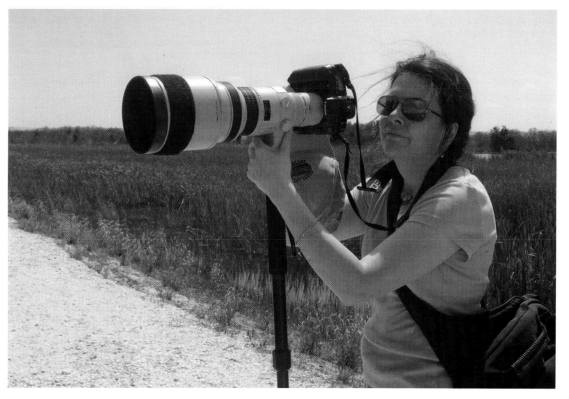

**Figure 1.15** Monopods are perfect for many outdoor activities because they allow the photographer to move and reposition quickly.

# Clamping Devices and Tripod Alternatives

Sometimes a monopod isn't enough, sometimes you don't want to lug a tripod around either, and sometimes you just need a third hand. Fortunately, there is another option that can help you with any one of these issues. While I don't claim you can toss your tripod and go with the ideas in the next few pages, they will give you some options or provide you with a third hand when you need it.

◆ **Plamps.** Plamps are small, articulated arms with spring-loaded clamps on each end. Nature photographers will clamp one end to a tripod leg and use the other to hold a plant (Plamp = "plant clamp" get it!) stem steady. You can also use a Plamp to hold a small reflector or diffuser in place to help improve the light falling on your small subject. They cost around $40 each.

◆ **Super Clamps.** These critters are heavy-duty clamps that latch onto pipes and doors and branches the way my wife does to a box of gourmet chocolate. Super Clamps are sturdy enough to support a pro camera and have a strong enough grip that they can actually break things. They're also capable of accepting a wide range of accessories making them very useful. With the right combination of accessories you can use these to support a backdrop, rig up portable strobes all over the room, or hold diffusers and reflectors where you need them. If you've ever seen a shot of a basketball player that looks like it was taken from the top of the backboard looking down to the floor, odds are it was done with a camera mounted on the backboard with a Super Clamp and remotely triggered by a photographer shooting from another location. Super Clamps cost from $25 to $50.

◆ **Magic Arms.** This is a Super Clamp accessory that's cool enough to merit its own mention. The Magic Arm is an articulating arm that mates to the Super Clamp. Unlock the Magic Arm and you can position it any way you like; get it in the right position, lock it, and it's sturdy and safe. I've used a Super Clamp/Magic Arm combo at track meets to mount my camera and big zoom on the tube of the quarter-mile track's fence. With the camera and lens on a ball head I could swing the lens around and cover the runners as they raced down the track photographing each runner in race. You can also use the combination to mount remote flashes or position light modifiers of various kinds. There are several different types of Magic Arms to choose from ranging in price from $80 to a little over $100. They can even be ordered with camera-mounting platforms.

◆ **Flex arms.** Don't need to mount your camera on a Super Clamp, but still need some help? You can get a flexible arm that lets you mount Super Clamps on each end and use the rig to hold a diffuser, reflector, or flash in place. You can also get a suction cup mount that's powerful enough to hold the flex arm in place with a flash or small camera attached. Flex arms cost anywhere from $18 to $25.

◆ **Window mount systems.** Often your car can serve as more than just transportation. In fact, it can make a pretty good shooting platform and blind. If you're into bird photography, you car can get you closer to the birds than you can on your own since the birds are less afraid of your stationary vehicle than they are of you. You can make your car even more effective by outfitting it with a window mount or car-top mount. Heavy-duty window mounts rest on your open car window and have

supports that place the weight of your camera rig against the inside of the car door. High-end window mounts are designed to support a lot of weight and can double as ground or car-top platforms and run a couple of hundred bucks or more. For smaller rigs, camera makers such as Nikon and others offer something that slides onto your window and supports your camera that way. While much cheaper, these can put a lot of stress on a car window; make sure you don't put too much weight on one of these and also be careful how much stress you put on it when operating your camera. (See Figure 1.16.)

- **Mini clamps.** There are some smaller clamps on the market that do feature a ¼-inch mount that can screw into the camera's tripod mount. While this might do the job with a small point-and-shoot camera, it won't support the weight of a dSLR. Still, these mini clamps can be useful for positioning small, remote flashes if nothing else.

**Figure 1.16** Window clamp.

## USING YOUR CAR AS A BLIND

As I mentioned earlier, cars can serve as workable photographic blinds (particularly for photographing birds). Here are some ideas you can use to make them even more effective. First off, leave your car in the same location for a few days if possible—this will give your target animal(s) time to get used to your vehicle in their area and get over any fear they might have of it. (Obviously this works better if it's a spot where your target animal goes to regularly.) When you're ready to shoot, come out wearing muted colors and set up your camera rig, then relax for a little while as the birds or other animals get used to the slight change in the car's appearance. Try a couple of test shots to see if the animals notice the noise your camera makes. If they do, try wrapping a towel around the camera's body to deaden the noise it makes.

# Other Tripod Alternatives and Accessories

Resourceful photographers have an arsenal of other, small useful accessories available to them when circumstances don't allow them to carry more traditional support. Sometimes you need to travel light; sometimes travel limitations just won't let you carry even a four-section tripod. The tools on this next list are small, lightweight, and versatile. Most important, they also tend to be inexpensive!

◆ **Beanbags.** The humble beanbag toy from grade school has a bigger brother that actually makes a pretty nifty camera support for a big tele- photo lens. You can place the beanbag on a wall or car hood and balance your lens on it. While you're not going to get tripod-like long exposures out of it, you will gain at least a couple of f/stops stability and reduce the weight you're trying to manage while shooting. Beanbags are nice because you can swing your lens around a bit while still benefiting from the support they offer. If you travel a lot, it's easy enough to fly with the beanbag empty to save

weight and then buy some cheap dried beans at a local supermarket to fill it back up. (See Figure 1.17.)

◆ **Sandbags.** Sandbags hang from a hook on the bottom of your tri- pod's center column to add weight to your tripod, thereby

**Figure 1.17** Beanbags and sandbags make excellent, portable supports that work on a variety of surfaces.

making it steadier. They can also be used to stabilize light stands on a windy day. Sandbags can also be emptied out for travel and refilled with sand or dirt once you're on location. They can also be used like beanbags as camera supports.

◆ **Gorillapods.** Gorillapods are all the rage right now amongst equip- ment freaks because they offer something gadget gurus love— versatility! You can stick a camera on one of these gizmos and place the rig on the ground and have a good, steady device, but that's not where the fun begins. You see, the Gorillapod has flexible legs that wrap around all sorts of things. So while you may want to set these things on the ground occasionally, they're also good for wrapping around tree branches or chain link fence posts or street lamps— the possibilities are endless. Gorillapods come in several differ- ent sizes; make sure you get one big enough to support your camera (when in doubt go with one that's sturdier than you think you need). (See Figure 1.18.)

◆ **Ultra pods.** This is another clever little device for those times you just don't want to lug a big, heavy tri- pod around with you. These cute little creatures collapse down real small, but can support a small dSLR. They also have a handy strap on one leg that allows you to wrap it around a pole to get it up off the ground.

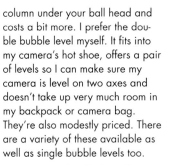

◆ **Quick Pod.** The Quick Pod's a support of a different type. This gadget looks a little like a collapsible golf club with a camera mount on one end. You mount your camera on the end (don't try this with a big, heavy pro dSLR) and now you can point your camera at you for a nice self-portrait from a reasonable distance. This would also work well for creating bird's eye view shots or getting your camera up and over a crowd at a parade or sporting event. There are all sorts of uses.

◆ **Pod.** Finally, there's even something known as a "Pod" (comes in black, yellow, red, blue, green, or silver to go with your outfit). The Pod is a small round cushion-like tool that can hold your camera steady on any reasonably flat surface (such as a car hood or inside a shopping cart—for that interesting behind bars look to your images). These come in a variety of sizes (the color coding actually designates which size Pod you're choosing and what size camera it's designed for so choose wisely). (See Figure 1.19.)

◆ **Leveling tools.** Once you've gone to all the trouble to get a good tripod and learn how to use it, there's one more thing you've got to worry about; that's making sure your photography's on the level, err, I mean that your camera's level. Sure, you can just eyeball it, but when you're working on uneven ground, that's a dicey proposition. You can also plan on fixing the image in Photoshop, but why not get it right when you're making the image? Leveling tools can range from a simple level you pick up at your local hardware store to a dandy little device called a double bubble level (say that three times fast at your next party!) to a tripod-leveling head that mounts on your tripod's center column under your ball head and costs a bit more. I prefer the double bubble level myself. It fits into my camera's hot shoe, offers a pair of levels so I can make sure my camera is level on two axes and doesn't take up very much room in my backpack or camera bag. They're also modestly priced. There are a variety of these available as well as single bubble levels too.

◆ **Bungee cords.** The basic bungee cord is a handy item for the traveling photographer since you can use it to lash gear to luggage carts or tie monopods to tripods or any number of other creative uses. Even more useful is the basic ball bungee cord. This is a bungee cord in loop form with a small plastic ball at the end. Wrap the cord around a branch or pole and slip the ball into the loop and it holds fast. These handy little devices offer all sorts of uses. I've even used them to bungee a remote flash to a monopod or tripod leg. Since my local big box department store sells these critters for something like $2.99 for a bag of 10, I have them scattered in my car and attached to the carrying straps of my camera bags and backpacks so I always have one or two handy if I need them.

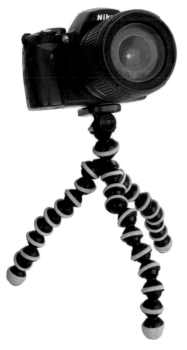

**Figure 1.18** The Gorillapod is a flexible tool—in more than one sense of the word.

**Figure 1.19** Pods can support your camera on any level surface.

# Shooting Long Exposures

Long exposures open your photography up to a completely new world. When you let your shutter remain open for seconds at a time, all sorts of images are possible. Moving water takes on a magical, mystical texture, while cars and pedestrians magically disappear from streetscapes. Long exposures let you maximize depth-of-field for great architectural shots and breathtaking landscapes. They also let you play with ghosts and other spirits.

Combine long exposures with the creative use of flash and even more possibilities occur. Add some colored gels to your flash and create your own eerie glows. The tripod and flash combination also lets you magnify the power of your flash through a technique called "painting with light" explained later in this book in Chapter 9.

Let's take some space to talk about how to make all these great things happen. I'll start with moving water.

◆ **Setup.** Set up your tripod making sure to bring the legs out as wide as possible in their normal range settings and get it to the height you want (hopefully without extending the center column). (See Figure 1.20.) Drape your camera bag over the center column. Next mount your camera on the tripod head and compose your photograph making sure it's level.

◆ **Planning.** Now, start planning your exposure. Exposures of 10 or 15 seconds or more produce a beautiful spun glass effect on waterfalls, streams, and creeks. The problem is, how do you get your shutter speed down that low?

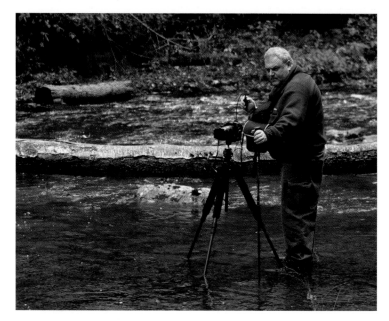

**Figure 1.20** A tripod is a must for a long exposure of moving water.

◆ **Shutter speed.** Start by cranking down your ISO. This not only lowers your shutter speed but also improves image quality. While you're at it, close down the lens to its smallest aperture (f/16 or smaller!). Still not enough? Now it's time to actually block some light from hitting your camera. It's a good time to stick a polarizing filter on your lens. Use it to reduce reflections in the water (sometimes those reflections are beautiful, but this isn't one of those times) and steal some light (polarizing filters can rob you of as much as two f/stops worth of light, in this case, a good thing). Still not enough? Now it's time for either a neutral density filter or a graduated neutral density filter or both (more on these helpful filters later). At this point you should have your shutter speed/f/stop combination right where you want it.

◆ **Execution.** Hook up your cable or remote release. Take one last look through the viewfinder. Lock up your mirror and block light from hitting the viewfinder. Trip the shutter and wait. Once you hear the shot click off (you'll see the LCD screen light up with your photo if you don't hear the shutter trip), check your image (with a magnifying loupe if you have one). Like the shot? Good. Take another couple of shots shifting your shutter speed about five seconds each way. You can end up with a shot like the one shown in Figure 1.21.

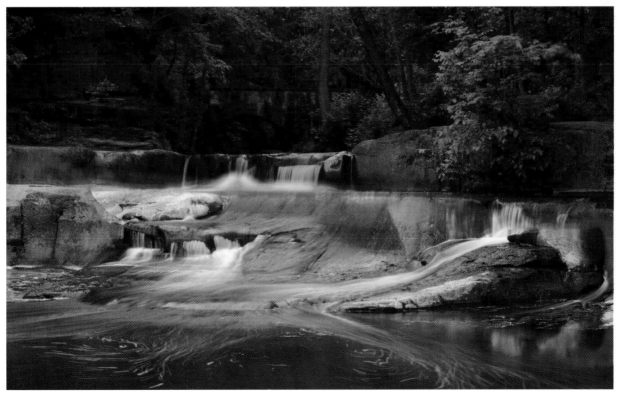

**Figure 1.21**
Long exposures of moving water create beautiful effects like this.

## TABLETOP VS fREESTANDING TRIPOD

Visit your local department store's camera section. Chances are you'll see at least a few tripods advertised that can collapse down from full size to table top, what a deal! Right? Well… not so much actually. You see, in order for a tripod to be able to go from better than five feet tall to a foot or less, it needs a lot of small leg sections. To make matters worse, those leg sections tend to be really thin. In other words, it might be okay as a tabletop tripod, but you're not going to want to put a dSLR and heavy lens on it fully extended. It's better to have a solid full-sized tripod and a tabletop model if you think you need one. Besides, we'll be looking at some other small, lightweight options that work just as well and serve more uses.

**Figure 1.22** A long exposure rendered this amusement park ride as a trail of lights.

## Cityscapes

Need to photograph a busy city street? You can keep your lens open so long that no individual pedestrian or vehicle stays in the frame long enough to register on the image. The technique is similar to the one described above, but emphasizes the longest possible shutter speed (30 seconds is usually the upper limit for a digital camera sensor, much longer than that and the sensor's heat buildup leads to unacceptable noise) and weighting down the tripod to keep traffic caused vibrations from shaking the camera.

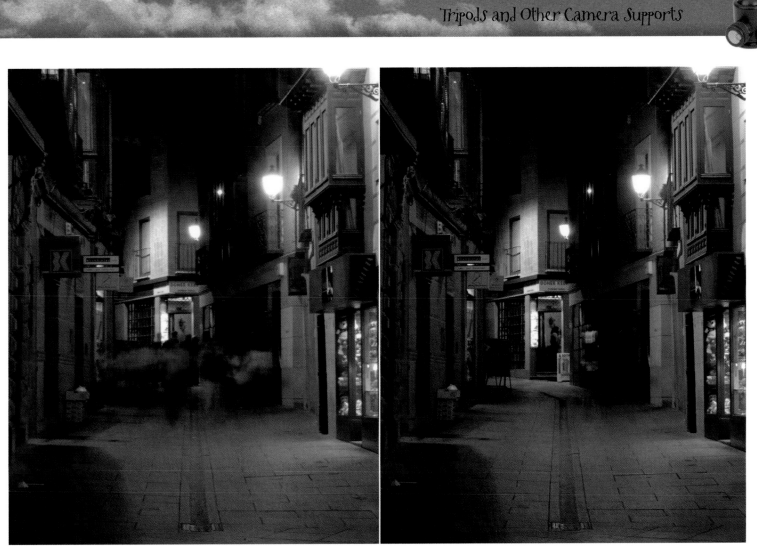

**Figure 1.23** With an exposure of one second, passersby on this European street are blurred (left); at right, with a 30-second exposure, they are rendered invisible.

# Shooting Panoramas

Many of the tripod heads listed above come with increment markings on their base to help you figure out how much to pivot the camera while you're trying to shoot a series of images to stitch together to form a panorama. For those who are serious about the panoramic format though, a tripod head designed for panoramic photography is the way to go.

The reason you need a special head for panoramas is because a regular tripod head places the body of the camera on the pivot point of the tripod. This means the camera's nodal point (the actual frame of reference for the image) is a couple of inches forward of the pivot point, resulting in every shot in the panoramic sequence a little bit out of alignment with the previous one.

Tripod heads designed specifically for panoramic photography allow you to position the camera so its nodal point is precisely over the center of the tripod. This way you can pivot the lens around that center point and create the best-aligned possible panorama. Panoramic-specific heads can run from about $75 to more than $200.

Here are a few tips to help you with creating panoramic images.

◆ **Planning.** First off, plan some overlap on each side of each image you create (at least 20%). This gives you some margin for error as you create your panoramas. Markings on your tripod head's panorama scale can help you overlap shots precisely (see Figure 1.24).

◆ **Alignment.** Also, align your camera vertically and plan on shooting a few more images rather than just a couple of horizontal shots. This will produce a much higher resolution image for you. Photoshop's PhotoMerge feature can stitch all these images together seamlessly. (See Figure 1.25.)

◆ **Lens choice.** Don't try to work with too wide a lens either, something in the 28mm to 35mm range works well. You can work with a narrower focal length, but if you get much wider, you may find your panoramic software has trouble handling the field of view. Of course, if you're stitching it together yourself, this might not be a problem.

**Figure 1.24** Markings on a panorama head allow overlapping your images.

◆ **Leveling.** Make sure your camera and tripod are perfectly level (and yes, you need to be sure each is level, you can't correct for one being off by adjusting the other).

◆ **Other considerations.** Try to shoot under even lighting and look for scenes that lend themselves to panoramic photography.

◆ **Thinking it through.** Think "manual." Determine an effective exposure setting that works for the whole scene. Set your white balance manually too. This way you won't get variations as you travel through the panorama. If you absolutely have to change exposure settings as you move the camera, make sure you make your changes via shutter speed rather than f/stop. Changing f/stops while shooting a panorama will create different depth-of-field looks and may affect the sharpness of the image from one shot to the next. Set your focus to manual as well and don't change the focus point from shot to shot.

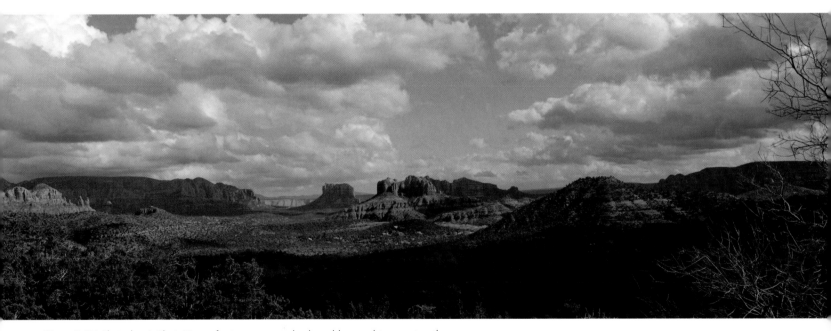

**Figure 1.25** Photoshop's PhotoMerge feature can seamlessly weld several images together.

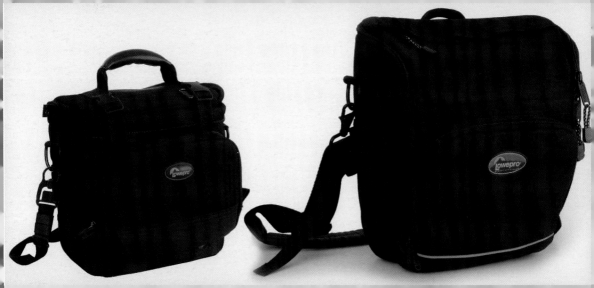

# 2 Toting Your Stuff

Bags, backpacks, and camera cases, oh my! Sooner or later you hit a point where you have to figure out a better way to carry all your stuff while you're out on a shoot. There are all sorts of choices out there and they come in a variety of shapes and colors, with many different features. How do you figure out what's the right bag or case for you?

For a start, how much gear are you going to have to carry? Are you going to be adding to your gear in the near future? What are you going to do with your photography? There's a big difference in the kind of bag you need if you mainly drive up to a shoot and go right to work or do most of your work in your home or a studio, but how about if you're interested in nature photography or backpacking photography? Are you a fair weather or indoor photographer only, or do you light up at the possibilities when Mother Nature turns ugly?

Bags designed for outdoor use frequently include built-in rain covers or at least offer a raincoat accessory. Bags that are designed to be used as part of a system offer the ability to add or remove extra compartments and can be customized, as you need them. For those who need bags for different conditions, this modularity can be very valuable as you tailor each bag to the needs of a particular shoot.

# Camera Bag Basics

Choosing the right camera bag isn't all that difficult, but making the right choice is pretty important. A poorly constructed bag puts your gear at risk to all sorts of dangers. A good bag protects your equipment while still leaving your gear accessible when you need it. A well-designed bag distributes the weight of your equipment at least reasonably well, stands up to some abuse and makes it possible for you to configure the layout of the equipment inside to your personal tastes.

Depending on the bag you choose, the amount of photography you do and the way you use your bag, it's reasonable to expect a camera bag to last anywhere from a year to several decades. If that seems like a huge swing; that's the point. Knowing what you're doing when you're choosing a camera bag is important.

Here are some of the basics you should be considering:

◆ **Material.** The most common material choices for camera bags are ballistic nylon and canvas, but other materials also show up from time to time. Ballistic nylon is strong and abrasion resistant and a little on the stiff side. Ballistic nylon bags take a lot of abuse without complaint. Canvas bags aren't as sturdy or long lasting, but they conform to the photographer's body better. Some of us consider them to be a bit more elegant too. Hard-working photojournalists who favor canvas bags do so even though they know they might not get more than a year's worth of use out of them. It's a cost of doing business expense as far as they're concerned.

◆ **Padding.** While it might seem like the more padding the better when your precious camera equipment is concerned, that's not always true. Some bag makers opt for padding for lens compartments, but not for the main compartment, others pad the whole bag for the most cushioning. Having trouble deciding? If you have to move around a lot, or move quickly with

your bag, the one with less padding will be less bulky and, if made of canvas, move better with you. Many newspaper photographers rely on such bags because they're easier to run with. If your bag's going to be jostled around a lot in the back of a car on the other hand, the extra padding and strength of a more traditional ballistic nylon bag will stand you in good stead.

◆ **Straps.** Avoid bags whose carrying straps are connected only to the sides or tops of the bag. This kind of construction is inherently weak because it puts all the bag's weight on that one point of attachment on each side. High-quality bags have straps that wrap all the way around the bottom of the bag as one continuous strap. If your bag has sturdy strap attachments, like those shown in Figure 2.1, you can replace the original strap with one that suits your needs better. The figure shows the UPstrap (www.upstrap.com) camera bag strap, with its patented non-slip pad. I especially like this strap for bags that I carry over my shoulder, as it reduces the chances of the bag slipping off and crashing to the ground.

◆ **Closures.** Camera bags can be designed with all sorts of snaps, buckles, clips, or zippers. Your choices can sometimes reveal a lot about your photography. A colleague of mine frequently invites me to lecture his sports journalism classes about sports photography. Ron is an enthusiastic amateur photographer who recently got a dSLR for Christmas. Before I spoke to his class he proudly handed me his new camera bag, which was sealed tight with zippers and clips and Velcro. "You're kidding, Ron!" I told my friend, "The game's going to be over before you ever get your camera out of this thing!" A good bag will offer at least two closure options. Option one is for when you're sticking it in the closet because you're not using it in a while (obviously this should hardly ever happen because you're shooting regularly right?) and a second easy-open, easy-close option such as that provided by Velcro under the top flap so your bag automatically seals a little. Bags that close this way won't accidentally flip open by chance, but can be tugged open quickly and easily. Add a set of clips or buckles and you've really got all you need to keep it properly closed.

**Figure 2.1** The UPstrap has a patented non-slip pad that keeps your bag securely on your shoulder.

◆ **Rain covers.** Some bags come with rain covers built in. (See Figure 2.2.) While the average photographer may not do a lot of photography in the rain, unexpected rainstorms still happen. The built in rain cover can protect your equipment while you head back to your car. For pros, shooting in the rain isn't an uncommon experience. My own personal rule is that if the subject I'm shooting is still doing their thing, then I should be able to continue doing mine. With the right gear (some of which we'll talk about later in this book) you won't have to let the weather scare you.

◆ **Compartment covers.** Every external compartment whether it's the bag's main compartment or an accessory one, should be covered by a flap when the bag or the compartment is closed. If it isn't and you get caught in a rainstorm, whatever's in that compartment will get soaked.

**Figure 2.2** Some camera bags have their own raincoats built in. These raincoats can keep your equipment dry even when you get caught in a sudden shower.

◆ **Stitching.** Good bags rely on quality stitching, not rivets. Check key points of attachment and look for something called a "box" stitch. This stitch looks like a box with an X through it, and is the strongest stitch used for camera bags. If a bag you're considering doesn't have a box stitch in sight, you should be concerned.

◆ **Attachment points.** Many camera bags offer D-rings or other attachment points. These make it possible for you to clip filter holders, water bottles, or other useful accessories to the bag. Even more advanced are bags that have attachment points designed for the many modular systems designed for photographers. These let you add lens cases, filter cases, and all sorts of other accessories. I own seven camera bags (having given away or sold three others). Of these, five accept modular attachments. These are the five bags I use. It's just so much more useful to add and remove pouches as I need them rather than be stuck with just the basic bag.

# Size Considerations

How big a bag do you need? A working pro who has more gear than could ever be carried needs versatility and may have a collection of bags ranging in size from small to huge. (See Figure 2.3.) (You can tell working pros who rely on only huge bags by their pronounced tilt in the direction their bag hangs.) Since many years of wearing a heavy camera bag can lead to back and shoulder problems, many of us try to find ways to keep our loads manageable, hence the range of bags.

For the photo enthusiast who doesn't have a lot of equipment, but hopes to build a camera system, choosing a bag can present a conundrum—buy a bag that fits what you have now, or one that will hold the system you hope to have? My advice would be to go with a modular system that starts with a basic bag that's a little bigger than your current equipment load. A bag that can hold a camera body, flash unit, and a couple lenses is a good starting point. Such a bag usually includes a couple of pockets for

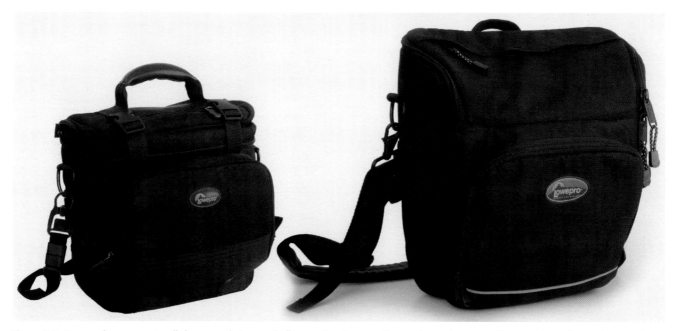

**Figure 2.3** Camera bags come in all shapes and sizes and offer varying degrees of versatility and security. Choosing the right size bag can be simple if you don't have much gear, but it can be a real challenge for the photographer who owns a lot of equipment.

accessories such as filters, extra batteries, and other odds and ends. Since it's modular, you'll be able to add a pair of lens cases if you add another lens or two, or a water bottle holder or a filter case.

Another question is what style of bag will you need? This is a bit more complicated because there are more than a few choices. We'll take a look at them over the next section of this chapter, but first here are some things to think about when it comes to choosing the right size camera bag.

◆ **Your gear.** How much equipment do you own? For many people (who don't own a lot of gear), their camera bag is going to hold every bit of photographic kit they own. (See Figure 2.4.) If this is the case, finding a bag that fits everything is easy. Some of us though, have enough equipment that trying to take everything we own just isn't feasible. Instead, we look at the requirements of a shoot and take what we think we'll need. Choosing the right bag for this sort of need is a bit harder.

◆ **Do you need a system?** You might be better off investing in a modular bag system (discussed later in this chapter). This kind of approach lets you modify your bag to your particular needs. For instance, if you were only going to carry a camera and lens plus spare batteries, why would you want to lug a big camera bag around?

◆ **Storage.** A camera bag designed for daily use makes some sacrifices as far as strength and security go; if you're going to store your gear for a while, perhaps something designed for greater protection is warranted. If so, should it be big enough for all your gear, or just the most valuable equipment?

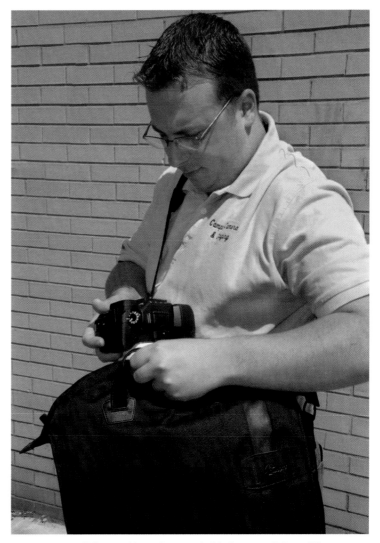

**Figure 2.4** A well-designed large bag can hold all your stuff, but still let you grab what you need without setting it down.

# Traditional Shoulder Camera Bag

A tried and true choice, the traditional camera bag has a strap that hangs over your opposite shoulder and positions the camera bag against your dominant side's hip (for a right-handed photographer, this means the strap rests on your left shoulder and the bag lies against your right hip). Don't get in the habit of resting the strap on the same shoulder as your dominant side; it's not very secure there. (I once lost a camera bag and some really nice images in Naples Bay in Italy that way while I was transferring from a small boat to a U.S. Navy destroyer.)

Let's look at some things to consider when buying a traditional camera bag:

◆ **Lens and body inserts.** Does the bag come with removable inserts and Velcro partitions so you can reconfigure it to your needs? This is pretty basic these days and most bags offer this feature.

◆ **Accessory compartments.** A good bag offers at least a couple of small compartments on the outside of the bag or built into the cover. These compartments are handy places to stick odds and ends such as the camera's field manual, a notebook or digital recorder, or extra batteries. (I even stick a tightly folded up $20 bill and a parking smart card in my everyday bag just in case I forget my wallet.)

## ORGANIZING YOUR BAG

Once you've chosen your camera bag, it's time to fill it. Before you start shoving gear in there willy-nilly, do some planning. Here are some questions you should be asking yourself. Your answers will help you figure out how to store things. How do you tend to use your equipment? What gear do you typically need on a shoot? What are you going to use most often?

If you're looking at a camera body, a couple of lenses and a flash for your basic outfit, it shouldn't be too hard to configure your bag, but, as my wife always says, "You've got to accessorize!" Some things that should make their way into your bag include a polarizing filter, extra batteries for your flash (and camera), cleaning cloth, Lens Pen or blower brush, small notebook or recorder (for taking notes on locations, ideas, and more), and extra memory cards.

It's also good to have some emergency items stashed away. Things like plastic bags and those small rain ponchos for use during sudden downpours can help keep you and your gear dry. Many shooters like to take about a foot of Gaffer's tape (more on this item in a later chapter) and wind it around a tongue depressor and toss that in the bag too.

Try to pack your bag the same way each time. Then, once you've been using it a while, you'll be able to reach in and grab what you need without having to look in the bag. This isn't a big deal for some types of photography, but if you're shooting sports, events, or even your 2-year-old, taking your eyes off your subject can result in a missed opportunity.

◆ **Hand strap.** Does it have a hand strap in addition to the shoulder strap? Sometimes you just need to pick your bag up and carry by hand rather than slinging it over your shoulder. Hand straps are useful for this, plus they can be used to add your bag's weight to a tripod's center column by hanging the bag from a hook at the base of the column.

◆ **Easy access.** Sometimes you want a bag that makes it easy to get at your equipment even when the bag is sealed shut. This is a time when a bag that offers access through the bag cover (via a zippered opening) comes in handy. With the zipper shut, it's a normal bag cover; with it open you can reach inside your bag to pull out a lens or accessory, but your bag is still mostly closed. (See Figure 2.5.)

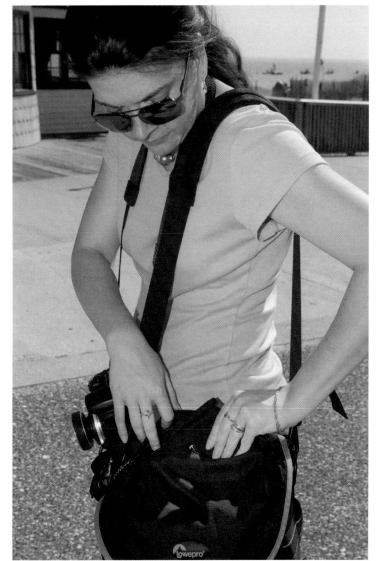

**Figure 2.5**
Easy access. Some camera bags make it possible to get things out of the main compartment without actually opening the bag cover.

# Photographic Backpacks

Camera backpacks are great when you have to haul a lot of equipment and want to carry the load as sensibly as possible. During the past 40 or 50 years, backpack design has undergone a revolution. Once upon a time backpacks (or "rucksacks") were literally sacks with a couple of shoulder harnesses. Unless you were an expert in load distribution and planning, you generally had a miserable time carrying any weight for any appreciable distance.

That's not the case these days. Backpacks, whether they're designed for photography or not, are capable of distributing the weight in such a way that your body carries it as efficiently as possible. If you love the outdoors and want to be able to carry lots of gear to remote locations while carrying that gear under your own power, a backpack is the way to go.

Here's what to look for in a camera backpack:

◆ **Size.** How big a bag do you need? Camera backpacks range in size from small daypacks that don't carry much more than body and lens and a few small odds and ends to monsters that when fully loaded could stagger a pro football offensive lineman (okay, I'm kidding, but only a little). As the bag's carrying capacity increases, so does its price too, so think this one over carefully. Remember, many camera backpacks are designed to be part of modular systems, so you can expand their capacity as you need to.

◆ **Chest strap.** Once you start looking at a bag that can carry a good sized load, construction features become incredibly important. A chest strap holds the two shoulder straps in position so a heavy bag doesn't start pulling off your shoulders.

◆ **Waist belt and hip padding.** A good waist belt and hip padding are vital in a larger camera backpack. In fact, it may be the most important feature the bag can have. In a well-constructed camera backpack (or cargo pack for that matter) the waist belt and hip pads take most of the bag's weight and put it on your hips instead of your back and shoulders. Your hips and legs are much more capable of bearing the weight and are where that weight belongs.

◆ **Shoulder strap tensioning straps.** These straps snug the shoulder straps tighter so your backpack fits more closely to your body. A good backpack, properly adjusted conforms to your body like your skin. It moves with you rather than against you and rides comfortably without chafing or rubbing against your body, which can cause blisters or sore spots.

◆ **Hydration bladder pouch.** Hydration bladders let you carry water in a backpack or knapsack and drink it without having to stop and pull out a water bottle. These bladders come with a long tube that ends in a bite valve. A well-designed pack has an outer pouch where you can slip the bladder and then thread the tube through a ring on your shoulder harness. You position the bite valve near your mouth and when thirsty can just turn your head a little and have a drink. You never have to break stride or take your hands from your trekking poles (if you're using them).

◆ **Tripod attachment.** Once you get to a medium-sized camera backpack you should start finding models that offer a way to attach a good-sized tripod. In fact, I wouldn't even consider a camera backpack that didn't offer some way of attaching a tripod unless I was looking at one of the really little versions. If you can't attach your tripod to the backpack how else are you going to carry it? (I do know of at least one photographer who prefers to carry his tripod on his neck and shoulders rather than attached to his backpack. He even does this for longer hikes.) (See Figure 2.6.)

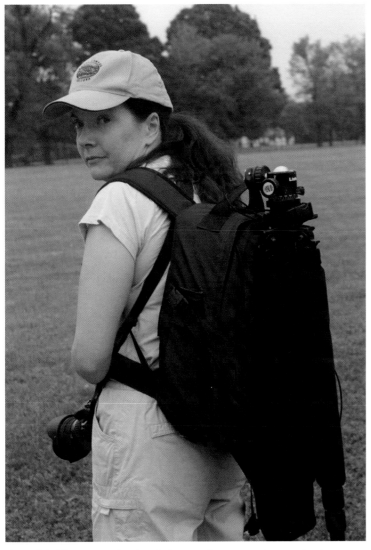

**Figure 2.6** Most camera backpacks have a place to attach your tripod.

## Backpack Accessories

There are several important types of backpack accessories. Not everyone will need these, but you should at least consider whether or not they make sense for your photography.

- ◆ **Camera raincoats.** These are usually pretty inexpensive, but can do a good job of keeping your pack dry. They're small enough that they won't take up much room in your pack either.

- ◆ **Modular accessories.** It's often useful to be able to add pouches and cases to the backpack's sides and various straps. My camera backpacks have little loops in the shoulder straps where I can attach a memory card wallet and pouch for trail snacks or a light meter. Such conveniences mean you don't have to remove your pack to get at the things you're most likely to need while hiking.

- ◆ **Packsafe.** Suppose you're camping for the night, or heading off to the lake for a swim. Do you really want to leave your backpack full of expensive camera equipment just lying in your tent? Packsafes are steel mesh webs that can be used to secure your backpack to a nearby tree and lock it in place. While it's not impossible to break through this system, it's unlikely that anything less than a thief with bolt cutters will have any success.

# HOW TO SHOP FOR A CAMERA BACKPACK

When shopping for a camera backpack it's important to really make sure the bag fits properly and can handle the load you need to carry (see Figure 2.7). Choose the size based both on how much you want to tote, and how much you can comfortably carry. If you check out a large backpack, and find that the equipment you typically carry in it weighs 35-40 pounds, you might want to reduce your expectations and go with a slightly smaller bag and less gear. For long treks, I find a lighter backpack and less equipment goes a long way (in several senses).

This is one of those times where going to a local camera store with a staff that knows what they're doing can really pay off. Your goal is to load the pack up with the typical equipment load you plan on carrying (including your tripod) and make sure you can get in and out of the bag's harness comfortably and easily. You also want to make sure the waist belt and hip pads fit your body securely and you can use the tensioning straps to fit the bag to your body snugly. Once all this is done, walk around the store for a few minutes, go up and down stairs if you can, change directions and postures. You want a bag that feels comfortable while you're moving with it on. It shouldn't limit your range of movement much either. You should also feel comfortable with the weight on your back and shoulders, especially since it should feel like your hips are carrying most of the weight. Pay close attention to anywhere where it feels like the bag is chafing any part of your body. It may not seem like much in the store, but on a five- or 10-mile hike, that chafing will become agonizing.

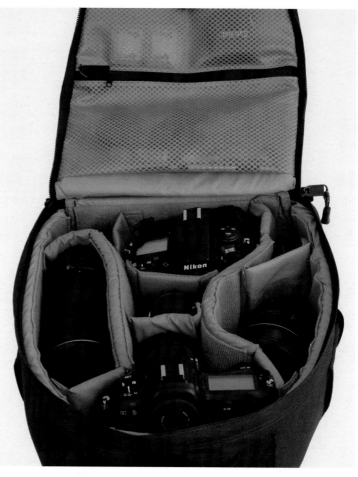

**Figure 2.7** Make sure the backpack you choose will hold all the gear you plan to tote around—and that you can lift it!

## Waterproof Camera Packs

It's even possible to find a waterproof camera backpack that's actually waterproof. These bags use seals similar to those on dry suits and are very effective at protecting their contents. These bags can work really well, but (and this is a very important but) there is maintenance necessary to ensure their integrity. For instance, the dry seal will need to be treated with silicone regularly and you'll have to be thorough in checking to make sure components are no worse for wear each time you go out. Also, usually it's only the sealed compartment that's truly waterproof, other parts of the bag may not be. These bags can be useful for certain situations, but keep in mind, they don't provide as much protection as some of the waterproof cases described later in this chapter and also that it can be a pain to get at your equipment. (See Figure 2.8.)

**Figure 2.8**
Waterproof camera packs make it possible for you to take your gear into places you normally wouldn't.

# Modular Systems, Belts, and Harnesses

There are a number of bag manufacturers that offer modular bag systems. While these systems are usually built around a basic shoulder-style camera bag, their versatility extends to sling bags and camera backpacks too. In fact, there are even bag-less options built around a chest pouch and belt combo.

These systems offer the ultimate in versatility. (See Figure 2.9.) You can pack as light or as heavy as you want, depending on your needs. There are choices for those who want traditional bags, waist belts, backpacks, or any combination of them. One of my favorite hiking combinations is a medium-sized camera backpack with accessory cases on the sides to carry an extra lens and a water bottle. Underneath the backpack is a modular system harness attached to a waist belt. The harness has a chest pouch with my camera and a lens inside, a small compartment

inside for lens cloth and a filter, plus an outer pouch for another filter or two. On the sides of the chest pouch I can attach a memory case on one side and a filter pouch on the other. The waist belt holds two or three lens cases for my more commonly used lenses while the backpack holds bigger lenses, food, extra clothing, and other necessities, plus my tripod.

The beauty of this setup is the weight is evenly distributed over my body making it comfortable to carry and—more importantly—makes my camera and most used lenses and filters easily accessible. This compares to when I just use the camera backpack and have to listen to my wife complain about my asking her to pull a lens out of the pack when we're hiking. LowePro, Tamrac, and Think Tank Photo are just a few bag makers who offer these systems. Often you can use one company's pouches on another's bags, but check to be sure first.

Modular systems offer a variety of components:

- **Basic bag, chest pouch, sling bag, belt pack, or backpack.** These form the nucleus of your system providing a container for your camera and lens plus some other accessories. They can be all you need or you can add to them.

- **Lens pouches.** These come in a variety of sizes to hold from small (50mm) to large lenses (400mm).

- **Cases.** These are rectangular rather than round and can be used to hold flash units, extra batteries, notebooks, cell phones, light meters, flat filters, and all sorts of other accessories (even a point-and-shoot if you want to carry a backup camera).

- **Specialized pouches.** These can be designed specifically for something like a GPS device, PDA, iPod, or other specialized device.

## WHAT YOUR MONEY BUYS

How much should a good camera bag cost? While there are really high-end (expensive) camera bags out there, a versatile, well-constructed camera bag should cost you less than $100. Factors that affect price include size, construction, whether it's part of a system or not, and name. Companies such as Lowepro, Tamrac, Tenba, and Billingham are just a few of the many companies that make camera bags. Lowepro and Tamrac make modular system bags in addition to regular models, while Billingham is a high-end bag maker with a variety of models, many of which probably cost more than your camera. These are not the only system or high-end bag makers though. Many other choices exist. For example, Crumpler is an up-and-coming company that produces bags with offbeat names, like "5 Million Dollar Home" and "Sinking Barge."

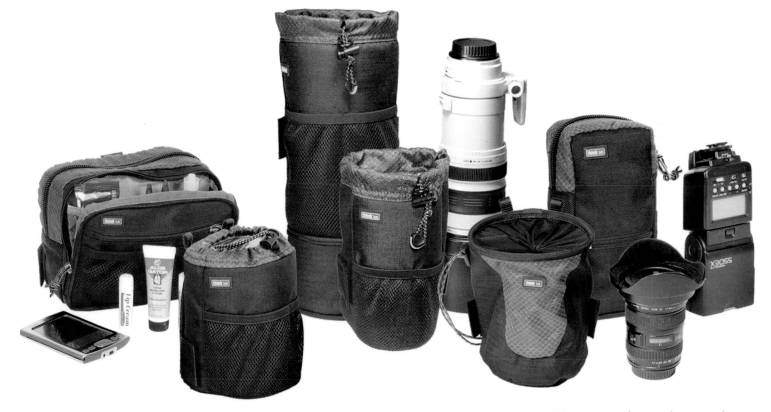

**Figure 2.9** Modular bag systems are versatile and offer photographers a wide variety of choices. A photographer can shift components from one bag to another as he configures his gear to meet the needs of a particular shoot.

# Sling Bags and Fanny Packs

These types of camera bags are relatively new and have only been around a few years. A sling bag or fanny pack is definitely worth considering if you need more security than a traditional bag (having the bag rest on your lower back results in less bouncing and less opportunity for it to bump into something). It you have a bad back, it will also be more comfortable to wear than an over the shoulder bag. (See Figure 2.10.)

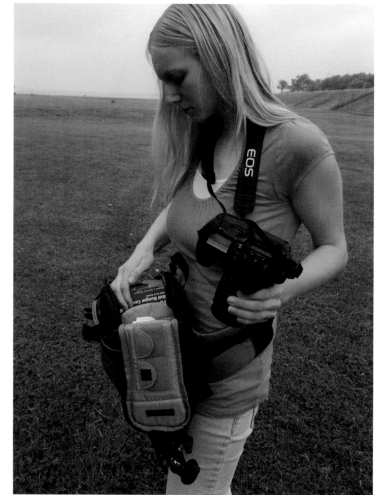

**Figure 2.10**
Belt pouches are an alternative to sling bags. They're comfortable and convenient. Many of them can carry extra gear in add on modular cases.

The downside to sling-style bags is that even the biggest of them doesn't carry nearly as much equipment as a larger over the shoulder bag. This means you'll be limited in what you can carry with one. An important consideration is how you like to walk around with equipment. If you're comfortable wearing your camera and lens around your neck and using your bag for extra lenses and such, you can carry more than the person who wants to have their lens mounted camera in the bag. This may sound like an easy decision, but trust me, if you ever plan on moving up to a pro camera body and lens combination, you'll find that wearing that big rig around your neck for a long period of time gets pretty uncomfortable.

Here are some things you should consider if you're thinking about a sling-style bag:

◆ **Initial load.** How much can you carry in the bag you're considering? Most sling bags don't offer that much flexibility when it comes to reconfiguring compartments. Perhaps you'll be able to divide a lens compartment vertically so you can store a pair of smaller lenses in one compartment, but that will be about it.

◆ **Modularity.** Can you attach extra lens or accessory pouches outside the bag? (See Figure 2.11.) If so, then you can add a couple more lenses to your bag if you need to.

◆ **Waist belt.** Does your sling bag offer a waist belt that keeps the bag from bouncing around if you have to run? A waist belt holds the bag securely to your body and coupled with the shoulder strap makes sure your camera bag doesn't go anywhere.

◆ **Accessory pockets.** The bag should have places where you can store batteries, business cards, extra memory cards, and other small, but useful items.

**Figure 2.11** You can expand the capacity of small sling bags and fanny packs by attaching modular accessory pouches, like this water bottle holder.

# Fanny Pack Camera Bags

Fanny pack camera bags are a popular choice for lightweight carrying options. They're useful for hauling a lens or two plus some accessories. There are bigger models available too, but after a while the load they're carrying becomes so heavy that the whole concept suffers from the effects of gravity. The idea of placing the bulk of the weight on the hips is a good one since they support the weight better than the back and shoulders (see Figure 2.12), but past a certain point these packs need to be augmented by a shoulder strap.

Fanny pack bags are a good choice for on-the-go photographers who want to wear their lens-mounted camera and just carry a couple of other items in an easily reached location. Once you get to the point where you want to carry more equipment (or your camera in the bag) the sling bag is a better option.

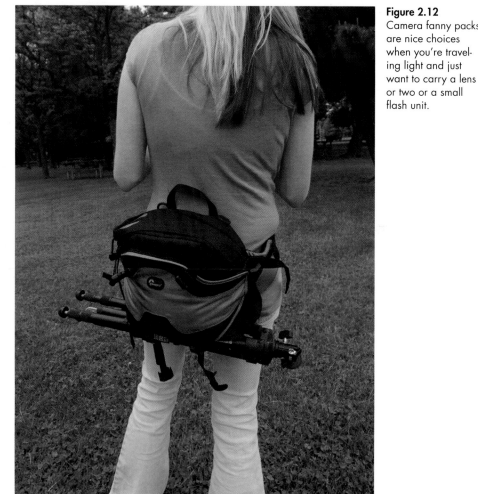

**Figure 2.12**
Camera fanny packs are nice choices when you're traveling light and just want to carry a lens or two or a small flash unit.

Here are some things you should consider if you're thinking about a fanny pack-style bag:

◆ **Waist belt.** How easy is it to adjust the waist belt once you've lifted the bag to your body? You should be able to cinch it tight or loosen it easily. The pack/belt should also have tensioning straps so you can snug the bag itself tighter to your body. Remember, the easiest way to get at your gear is to loosen the bag a little and swing it around, then swing it back. If it's hard to uncinch and cinch the belt, this can become a frustrating task.

◆ **Outer pockets.** An outer pocket gives you a place to store change or ID (see Figure 2.13).

◆ **Rain cover.** Larger bags should have a built-in rain cover.

◆ **Padding.** You can either go for heavily padded, or adapt a non-camera waist pack to use for your photography. Sometimes these can be better choices because they don't look like camera bags. If you're going to go this route, look to lens cases or wraps (several companies make these) to protect your gear since the bag doesn't offer much protection.

**Figure 2.13** Outer pockets provide quick access to store small items, like this external electronic flash.

# Travel Cases

Sometimes you need to pack up your gear for getting from one destination to another. There are a variety of cases designed to carry and protect your gear. These cases are usually offered in aluminum or plastic and offer some kind of user customizable foam padding. There are even waterproof versions available.

There are a lot of good quality travel cases on the market. Some of the best-known names include Halliburton (aluminum cases), Pelican (waterproof plastic cases), and Porters (rolling hard cases). Depending on your needs, one of these cases can certainly be a worthwhile investment.

Here are some things you should consider if you're thinking about buying any one of these cases:

## Hard Cases

These are great for storage and transport, but not good for easy access or as a shooting bag. Hard cases come in a variety of shapes and sizes. Some are designed to hold a camera kit, while others make great storage for odds and ends. I have one

**Figure 2.14**
A hard case with lots of fold-out compartments can hold a variety of equipment.

aluminum case that has a main compartment on the bottom and two wings that fold out from the top (kind of like what you see on crime scene television shows). (See Figure 2.14.) This is great for carrying all sorts of little things that come in handy such as an extra flash, batteries, cleaning gear, the little reduction screws for mating a 1/4-inch tripod socket and 3/8-inch screw hole like the ones found on European tripods, jeweler's screwdrivers, radio slaves, and other things I don't normally keep in my camera bag. I keep this in the trunk of my car and if I need something, it's there.

What should you look for in a hard case?

◆ **Space.** How much do you need? The versions of these cases designed for camera kits usually offer some kind of foam padding insert. The photographer cuts out spaces for the equipment he or she wants to store in the case. Once you cut it, you can't change your mind without having to either try to glue the foam back together or buy another foam insert for the case.

◆ **Dividers.** Some cases offer compartments with removable dividers. You can move these around to allocate space as you see fit. While they're more versatile than the foam insert style, they don't protect your gear as well.

◆ **Carrying strap.** Since a fully loaded case can get quite heavy, it should offer a carrying strap so you can carry it like a bag or like a suitcase.

◆ **Gasket closures.** Your case should seal tight so moisture and dust can't get in.

## Waterproof Camera Hard Cases

Hard plastic waterproof cases are great for element-proof storage and travel and transport via canoe, kayak, or powerboat. While they're not practical as an everyday bag, they're perfect for those times when you need to get on the water. I've used mine while white water rafting and kayaking and they've kept my stuff dry and safe even when I've done an Eskimo roll or had to bale out of my kayak in a rapid.

There are a couple of really important things to take care of with these cases though. First off, they have a small screw in the bottom of the case for when you're flying. You need to set this screw to the open position for when the bag is in a pressurized aircraft. Then when you land, you need to be really sure that you've returned the screw to its closed position. Also, it's very important to take good care of the rubber o-rings that enable the case to get a good seal. If you don't maintain these properly, your case can leak and your equipment can be damaged.

What should you look for in a waterproof case?

♦ **Space.** How much do you need? These cases almost always offer some kind of foam padding insert. Just like in the aluminum hard case once you cut it, you can't change your mind without having to either try to glue the foam back together or buy another foam insert for the case.

♦ **Dividers.** Some versions also offer divided compartments. Look for one where you can move the dividers around however you need to.

♦ **Replacement O-rings.** Sooner or later, you're going to need to replace the O-rings. How hard is it going to be to get a replacement set?

## Rolling Cases

A number of bag/case manufacturers offer some form of rolling camera case. Sometimes they're based on the rolling backpack design and sometimes they're based on a rolling case model with either soft-sided or hard-sided versions available. (See Figure 2.15.)

These bags let you haul a much greater equipment load because

**Figure 2.15** Rolling cases provide your gear with lots of protection and can keep it safe in a variety of extreme conditions.

you're not supporting its weight with your body. One of the most interesting designs is the Porter's case, which in addition to being a perfectly functional hard-sided rolling case also serves as a luggage cart that can hold additional bags. This rolling case can be positioned vertically when you're just using the one bag or lowered to a horizontal position so you can stack other bags on top of it.

I hated checking luggage even before the airlines started charging extra for it. I especially dislike checking luggage when traveling overseas, and there's a chance my luggage could end up in an entirely different country. And, of course, I've never found the idea of checking camera equipment acceptable. So, I've embraced rolling case technology, and come up with an odd-ball way of making my carry-on luggage work efficiently for me. Here's the method to my madness:

♦ I pack all the camera equipment, including camera bodies, lenses, battery chargers, filters, and anything else valuable in a medium-sized backpack. (I use the one shown in Figure 2.7 earlier in this chapter.)

♦ I put that backpack *inside* a 22-inch roller suitcase, along with my Gitzo Traveler tripod. Also inside the suitcase are some clothing, toiletries, and other necessary items. I use those vacuum packs that can compress several pairs of slacks and a couple shirts into an incredibly small area.

♦ I also take along the allowed "personal item," which in my case is the size of a small briefcase, and which holds more slacks and shirts, an Acer Aspire One netbook or, sometimes, a Dell laptop. I've never had a problem carrying the 22-inch roller and personal item onboard a plane, either in the USA or Europe. If I think I'll need a monopod, I carry one separately.

♦ When I arrive at my destination, the backpack comes out of the roller case, which then becomes my suitcase for the rest of the trip. On a recent visit to Major League Baseball Spring Training, this packing method let me take along two pro camera bodies, a 70-200mm f/2.8 zoom, 14-24mm f/2.4 ultra-wide zoom, a 10-17mm fisheye zoom, two teleconverters, the Gitzo Traveler tripod, the Dell laptop, two weeks' worth of clothing (a hotel with a laundry is a must), and everything else I needed. Everything went right in the overhead bin of the airplane—without hogging more than my fair share of space.

# Camera Vests and Chest Pouches

Sometimes you're better off wearing all your equipment rather than carrying it. Camera vests give you this option. While some people adapt fishing vests to accept their photographic equipment, this can be a challenging task because many of the pockets are not designed with lenses in mind. Vests designed for photography tend to offer pockets designed to meet a photographer's needs. (See Figure 2.16.)

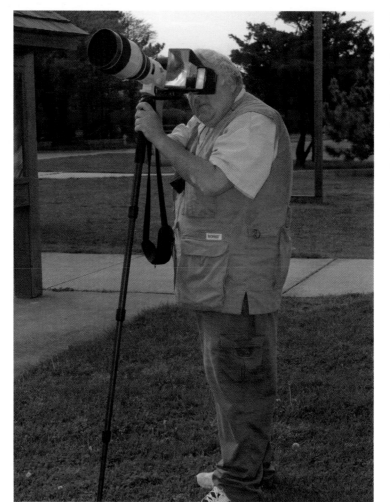

**Figure 2.16**
Camera vests can be a pleasure to use provided you don't load them up with more weight than you can comfortably carry. Test different gear/pocket configurations to see how to best distribute the weight of your gear.

There are a pretty good variety of camera vests on the market. One company even offers a version that looks like a tuxedo vest for wedding photographers! There are also choices between long and short vests depending on your preferences.

A camera vest can help you carry a modest amount of equipment comfortably, but when you start loading one up, the weight can strain your back. Sports photographers like them because they can carry a main camera with a big telephoto lens mounted on a monopod and a backup body, lenses, flash, and accessories in the vest. This makes it easier for them to move around than a camera bag might.

Camera vests can also help in other ways. When I was assigned to Operation DEEP FREEZE as a Navy journalist, we were severely limited to how many bags we could bring with us to the ice (two bags). Since we'd be there for four months at a time, I was reluctant to give up a bag of personal items for a bag of camera equipment, so I'd wear my gear in a camera vest and pack a camera bag in one of my luggage bags. This let me carry my photographic gear plus have a couple of choices of how to carry equipment while I was in Antarctica. I've used this same trick on commercial flights from time to time, but not since tighter travel restrictions went into effect. Check first with your airline before trying something like this these days. If nothing else, you should be able to wear the vest with a few items in it even if you can't wear it fully loaded.

There are several things to consider when shopping for a camera vest:

◆ **Length.** How long a vest do you want? Some people prefer standard length vests since they can carry more gear, others prefer shorter ones that stop just above their hips.

◆ **Size.** Since you won't want to wear your camera vest under your winter coat, you need to plan on one that's big enough to wear over your winter clothing while still being functional in summer heat.

◆ **Pockets.** Does the vest have the right pocket configuration to meet your needs? Just because a vest has been designed for photography, doesn't mean it's been designed for your photography.

◆ **Appearance.** Worried about your vest identifying you as a photographer with a lot of expensive equipment? There are vests available that are designed to hide the fact that they're camera vests.

◆ **Color.** Buy a light-colored vest. Dark-colored ones soak up too much heat in the summer. That's not good for you or your gear.

◆ **Mesh backs.** A mesh back will help you stay a little cooler when shooting in the summer.

# Chest Pouches

Chest pouches are a handy way to carry your camera right where you need it. These rigs can be more comfortable to carry than wearing your camera by neck strap and make a good option if you're wearing a backpack or daypack. (See Figure 2.17.)

You can go with a simple chest pouch that just holds your camera and lens or look for system chest pouches that have extra pockets for filters and memory cards, deep compartments that can squeeze in an extra lens, or even attachment points for add-on pouches so you can carry extra lenses.

**Figure 2.17**
Chest pouches provide a convenient and comfortable way to carry your camera and lens plus a few small accessories. Combined with a backpack or camera backpack, they can be part of a comprehensive carrying system.

If you're considering a chest pouch, here are some things to think about:

◆ **Size/capacity.** Chest pouches are not very adaptable. If you buy one designed to hold a camera body and small lens and then later need to be able to carry a longer lens, you're going to have to buy a new chest pouch. There are some versions that offer deeper lens wells (see Figure 2.18). You can put a small lens in the bottom of the well and a longer lens above it.

◆ **Expandability.** Buying a chest pouch that can accept add-on pockets will give you more options. These pockets can be for extra lenses or memory cards or even a water bottle.

◆ **Harness.** How do you wear the pouch? Some chest pouches only come with a very simple neck strap; others offer a much more capable harness that fixes the pouch securely to your chest. My chest pouch came with a neck strap and a chest harness plus cinch straps so I can snug it properly to my body.

**Figure 2.18** Deeper lens wells can be useful if you need to carry longer lenses.

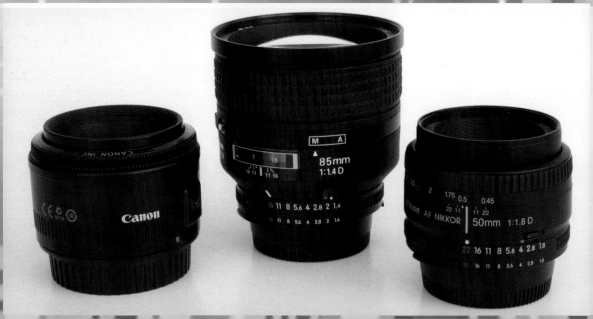

# 3 Choosing Lenses

One of the reasons for moving up to a dSLR is for the versatility it offers. The ability to swap lenses is one of the key attributes of this style of camera. Established camera systems such as the ones offered by Canon, Nikon, Olympus, Pentax, Sigma, and others offer a wide variety of lens choices. These lenses do much to upgrade the capabilities of your camera. It can be a real challenge to pick the right lens or lenses, particularly when you're on a tight budget. Making the most of your equipment dollar makes it necessary for you to prioritize when it comes to matching glass and needs.

Lenses prove their worth by providing a different perspective and not in saving a photographer a few steps. There are certainly times where a longer or wider focal length is the only way of getting a shot, but in many others the challenge is picking the right lens to produce a particular effect such as extended depth-of-field or selective focus.

There is a wide range of considerations when it comes to choosing the right lens or lenses. Let's take a look at them.

# Choosing the Right Lens

"What lens should I buy?" is one of the most frequent questions I get. Unfortunately, there really isn't a standard answer to it. It helps to think about what kind of photography you're most interested in. If shooting sports is going to be your thing, then a 70-200mm or 70-300mm zoom is a good first choice. If you're more interested in candid shots of your family and friends, then a 24-80mm or 17-85mm lens is a good starting point. Landscape photographers might be better off starting out with an extreme wide-angle zoom such as a 12-24mm or 17-40mm lens.

You might be tempted to go for an "all-in-one" type lens such as an 18-250mm superzoom. These lenses can be attractive because of their great range of coverage (and they can be the right choice for certain situations) but are usually not quite as sharp at all focal lengths and may have "slow"

maximum apertures compared to lenses with less ambitious focal length ranges. Still, if you're shooting in an environment where changing lenses is a problem, or if you have to travel with the bare minimum of equipment, these lenses can make sense. Be sure to test one out and see if you're comfortable with the images it produces. (Keep in mind, lenses have what are known as "sweet spots" which are discussed later in this chapter. If you stay in the sweet spot of one of these lenses, your image quality should be very good. It's when you leave the sweet spot the drop in quality can be a problem.)

One of the most important considerations when choosing a lens is the field of view. You can mount a wider lens on your camera when your back is against a wall and you need a lens with a wider perspective. Wide angles are

great for interior photos, pictures outdoors in crowded surroundings, and for those times when you want to take advantage of the wide-angle lens's perspective "distortion." Telephoto lenses bring things closer or reduce the range of sharpness (so you can choose which portions of your picture are in focus, and which are not). These long lenses can seemingly compress the relative distances, too, making objects that seem widely separated appear to be right next to each other.

There are also *macro* lenses that let you focus as close as an inch or two from the front of the lens, and lenses that are "faster"—they admit much more light to the sensor, so you can take pictures in lower light levels or at shutter speeds that freeze action. Some lenses offer extra sharpness for critical applications where images will be examined closely

or enlarged. Some have special features, such as vibration reduction (also called image stabilization), which partially counteracts a photographer's unavoidable shakiness. There are even lenses that provide intentionally distorted extreme wide-angle fisheye perspectives that can be used as a special effect.

Other than focal length and field of view, here are some things you should consider when buying a lens or set of lenses, like those shown in Figure 3.1.

◆ **Maximum f/stop.** Lenses vary in their ability to gather light. If you need to work under poor lighting conditions and will have your use of supplemental light restricted, choose lenses that can gather a lot of light, that is, which have relatively large maximum apertures (smaller numbers), such as f/2.8-f/3.5 or larger. However, the greater a lens's light gathering capability, the more expensive it will be compared to a similar focal length of lower ability.

◆ **Durability.** One of the big differences between pro gear and less expensive equipment is that equipment designed for professional use is made to withstand the abuse this equipment suffers from heavy use. Pro lenses will use higher-grade components, be manufactured to tighter tolerances (so there is less variability from lens to lens from the same vendor), better sealed against the elements, and capable of withstanding much greater use.

◆ **Lens mount compatibility.** Because dSLRs come with a variety of imaging sensors (which differ in size) buying a lens has become more complicated. You need to be sure a lens will work on your camera and also ask if it will work on cameras you might buy in the future. Another issue is that sometimes legacy lenses will work on some models but not on others. For example, with the Canon line, lenses with the EF designator in their name will mount on any current Canon digital or film camera, but the digital-only EF-S lenses are compatible only with the EOS xOD (20D, 50D, etc.) and Rebel cameras. Nikon lenses manufactured prior to 1977 require a small modification to work with most of the company's digital cameras.

◆ **Autofocusing speed.** How effective is a lens's autofocus? Autofocus speed is very important for telephoto lenses and sports photography, but not so much for wide-angle lenses and landscape photography. Still, even within the same class of lenses, some autofocus faster than others. That speed may depend on the focusing capabilities of the camera or, in many cases, the type of autofocus motor included within the lens.

◆ **Close focusing ability.** How close can a particular lens focus? Some lenses are described as "macro" lenses even though they're nowhere near macro capability (discussed in detail later in this book). Still, these lenses will focus closer than a similar focal length.

◆ **Image stabilization/vibration reduction.** Since keeping your camera and its lens as steady as possible helps make for sharper photographs, technology that assists you in this can be an important consideration when you're buying a lens. It can also drive up the cost significantly.

◆ **Age of the lens design.** The older the lens design, the more likely it was designed for film and not digital sensors. That can be a factor, because newer lenses are developed so that the light emerging from the back of the lens is focused more precisely on the tiny photosites in the sensor. Film is much less fussy about the angles light comes from, and so older lenses may not provide the same image quality on digital SLRs. Even so, such lenses can produce beautiful results, and should also be a little cheaper to boot, since they don't merit the premium newer lens designs demand.

**Figure 3.1** Lenses come in a variety of shapes and sizes.

# The "Crop" Factor

Modern camera lenses prior to the digital era were originally designed to project an image on a 35mm piece of film, measuring 24 × 36mm (roughly 1 × 1.5 inches). Since producing large sensors is very expensive, most dSLR imaging sensors are smaller than 35mm film, and this causes something known as the "crop factor" (sometimes erroneously and confusingly called a "multiplier").

The misnomer comes from the fact that, in cropping a lens's original coverage area or field of view, the apparent magnification seems to have "multiplied" the focal length of the lens. But in fact, nothing of the sort has taken place. The lens still has the exact same focal length as before and offers the same depth-of-field at a given distance as any other lens of its focal length on a camera of any sensor size. The image has simply been cropped to a tighter field of view. You could produce exactly the same effect by taking an image shot with a "full-frame"

camera and cropping it in an image editor (except that you'd be throwing away pixels, and reducing the resolution of your image).

The term *full frame* itself is misleading, implying that only a 24 × 36mm image provides the "full" picture. Friends who own medium-format digital cameras with 48 × 36mm sensors note that, in comparison with *their* full-frame cameras, so-called full-frame cameras should be labeled as *half-frame* models.

For those who used film cameras prior to switching to digital models, it's often convenient to figure out the equivalent focal length of a lens when mounted on a digital camera, compared to the field of view it would have on a full-frame or film camera. The "multiplier" factor nomenclature came about simply because we humans are better at multiplying in our heads than we are at doing division. To compare the field of view of a lens on a typical cropped camera

with a common digital model, we'd properly need to divide the lens's focal length by 0.667. (See Figure 3.2.) Not up to the task? It's simpler, then, to use the reciprocal of 0.667, and *multiply* the focal length by 1.5X. Just remember that you're *dividing* the frame into a smaller size through cropping, not *multiplying* the focal length of the lens.

Even if you never used a film camera, understanding the crop factor is still important when buying a lens for your digital camera, because there are many different crop factors. To avoid comparing apples to oranges, when talking with other photographers, you'll need to know whether your camera has a 1.3X crop factor (found in certain Canon models like the

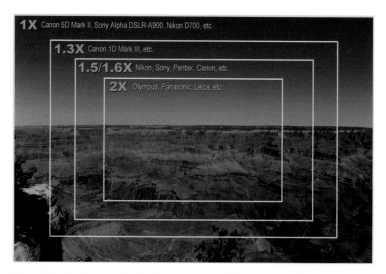

**Figure 3.2** Smaller sensor sizes produce these fields of view with cameras having 1X, 1.3X, 1.5/1.6X, and 2X crop factors.

Canon EOS 1D Mark III), a 1.5X crop factor (available in many cameras from Nikon, Sony, Pentax, and others), 1.6X (Canon's 50D and Rebels), or 2X (Olympus). Given those various crop factors, a single 100mm lens might have the equivalent field of view of 130mm, 150mm, 160mm, or 200mm, depending on the camera model. Know your crop factors if you want to be able to compare use of a given lens or focal length on several different camera models.

The crop factor tends to come in handy when you're working with telephotos, because there is no loss of light-gathering ability, and the higher pixel density of the cropped frame (compared to a cropped full-frame image) means no loss in sharpness. For example, shoot a 100mm lens on a 1.5X crop factor camera with a 12-megapixel sensor, and you'll end up with a much sharper picture than if you took the same shot with a full-frame (1X factor) camera and cropped to the equivalent 5-megapixel center portion of the image. Unfortunately, the crop factor also "multiplies" the apparent focal length of wide-angle lenses, so your wide 24mm wide angle is magically (or tragically) transformed into a 36mm moderately wide-angle lens.

If you upgrade to a full-frame camera and still have some lenses designed for "cropped" models, you can often still use your existing lenses. Figure 3.3

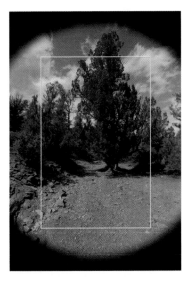

**Figure 3.3** Vignetting from using a lens designed for a smaller imaging sensor than the one this image was made with. Note, the image hasn't been ruined; all the photographer has to do is crop out the offending vignetting in an image editing program.

shows a picture taken with a full-frame model, using a Tokina 12-24mm zoom designed for a 1.5X crop factor. The image area the lens was designed for is shown within a yellow border. The image isn't completely ruined; indeed, cropping to the yellow border (or, perhaps, a slightly larger area that avoids the edges of the vignetting), yields a usable picture. Moreover, lenses like this one often expand their image circle when you zoom in; the Tokina fills the full 24 × 36mm image frame at 18-24mm focal lengths.

Here are some additional things to consider.

- **Lens design.** Many lens makers are now designing lenses specifically for digital camera bodies. These lenses work more effectively with modern imaging sensors, focusing the light on the sensor's photosites more efficiently. The drawback is they don't work or don't work well with cameras that have a larger imaging sensor than they're designed to work on, unless you're willing to crop the picture in your image editor.

- **Lens mount compatibility.** Some camera makers, such as Canon and Sony (formerly Minolta), have changed their mount design over the years. Earlier lenses from the pre-autofocus days, won't work at all on more recent cameras. In addition, Canon lenses marked with the EF-S designation (the S stands for *short backfocus*) can't be safely mounted on Canon 1.3X and 1.0X-crop cameras (or even on the 1.6X-crop Canon EOS 10D). Other makers, most notably Nikon, have kept the same lens mount since the 1950s, but have made changes to some of their cameras that preclude the use of older lenses with those models unless slight modifications are made.

- **Shutter speed considerations.** When considering what shutter speed you should use it's a good idea to base it on the effective focal length instead of the actual focal length. Usually shutter speed is based on the reciprocal of the focal length rule (1/focal length) but with dSLRs, it should be 1/effective focal length. (So, with a 200mm lens, you'd want to use at *minimum* 1/300th second shutter speed—and probably faster.) This is just a guideline that depends on your ability to hold a camera steady and tends to vary from person to person.

# Prime Lens Versus Zoom

There are two basic types of lenses, prime (or fixed focal length) and zoom. Each type has its strengths and weaknesses. If you're building a lens kit, assembling the right mix of lenses can prepare you for a wide variety of shooting situations and contingencies.

## Prime Lenses

Prime lenses, like those shown in Figure 3.4, offer only one choice of focal length, whether it is 14mm, 50mm, or 135mm. While a prime lens limits you to a single field of view at a given distance, it can also offer you some big advantages over a zoom lens.

Let's look at a few:

◆ **Cost.** Because it's theoretically easier to design and build, a prime lens is often cheaper to manufacture than a zoom lens. I say *theoretically* because some lenses, such as certain exotic 50mm f/0.95 optics, are not easy to design, build, or afford. But most camera vendors offer a killer 50mm f/1.8

lens for about $100 that will surely be one of the sharpest lenses you own. However, prime lenses can be costly, particularly as their focal lengths and maximum apertures increase. A fast 500mm or 600mm telephoto can be priced at $8,000 or more. Although it can't be fitted to a digital SLR camera, Leica's 50mm f/0.95 lens costs $11,000!

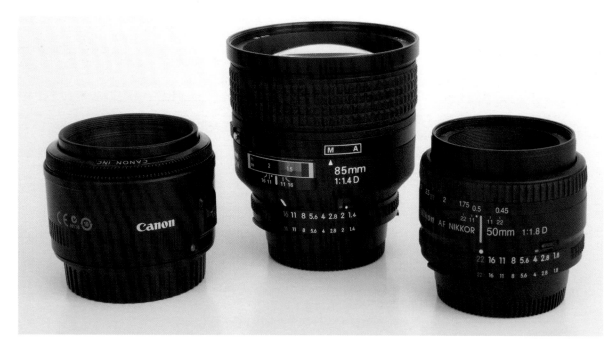

**Figure 3.4**
Prime lenses such as these can offer lighter weight, faster autofocusing, and cheaper prices than their zoom counterparts.

- **Quality.** Prime lenses have fewer components than a zoom lens, and there are fewer optical factors to take into account (such as shifting focus points or the distortion caused by lens aberrations). This also means there are fewer things to go wrong and fewer problems likely to occur in their use. Often, even a modestly priced prime lens may be of comparable quality to a manufacturer's high-end zoom lenses. With very few exceptions, prime lenses are sharper than zooms.

- **Light gathering ability.** Prime lenses can generally be built with larger lens openings than comparably priced zoom lenses. The fastest zoom lenses are only capable of a f/2.8 maximum aperture, but prime lenses can go down to f/1.4 and stay reasonably priced (they can actually go to even larger apertures but "reasonable" won't describe their price, as I noted).

- **Autofocusing speed.** Prime lenses have less glass to push around, so they can autofocus faster than a zoom lens can.

- **Size and Weight.** A prime lens will weigh less than a comparable zoom lens that includes the same focal length. Of course, a set of prime lenses covering the zoom's focal lengths will weigh more than the single zoom lens.

## Zoom Lenses

As good as prime lenses are, there are still some things that zoom lenses can do better. While the obvious—they cover the same range as several lenses—comes to mind, a zoom lens can also do something no prime lens can—change focal length during exposure. An interesting creative technique many photographers use is to set a slow shutter speed and then carefully zoom the lens during the shot; this can result in a very creative image. (See Figure 3.5.)

**Figure 3.5** The "zoom" effect. Here the photographer has set a very slow shutter speed and slowly zoomed the lens while the shutter was open, resulting in this image.

Zooms come with various effective ranges, which you should consider carefully. What range of focal lengths do you need? Lenses that cover very large ranges tend to be larger and heavier, and more expensive. Do you absolutely have to have a 50-500mm zoom lens? If so, be prepared to write a check with four digits to the left of the decimal point. Here are some typical zoom ranges:

◆ **Wide-angle zooms.** These cover expansive fields of view, such as 10-20mm, 12-24mm, or 17-35mm (although the latter is a wide zoom only when used on a full-frame camera). Use these for landscapes and interior photography.

◆ **Intermediate zooms.** You'll find these in 24-70mm or 24-85mm focal lengths, making them good for interior sports (many have f/2.8 maximum apertures), and portraiture of both groups and individuals.

◆ **Tele-zooms.** Moderate telephoto zoom lenses begin at about 70mm and extend to 200 or 300mm. I use my 70-200mm f/2.8 for indoor sports and portraits on a full-frame camera (it's a bit too long for indoor sports shooting on a cropped-sensor camera, because a wider angle is often desirable). I also use it for outdoor sports with any camera.

◆ **Long zooms.** You'll find hefty telephoto zooms in a longer range, such as the 200-400mm f/4 lens offered by Nikon. These are good for sports and wildlife photography, and, unless you have the physique of the Governor of California, must be used on a monopod or tripod to avoid fatigue and inevitable camera shake. (If such a lens has image stabilization anti-shake features, you probably still need some support because of its weight.)

◆ **Do-everything zooms.** You can find 18-250mm zooms, 50-500mm zooms, and other ambitious optics that can do everything—almost. Unfortunately, they are often very slow (with, say, f/6.3 maximum apertures at the maximum focal length, and only f/4.5 at the wide position), heavy, and not cheap.

Focal length range aside, there are other reasons why you should consider zoom lenses:

◆ **Value.** While they're more expensive than prime lenses, a zoom lens will give you the equivalent focal lengths of several prime lenses making it a cheaper purchase than buying a series of prime lenses. Figure 3.6 shows the range of a typical 18-250mm zoom lens, from wide (left) to telephoto (right.)

◆ **Quality.** While it's harder and more expensive to build a high-quality zoom lens, it's been a long time since zooms were the poor cousins of prime lenses. Computer-aided design and improvements in manufacturing techniques and technology have made it possible for lens makers to design some outstanding zooms. Pro-quality zoom lenses are capable of remarkable images (they also cost remarkable prices).

◆ **Light gathering ability.** Zooms max out at f/2.8, but that's fast enough for most shooting situations. As newer imaging sensors become capable of working at higher and higher ISOs with less noise, light gathering ability becomes less of a problem. I have several cameras that perform so well at ISO 3200 that they've given new life to some of my older, slower zooms, which can now be used effectively under much dimmer lighting conditions than before.

◆ **Autofocusing speed.** While a prime lens will still autofocus faster than a zoom, pro-quality zooms are still incredibly fast. The difference is more pronounced when you're comparing an inexpensive zoom to a prime lens.

◆ **Versatility.** You can grab your camera and just a couple of zooms and be ready for almost any contingency. You might need twice as many prime lenses.

**Figure 3.6** An 18-250mm lens provided this very wide view (left) and detailed closeup (right) of Flagler College in St. Augustine, Florida, from the same shooting position.

# Wide-Angle Lenses

Once you start building a lens collection, the question becomes what lenses do you need? There's a strong argument that at least some kind of wide-angle lens or two should find its way into your camera bag. Thanks to the multiplier/crop effect, your ability to squeeze things in gets a little tougher.

The definition of "wide angle" keeps changing too. In the film camera/full-frame era, a 35mm lens was a wide angle and a 20mm optic was an extreme wide angle. Today, full-frame cameras have 14mm lenses available (both zoom and prime) at the wide end, and cameras with cropped sensors that can easily be fitted with extreme wide-angle zooms may reach the 10mm focal length at the widest end.

Wide-angle lenses can do a lot of things for your photography. While most people think of them as tools for getting more into the photo as in the landscape shot shown in Figure 3.7, they have

**Figure 3.7** Wide-angle lenses are useful in creating landscape photos. When composing a landscape shot with a wide-angle lens, consider including a strong foreground element to make the image more interesting.

many other uses for creative shooting.

◆ **Depth-of-field.** Wide-angle lenses have greater effective depth-of-field than lenses with longer focal lengths. This is great for landscapes and other photos that benefit from as much depth-of-field as possible.

◆ **Isolating your subject.** Wide-angle lenses increase the apparent distance between objects. This effect can be used to add space between your subject and background clutter.

◆ **Shooting from the hip.** Because of their wide field of view and inherent depth-of-field, wide-angle lenses are great for candid photography. Once you're familiar with your lens's field of view, you don't even need to use the viewfinder, you can just aim the camera and shoot.

◆ **Wide-angle effect.** Wide-angle lenses tend to produce several types of real and apparent distortion. Real distortion is the inward curving of straight lines nearest the edges, known as *pincushion* distortion. Apparent distortion can be the strange perspective effects you get when some objects are nearer to the camera/lens and seem large and/or distorted in your finished image.

## Wide-Angle Choices

For highest quality and greatest light-gathering ability, prime lenses are still the best choice for extreme wide-angle lenses. Best quality lenses in this class will feature aspherical lens elements to help correct for the distortion so common to this class of lenses. For many extreme wide-angle prime lenses it's possible to get a f/2.8 maximum aperture. Generally a 14mm f/2.8 lens is the widest, fastest prime lens you can find without going to a fisheye lens.

Wide-angle zoom lenses have gained a lot of popularity during the past decade as these lenses have consistently improved in range and quality. At the extreme end, wide-angle zooms can include such choices as a 10-22mm or 12-24mm zoom. While a 12mm zoom range may not seem like much, it's actually pretty significant in terms of magnification basis. A 12-24mm range on a percentage basis is just as extreme a range as a 200-400mm range on a telephoto zoom.

When using a wide-angle zoom (or any extreme wide-angle lens) keep in mind that including a strong foreground element can make your picture more interesting. Lacking such an element can produce an image without a point of central interest.

Some things to consider when using wide-angle lenses:

◆ **Shutter speed.** You can often get by with a slower shutter speed using a wide-angle lens (still following the reciprocal of the focal length rule) because of their extreme field of view. This means you can maximize the depth-of-field for shots made with a wide-angle lens.

◆ **Depth-of-field.** These lenses are capable of extreme depth-of-field. This is a valuable tool in creating compelling landscape photos or other photos in which deep focus can be an effective creative tool.

◆ **Hyperfocal distance.** A popular technique among landscape photographers is to focus the lens to its hyperfocal point. This is a point of focus where everything from a minimal distance (usually a foot or two) through infinity is in focus thanks to depth-of-field. You can find charts online that show you the hyperfocal distance for lenses at popular focal lengths, apertures, and crop factors.

◆ **Filter problems.** Some wide-angle lenses, such as my 14-24mm zoom lens and 10-17mm fisheye zoom, can't be outfitted with filters at all. They have no filter threads. In addition, even if your wide-angle lens accepts filters, you can end up with problems when using polarizers (in addition to vignetting, described next). Polarizing filters work best when the sun is at a 90-degree angle from the axis of the lens. If your lens itself has a field of view of 90 degrees or more, it's guaranteed that some portions of the image will be at an angle that's less favorable for polarization. You end up with a photo that is darker (more polarized) at one edge and lighter (less polarized) at the other.

◆ **Vignetting.** You should be careful when stacking filters on an extreme wide-angle lens because of the possibility of the edges of the filters showing up in your photographs. Many extreme wide-angle lenses are capable of accepting small gelatin filters in a rectangular filter holder at the rear of the lens. Some filter manufacturers offer low-profile filters designed specifically to avoid vignetting with extreme wide-angle lenses. Usually you're fine with one filter, but when you start adding filters, vignetting can occur. As noted elsewhere in this chapter, vignetting doesn't automatically ruin an image, but the cropping necessary to get rid of the effect may be a problem.

# Extreme Wide-Angle Lenses

At the extreme range of the wide-angle spectrum are "fisheye" lenses. These optics feature lens elements that bulge out the front of the lens kind of like a fish's eye, hence the name. What's significant is the field of view they're capable of portraying.

Fisheye lenses are capable of capturing as much as a 180-degree field of view or more. Shoot with one of these babies and the person standing beside you will show up in the photo.

There are two types of fisheye lenses.

◆ **Circular.** These fisheye lenses project their image onto a circular field. You only get this effect though when shooting with a full-frame sensor, or a 35mm film camera. When you're working with a smaller imaging sensor, then parts of the circular field are cut off, producing a strange vignette-like effect. These lenses are capable of capturing a 180-degree field of view. (There have been circular fisheye lenses with even greater fields of view.) (See Figure 3.8.)

◆ **Diagonal.** A diagonal fisheye projects its image onto a rectangular frame. These lenses also capture a 180-degree field of view.

**Figure 3.8** Circular fisheye lenses produce a round image—but those intended for full-frame cameras may be cut off by the crop factor.

## Working with a Fisheye Lens

It can be challenging to shoot with a fisheye lens. For one thing, you're always at risk of getting your shoes in the photo. For another, these lenses produce a lot of distortion. You should also try to keep your camera as level as possible because tilting it will make straight lines even more distorted.

While these lenses produce a lot of distortion, like that shown in Figure 3.9, there are some software products that can help correct any undesirable distortion. Some are designed as standalone programs; others as plugins for photo-editing software. Some, like DxO Optics, can be used in both modes.

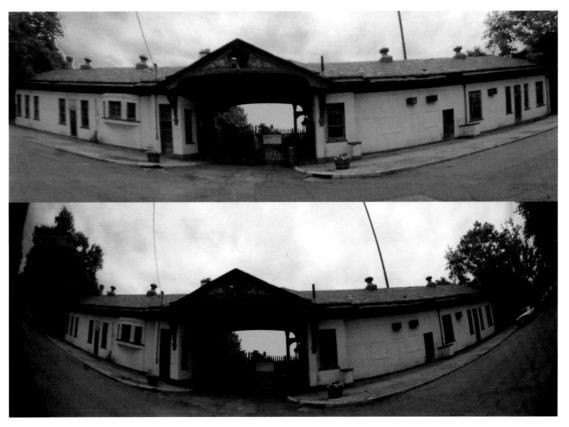

**Figure 3.9** Fisheye lenses produce a lot of distortion, but they also make it possible to take in a lot of territory. Keeping these optics level during a shot can reduce some of the exaggeration and software is available to correct for some of the distortion. At top, the fisheye curvature has been partially corrected; at bottom, the original image.

# Mid-Range Lenses

Mid-range lenses and zooms that roughly cover the 30mm to 60mm focal length (plus some additional focal lengths on either side of that range) sometimes get tagged with the "normal" label because their field of view comes closer to matching the field of view of the human eye. (See Figure 3.10.) During the film years, a 50-55mm lens was often sold with 35mm cameras as the "normal" lens. While this lens doesn't exactly approximate human eyesight, it did represent a reasonable compromise between telephoto and wide angle. Like many compromises though, this one didn't always serve very well. Many photographers felt that normal lenses were a bit boring, neither fish nor fowl, giving you no wide-angle perspective, nor telephoto reach. (Of course, with the crop factor, a 50mm lens is now a short telephoto; a normal lens for a digital camera is more on the order of a 28mm to 30mm lens.)

**Figure 3.10**
Mid-range zooms make popular starter lenses for many people buying their first dSLR. These optics provide a reasonable compromise for shooting groups and landscapes, while offering enough reach to be used for single-person portraits.

Over time, mid-range zooms started replacing the 50mm lens as the standard optic photographers wanted for their camera. These days zooms in the 24-85mm and 24-105mm tend to be the most popular mid-range zooms. They're small, lightweight, offer decent range and produce good quality images. Best of all, one of these lenses probably won't break the bank unless you're looking for a particularly "fast" (great light-gathering ability) version. But, a fast, f/2.8 mid-range zoom can be great for events like weddings, and well worth the cost. (See Figure 3.11.)

Here are some things you should consider when buying a mid-range prime lens or zoom:

◆ **Maximum aperture.** The main price driver on these optics is their light-gathering ability. Gaining one f/stop (a doubling) of light can effectively double the cost of the lens. Of course, when you're looking at the fastest lens in a manufacturer's offerings, there are usually other reasons for the high price such as build quality, tighter tolerances on lens elements, and image stabilization.

◆ **Image stabilization.** Many of these lenses are offered with image stabilization or vibration reduction. This is a handy feature on this kind of lens because blur due to camera shake can be a real problem at the lens's longer end.

◆ **Close focusing ability.** Lenses in this class often offer some form of macro or close focusing capability, which is defined as either the ability to produce an image on the sensor that is roughly life-size or half-life size (1:1 or 2:1), or which can focus to within a few inches of the camera. (Close focusing depends on the focal length, too—a 50mm lens needs to focus much more closely than a 200mm lens to be considered a "macro".)

◆ **Full-time manual focus.** Can you adjust focus manually on the lens while autofocus is engaged? Some lenses let you do this. It can be handy if you want to tweak focus slightly without disengaging autofocus first.

**Figure 3.11**
A zoom range of about 24-70mm is especially useful at events like weddings, because they provide a wide enough field of view for group shots, and can zoom in for flattering individual portraits, too.

# Telephoto Primes and Zooms

Usually a lens is considered a telephoto once it reaches about 85mm (or the equivalent with a cropped sensor). In other words, with cameras having various crop factors, the equivalent telephoto range begins at an actual focal length of roughly 43mm (2X crop factor), 60mm (1.5/1.6X crop factors), 65mm (1.3X crop factor), and 85mm (1X crop factor). Such lenses are generally referred to as short telephotos or "portrait" lenses because they produce the most flattering rendition of facial features when shooting head-and-shoulders portraits.

The most popular prime lens in the short telephoto range is undoubtedly the 85mm optic, which was a prized portrait lens in the film days, and remains useful in the digital era. Other popular telephoto primes include 200mm and 300mm lenses, which are ideal for sports. Telephoto zoom choices in this

class are the 70-200mm or 70-300mm zooms. Pros tend to favor the former because it's available with an f/2.8 maximum aperture for many lens mounts. Those who aren't worried about shooting available light photos in poor lighting tend to favor the extra reach of the 70-300mm lens. There are versions of either lens that have image stabilization, too.

These are great lenses for sports photography (as shown in Figure 3.12), portraiture, and just chasing after the kids in the backyard. In fact, many photographers choose this focal length as their first lens choice when buying a camera. Add a 24-80mm intermediate zoom, and you've got the beginnings of a solid lens kit. Buy a 1.5x teleconverter (an attachment that *does* multiply the actual focal length of a lens) and, with your camera's crop factored in, you've got the ability to reach out pretty far as well.

**Figure 3.12** Telephoto zooms take you from portrait to sports. These lenses are frequently one of the first choices a new dSLR owner makes.

Choosing the right telephoto or telephoto zoom can be a challenge. Because the lens type is so popular, there are tons of models on the market. How do you pick the right one for you?

◆ **Prime or zoom.** At the low end of the price range, a single telephoto prime lens will cost more than an inexpensive telephoto zoom. There are things that make the prime lens worth its price, such as speed and (often) exquisite sharpness even wide open or almost wide open. But if you're on a tight budget, such lenses might not be worth the cost to you. Prime lenses will offer greater light gathering ability and faster autofocus, but zooms will offer greater range.

◆ **Which model?** Camera makers will frequently offer more than one version of this type of lens. You can find fast and slow versions of the same lens and, particularly in the Canon line, lenses of the same focal length range both with and without image stabilization (vibration reduction).

◆ **Focal range.** If you're sticking with prime lenses, what range should you own? A good two-lens combo is the 85mm and the 200mm. Add a 135mm telephoto if you want an in-between lens. Should you prefer a zoom lens, your choice usually comes down to a 70-200mm or 70-300mm but there are other choices too. If light-gathering ability is paramount (see Figure 3.13), there are some nice

choices in the 70-200 range with f/2.8 maximum apertures (figure $1,000 to $1,800 or more as a rough price range). While the 70-300 won't be available with such a maximum aperture, if you don't need the extra f/stop or so, you can find some pretty nice lenses.

◆ **Image stabilization.** Some form of image stabilization or vibration reduction technology can be found in many of these lenses. As I hinted at earlier, Canon offers three different 70-300mm lenses ranging in price from about $200 to more than $1,200 and at least two more 70-200mm lenses. Third-party lens makers offer additional choices. The would-be lens buyer looking to buy a 70-300mm optic can be faced with an overwhelming array

of choices at just this focal length. (The note at the end of this section offers some advice for dealing with this problem.)

◆ **Full-time manual focus.** Can you adjust focus manually on the lens while autofocus is engaged? Some lenses let you do this. It's useful for fine-tuning focus.

**Figure 3.13** A fast telephoto zoom can put you right in the front row at a concert, even if you're stranded in one of the cheap seats.

## CHOOSING THE RIGHT LENS

If you're one of those photographers trying to decide between a bewildering array of choices for just one focal length, don't be discouraged. There are some things you can consider to help you whittle down your options. First off, make an honest assessment of what you can afford. There's always a reason to spend more money for better equipment, but that doesn't mean you have to do it right now. You can start out with a less expensive lens and then upgrade later on when you can afford it. Having said that, let me also say that buying the least expensive option of a popular focal length is frequently a poor choice. Bottom-end lenses are cheap for a reason, so try to stay away from the very cheapest lenses. Used lenses give you another option and you can frequently find good deals that way.

Also, when you're considering a zoom lens, you may have to choose between a two-ring zoom versus a "push-pull" zoom. Push-pull zooms (you change focal length by sliding the lens barrel forward or back) have fallen out of favor with digital photographers because of concerns that the push-pull action can suck dust into the lens and possibly onto the imaging sensor. The main advantages of a push-pull zoom over a two-ring model is that it's easier to zoom the lens while following action and you can create a smoother zoom while zooming with the shutter open. Still, you can do both of these things with a two-ring zoom too.

# Image Stabilization/Vibration Reduction

Image stabilization/vibration reduction/anti-shake features get a lot of attention. However, when it comes to lenses, only Nikon and Canon offer optics with image stabilization/vibration reduction capabilities built in. Other vendors (including Sony, Pentax, Samsung, and Olympus) that include this feature incorporate it into the camera body itself. On the one hand, camera-body stabilization means that you don't have to buy a special lens to gain the capability. But on the other hand, by including stabilization in the lens, vendors like Nikon and Canon are able to optimize the feature for a particular lens and, if stabilization fails mechanically, you need to send in only your lens for repair—not your entire camera. In this chapter on choosing lenses, I'm going to address only stabilization built into the optical component.

Lenses offering this feature help keep the lens steadier through the use of tiny gyros and a floating lens element that moves to correct

for camera shake, providing as much as a four-stop improvement; that is, if you needed to shoot at 1/250th second to counter camera shake, you may be able to use a slower shutter speed of 1/125th to 1/15th second to achieve the same camera steadiness. In Nikon and Canon lenses,

several piezoelectric angular velocity sensors operate like tiny gyroscopes to detect horizontal and vertical movement, which are the usual sort of camera shake you'll experience—up-and-down or side-to-side shaking, rather than rotation around the optical axis. Once motion is

detected, the optical system uses prisms or adjustments in one or more "floating" lens elements to compensate. Lenses that can be adjusted to compensate only for up and down motion can successfully use image stabilization even when you're panning. (See Figure 3.14.)

**Figure 3.14** Newer image stabilization systems can operate even when panning the camera.

Depending on the lens you may have more than one image stabilization setting. One is intended for when you're hand holding the lens, when stabilization needs to be most aggressive. Some lenses even have a special Active mode for situations when the camera is subjected to extreme shaking. (See Figure 3.15.) Another setting will be for when the lens is mounted on a tripod, to prevent the lens from trying to stabilize a lens that really isn't moving very much. You may also have a choice between regular image stabilization and an image stabilization setting designed to help you steady the camera while panning it. (Panning is the act of swinging the lens horizontally while following a moving subject with the shutter open.) This setting counters up/down camera shake, but ignores movement in side-to-side directions.

No matter how it's implemented, image stabilization can counter camera shake caused by too-slow shutter speed in conjunction with other factors that range from something as mundane as the photographer breathing to attempting to shoot from a moving vehicle. Suppose you're shooting in a situation with a 400mm lens that calls for a shutter speed of 1/500th second at f/2.8 for acceptable sharpness. Unfortunately, you're using a zoom lens with a maximum aperture at that particular focal length of only f/5.6. Assume that you've already increased the ISO rating as much as possible, and that a higher ISO either isn't available or would produce too much noise. Do you have to forego the shot? Not if you're using a camera or lens with image stabilization/vibration reduction. Go ahead and shoot at the equivalent exposure of 1/125th second at f/5.6.

There are some things to keep in mind when using image stabilization:

◆ **Fixes camera shake only.** It will neutralize a wobbly camera, but won't allow you to capture faster-moving objects at a slower shutter speed.

◆ **Use of panning techniques and tripods may interfere.** The intentional camera movement of panning may confuse some types of image stabilization. Use of image stabilization when the camera is on a tripod leads to wasted application of the feature, or, worse, unneeded compensation that adds to the blur. However, newer image stabilization systems can recognize horizontal motion as panning, and interpret extraordinarily low levels of camera movement as tripod use, and take this into account.

◆ **Performance hit.** Image stabilization can slow down your camera slightly. However, I successfully use image stabilization when shooting sports, and it operates quickly enough so you can still shoot modest bursts of shots.

◆ **Versatility.** Image stabilization isn't limited to long-range telephoto or close-up photography. If you find yourself in a museum or concert, where flash photography is discouraged or not allowed, image stabilization can be a life-saver, letting you shoot with normal or wide-angle settings at shutter speeds as slow as 1/4 second.

**Figure 3.15**
Look for special anti-shake modes, such as "Active" mode, which is particularly aggressive about stopping vibration.

# Specialized Features and Accessories

You'll find that some specialized features and accessories can make your shooting more convenient, improve your image quality, or enable you to get shots that you just can't capture otherwise. Image stabilization, "fast" optics, and accessories like telephoto converters all can be useful.

## Fast Glass (sic)

A fast maximum aperture, already discussed in this chapter, is useful enough to be considered a special feature. Photographers often refer to lenses with large maximum apertures as being "fast lenses." (I never refer to lenses by the excessively jargony term "glass," if only because there are a significant number of lenses with elements made of other substances, including plastic and quartz.) Fast lenses are prized by working pros who have to shoot under available light conditions without being able to use a flash. Photojournalists and documentary-style wedding photographers are just two of the types who have to deal with these constraints, but many other photographers also embrace available light photography for a variety of aesthetic reasons.

What qualifies a lens as "fast?" Well, for a start, it should be the fastest optic in its particular focal length, or at least, faster than f/4 at its maximum aperture. It gets a little tricky because a 50mm f/1.4 is fast by any stretch, but 50mm f/1.2 and 50mm f/0.95 lenses have been offered over the years. The same goes for the 85mm focal length. While you can find f/2 and f/1.8 offerings, faster versions are available. Then when you get to 500mm and 600mm lenses, f/4 tends to become the new standard. (Sigma does offer a 200-500 f/2.8 lens which is "fast" glass by anybody's definition; it's also expensive, with a $24,999 price tag. It does qualify for free shipping though.)

So do you need fast lenses? Well, usually, if a camera maker goes to all the trouble to produce such lenses, it also does other things to ramp up its quality. A 300 f/2.8 telephoto is significantly larger than a 300 f/4 (and about three times the price too) but the larger size of the lens means the camera maker can install more powerful autofocusing motors because it has more room to work with. This means the fastest lenses a manufacturer offers will usually be the best lenses it offers too.

On a more practical level, if you want to do a lot of candid photography, lenses that let you create quality images in low light without having to resort to using a flash make it easier for you to be inconspicuous. This can help your efforts to capture your subjects being themselves. If you're a budding pro who wants to work in photojournalism there are often times where you have no choice but to work without flash (courtrooms or museums for example). So how can fast lenses help you?

◆ **Greater hand-holdability.**
Lenses with large maximum lens openings make it possible for you to use faster shutter speed. This can reduce the chances of blur from camera shake when you trip the shutter. It can also make it easier for you to freeze motion, handy when you're shooting sports or wildlife.

◆ **"Sweet" spot advantages.**
Every lens has a "sweet" spot, an aperture setting that gives you the best quality image. Generally this spot is two to three f/stops from the wide-open point. On an f/2.8 lens, this generally means f/8.

◆ **Selective focus.** Large maximum apertures minimize depth-of-field. Combine this with a telephoto lens and you have the ability to throw the background completely out of focus. This becomes valuable when you want your subject to stand out from the background. (See Figure 3.16.)

**Figure 3.16**
Selective focus is a great way to isolate your subject from the background without having to resort to digital darkroom trickery. A large lens opening with a long lens brought fairly close to the subject all combine to make the background almost unrecognizable.

# Teleconverters

Sometimes your telephoto lens just isn't long enough. When this happens, a handy little device known as a teleconverter can come to the rescue. Teleconverters are lens elements that mount between the camera body and the lens and serve to multiply the focal of the lens they're being used with. See Figure 3.17 for examples of some teleconverters.

As nifty as these options can be, there are some drawbacks to using them. First off, teleconverters rob you of light at a time when you may need it most. A 1.5x teleconverter costs you one f/stop of light, a 2x teleconverter costs you two f/stops worth of light, and a 3x teleconverter costs you three f/stops worth of light. Stack teleconverters and you multiply their magnification

power and their light robbing effect.

Teleconverters can also diminish the optical quality of your lens and slow its autofocusing speed. The best quality teleconverters such as the pro series ones made by Canon and Nikon do a great job. I have a Canon 1.4x teleconverter and there's almost no difference to using it or not using

it when it comes to lens speed and image quality. My 2x teleconverter is also good, but I can tell the difference in speed and quality when I use it. Each one goes for close to $300 new. You can find cheaper alternatives through third-party lens makers, but will pay a price on both autofocusing speed and image quality.

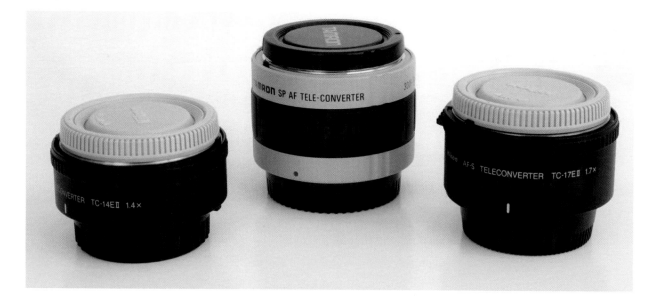

**Figure 3.17**
Teleconverters are frequently matched to specific lenses or lens types.

So why should you consider a teleconverter or set of teleconverters?

◆ **Versatility.** Teleconverters let you make do with fewer lenses because you can boost the reach of a lens you already own rather than buying another optic. But keep in mind that some converters can be used only with certain lenses. Canon's L series teleconverters can be used only with certain Canon telephoto lenses. Nikon's TC-E II series (1.4X, 1.7X, and 2.0X) can be used on roughly nine of the company's optics.

◆ **Less weight in your camera bag.** Most of the time you'll only need to carry one telephoto or telephoto zoom and a couple of teleconverters rather than multiple long lenses. This helps make your load lighter. (Figure 3.18 shows an example of a telephoto shot with a teleconverter attached.)

◆ **Increased close focusing distance.** The magnification of teleconverters decreases your closest effective focusing distance so one can turn your non-close focusing lens into a close focusing one.

**Figure 3.18**
Teleconverters are frequently matched to specific lenses or lens types. A teleconverter can increase the focal length of your lens, which can be essential when shooting wildlife.

# Specialized Lenses

Some lenses have specific, specialized purposes, such as to correct perspective or to provide special soft focus effects when shooting portraits and other types of images. Macro lenses are specialized lenses, in a sense, because they work best when used for close-up work, but they are so common that most would hardly consider them to be a specialty item. (See Chapter 4 for more information on macro lenses.) If you have a need for one of the true specialized lenses, you'll know it. This section explains some of the more popular odd-ball lenses.

## Perspective Control (PC) Lenses

PC lenses are for the photographer who's concerned with being "perspectively" correct rather than politically correct. These high-priced optics are primarily designed to correct for the problems that come from tilting the lens in order to take in a subject that's too big to be photographed with the camera level (such as buildings).

Unfortunately, once you tilt the lens a type of distortion known as "keystoning" occurs. This problem manifests as trapezoidal shapes in places that are supposed to be rectangular and lines that are supposed to be parallel end up converging. Perspective Control lenses feature the ability to shift lens elements to correct that distortion (hence another common name for these lenses "Tilt/shift" lenses). These lenses are invaluable for architectural photography and often useful for landscape photography. They're also pricey, usually costing somewhere around a grand apiece or more.

However, PC lenses aren't limited to architecture or landscapes. I've seen some absolutely amazing PC photos by wedding, fashion, and portrait photographers like Parker Pfister (http://www.parkerjphoto.com), who use the tilt/shift capabilities to tweak depth-of-field in amazing and creative ways. You can, for example isolate focus on an upturned face, with the photographer above the subject, and throw other parts of the image, from ears to hairline, wildly out of focus. Tilt/shift lenses can also be used for product photography to extend focus range much as was/is done with 4 × 5-inch to 8 × 10-inch (and larger) film "view" cameras with their tilting backs and front lens mounts.

But for traditional architectural applications, here are some things to consider about PC lenses:

◆ **Improve the quality of your images.** Getting rid of the keystone effect will make your architectural pictures look better.

◆ **Fill the frame better.** All too often, in an effort to avoid keystoning, the photographer backs up in order to keep the camera level, leaving much of the frame empty. Cropping the resultant image costs you resolution and pixels.

◆ **Autofocus lost.** Even autofocus mount tilt/shift lenses don't autofocus, so you'll need to focus manually. However, given the careful composition used with most PC photography, you probably would have done that any way.

## Focus Control Lenses

Sometimes you can record too much detail. Often a photographer wants to concentrate the viewer's eye on just the subject. While selective focus techniques with long lenses work well, sometimes you need to use a more modest focal length. This is where lenses with focus controls come in. There are several types, including "defocus control" lenses, "soft focus" lenses, and "distortion" lenses.

Defocus lenses can be razor sharp when the photographer wants them to be, but have a defocus control that can be used to soften their effect. This control can provide an effect similar to selective focus but without the focal length usually associated with it. Nikon makes several of these (they include "DC" in the lens name). For the serious portrait photographer, these lenses can be powerful tools for a variety of uses.

◆ **Wedding portraiture.** These lenses are very useful for candid portraits during wedding receptions and bridal portraits during wedding safaris (photo trips to interesting locations for memorable portraits).

◆ **Swimsuit shots.** Defocus lens are great for cleaning up distracting backgrounds.

◆ **Still life photography.** These lenses give excellent control over foreground or background elements for exceptional still life photography.

## Soft Focus Lenses

Sometimes a lens can be just a little bit too sharp. As strange as that may sound, recording every flaw, blemish, and wrinkle may not be the best approach for a portrait session. Soft focus lenses are designed to create a softer effect and are popular for glamour and boudoir photography because they help hide blemishes and create a dreamy effect. (See Figure 3.19.) Canon makes an excellent soft-focus lens, called the EF 135mm f/2.8 with Softfocus telephoto lens. Some things to consider about soft focus lenses:

◆ **Soft focus is not out of focus.** While soft focus lenses do create a soft and dreamy effect, that effect is not the same thing as being out of focus. Soft focus lenses produce an image that holds together and maintains a recognizable subject.

◆ **Conceptualizations.** Soft focus lenses are useful for creating "concept" images that create a mood or feel.

◆ **Still life photography.** These lenses are also good choices for still life images.

◆ **Nudes.** Soft focus lenses are good choices for nudes because of their soft and dreamy effect.

**Figure 3.19** Soft focus lenses are good for glamour portraits, still life, and conceptual photography.

# Distortion Lenses

The Lensbaby, which comes in several varieties, uses distortion-heavy glass elements mounted on a system that allows you to bend, twist, and distort the lens's alignment to produce transmogrified images unlike anything else you've ever seen. Like the legendary cheap-o Diana and Holga cameras, the pictures are prized expressly because of their plastic image quality. Jack and Meg White of the White Stripes are, in fact, selling personalized Diana and Holga cameras on their website for wacky *lomography* (named after the Lomo, another low-quality/high concept camera). The various Lensbaby models are for more serious photographers, if you can say that about anyone who yearns to take pictures that look like they were shot through a glob of corn syrup.

**Figure 3.20** Everything is uniquely blurry outside the Lensbaby's "sweet spot," but you can move that spot around within your frame at will. They can be used for selective focus effects, and can simulate the dreamy look of some old-style cameras.

Lensbabies are capable of creating all sorts of special effects. You use a Lensbaby by shifting the front mount to move the lens's sweet spot to a particular point in the scene. This is basically a selective focus lens that gets very soft outside the sweet spot. (See Figure 3.20 for an example.) There are four different types of Lensbabies. Prices range from $100 to $270 with other accessories available to produce different effects.

◆ **Macro.** A Lensbaby accessory makes it possible to use this tool for macro photography.

◆ **Wide-angle/telephoto conversion.** Add-on lenses convert the basic Lensbaby into a wide-angle or telephoto version.

◆ **Creative aperture kit.** Various shaped cutouts can be used in place of the regular aperture inserts that control depth-of-field. These shapes can include things like hearts, stars, and other shapes.

◆ **Optic swap kit.** This three lens accessory kit provides different adapters that include a pinhole lens, plastic lens, and single glass lens.

The latest Lensbaby models have the same shifting, tilting lens configuration as previous editions, but are designed for easier and more precise distorting movements. Hold the camera with your finger gripping the knobs as you bend the camera to move the central "sweet spot" (sharp area) to any portion of your image. With two (count 'em) multicoated optical glass lens elements, you'll get a blurry image, but the amount of distortion is under your control. F/stops from f/2 to f/22 are available to increase/ decrease depth-of-field and allow you to adjust exposure. The 50mm lens focuses down to 12-inches and is strictly manual focus/manual exposure in operation. At $300 or so, Lensbabies are not a cheap accessory, but there is really no other easy way to achieve the kind of looks you can get with a Lensbaby. (See Figure 3.21.)

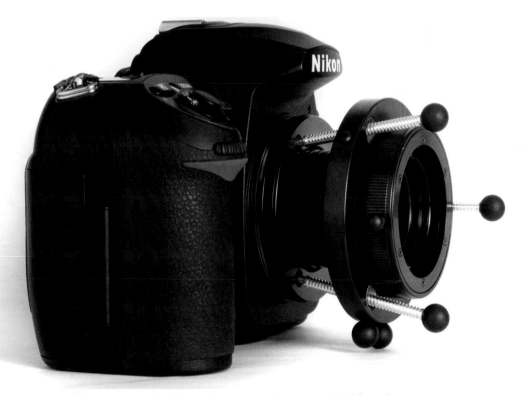

**Figure 3.21** Lensbabies are specialized lens replacements with some special soft-focus features.

# Digiscoping—The Marriage of Spotting Scope and Digital Camera

During the early days of digital photography some poor bird-watcher was frustrated because he couldn't afford a dSLR because he'd blown a bundle on his spotting scope. The frustrated hobbyist kept asking himself, why can't I use my point-and-shoot digital camera on my very expensive spotting scope?

Some aluminum, a pair of pliers, a few hours of tinkering, and wham! The birder had found a way to position his digital camera so it was held in place where it could peer through the spotting scope and be used to create images. These days of course, it's much easier. For one thing, dSLRs have gotten a lot less expensive than they were seven or eight years ago, for another, a small industry developed to create ways of mating cameras and spotting scopes.

You can do some pretty cool things with a camera and digiscope, exemplified by the work of Steve Kerr, who is shown in Figure 3.22. Examples of his shots are shown in Figures 3.23 and 3.24.

◆ **Super magnification.** Spotting scopes offer pretty impressive range. A 30x spotting scope married to a dSLR can provide a much more powerful optic than a conventional telephoto lens. (See Figure 3.22.)

◆ **Steadiness is key.** dSLRs are heavier than point-and-shoot cameras so if you're going to attach one to a spotting scope you should consider the need for extra support rather than letting the camera's entire weight sit on the adapter scope connection. A small tripod can do the job.

◆ **Less weight to carry.** Digiscoping lets users get away with carrying less equipment than if they were lugging a telephoto lens, camera, and spotting scope.

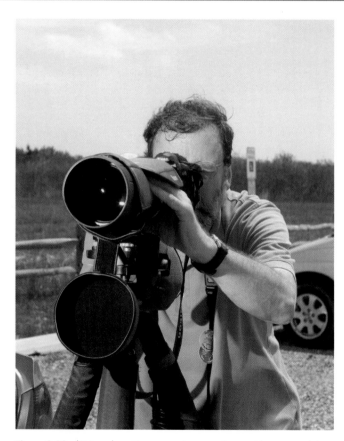

**Figure 3.22** dSLR and spotting scope team up to provide a powerful photographic system.

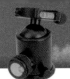

**Figure 3.23** Stunning long-distance wildlife shots can be captured with a digiscope setup.

**Figure 3.24** A camera and spotting scope combination can provide results rivaling much more expensive lenses.

# 4 Gear for Getting Up Close and Personal

ometimes you just have to think small. There's an amazing photographic world just waiting to be visited. You don't even have to leave home to find it. Macro and microphotography offer a wonderful challenge for photographers. If you're looking for new inspiration or a new challenge, giving this discipline a chance can do just that. If you're already a fan of things small, well, let's see if we can introduce you to some tools that will open up your creative efforts too.

Whether you call them macro, micro, or close-up lenses, all have features that let you focus at relatively close distances and are indispensable when you want to capture an intimate portrait of a blossoming flower, the fine detail of an exquisite antique timepiece, or a product shot of a small component for your company's catalog. Digital SLRs are perfect for this kind of photography because they simplify framing and focusing close-up subjects, and, thanks to interchangeable lenses, can be fitted with optics that are specially designed for this kind of work. Even so, you don't need to buy expensive special lenses to shoot macro images, as the lenses you already own might be up to the task if fitted with an inexpensive close-up attachment. Or, that $99, 50mm f/1.8 lens can be adapted easily for this kind of photography.

# What's Close-Up Photography?

There is an almost bewildering array of tools available for the person interested in close-up photography—also called macro or microphotography. Choosing the right gear can be a challenge, so we're going to take a good look at each one in this chapter and look at their strengths and weaknesses. The good news is that there are workable options for every price range. (See Figure 4.1 for some examples.)

When shooting close-up pictures, there are four key factors to keep in mind: magnification; perspective/subject distance; depth-of-field; and lighting. Here's a quick rundown of each:

## Magnification

Macro photographers are much more interested in the *magnification* of the subject, rather than how close the subject is to the camera or lens. A 50mm lens

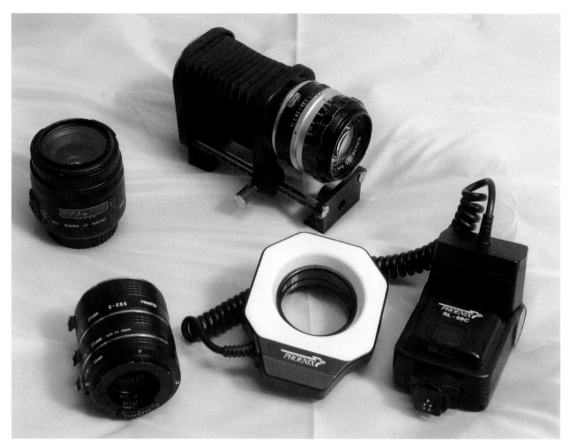

**Figure 4.1** Close-up, macro, and microphotography can offer up exciting new vistas for photographers. There are many challenges to be met for the best quality results and many equipment options for creating such images.

focused four inches from a subject (measured from the sensor plane) produces the same nominal image size as a 100mm lens focused on the same subject at eight inches. So, in terms of how close your close-up picture is, the apparent magnification of the image is more important than the subject distance or the focal length of your lens. (Both of these *are* important, but for different reasons, as I'll explain later in this section.)

With flat subjects, there really isn't much of an advantage in using one lens over another with the same magnification, other than the ease of lighting and perspective differences (both discussed later). Because final image size depends on both the lens focal length and distance to the subject, *magnification* is used to express how an image is captured. If the magnification is 1X, the object will appear the same size on the sensor (or film) as it does in real life, completely filling the frame. At 2X magnification, it will be twice as big, and you'll only be able to fit half of it in the frame. At .5X, the subject will be half life-size and will occupy only half the width or height of the frame. These magnifications are most commonly referred to as ratios: 1X is 1:1, 2X is 2:1, .5X is 1:2, and so forth. As you work with close-up photography, you'll find using magnifications more useful than focusing distances.

## Perspective/Subject Distance

Perspective and subject distance come into play when photographing subjects that are not flat. While lenses of different focal lengths may provide the same amount of *magnification* at distances proportionate to their focal lengths, they don't provide the same *perspective*. Parts of a subject that are much closer to the lens, relatively speaking, than other parts are rendered much larger.

Just as noses grow in apparent size and ears shrink when shooting portraits with a wide-angle lens, if you're taking a macro photograph of, say, a small figurine, the portions of the figurine closest to the lens will look oversized when using a macro lens with a shorter focal length, and more normal when shot with a macro lens having a longer focal length. That's true even if the magnification provided in either case were exactly the same.

Changing subject distance by using a longer or shorter lens has other effects. Close-up lenses used for medical photography often have 200mm or similar focal lengths, to allow maintaining the proper distance from the surgical field. Or, you might be photographing living creatures that become apprehensive when a photographer pokes a macro lens at them from a couple inches away.

When you're shooting tabletop setups, especially product shots or things like architectural models, perspective becomes especially important. Use the right macro lens and distance, and your perspective and lighting will be realistic and flattering. Use the wrong macro lens (say, one with too short a focal length) and your model may more closely resemble a badly lit mockup.

## Depth-of-Field

Depth-of-field is most important when working with three-dimensional objects. Depth-of-field is related to the focal length of the macro lens you use; that is, a 50mm macro lens will have more depth-of-field at a given *distance* than a longer lens. However, for a particular subject size on the sensor (the magnification), you'll find that depth-of-field will be similar, so it will not be an overriding factor in choosing the focal length of your lens. All lenses have limited depth-of-field when used to photograph subjects up-close, so you'll have to deal with it whether you're using a short macro, telephoto macro, or tele-zoom macro lens, as well as ordinary lenses pressed into service for close-ups. Choose your focal length based on perspective and appropriate distance first, and the magnification you hope to achieve. Depth-of-field provided by a given lens is also related to the f/stop used, with larger f/stops providing less depth-of-field, and smaller f/stops offering more. (See Figure 4.2.)

**Figure 4.2**
Wide open (left), there is very little depth-of-field; the range of sharpness is deeper at f/8 (middle); at f/22, several rows of crayons are in focus.

Tip

Because of the shallow depth-of-field involved in macro photography, backgrounds tend to blur out. This alone doesn't guarantee a pleasing background though. Sometimes you need to position a piece of colored material behind your subject to provide a more neutral background than occurs in nature. One option is to get a collapsible 5-in-1 reflector designed for such situations. These devices can be used as diffusers, reflectors, and backgrounds depending on whether you use them covered or not or depending on which direction you face them.

## Lighting

When you're shooting three-dimensional objects, one thing you'll have to contend with is the need to illuminate your subject. A longer focal length gives you more room to place lights or even simply to allow the existing lighting to make its way to your subject. There are special lights, called *ring lights* (shown in lower center in Figure 4.1, and also later in this chapter) that wrap around the front of the lens to provide diffuse, even lighting even at close distances.

So, what's the difference between macro photography, close-up photography, or any of the other terms you'll hear applied to this kind of work? Here's a quick summary of the terminology:

◆ **Close up.** Anything from 1:10 to 1:1 is generally accepted as close-up photography. Many lenses offering this range are mistakenly referred to as "macro" lenses.

◆ **Macro.** Sometimes known as "photomacrography," in order to be considered a true "macro" lens, the optic must be capable of creating a 1:1 or "life-size" image down to a 50:1 or 50 times life-sized.

◆ **Micro.** Sometimes called "photomicrography," this is usually done with the camera mounted on a microscope and offers ratios ranging from 25:1 to 1500:1. (See Figure 4.3.)

◆ **Microphotography.** Teeny tiny photographs are called microphotographs. This term was sometimes applied to microfilm or microfiche, which have largely been supplanted in favor of digital image/document storage these days, even though large databases of microfilm still exist and it is still in use. (Check your local public library or newspaper "morgue.")

**Figure 4.3** This Meiji Techno photomicrograph (left) was taken with a digital camera through a microscope; the macro photograph (right) was taken using a 300mm f/2.8 lens equipped with an extension tube.

# Close-up Attachments

The least expensive option for adding macro photography to your shooting arsenal may be a simple gadget called a *close-up lens,* which attaches to the front of your existing lens as if it were a filter. Although called "lenses," these popular macro accessories cost only $50 or so, and aren't used as standalone lenses. Fastened to the front of your lens, they enable it to focus closer. Of course, close-up lenses *are* technically simple lenses; but they lack the mounts and focusing mechanisms that would allow you to use them all by themselves. Instead, they must always be used attached to another lens.

Because they are used like filters, you'll need to buy one that fits the lens you'd like to use it with. Unless you have a bunch of lenses that all use the same filter thread, you'll want to start with an attachment that fits your favored close-up lens. I recommend using these accessories on sharp, prime lenses, such as a 50mm f/1.8 (available for

around $100), or, possibly, on a 35mm f/2 optic. Both will gain close-focusing capabilities when one of these attachments is mounted on the front, and are usually of high enough quality to provide great results even with the mild loss of sharpness that lens attachments entail. (There are always trade-offs, after all.) You can also use close-up attachments on zoom lenses, although most will require larger (and costlier) sizes, and will probably suffer more noticeable loss of sharpness.

Close-up lenses, like the one shown in Figure 4.4, are generally labeled with their relative "strength" or magnification, using a measure of optical power called "diopter." The diopter value of a lens measures its refractive power, expressed as the reciprocal of the lens' focal length in meters. A diopter with a value of 1 would, all by itself, focus parallel rays of light at one

meter; a 2 diopter would focus the light at 1/2 meter; and a 3 diopter would focus the light at 1/3 meter.

Of course, these lenses aren't used that way. To calculate their close-focusing abilities, you need to factor the close-up device's magnification power with the actual focusing abilities of the lens. In this configuration, close-up lenses are available in magnifications from +1 diopter (mild) to +10 diopters (strong).

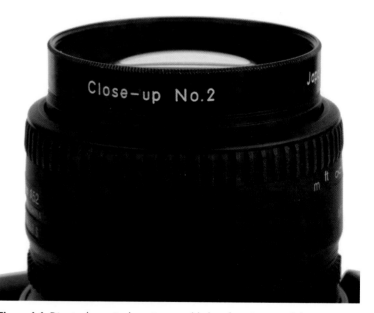

**Figure 4.4** Diopter lens attachments can add close-focusing capabilities to non-macro lenses.

The actual formula used to calculate the effect of a diopter lens is:

## Camera Focal Length/ (1000/diopter strength)= Magnification at Infinity

Therefore, a +4 diopter mounted on a 125mm lens would work out to 125/(1000/4)=0.5, or half life-size *when focused at infinity*. Magnification is larger when a lens equipped with a diopter attachment is focused even closer. For example, if a 50mm lens normally focuses as close as one meter (39.37 inches; a little more than three feet), a +1 diopter will let you focus down to one-half meter (about 20 inches); a +2 diopter to one-third meter (around 13 inches); a +3 diopter to one-quarter meter (about 9.8 inches); and so forth. If your lens normally focuses closer than one meter, you'll be able to narrow the gap between you and your subject even more. Close-up lenses can let you grab extreme macro shots like the one shown in Figure 4.5.

Diopter attachments can be stacked to provide greater magnification. You can purchase several close-up lenses (they cost roughly $20 each and can often be bought in a set) so you'll have the right one for any particular photographic chore. You can combine several, using, say, a +2 lens with a +3 lens to end up with +5, but avoid using more than two close-up lenses together. The toll on your sharpness will be too great with all those layers of glass. Plus, three lenses can easily be thick enough to vignette the corners of your image.

**Figure 4.5** Stack several close-up attachments together to get extreme close-ups like this one of a cupcake.

The key factors when using diopter attachments are these:

◆ **Quality varies.** As with filters, the quality of construction and the glass itself can vary from vendor to vendor. While most filters are simply flat pieces of glass with an antireflection coating, and then mounted in a frame, diopter attachments are true lenses. So, the quality of the lens can impact the quality of your final image, particularly if you do choose to stack a pair of them together. More expensive diopter lenses may consist of more than one element, such as the two-element diopters known as *achromats.*

◆ **No effect on exposure.** Close-up lenses have virtually no effect on exposure, which is not true with other macro options that increase magnification by lengthening the distance between the lens and the sensor.

◆ **Works with multiple lenses.** A diopter attachment can be used with any lens having a compatible filter thread size or appropriate step-up or step-down ring.

◆ **May cause vignetting.** As with filters, a close-up lens or stack of lenses can cause vignetting.

◆ **No infinity focus.** With a close-up lens attached, your lens will no longer focus to infinity; it can only be used for macro focusing.

# Ready for Your Close-up? Macro Lenses Are the Answer

The next step up, in terms of cost and improved image quality, is the true macro lens, like the one shown in Figure 4.6. These are a great starting point for photographers interested in close-up photography. These optics are specifically designed for this kind of work and offer the best

**Figure 4.6** True macro lenses offer at least 1:1 magnification, although some require an extension tube to achieve that. These optics are a great choice for macro work because they're specifically designed for the needs of this type of photography.

quality images and the greatest ease of use.

Both camera manufacturers and third-party lens makers design and offer some truly outstanding glass in this category. Just be sure you know what you're buying. Just because a lens carries the word "macro" in its name doesn't mean it's a true macro lens, particularly in the zoom category. Often these lenses offer what's known as "close-focusing" ability in the range of 1:4 or 1:3 magnifications, well short of what's considered true macro. Generally, you're looking at a prime lens if you want 1:1 magnification or greater and may have to also invest in an extension tube or macro coupler (both described later in this chapter) for best results.

True macro lenses will be prime lenses and usually somewhere between 50mm and 200mm in focal length (although some wide-angle macro lenses do exist).

When shopping for a macro lens, keep the following things in mind:

◆ **Focal length.** The longer the focal length, the more distance you can keep between you and your subject. This can be very important in macro photography when you're working with live subjects such as insects and spiders, which you may want to keep at a distance for more than one reason. (See Figure 4.7.) If you do a lot of close-up photography, you might want to have several different focal lengths in your arsenal, or purchase a macro zoom lens that allows changing from one focal length to another. I own both 60mm and 105mm macro lenses. I prefer them over a macro zoom because they each focus more closely than the typical zoom options, and have larger maximum apertures (f/2.8 in both cases).

◆ **Autofocus.** Does the lens allow autofocus with your dSLR? Most cameras allow autofocus only when using f/stops of f/5.6 or larger. There are telephoto macro lenses that have maximum apertures that are smaller than that when cranked out to their maximum zoom position. In addition, if you mount a lens on a bellows,

some extension tubes, or flipped backwards with a reversing ring (all these options are discussed later in this chapter), you can lose autofocus capabilities. Surprisingly, lack of autofocus is not necessarily a deal-breaker. I find that most of my close-up photography is done with the camera mounted on a tripod and locked into position. Focusing manually is easy and more accurate (does your autofocus lens know exactly what plane of focus you want?). Given the shallow depth-of-field even with a lens stopped down to f/22, manual focus is often a better choice.

◆ **Vibration reduction/image stabilization.** Some macro lenses have built-in VR/IS compensation which, along with autofocus, is most useful when you're stalking the wild tree frog (or other elusive subject) with your camera handheld. Both features can transform your camera into a close-up point-and-shoot, which can mean the difference between getting a shot and not getting a shot. However, if you're in tripod mode, image stabilization is less useful. I'd opt for a remote release instead, eliminating camera shake at its source (human vibration).

◆ **Does the lens have a tripod collar?** Many high-end macro lenses come with a tripod collar, as described in Chapter 1. This feature is handy because often you're placing your lighting on the end of the lens instead of the hot shoe (the light from a hot shoe mounted flash tends to strike the end of the lens causing a shadow on the subject). Once you start adding the weight of a ring flash or double flash configuration on the end of the lens it can put a lot of stress on the camera's lens mount if the camera body is mounted on the tripod instead of the lens.

◆ **Greater magnification potential.** You can still combine a macro lens with an extension tube or bellows (described later) to get even greater magnification. This significantly increases your macro capabilities.

**Figure 4.7**
A longer focal length allows shooting close-ups from a distance, which can be helpful with subjects that you don't want to get close to—or that don't want you to get too close to them!

# Bellows

One choice for macro photography is to use a bellows attachment between your lens and camera. What the bellows does is extend the distance between the optic and the imaging sensor. This dramatically increases your lens' ability to focus close to something. In fact, you can turn a non-macro lens into a macro lens this way.

Keep in mind, a bellows rig will rob you of some light, because the increased distance between the aperture and sensor plane makes the lens opening appear "smaller" to the sensor. As is the case most of the time with macro photography, having a lighting plan in mind is an important part of your macro efforts. Good lighting can significantly improve your work; insufficient lighting or poorly managed lighting can ruin an otherwise good photo.

A bellows gives you very precise control of camera and lens position. Good quality models will even let your camera retain most

or all of its electronic functions. On the downside, such deluxe models are not cheap. A good auto bellows can set you back from several hundred dollars to close to a grand. I get along just fine with an older model with absolutely no automatic features.

◆ **High quality images.** You use your camera's lens with the bellows, without adding any more glass to the process. This gives you a good shot at the best quality optics you have being used at their best.

◆ **Precise control.** A bellows attachment allows for very precise movement of the camera and lens. When you're dealing with true macro ratios, it's easier to focus by moving the camera back and forth than it is by using the focusing ring. It may still be necessary to use a focusing rail as well since changing the bellows position also changes the magnification. If you need specific magnification then you'll set the bellows to the specific length and use the focusing rail to move the entire camera/bellows rig forward and back to achieve proper focus.

◆ **Magnification control.** Since you can shift the lens forward and back on the focusing rail, you can change the magnification size of the object you're photographing. This isn't always possible with other macro tools.

◆ **Tripod stability.** A camera, lens, and bellows rig is a little bit unwieldy when it comes to hand-holding requiring a tripod. The reality though is you shouldn't be trying to handhold anyway since the tiniest bit of movement is going to throw the critical area out of focus.

Because a bellows attachment may be somewhat of a strange beast for many of you, I'm going to describe all the parts and pieces of a typical unit, as shown in Figure 4.8.

◆ **Base.** The bellows attachment can rest on this base or, more frequently, attach to a tripod or other support using the tripod socket on its underside. Once the base is secured to the tripod, the other components can be moved as desired.

◆ **Camera mount.** This component, mostly hidden on the back surface in the figure, is a lens bayonet flange, which connects to the lens bayonet of your camera, just as a lens does. It's attached to the *rear standard,* which is the back half of the bellows component. If you own a camera with more of a prism "overhang" than the bellows was designed for, you may need to attach a thin extension tube to the rear of the camera mount first, to allow clearance when you mount the bellows on your camera. One nifty feature to look for is the ability to rotate the entire bellows around this camera mount so that, even if the bellows is attached to a tripod, you can shift the camera from a horizontal orientation to vertical, or any position in between.

◆ **Lens mount.** Your close-up lens attaches here. It's mounted on the *front standard,* which is the forward half of the bellows component.

◆ **Bellows.** This is the telescoping fabric or leather component that expands or contracts as the standards move.

◆ **Adjustment knobs.** There are several of these mounted on the opposite side of the bellows; only one of them is visible in the figure. These knobs, one for each of the moving parts of the bellows (the rear standard, front standard, and bottom rail), are rotated to move that component forward or back along a geared track. For example, you can turn the knob visible in the figure to move the front standard forward, independently of the rear standard.

◆ **Locking knobs.** After the rear and front standards or bottom rail are moved to the desired position, these knobs are locked to fix the bellows attachment in place. You can lock/unlock any or all knobs, leaving the other components free to move, if you like. The knob at right locks and unlocks accessories, such as a slide copying adapter, that can be inserted into an *attachment mount* on the front of the bellows.

◆ **Top rails.** These are the rods, each with indents for the gear mechanism, that transport the front and rear standards.

◆ **Bottom rails.** The entire bellows mechanism (other than the base) can be moved forward or back along these rails. One cool application for the bottom rail is as a focusing or positioning aid. Once

you have the other components of the bellows locked in where you want them, you can move the entire unit along the bottom rail to change subject distance slightly, or to change the focus plane forward or back.

◆ **Shift lock.** The front standard can be shifted a few millimeters to the left or to the right, changing the view of the subject slightly while keeping the sensor focal plane parallel. The shift lock fixes the front standard once it has been moved to the desired position. Shifting is an advanced technique (first used by photographers with those huge sheet-film view cameras), used to avoid the perspective distortion you get when the camera is turned (instead) to adjust the view.

◆ **Swing lock.** The front standard can also swing (rotate) around a centered vertical axis, and then lock using this control. The effect is to change the depth-of-field at the same time, so that it's at an angle. That is, objects arranged in the appropriate diagonal parallel to the front standard's swing will be in correct focus. This is another advanced technique, similar to those provided by tilt-shift lenses described in Chapter 1.

◆ **Attachment mount.** For fastening accessories such as a slide copying adapter.

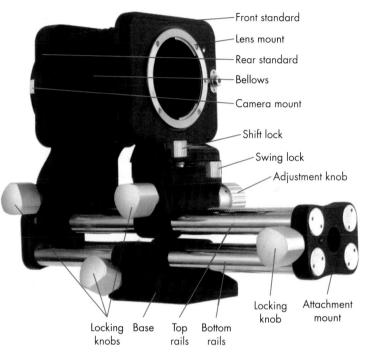

Figure 4.8 A high-quality bellows attachment can work with your camera's electronics to give you at least some auto capabilities and lots of control over your macro work. These devices really help you increase the magnification you can achieve.

# Bellows—On the Cheap

At a grand a pop for a high-end bellows, maybe there should be a cheaper option. Fortunately there is. It's still a "you get what you pay for" option, but the compromises are in ease of use and not necessarily image quality. A little inconvenience to save a bunch of money works for me sometimes. (Like many pros, my rule of thumb is to buy the best gear possible for the photography that pays the bills. For hobby or just plain old fooling around, I've gotta look for bargains too.)

It isn't too hard to find a cheap, completely non-electronic bellows unit on eBay. These are usually coming from Honk Kong or Singapore and run about $30 plus about $10 shipping. You can't use autofocus and you can't set the camera's aperture either, but you can get them to work with your camera. You just may have to overcome some challenges. Or, you can find an old (old!) non-electronic bellows among the collection of an old (old!) film photographer (like me).

The bellows shown earlier and in Figure 4.9, fully decked out, and attached to a Nikon camera, is about 40 years old. I saw one on eBay recently for less than $75. Although it lacks all automatic pieces, the device is a precision jewel of a tool.

While old Nikon bellows units are most plentiful, you may be able to find one to fit your non-Nikon camera. In addition,

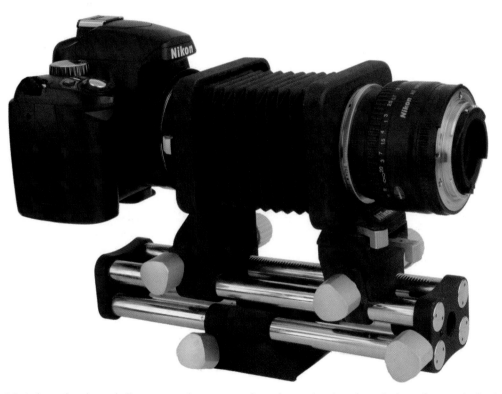

**Figure 4.9** A cheap, barebones bellows unit can be more complicated to work with and may lack autofocus and other handy features, but can still help you take interesting macro photos. If you're on a real tight budget, it can be a workable option.

if you're willing to do a little adapting, you can use a Nikon bellows on other brands, such as Canon. I shoot both Canon and Nikon cameras, and here's a list of the maneuvering I had to do to use this bellows on a Canon camera. (If you're already using a Nikon mount camera you'll have less trouble.) The biggest challenge is that you need a lens where you can set the aperture the old-fashioned way, by turning the aperture ring on the lens. This is a bit of problem with Canon and several other brands, since these lenses don't even have an aperture ring anymore.

◆ **Buy an adapter.** I found an adapter that lets me use Nikon-mount lenses and accessories on a Canon camera. Mine cost less than $20, and you can find Nikon-to-*Brand X* adapters for other models. In many cases, you won't be able to focus a lens that has been mounted to your camera in such a manner all the way to infinity—but with close-up photography, you probably don't care about that, anyway.

◆ **Buy an old Nikon lens.** There are tons of old Nikon lenses gathering dust in used camera stores and on eBay. Find one with really clean glass. Since the camera and lens don't have to talk to each other (or even come in contact) it doesn't matter who made it. I bought one from my local camera store for $25 a couple of years ago. Look for something in the short telephoto range (100mm or so) although a 50mm lens will work too. Best of all is probably an old 55mm f/3.5 Micro-Nikkor. I've seen these for as little as $50 on eBay, and they are super sharp, and work well both on a bellows and mounted directly on a Canon camera with my adapter. (You can focus to infinity with such a setup, too.)

◆ **Set the camera to aperture priority automation.** Without automatic meter coupling, you want to use aperture priority (Av on a Canon and some other cameras). The camera's auto exposure will meter exposure based on the light entering the camera, and set the shutter speed appropriately. You could also use manual exposure if you want.

◆ **Open the lens aperture to its widest setting to focus.** Remember, even with a lens that has an aperture ring, the lens opening won't change unless you select a specific f/stop. Open the lens wide, because you want to let as much light in as possible to focus.

◆ **Stop down the lens to shoot.** Close down the lens to the f/stop you want to use to take the picture. It will probably be a small stop, such as f/16 or f/22. You want as much depth-of-field as possible.

◆ **Control the light as best you can.** If at all possible you want to get your flash off the camera and positioned over your subject. There are two reasons for this. When the flash is locked in the camera hot shoe, it is aimed higher than your subject's position when doing macro photography. In addition, by getting the flash closer to the subject, you're increasing its effectiveness. This is where other gear comes in very handy. If you have either an off-camera shoe cord or a wireless flash controller like the Canon ST-E2, your camera can control the flash's light output, making the whole exercise of getting proper exposure a piece of cake.

**Tip**

When using older Nikon bellows (or extension tubes, or lenses)—those made before 1977—on most newer Nikon cameras—those produced *after* 1977—you should be aware that the lens mount of the old gear can damage an autofocus pin (located at about the 7 o'clock position when looking at the camera from the front). While lenses can be modified to eliminate this danger, all you need to do with bellows or other equipment is to insert a short (15-20mm) non-automatic extension tube between the accessory and the camera. If you're using a Nikon D40, D40x, or D5000, you can forget this step, unless you need the extension tube as a spacer to move the bellows farther away from the camera body. The D40/D40x/D5000 all lack the autofocus pin, and are thus not subject to damage from the older devices.

# Extension Tubes and Other Accessories

Extension tubes and other accessories provide a simple and low-cost entry into the world of macro photography. Basically, an extension tube is what the name implies, a tube designed to move the lens father away from the imaging sensor. This shift decreases the minimum focusing distance the lens is capable of achieving.

Extension tubes can be bought singly or in sets of three and can be used the same way (see Figure 4.10 for an example). Camera manufacturer models can be a little bit pricey, costing somewhere around $100 or more per tube. Third-party options are available for less and can be a workable alternative. Either way, they're a cheap alternative to a macro lens.

As far as macro photography options go, extension tubes are worth considering for several reasons.

◆ **Nothing comes between your glass and your imaging sensor.** Unlike teleconverters, extension tubes have no glass elements, so the risk of cheap glass degrading an image is minimized.

◆ **Use one, two, or three at a time.** You can combine extension tubes to get exactly the magnification you need.

◆ **Use on a variety of lenses.** Extension tubes can be used on all sorts of lenses. This can be a huge advantage because sometimes you don't want to get too close to your subject (wasps, spiders, ex-wives, and their attorneys). I've used extension tubes with my 300 f/2.8 with excellent results.

◆ **Convenience.** Extension tubes are small and lightweight. It's easy to toss one in a camera bag or fanny pack just in case you need it while on a shoot.

◆ **Light loss.** You do lose some light with extension tubes. The amount is manageable.

◆ **Loss of infinity focus.** One disadvantage to extension tubes is in getting closer focusing ability you lose the ability to focus at infinity.

◆ **Auto features will still work.** Auto-extension tubes (both manufacturers' and third-party brands) will usually maintain a connection between camera and lens so auto-exposure and autofocus will still function.

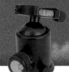

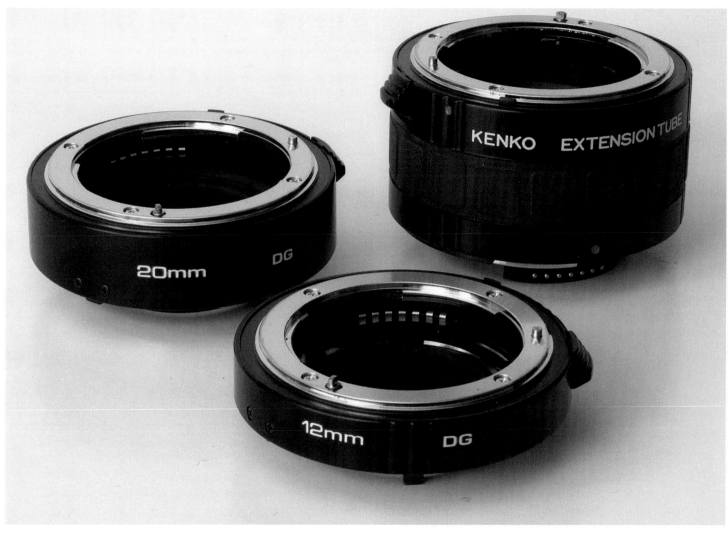

**Figure 4.10** Extension tubes are effective macro aids that don't take up much room in a camera bag, are relatively inexpensive, and easy to use.

# Focusing Rails

Focusing is one of the trickier things you have to worry about when doing macro photography because unless you're using an internal focusing lens, as you focus, the end of the lens gets closer to your subject creating a very real risk that it might hit whatever it is you're trying to shoot.

Another problem is that critical focus is so important and so difficult to get just right. When you're dealing with a life-size reproduction (or smaller), being off by just a little is all it takes to ruin the shot, especially with the minimal depth-of-field involved. An easier approach is to focus the lens to its closest focus point then move the camera back and forth to bring the subject into precise focus. Focusing rails make this much easier since they provide very precise control (see Figure 4.11).

◆ **Stack them.** Focusing rails can be stacked perpendicular to each other so the camera can be moved forward and back and from side to side. Some focusing rails are designed with both sets of movements already built in. This is much easier than trying to reposition the tripod (or your subject, which might not want to be moved).

**Figure 4.11**
Focusing rails offer precise control of your camera's positioning enabling you to achieve the critical focus vital for macro photography.

◆ **Multiple positioning controls.** Most focusing rails have both a coarse and fine control option so you can quickly get your camera to approximately the right spot then switch to fine control for precision focus. When as little as a 1/16 of an inch worth of movement can wreck the shot, fine control is vital. Some focusing rails even offer the ability to slide the rail back and forth (for big movements) before converting to precision control. This makes it easy to move the lens out of the way (to add filters, change lenses, or extension tubes) and then get your rig back into rough position before you use the fine controls for precise positioning.

◆ **Modest cost.** Focusing rails cost anywhere from $85 to $175. This can be a worthwhile investment if you do a lot of macro photography.

◆ **Pan/tilt heads work well.** Focusing rails work well on pan/tilt heads. They can be used on other types of tripods as well.

◆ **Practice, practice, practice.** It takes some practice to get used to using a focusing rail and also to figure out what equipment configuration is most comfortable for you. Keep in mind that the combination of camera, lens, macro choice (bellows, extension tubes, macro coupler, or whatever you're using), plus ring light or flash, makes for a fairly heavy rig. It's a good idea to make sure you're comfortable using whatever setup you put together.

## Macro Couplers and Their Lens Mates

There are lots of ways to do macro photography. One of the cheapest takes advantage of your extra lens if you have one. An adapter known as a macro coupler lets you join two lenses (one of which is reversed) together to take advantage of the combo's increased close focusing capability (see Figure 4.12 for an example).

Macro couplers offer an inexpensive way to get into macro photography, so long as you can find one that matches up to your lens combination. The couplers cost from $8.95 to $24.95 or so, but you may be limited as to how you can combine your lenses (usually you're looking at two lenses with the same size filter threads, although you can use a step-up or a step-down ring if the threads aren't too far apart in diameter).

Depending on the combination of lenses, you can achieve up to an 8x increase in magnification. To determine your magnification, divide the focal length of the prime lens via the reversed lens. If you're using a 20 mm lens as your primary lens and a 50mm lens as the reversed lens, this would give you a 4:1 magnification (four times life size). You'll still get autoexposure too, but will lose infinity focus and will end up with very shallow depth-of-field. Autofocus will still work, but you're better off focusing manually with macro.

Another alternative is to use a reversing ring, which allows mounting a single lens in a reversed position (front of the lens facing the camera) to provide better image quality and increased magnification. Non-macro lenses are designed to provide the best image quality when the distance from the subject to the front of the lens to the optical center is greater than the distance from the center to the sensor plane. However, the actual relationship may be flipped when shooting extreme close-ups: the subject may be, say, only an inch or so from the front of the lens, while the sensor is located two or more inches aft. By reversing the lens, the intended orientation is restored, and maximum image quality results. This technique works very well with prime lenses with about 50mm focal lengths, as shown in Figure 4.13.

Some things to consider when it comes to macro couplers and reversing rings.

- **Inexpensive.** A macro-coupling ring or reversing ring is an inexpensive introduction to macro photography.
- **Image quality.** The macro coupler/reversing ring itself won't affect the image quality, but the lenses you use will.
- **Lens combos.** Use a longer lens (200mm is a nice choice) mounted on your camera. The lens you choose for the other end of the macro coupler can determine the magnification power of the combo. A 100mm lens will give you a 2x magnification, while a 50mm lens will give you a 4x magnification, and a 24mm lens will give you approximately an 8x magnification.
- **Tripod and focusing rail helpful.** At these magnifications, precise positioning of the camera/lens combo becomes very important.

**Figure 4.12** Macro couplers offer an inexpensive way of achieving powerful magnifications if you have a couple of lenses that can compliment each other.

**Figure 4.13** Reversing rings increase magnification and improve image quality.

# Teleconverters for Macro Photography

While a teleconverters' first purpose is to magnify the focal length of a lens, a secondary benefit of these tools is that they provide the same extension effect as a similar length extension tube. This means a teleconverter extends the close-focusing capability of a lens (see Figure 4.14 for an example).

Does this mean it's better to buy a teleconverter for macro photography than an extension tube since you'll get more bang for the buck? Well... not necessarily. Unless you're buying your camera maker's best-quality teleconverter, the loss in image quality compared to an extension tube will be higher. Also, teleconverters steal more light than an extension tube does.

Still, if you have neither, and feel the teleconverter is a higher priority purchase on a limited budget, then its ability to give you closer focusing with a lens you already own will be a plus.

◆ **Keep your distance.** Using a teleconverter lets you fill the frame with a subject that wouldn't usually fill the frame. You're getting increased magnification from the teleconverter, without having to back up because of it.

◆ **Light loss.** Using a teleconverter for close-up/macro photography doesn't change the fact that there's significant light loss involved (one f/stop for a 1.4x, two f/stops for a 2x, three f/stops for a 3x).

◆ **Shutter speed concerns.** When combining teleconverter and lens the greater magnification also magnifies any lens movement. Using a faster shutter speed, tripod, or flash units will help.

◆ **Quality counts.** The better the optical quality of the lens you're using and the better the quality of the teleconverter, the better your results will be.

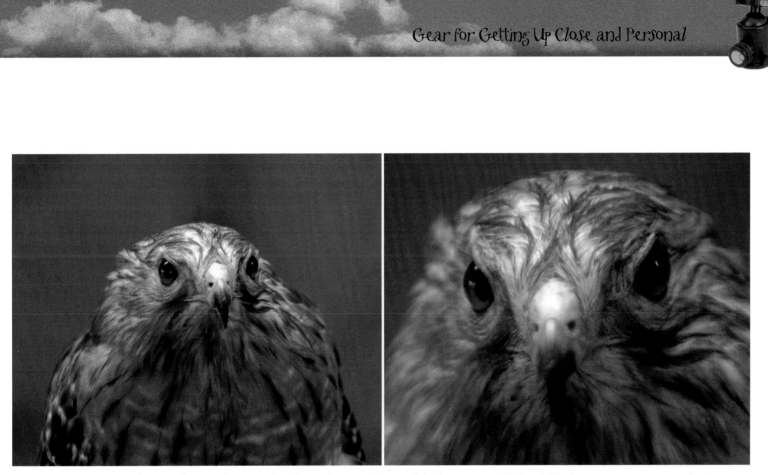

**Figure 4.14** At its minimum focusing distance, this zoom doesn't provide a true close-up of this hungry raptor. With a 1.7X teleconverter, a true macro shot is possible at the same distance.

# Using Your Camera on a Microscope

There's a wide assortment of microscope adapters available for attaching your camera to a microscope. These adapters will help you get great micro images. (See Figure 4.15 for an example.)

While adapting your camera to a microscope is pretty easy, getting good images isn't a given. For a start, you still need to set up your microscope, prepare your slides, and light them properly.

Once your microscope and slides are properly prepared, get your camera ready.

- **Make sure you have enough contrast.** There are several ways of controlling contrast: through the use of filters, or by your camera's internal controls, or through the use of RAW format controls.

- **Make sure everything is level.** Start by leveling the table your microscope is on and work your way up from there, making sure the microscope and camera are level too.

- **Lighting.** Depending on your subject matter, it may be necessary to bring additional light on to your subject. You can configure a flash unit to illuminate your slide by using either an off-camera shoe cord (which maintains through-the-lens exposure) or a wireless flash system. Use your camera's exposure compensation controls if you need to compensate for light background/dark background changes.

- **White balance.** Make sure to do a custom white balance for your microscopy set up rather than relying on your camera's auto white balance setting.

- **Max your resolution.** Shoot at your highest resolution setting with minimal compression, or better still, use RAW format. This gives you the most options when it comes to color and exposure correction and printing.

**Figure 4.15** Digital cameras are well suited to the demands of photo microscopy. *Photos courtesy of Meiji Techno.*

# Lighting for Macro Photography

One of the great challenges for macro photography is caused by the shallow depth-of-field inherent in working so close to your subject. Because there's so little depth-of-field, it benefits the macro photographer to get as much light on the subject as possible in order to maximize depth-of-field.

The good news is that it isn't hard to come up with enough light for macro photography, provided you get your flash off your camera's hot shoe and closer to whatever it is you're photographing. Remember though to be careful not to position your lights so they fire into your lens as this will cause lens flare. Ideally you want your light (or lights) to illuminate your subject from about a 45-degree angle from each side.

This also greatly improves the quality of your light as your small flash turns into a giant, soft light source as it towers over whatever tiny object you're photographing.

There are a variety of ways of getting your flash off the hot shoe and in a better position to light your subject. There are also some special lighting options just for macro photography.

◆ **Off-camera shoe cord or wireless through-the-lens exposure.** Either of these devices will let you reposition your flash so it's right over your subject. The inverse square law (which drastically reduces your light output as your source of illumination moves farther and farther from your subject) now works in your favor with incredible increases in power as it gets closer to your subject. For example, your flash becomes 16x more powerful as it moves from a foot away from your subject to just three inches away.

◆ **Ring lights.** Ring lights are circular strobes that mount on the front end of your lens. This puts them closer to your subject and bathes it in soft, even light. The light from a ring light is a little bit on the flat side, making it better for more two-dimensional objects such as stamps and coins. (A ring light is shown in Figure 4.16.) A photo taken with a ring light is shown in Figure 4.17.

◆ **Brackets.** It's possible to buy a flash bracket that positions a pair of strobes at the front end of your lens much like a ring light. This also lights your subject from both sides at 45-degree angles. It's easier to vary the light output this way than with a ring light (either by dialing down the power of one flash if it has that kind of control or by taping a neutral-density gel over the flash head).

◆ **Light stands or magic arms.** Use light stands or magic arms to position a flash or flashes close to your subject to provide the light you need.

**Figure 4.16** A ring light provides soft, even illumination for macro photography. Because it's mounted on the end of your lens it's close enough to your subject to provide plenty of light.

**Figure 4.17** A water droplet on a wet tulip photographed using a ring light.

## INVERSE SQUARE LAW

The power of light changes dramatically as your subject's position changes in relation to the position of your light source. The reason for this is something known as the inverse square law of light (yes, it's physics). What happens is every time you double the distance, the power of the light is quartered, while every time you cut the distance in half, the power of the light is quadrupled. Confused? (Yeah, so were my Introduction to Photography students when I brought this subject up in class.) Just remember that as you increase the distance from your light source to your subject, you increase the surface area your light has to cover, but while you double the distance, you square the surface area. While this is a pain when you're increasing the distance from flash to subject, it really works in your favor when you're getting closer to your subject. If you get your flash off camera and just a couple of inches away from your subject, you won't have any trouble getting f/16-f/32 if you want.

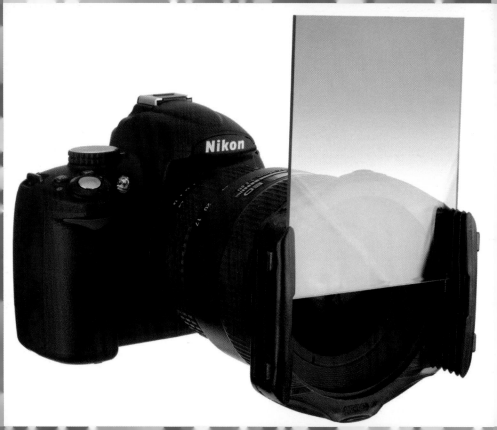

# 5 Altering Reality with Filters

Sometimes reality just isn't what you need it to be. For most people, altering reality can get you in trouble, and, indeed, in the photojournalism world is specifically forbidden. But when we're not looking for documentation and want to maximize the amount of creativity we can apply to our images, photographic filters open up a world of possibilities. They can make your scene confirm a little more closely to your photographic vision.

Filters are add-on disks or squares of glass, gelatin, or some other transparent/translucent material that you fasten to the front of your lens (or, sometimes, drop into a special slot at the rear of the lens barrel). They modify the light in some way, changing its color, reducing the amount of light that reaches the sensor (frequently both at the same time), or, in the case of *polarizing* filters, wholly or partially eliminating glare.

Now I know at least some of you are reading this and thinking: "Well yeah, but isn't that what Photoshop is for?" Yes, Photoshop has changed the way we use some types of filters, but it hasn't eliminated the need for them. There are certain things you just have to do when you're making the photograph; a Photoshop filter applied in post-processing just won't do the same job. Removing glare with an image editor can be a tedious and often fruitless task. There are utilities that *mimic* the appearance of infrared photography, but to those who really know IR imaging, they don't even come close to the real thing. Unless your camera has been converted for infrared shooting, you really must use an IR filter. Soft focus filters in Photoshop don't provide exactly the same effects as a soft-focus lens or attachment.

When you want the most versatility, having the right set of filters and knowing how to use them becomes important. Also keep in mind that filters can also be used in front of a flash or studio light to change the color of the light it produces, too. In fact, a photographer will sometimes use a combination of filters on lens and flash for really special effects!

So what are the considerations in buying a filter? This chapter will tell you everything you need to know.

# The Three Qs of Filter Buying: Quality, Quality, Quality

Filters come in two varieties: cheap and fairly expensive. The cheap filters are the ones that you receive for free from your grateful photo dealer, or as part of a "bargain" bundle (which is likely to include a cheap tripod and some other useless gear). You may also *buy* cheap filters for prices of $5 to about $20. Bargain-basement filters are not a total waste of money. They make great lens caps. I have been known to use one on a walk-about lens mounted on a walk-about camera, when I'm out and not intending to take any serious pictures. If an opportunity pops up, I can bring the camera to my eye and take a picture immediately. If the filter happens to be dirty, I can wipe it off with a shirt-tail first. If I have a little more time, I'll probably remove the cheap-o filter/lens cap before shooting. Such filters are also great for experimenting. You can smear them with petroleum jelly to create a dreamy soft-focus effect. I rifle through my camera

store's junk box from time to time looking for inexpensive filters I can use.

But for serious applications, I use serious filters. This kind of filter costs more, but not *that* much more than you might think. In a sense, a good filter is a potential once-in-a-lifetime investment, like a tripod or studio light stand. If you buy a decent one in the first place, you'll have little need to replace it over the next few decades—until you reach a point

that you no longer own a lens that fits that particular filter size. Or, if you shoot in sandstorms a lot or your filter encounters an unidentified flying object, it's possible that the filter will be damaged and need replacement.

But, in most cases, spending a few extra dollars to get a good filter will pay off, because your filter will last a long, long, time. I have a set of eight decamired filters (a type of precision color correction filter) that I purchased in

college, and which I used regularly right up until I converted to digital photography (which largely made them obsolete). Good filters are a good investment and, more importantly, they can help you take good pictures. If you're interested in experimenting with things like infrared photography, a good IR filter, such as the one shown in Figure 5.1, is essential to achieve effects like you see in Figure 5.2.

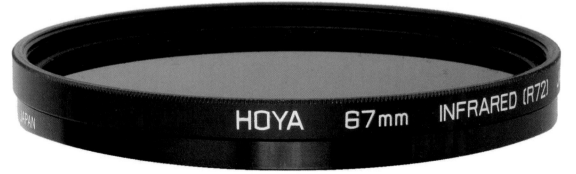

**Figure 5.1** Infrared photography is one pursuit that absolutely demands the use of a filter.

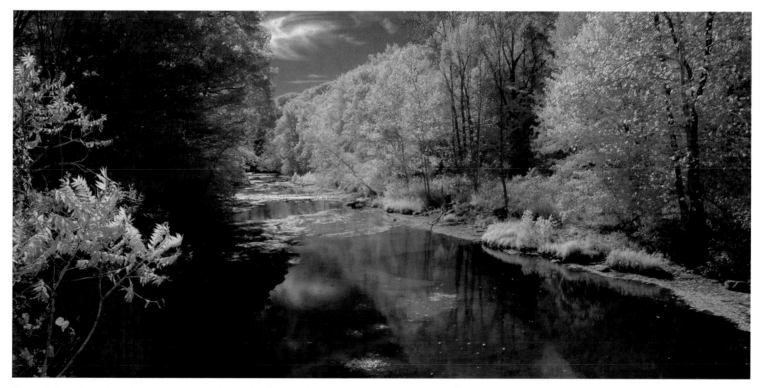

**Figure 5.2** High-quality infrared filters aren't cheap, but they can be your gateway to a new outlet for your creativity.

Here are some things to think about when considering buying filters:

◆ **Good filters filter what they are supposed to—and nothing else.** Filters are intended to *remove* something from the light path, unless they are clear glass filters designed for "protection" (more on that later in this chapter). The best filters are made from high-quality glass or resin and should be either completely neutral in color or precisely the exact color they're supposed to be. Inexpensive filters may have a slight color-cast, and may cause unwanted optical effects, such as flare. Proponents of cheap filters may defy you to point out an instance where the effects of the filter are visible in your finished image. While, granted, the difference may be small, the fact that you personally are unable to detect it doesn't mean it's not there. It may mean that you just don't know what to look for.

◆ **Glass, resin, or gels.** Glass is generally better, but there are a couple of ways that glass filters are constructed. The better way is for the glass to be made with the ingredients that give it its effect added while the glass is still

molten. The other approach, sandwiching multiple pieces of glass around a colored gel and then fusing the sandwich together makes for cheaper glass filters. Over time though, imperfections can creep in as the sandwich loses it integrity from temperature changes and being bounced around in a camera bag. Gels are pretty flimsy; in fact, they're usually used in special mounts at the rear of certain lenses (usually extreme wide-angle lenses or very long telephotos) instead of the front of the lens.

◆ **Larger filters cost more.** One type of filter I prefer costs $35 in a 52mm screw-in mount (that is, the filter has male threads that screw into matching female threads around the perimeter of a camera lens). I use that size on a 105mm macro lens, several 50mm f/1.8 lenses, and some older optics that I still use. Most of my best lenses use a 77mm thread, standardized by the lens manufacturer as a mercy to us cash-strapped photographers. The exact same brand and model filter costs $85 in the 77mm size. You'll want to keep that in mind when planning your own filter arsenal. If all your lenses use the same size filter (so you don't have to duplicate your set), and that size is modest (say, 62mm or 67mm), you can afford more filters, and will have fewer to carry around.

◆ **Brass or aluminum frame.** Circular filters are usually made with either a brass or aluminum frame. In this case there are advantages and disadvantages to each material. Brass is harder, so it's less likely to lock to your lens, but it's also more likely to break a glass filter because it won't absorb shock. Aluminum, on the other hand, isn't as hard as brass, so it's more likely to bind to your lens. It won't transmit shock to the filter as readily though, so it's less likely to cause your filter to crack if it receives a hard tap. I tend to panic at the thought of my lens or filter receiving a "hard tap," so I may be more careful than most, as well as insistent on always having a protective lens hood mounted to my lens. So, I use brass-frame filters almost exclusively because they are more rugged and easier to slip on and off the lens. Because both brass and aluminum filter frames are usually given a black surface, check out the filter's specifications from the vendor's website to determine which type of material a given product consists of.

◆ **Thickness.** Another reason I prefer my brass filters (B+W brand, the version made in Germany) is that these particular filters are a bit thinner than any aluminum filters I've used. They can be mounted on

fairly wide-angle lenses without the filters themselves intruding into the picture area (as described shortly). You may be able to "stack" several thinner filters together, so you can use more than one at once. (However, not all filters, especially the very thinnest ones, have a front female thread to allow attaching additional filters.) I don't recommend stacking filters, because additional layers of glass will eventually affect your images, no matter how good the filter is, but it's a useful creative option nevertheless.

◆ **Coating.** Ideally, a filter will remove only the photons it is supposed to, and won't add any. But when light strikes the front surface of a filter, it's possible that some of those photons will go awry, and bounce around on their way to the sensor, causing a phenomenon known as *flare*. Flare robs your image of sharpness while reducing contrast. It can cause those little globs of light, distracting "rays," and other visual artifacts that nobody wants (unless they *do* want it, for "effect," and add using an image editor's Lens Flare filter). Fortunately, many filters (and virtually all lenses) receive one or more coating layers that greatly reduce unwanted reflections. More expensive filters usually have the most effective coatings.

◆ **Square or round.** Filters can be mounted to your camera several ways. Most common are round filters that screw into the front of your lens; also popular are rectangular filters, like the Cokin System (more on that later), which slide into an adapter mounted on the front of your lens. As I mentioned earlier, there are also filters that have been cut to fit in a small slot at the rear of certain lenses. You'll find rear filters used with wide-angle lenses that have bulging front elements, or such a wide field of view that any filter at all mounted on the front would surely intrude into the picture area. Rear filters are often the only economical choice for very fast telephoto lenses that accept only ginormous, special-order filters (say, 122mm or larger). I've seen 122mm UV (ultraviolet) filters with a list price of $320, and discounted to "only" $229. No thanks.

Once you've chosen the brand, type, and size filter you want, there are even more things to watch out for.

◆ **One size does not fit all.** Attachments designed with a specific diameter won't fit lenses with other diameters without use of a step-up or step-down ring. For example, to mount a 67mm filter on a lens with a 62mm filter thread, you'd need to use a 62mm-to-67mm adapter ring. Step-up and step-down adapter rings can allow you to use the same filter on multiple lenses with different diameter threads. They have a male thread of one size to screw into a specific lens diameter, and a female thread of a different size to accept a filter of another diameter. These adapters can cost $10-$20 and are well worth the cost.

◆ **Vignetting.** As I noted earlier, a filter or other add-on may intrude into the picture area, particularly when used with wide-angle lenses, at smaller apertures (which have greater depth-of-field), and when shooting close-ups (which brings the plane of focus closer to the front of the lens). The result is darkened corners.

◆ **Lens/filter conflicts.** Some lens barrels *rotate* during focusing (while others use *internal focusing* and may not change length or rotate). This rotation can cause problems when using a filter that needs to be used in a specific orientation, such as a polarizer (which is rotated until the desired degree of reflection-removal is achieved), gradient filters (which have a particular density and/or color in one portion, and a different density/color in another), and

when using certain special effects attachments (such as "kaleidoscope" lenses that change rendition as they are rotated).

◆ **Lens/lens hood conflicts.** If you're using a lens hood that fastens to the filter thread rather than to a bayonet on the lens barrel, certain unpleasantries can occur. One of them is vignetting (described above), which is almost inevitable with wide-angle lenses when you attach the filter first and then screw in the lens hood (which is now moved farther away from the front element of the lens, and potentially visible in the picture area). A lens hood may interfere with your ability to adjust a filter, such as a polarizer or star filter, which must be rotated to the orientation you want. Another drawback of this configuration is that each time you decide to switch filters, you must remove the lens hood first. It's also easy to screw a lens hood into a filter thread too tightly, making it difficult to remove. Some attachments have no matching filter thread on their front rim (polarizers frequently don't) so you have no way of attaching a lens hood in the first place.

## FILTER COATINGS

Optical coatings are not exclusive to filters, or even to photographic lenses. Telescopes or the eyeglasses you wear also use coatings to reduce reflections and flare. The first effective anti-reflection coatings were developed in Germany and kept as a military secret until early in World War II. Today, they've been enhanced by using multiple layers, which greatly increase their effectiveness. That's because anti-reflective coatings consist of alternating thin film layers each of which bends light in a slightly different way, so that the undesired photons cancel each other out. Coatings can also be used to make an optical surface harder and more scratch resistant, which is one reason why you can carefully clean filters and lenses with the right kind of cloth, tissues, or other tools.

# Filters to Protect Your Lenses

Do you need to use a filter to protect your lens? I have a definitive answer: yes, no, and maybe. There are three schools of thought when it comes to using filters to help protect your lenses. The first says it's smart to use an inexpensive filter to help protect your expensive glass from dust and scratches. The second says why stick a cheap filter in front of an expensive piece of glass? I subscribe to the third school of thought: I put an *expensive* filter in front of an expensive piece of glass, but virtually always remove it before shooting. Five of my best lenses each have an $85 B+W UV filter on the front, and, as I mentioned earlier in the chapter, I can snap off the lens cap and shoot a grab shot with the filter in place if I need to. And if an evil wind, misty rain, or a gritty sandstorm is afoot, I can still fire away. (Although, when I am not doing photojournalism, wind, rain, and sand usually are enough to send me packing.) The second and third alternatives

don't put much stock in the "protective" qualities of filters, except when shooting under dire environmental conditions.

Each of the three sides' arguments can be persuasive. No matter how careful you are, if you're not using a filter, some dust, mist, or other foreign substances can get on your lens. If you know how to clean your lens properly, that's not a problem. But, if you don't know how to clean a lens, or don't have the proper tools, the more often you have to clean your lenses, the greater the likelihood of leaving cleaning marks or clumsily rubbing off some of the vital multi-coating that helps prevent lens flare. Yet, there are other ways to protect your lens. First off, a good quality lens shade, properly matched to a particular lens, will help protect your expensive glass. Coupled with a lens cap and reasonable care when shooting, you can minimize the risk of dust and accidents.

I suppose it comes down to what your shooting style is like. Are you a careful and deliberate photographer who can take the time to set up each shot and treat your equipment as carefully as possible or are you more frenetic? I'm cautious when I am shooting landscapes, wildlife, and architecture, and almost never need a protective filter under favorable environmental conditions.

As with most controversies, there are pros and cons for each side. You'll find many photographers who have never used a protective filter and who have suffered no mishaps in 30 to 40 years that a lens hood wouldn't counter. A significant percentage of those who are most adamant about using a protective filter have tales of woe about smacking or dropping a lens or two that was "saved" by the filter. I don't know if the non-filter users are more careful and/or lucky, or whether the filter proponents are clumsy, careless, or unfortunate. The real bottom line: if you're convinced you need a fil-

ter to protect your lens, you *really* need one. Otherwise, you're sure to have an accident and regret it for the rest of your life.

Here are the relevant pros and cons. First, the no-filter-required arguments:

- **No filtering required.** It's known that general-purpose UV and skylight filters have no effect in the digital world. However, strongly yellow UV filters, such as a Haze2A or UV17 can reduce chromatic aberration. If you're not using a lens plagued with this defect, you really don't need to be filtering anything. A piece of clear glass (an "optical flat") would provide the same effect—good or bad.

- **Varying performance.** Lower-quality filters can cause problems with autofocus and can degrade the image. That means if you use a protective filter at all, you should use one of high quality. A $20 filter might do more harm than good. A very good filter, on the other hand, can cost $70 to $100 or more in larger filter sizes (and don't forget you'll need one of these for each and every lens).

◆ **Cost.** If you are using a $1,500 lens, an $85 filter might make sense to you. But an $85 filter for a $180 lens makes little sense. But, oddly enough, that cheap lens might have little quality to spare and would, ironically, benefit more from a pricey filter than the expensive lens that is so sharp you won't notice a little degradation. If you have nothing but inexpensive lenses, consider self-insuring: not buying three $85 filters will save you $255, almost enough to replace a $275 lens that is damaged. (If you expect all three filters to suffer an accident, you're probably clumsier than the average photographer.)

◆ **Softer images.** Adding another element can degrade image quality due to aberrations and flare. Why reduce the quality of every image you take to guard against an accident that may never happen?

◆ **Damage from a broken filter.** A badly broken filter can scratch the optical glass element behind it. For every lens "saved" by a protective filter, you may find one that's really been whacked, sufficiently that the filter is cracked, crushed, and the pieces driven into the glass behind it. In some cases, the damage might have been less had the protective filter not been in place.

◆ **Lens hoods provide better protection.** I don't use protective filters most of the time, and have never had an accident where one would have helped. However, I've gently bumped the front of my lens up against objects, and my lens hood prevented any damage every time. The insidious thing about filters is that when one is being used, the camera owner may actually be less likely to use a lens hood—which should always be your first line of defense. Figure 5.3 shows how a lens hood shields the front element of your lens.

And on the other side of the fence:

◆ **Protection from small sharp and blunt objects and falls.** If the lens is dropped, the filter may well suffer scratches or breakage instead of the front lens element. Small pointy things can sneak past a lens hood and strike the front of your lens. A lens hood is great at blocking a door that opens unexpectedly, but will not help if the first thing that hits your lens is a doorknob.

◆ **Reduced cleaning.** One can clean the filter frequently without having to worry about damaging the lens coatings; a filter scratched by cleaning is much less expensive to replace than a lens. I must admit, though, that this rationale applies most to those who don't know how to clean their lenses properly.

◆ **Makes a good lens cap.** I keep mentioning this, because most people tend to forget about this alternative. A protective filter can do its job and still not interfere with image quality. Keep a screw-on filter mounted on your lens at all times—without a lens cap protecting the filter. Then, if an impromptu opportunity for a picture appears without warning, you can flip your camera on (if necessary), sight through your viewfinder, and take a picture. There is no time lost fumbling for the lens cap. If you have more time, *take the filter off.* I usually don't care if one of my "grab" shots with filter in place is not as sharp as it could have been. It's a grab shot, an opportunity that would have been lost entirely.

**Figure 5.3** A lens hood—not a protective filter—should be your first line of defense against lens damage. Then, decide for yourself if a filter will provide additional safety.

What should you consider when trying to protect your lens?

◆ **Filter use.** If you frequently need to change filters, then keeping a protective filter on your lens may not be a good idea because you're going to be removing it a lot anyway.

◆ **Skylight filter.** This is a popular choice for lens protection. Skylight filters have a very light pinkish cast that can warm an image slightly. There are two versions, the 1A and the 1B with the 1B being the stronger of the two. They can be useful when you're shooting in the shade and there's a bluish cast to the light.

◆ **UV filters.** UV filters are designed to filter out ultraviolet light. Lots of people like using them for protection too, because they're clear and have no apparent colorcast. As I mentioned, there's no big need to filter out ultraviolet light with digital sensors, and it isn't really a problem at low elevations either.

# Polarizing Filters, the Photographer's Friend

If there's any one filter that should be in every photographer's bag, this is it. Polarizing filters are useful in many ways—most of which are impossible to re-create in Photoshop. In fact, these little pieces of glass are so useful, it's not unusual to see a photographer carrying more than one. This is because we've reached the point where polarizing filters come in several tasty flavors, each one just right for certain photographic possibilities.

Light becomes polarized (and therefore susceptible to the effects of a polarizing filter) when it is scattered by passing through a translucent medium. So, light from a clear-blue sky becomes polarized when it passes through the dust-laden atmosphere. Light striking, passing through, and reflecting off water also becomes polarized. The same is true of

many other types of objects, including foliage, and the partially transparent paint on an automobile body (think about it: that's why cars need several coats of paint). Nontransparent or translucent objects, like the chrome *bumpers* on the automobile aren't transparent, and don't polarize the light. *However*, if the light reflecting from the metal has already been partially polarized (that is, it is reflected skylight), you still might be able to see a reduced amount of glare reduction with a polarizing filter.

How does it work? A polarizer contains what you can think of as a tiny set of parallel louvers that filter out all the light waves except for those vibrating in a direction parallel to the louvers. The polarizer itself consists of two rings; one is attached to the lens, while the outer ring rotates the

polarizing glass. This lets you change the angle of the louvers and selectively filter out different light waves. You can rotate the ring until the effect you want is visible. The amount of glare reduction depends heavily on the angle from which you take the photograph, and the amounts of scattered light in the reflections (which is determined by the composition of the subject). Polarizers work best when the sun is low in the sky and at a 90-degree angle from the camera and subject (that is, off to your left or right shoulder). Blue sky and water, which can contain high amounts of scattered light, can be made darker and more vibrant as glare is reduced. You can also reduce or eliminate reflections from windows and other nonmetallic surfaces.

As you might expect, polarizing filters solve problems and enhance images in several ways. Let's look at them:

- ◆ **Reduce or eliminate reflections.** Polarizing filters can reduce or eliminate reflections in glass, water, lacquer-coated objects, nonconducting surfaces, and plastic. They don't have any effect on reflections on metallic surfaces. Figure 5.4 provides an illustration.

- ◆ **Increase contrast.** A polarizing filter is the only filter that can increase contrast in color imagery by eliminating those pesky reflections.

- ◆ **Darken pale skies.** Polarizing filters block a lot of light (as much as two f/stops), and because the effect is strongest when dealing with polarized light (such as light in the sky), this can help darken pale skies considerably. At the same time, it will also make clouds stand out more strongly, as you can see in Figure 5.5.

**Figure 5.4**
A polarizing filter does a good job on lacquer, but is not as effective on shiny chrome.

**Figure 5.5** Using polarizing filters can get rid of reflections, increase contrast, and turn pale skies bluer.

When considering a polarizer, there are some important considerations. First off—linear or circular? This one's pretty easy: if you're using an autofocus camera, you want a *circular polarizer*, usually abbreviated CPL. Now, keep in mind, when we're talking about linear and circular, we're not talking about the shape of the filter. All polarizers are furnished in a circular frame for easy rotation. While both types transmit linearly polarized light that is aligned in only one orientation, a circular polarizer has an additional layer that converts the light that remains into circularly polarized light that doesn't confuse the metering and autofocus sensors in digital SLRs.

The second thing to watch out for is the use of polarizers with wide-angle lenses. Such filters produce uneven results across the field of view when using lenses wider than the equivalent of about 28mm (which would be a 17-18mm lens on a camera with a 1.5X to 1.6X crop factor). As I mentioned earlier, polarizers work best when the camera is pointed 90 degrees away from the light source, and provides the least effect when the camera is directed 180 degrees from the light source, as when the light source is behind you. The field of view of normal and telephoto lenses is narrow enough that the difference in angle between the light source and your subject is roughly the same across the image field.

But an extra-wide-angle lens may have a field of view of about 90 degrees. It's possible for subjects at one side of the frame to be oriented exactly perpendicular to the light source, while subject matter at the opposite side of the frame will actually face the sight source (at a 0-degree angle). Everything in-between will have an intermediate angle. In this extreme case, you'll get maximum polarization at one side of your image, and a greatly reduced polarization effect at the opposite edge. Use caution when using a polarizer with a very wide lens. This phenomenon may not even be a consideration for you: many polarizers will intrude into the picture area of wide-angle lenses, causing vignetting, so photographers tend to avoid using them entirely with the very widest lenses.

# Polarizing Filters—with Special "Extras"

Polarizing filters are so useful many photographers don't want to take them off their lenses even when they need to use another filter too. Sometimes you need to combine a polarizing filter (to eliminate reflections in water and foliage), a warming filter, and a graduated neutral density filter (to darken the sky a bit). These filter stacks can lead to vignetting.

As a result, several filter makers came out with specialized polarizing filters capable of pulling double duty.

◆ **Hoya Moose's filter, B&W warming polarizer.** There are several circular polarizing filters that are also color-balanced to warm the light. The Moose's filter is named after nature photographer Moose Peterson, who says he never shoots without a warming filter on his lens. The B&W version combines the effect of a circular polarizer with an 81B warming filter. (See Figure 5.6.)

◆ **Singh Ray Gold-N-Blue Polarizer.** This is a popular choice among landscape photographers, once they've made the effort to learn how to use it properly. As the name implies, it adds blue and gold color-casts to the image. One of the challenges is that while the image might look great in the viewfinder, the resulting photograph will not match that view.

The culprit in this case is the camera's attempts to white balance the gold and blue tones at the same time. It's best in this case to set your camera's white balance to daylight and then correct for neutral tones in the image in Photoshop. You can either do a test shot with a gray card in the foreground or make note of a neutral object somewhere in the scene. Singh Ray has additional information on using this filter on a blog at the company's website.

◆ **Cokin Vari-color polarizers.** Cokin offers a series of these rectangular polarizers that combine color pairs such as red/green, red/blue, pink/orange, blue/yellow, or blue/lime. As you rotate the filter holder from horizontal to vertical the filter changes color-cast. The Cokin system will be discussed in greater depth later in this chapter. Cokin also offers polarizing filters with just one color tint to them. (Color tints will add a color-cast in color photography, but have

a different effect when you're shooting black-and-white images.) Then the color-cast acts to affect how light or dark a particular color will be recorded in shades of gray. A very rough rule of thumb is that objects that are the same color as the filter will be lightened and its compliment will be darkened.

◆ **Hoya variable color polarizers.** Hoya also offers a line of variable color polarizing filters. These circular filters match a gray polarizing filter with two color polarizing filters. As you maneuver the filters, different color effects are possible.

◆ **Tiffen warm polarizer.** Tiffen also offers a warm polarizer. This one effectively combines a polarizing filter with a red 25 filter. This will provide a warmer cast to skin tones in color photography and make for more dramatic black-and-white images because of its increased contrast.

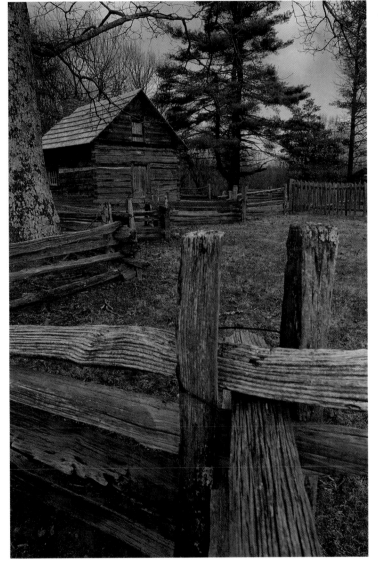

**Figure 5.6**
This shot of a homestead along the Blue Ridge Parkway benefitted from both the polarizing and warming effects of the Hoya "Moose's" filter.

# Neutral Density Filters

There are times when you can have too much light. In Chapter 1, I showed you the long exposure technique for blurring moving water or eliminating people and moving vehicles from scenes. When reducing ISO and closing down the aperture aren't enough to get the desired shutter speed, you need a neutral density filter to block additional light.

*ND* filters, as they're known, come in a variety of "strengths", and vendors use somewhat confusing nomenclature to define how much of the light is blocked. You'll see neutral density filters from one manufacturer labeled according to something called a *filter factor*, while others, from different vendors, are labeled according to their *optical density*. There are actually no less than *four* variations of naming schemes, all equally cryptic; and even if you understand the difference you still probably won't know which is which, or why.

For example, one of the ND filters I own of a particular value is labeled, by different manufacturers, with the following names: ND8, 8X, ND 0.9, and "Three Stop." All three monikers mean that the filter reduces the amount of illumination by three full f/stops. If the correct exposure were 1/500th second at f/8 without any filter at all, you'd need an exposure of 1/60th second at f/8 with the filter in place. (Or, if your goal were to use a larger f/stop instead, you could shoot at 1/500th second at f/2.8 with the filter attached.)

Only the last terminology ("Three Stop") actually explicitly tells you what you want to know. Here's an explanation:

♦ **Filter factor.** You'll see ND filters referred to as ND2, ND4, ND8, or ND 2X, ND 4X, ND 8X. Both versions mean the same thing: you need to increase the base (filterless) exposure by 2X, 4X, or 8X when the filter is in place. That nomenclature is only mildly confusing if you understand that to double exposure you need to increase it by one stop; to quadruple it, increase by two stops; and for eight times the exposure, increase by three stops. Nifty. Now, off the top of your head, how much extra exposure does an ND6/6X filter call for?

◆ **Optical density.** Another way of expressing a neutral density filter's strength is by specifying its optical density. Each 0.3 value of optical density reduces the amount of light transmitted by one f/stop. So, an ND 0.3 filter blocks the same amount of light as an ND2 or 2X filter; an ND 0.6 is the same as an ND4 or 4X filter; and ND 0.9 has the same power as an ND8 or 8X filter. One of my favorite neutral density filters is an ND 1.8, which corresponds to an ND64 or 64X. One quick way of mentally calculating how many stops of neutral density such a filter provides is to divide it by .3—that ND 1.8 gives you six stops of light blocking power!

While you might see stronger or weaker neutral density filters available, the basic ND2, ND4, and ND8 set will handle most situations, because they can be stacked and used together to provide higher light-stopping values. Stacking filters does increase the chances of noticeable image degradation, color shift (because neutral density filters are rarely 100% color-neutral, despite their name), and/or vignetting. My six-stop ND 1.8/ND64 filter allows me to shoot at 1/6th second at f/16 at ISO 100 in full daylight!

When choosing ND filters, consider these factors:

◆ **ND filter types.** ND filters can be found in both round types, which screw into the filter thread on your lens, and rectangular types that fit into holders that mount on the lens.

◆ **Stackability.** If you're not using a very wide-angle lens, you can stack multiple ND filters to reduce even more light, keeping in mind the color shift and vignetting problems I mentioned earlier. You should use high quality filters to avoid optical problems when the filters are stacked. I sometimes use a polarizer with a neutral density filter when I need both polarization plus even more light reduction than the polarizer provides alone.

◆ **Vari-ND.** Singh Ray makes a variable neutral density filter that is capable of producing from a two to eight stop reduction in light. The company also makes a companion filter that can reduce light by an additional five f/stops. I spoke to a company representative while researching this section who stressed that these are not easy filters to use. The company suggests anyone considering buying one check out their website first and visit its blog to read up thoroughly on the filter (www.singh-ray.com). Considering the cost of this kind of filter ($340 to $390 for the Vari-ND and $250 to $330 for the companion filter), it's good advice.

◆ **Material.** Neutral density filters come in both glass and resin versions. Glass is better because resin versions may not be completely flat. The resin versions are more prone to a color-cast too. As you might be guessing about now, glass neutral density filters tend to be more expensive.

Here are some of the things you can use neutral density filters for:

◆ **Slower shutter speeds.** Many digital SLRs have ISO 200 as their lowest ISO setting; others have a minimum of ISO 100, and only a very few go as low as ISO 50. The average lens has f/22 as its smallest f/stop. So, outdoors in bright daylight you may find it impossible to use a shutter speed longer than 1/50th or even 1/100th second. If your mountain stream is not in bright sunlight, it's still unlikely you'll be able to use a shutter speed any longer than about 1/30th to 1/15th second. That's a shame when you have a beautiful waterfall or crashing ocean waves in your viewfinder and want to add a little creative motion blur. An ND8 filter can give you the 1/2 second to several-second exposures you'll need for truly ethereal water effects, as shown in Figure 5.7.

◆ **Larger f/stops.** Frequently there is too much light to use the large f/stop you want to apply to reduce depth-of-field. The wide-open f/stop you prefer for selective focus applications might demand shutter speeds of 1/4000th second or higher. With a 2X or 4X ND filter, the apertures f/2.8 or f/2 are available to you. ND filters are often used to avoid a phenomenon called *diffraction*, which is the tendency of lenses to provide images that are less sharp at very small f/stops, such as f/22 or f/32. If the shutter speed you want to use calls for such a small f/stop, you can add a neutral density filter and shoot the same image at f/16 or f/11.

◆ **Split the difference.** If creative or practical needs dictate, you can *split* the effects among all the exposure factors: an ND8 filter's three-stop light-blocking power will let you use a shutter speed that is half as fast, an f/stop that is twice as large, and an ISO setting that is twice as sensitive, all in the same photograph if that's what you want.

◆ **Countering overwhelming electronic flash.** I have several older manual studio flash units that are simply too powerful for *both* my available range of f/stops and ISO settings, even when switched from full power to half power. Newer units generally offer 1/4, 1/8, 1/16, and 1/32 power options and may be continuously variable over that or an even larger range. But lower power may not be the ideal solution. It's common for the color temperature of electronic flashes to change as the power is cranked way down. An ND filter, instead, allows me to shoot flash pictures with these strobes at my camera's lowest ISO setting and apertures larger than f/22, reducing the need to shoot at a lower power setting.

◆ **Vanishing act.** Create your own ghost town despite a fully-populated image by using a longer shutter speed. With an ND8 filter and shutter speeds of 15 to 30 seconds moving vehicular and pedestrian traffic doesn't remain in one place long enough to register in your image. With enough neutral density, you can even make people and things vanish in full daylight.

◆ **Sky and foreground balance.** A special kind of neutral density—the split ND or graduated ND filter, is a unique tool for landscape photographers. In the average scene, the sky is significantly brighter than the foreground and well beyond the ability of most digital camera sensors to capture detail in both. An ND filter that is dark at the top and clear at the bottom can even out the exposure, restoring the puffy white clouds and clear blue sky to your images. There are other types of split and graduated filters available, as you'll learn from the next section.

**Figure 5.7** Neutral density filters reduce light striking the lens making it possible to use slower shutters speeds and get much longer exposures.

# Graduated Neutral Density Filters

Graduated neutral density filters are a special type of ND filter, one that's almost indispensable for landscape photography. They are particularly important in digital photography for a couple of reasons. The first is that digital cameras often have trouble capturing high-contrast light. The second is that they can have difficulty recording detail with overcast skies.

Digital imaging sensors have gotten a lot better at handling high contrast light than they were just a few years ago, but they're still not capable of handling typically contrasty conditions you frequently run into when shooting under extreme lighting conditions. That's one reason for the current High Dynamic Range (HDR) photography fad among avid users of image editors and utilities like Adobe Photoshop and Photomatix.

Graduated neutral density filters come in a variety of shapes, sizes, densities, and even area of coverage. These filters are so useful that pro landscape photographers may own a half dozen or more. You can find round ones and square ones, but rectangular ones that are longer than they are wide are the best choice. Here's what you need to know about them:

- **Soft edge or hard.** You can find these filters transitioning from dark to light ending in either a soft transition to a clear area (as shown top left in Figure 5.8) or ending in a hard transition to clear area (shown at top right in Figure 5.8). The center bottom filter is a split-color filter, discussed in the next section.

- **Reverse graduated neutral density filters.** The typical graduated neutral density filter is darkest at one of the outside edges and gradually gets lighter. The folks at Singh Ray responding to requests

from landscape photographers created a filter where the transition moves from clear at the outer edge to darker in the middle of the filter then back to clear at the other edge. This filter is a good choice for sunset and sunrise photography when the brightest part of the image is the sun right on the horizon with the foreground and sky both being darker than the center of the image.

**Figure 5.8** Graduated neutral density filters can have a soft transition (top left), hard-edged transition (top right), or fade from one color to another (bottom).

- **Cost range.** GNDs, as they're known, can vary greatly in price from $22 for smallish resin versions to upwards of $150 for high-quality glass versions. This is a case where you get what you pay for and if your budget allows for it, a good quality glass version will do a better job. Still, it's better to have and use a GND, even a resin one, than it is to not use one.

- **Filter length.** The most versatile GNDs are rectangular and longer than they are wide. These can be shifted up and down in the filter holder to best match up the effect with the portion of the sky that needs holding back.

- **Software approaches.** It's possible to simulate the effect of a GND in image-editing programs, some of which even have a specific software filter to mimic the effect. The problem is you're dealing with overexposed highlight areas where no information has been recorded by the imaging sensor. These software approaches will darken a too-bright area, but won't restore any detail (clouds that might have been recorded) because there is no record of it.

Here's a quick summary of the things you need to know to use a graduated or split-density filter:

◆ **Choose your strength.** Some vendors offer graduated/split ND filters in various strengths, so you can choose the amount of darkening you want to apply. This capability can be helpful, especially when shooting landscapes, like the one shown in Figure 5.9, because some skies are simply brighter than others. Use an ND2 or ND4 (or 0.3 or 0.6) filter for most applications.

◆ **Don't tilt.** The transition in the filter should match the transition between foreground and background, so you'll want to avoid tilting the camera—unless you also rotate the filter slightly to match.

◆ **Watch the location of your horizons.** The ND effect is more sharply defined with a split ND filter than with a graduated version, but you need to watch your horizons in both cases if you want to avoid darkening some of the foreground. That may mean that you have to place the "boundary" in the middle of the photograph to properly separate the sky and foreground. Crop the picture later in your image editor (as I did for Figure 5.9) to arrive at a better composition.

◆ **Watch the shape of your horizons.** A horizon that's not broken by trees, mountains, buildings, or other non-sky shapes will allow darkening the upper half of the image more smoothly. That

makes seascapes a perfect application for this kind of neutral density filter. However, you can use these filters with many other types of scenes as long as the darkening effect isn't too obvious. That makes

a graduated ND filter a more versatile choice, because the neutral density effect diminishes at the middle of the image.

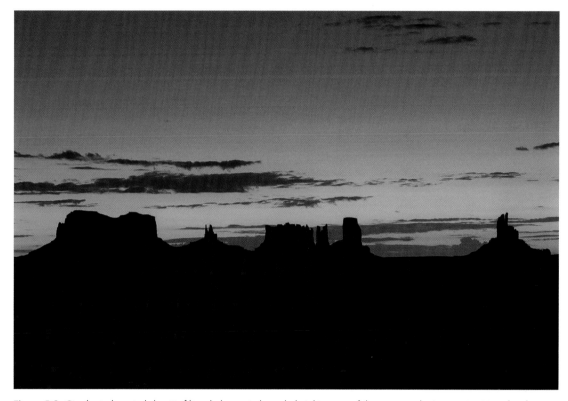

**Figure 5.9** Graduated neutral density filters help control overly bright areas of the scene reducing contrast to a level your camera can handle.

# Color Control and Special Effects Filters

Sometimes you want color with just a little more oomph, and sometimes you want color that should be there, but isn't. Fortunately, there's a whole class of filters designed to help with those problems.

While you can certainly tweak image colors in an image-editing program such as Photoshop, it's still frequently easier to get the effect you want out in the field by using a filter. The advantage to this is you are in a position to check the result either via your camera's LCD screen or through a portable hard drive/view or laptop computer. This approach gives you the chance to try again if the resulting effect isn't to your liking. If you wait until you get home, you may not be able to get the effect you want on your computer and then, you're stuck.

Here are some of the choices available:

◆ **Intensifiers.** Sold under several different names (intensifiers, enhancers, Didymium filters) they serve to intensify just one or two colors while not affecting any others. A "redhancer", for instance, will make the reds in a scene stronger without influencing any other colors. These filters can be useful for landscape or fall foliage photos. There are a wide variety of these filters on the market (one camera store lists 10 different versions in the 77mm size alone).

◆ **Split color.** These filters follow the same approach as split-graduated neutral density filters except they're not neutral and are more concerned with adding a color-cast than blocking light (although the darker part of the filter will rob you of some light). These filters are useful for changing the color of the sky while leaving the foreground unaffected. Sepia, tobacco, and orange versions of this filter are

popular (a certain cable TV channel seems to use them for all their documentaries) but they are also available in other colors such as blue, green, red, brown, and yellow. One such filter is shown at the bottom in Figure 5.8 in the previous section. They may have a transition from one color, such as amber, brown, red, cyan, or blue, to clear, or from one color to another contrasting hue. For example, filters that have a ruddy sunset glow on one half, and a blue tone on the other can simulate sunrise or sunset effects, or simply add an interesting color scheme, as in Figure 5.10. You'll find dozens of graduated filters available to provide the looks you want. Because the density in these filters can cancel out overly bright portions of the image and bring those areas within the dynamic range of your sensor, the effects you get with graduated/split filters can be superior to the same treatments applied in an image editor.

◆ **Sunrise/sunset filters.** While it's possible to use an orange or red split color filter to get a sunset/sunrise like result, such an image rings a bit hollow because while the sky looks like it was shot when the sun was low in the sky, the foreground doesn't. For years photographers would use a rectangular filter holder and position a stronger color filter in the top half of the holder and a weaker version upside down in the bottom half to create a more realistic sunset/sunrise image. Cokin eventually came up with a sunrise/sunset filter that gradually transitions from a light orange to a darker one so you only have to carry one filter for that effect these days.

**Figure 5.10** A variety of filters, like the split color filter used for this shot, exist to help you make colors more intense or get Mother Nature to cooperate with your photographic needs.

## Special Effects Filters

Special effects filters can do a variety of things from creating star-like effects to double images to multi-color images and more. While some of these effects can be created in software, some can't, and as always, there are certain advantages to achieving an effect in the field where you can make adjustments to exposure and camera positioning if need be.

◆ **Cross Screen filter.** This filter, sometimes called a star filter, gives light sources a star-like effect. You can achieve a similar result by stretching a black nylon stocking over a lens or holding a piece of window screening in front of the lens. (See Figure 5.11.)

◆ **Soft FX filter.** Helps soften small blemishes and wrinkles without degrading other elements of the photo.

**Figure 5.11** A star/cross-screen filter effect.

◆ **Split field filter.** This filter is half diopter, half clear. It's used in situations where you want to have a close-up element and a distant one and need both to be in focus.

◆ **Radial zoom filter.** A clear center spot doesn't affect your subject in the center, while everything else in the frame is turned into a zoom effect.

◆ **Multi-image filter.** Takes whatever's in the center of the frame and creates multiple versions of it. There are 5, 7, 13, and 25 models, which multiply the subject by the number of the filter. (See Figure 5.12 for an example.)

◆ **Rainbow filter.** Puts a rainbow into your image. While it's an interesting idea, it seems to be very difficult to get a natural-looking effect with this filter.

◆ **Mirage filter.** Creates a reflection of your subject similar to a reflecting pool.

**Figure 5.12** Multi-image filter effect.

# Cokin Filter System

Photographers owning multiple lenses, each taking a different-sized filter thread, have long had reason to hate round filters. Say you owned three different lenses and each one needed a different-sized filter. That meant you had to buy multiple copies of the each type of filter. That can be an expensive and impractical situation. Certainly, you can buy a step-up or step-down ring, adapters that let you mount a filter to a lens that would normally take a different-sized filter, but you'd still need to own a complete set of them for your lenses. But stepping adapters have limitations: you can't mount a 62mm filter on a lens that normally requires a 77mm filter—vignetting will result. And, with wide-angle lenses, the thickness of the adapter may result in

vignetting, even if you're mounting a larger filter on a smaller diameter wide-angle lens. In addition, adapters often bind up with the filter they're mounted to and you can't separate them even with a filter wrench.

A French company by the name of Cokin pioneered a square filter system that relies on a slotted filter holder that can hold multiple filters. The system, which comes in several sizes, is built on a series of adapters that fit the filter threads on a lens. You buy an adapter ring for each lens and then just slide the rectangular adapter over the ring to fit it to whatever lens you want to use it on. The company makes a variety of filters for its system and several other filter makers (Singh Ray, Tiffen) also offer rectangular fil-

ters that will fit into the Cokin holders. Cokin offers more than a hundred different filters for its system.

Slotted filter holders that attach to the front of a lens and accept square filters are nothing new, dating back to the 1950s and earlier. But their dramatic increase in popularity in more recent times can be traced directly to the introduction of the Cokin Creative Filter System in 1978. Developed by French photographer Jean Coquin, the popularity of the Cokin system (as well as derivative filter holders based on the Cokin design) can be traced to several factors. The most important are *standardiza- tion*, which allows Cokin holders and filters to be used with the

vast majority of digital SLR lenses (plus point-and-shoot models and camcorders); and the *vast num- ber* of different types of filters available. There are hundreds of different filter models offered for special effects, color correction, neutral density, diffusion, and other applications.

The factors to consider in going with the Cokin system or similar accessories are varied. Among the pros:

◆ **Simplicity.** Drop-in filters are even easier to use than the screw-in kind. Slide them into the holder frame (see Figure 5.13) and you're ready to go. Several filters can be used in combination, and quickly changed when you want to use a different filter.

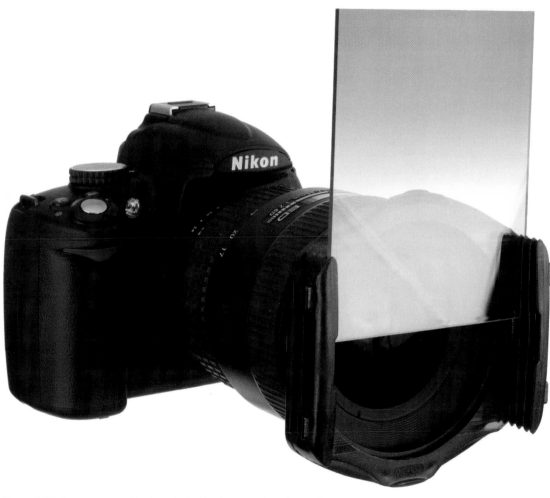

**Figure 5.13** Drop a square filter into the holder frame and you're ready to go.

◆ **Cost.** If you already own a filter holder (priced at about $20 for an adapter-ring/filter holder set), your subsequent filter purchases can be very inexpensive. Many individual square filters can be purchased for less than $20 each, with more specialized slide-in circular filters (including polarizers) priced at $25-$50 or more. When you consider that a 77mm screw-in polarizer can easily cost more than $100, these filters are bargains.

◆ **Interchangeability.** You can buy adapter rings for filter mounting systems for many different thread sizes, so you might be able to use the same filters on many different lenses in your collection.

◆ **Do-it-yourself.** You can easily make your own filters, including star filters and other special effects add-ons, from square pieces of optical-quality polycarbonate. Indeed, if the techniques you want to explore include soft-focus or diffusion, the optical quality of the material may not even matter that much.

There are also some cons to consider:

◆ **Vignetting.** The filter holder extends at least 0.75 inches in front of the lens. The entire contraption can show up within the frame when using wide-angle lenses. You can often minimize this by using a filter holder that's larger and holds larger (and more costly) filters.

◆ **Problems with lens hoods.** The filter holder makes it impossible to attach the lens hood furnished with your lens. While the holder itself provides some shielding from extraneous light, you can still get glare on the lens. Cokin sells a lens hood attachment for its filter holders that provides a partial solution: its coverage may not exactly correspond to the lens's field of view, but may be fairly close.

◆ **Rotation complication.** The front of some lenses rotate when focusing, which means the entire filter holder may rotate. The retaining ring used with the Cokin system can rotate independently of the filter holder itself, so you can maintain the desired orientation even if your lens rotates.

◆ **Extra stuff hanging on your lens.** One reason I prefer the standard-filter-size option over filter holders is that the latter are a little klutzy and require fastening a bunch of extra stuff to the front of your lens. Of course, some kinds of work, such as scenic and infrared photography are often slow-moving contemplative pursuits involving non-mobile subjects such as landscapes, so all this paraphernalia may not be a concern for you.

## Cokin Recipes

As you investigate the Cokin system, you'll see that its flexibility accounts for much of its popularity. The first step in setting up is to purchase a filter holder suitable for your camera and lens, and a retaining ring to attach the filter holder (see Figure 5.14). The company also offers "magnetic" filter holders (primarily for amateur cameras without a filter thread, but which can accept Cokin's stick-on metallic strip) and shoe mount filter holders that attach to the camera's tripod socket and extend out in front of the camera and lens.

For thread-attached holders, there are several different sizes, scaled to fit square filters of various widths (although round filters mounted in plastic frames can also be used). You'll probably want to avoid the A (Amateur) series, which use 67mm × 67mm filters, suitable for lenses with filter diameters up to 62mm, because so many interchangeable lenses have larger diameters than that.

Instead, look for the larger P (Professional) series holder, which uses 84 × 84mm filters, and is suitable for lenses with front diameters of up to 82mm. For lenses that are even larger, Cokin offers the Z-Pro series (100 × 100mm filters), and X-Pro series (130 × 130mm filters—more than five inches square), used primarily for medium format film and digital cameras (or larger). You'll also want to purchase an adapter ring for your lens or lenses with the correct diameter for your lens's filter thread. You can attach this ring to your lens and slide the filter holder right on.

There are more than 200 different Cokin filters, but other manufacturers also produce filters and holders in the A and P series "standard" sizes. You can place two different square filters in the pair of slots on the holder. They're held in place by friction, so you can move them up and down to partially or fully cover the lens when you want to vary your effect. A third, circular filter, can be dropped into a special slot that's closest to the camera lens. These include star filters, polarizers, and other filters, and they can be rotated within the slot to produce a particular effect (say, to vary the amount of polarization).

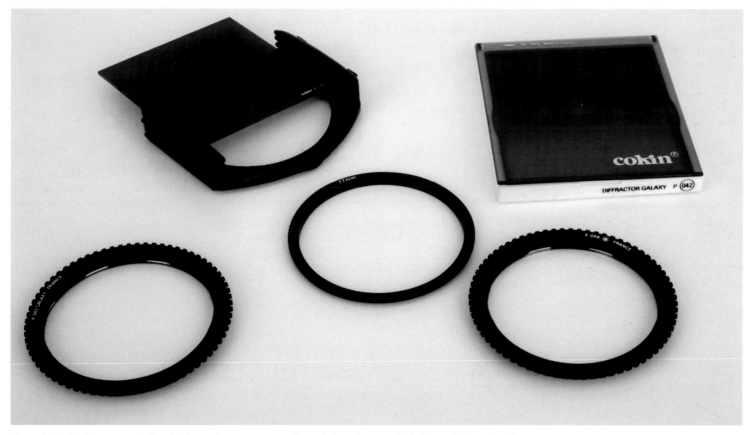

**Figure 5.14** Purchase a single filter holder and a retaining ring for each lens diameter the holder will be used with.

# Filters and Flash

An interesting technique photographers use is to combine a filter over the lens and another over a flash unit. This technique takes advantage of the limited distance light travels from the flash unit compared to the infinite effect of the filter on the camera lens.

One trick is to use color complements to cancel each other out. If you place a red filter on your camera and a green filter on your flash, then the area of the image that receives light from the flash will be normal looking, but everything beyond flash range will be tinted red. Blue/orange is another workable pair for this trick and can be nice when you're photographing people in front of a landscape. The blue filter goes on your flash (as shown in Figure 5.15) and the orange filter on your lens. Your human subjects will photograph normally and your landscape will photograph warmer thanks to the orange filter.

Another version of this trick is to set your camera's white balance to Tungsten lighting when shooting outdoors, and use an orange gel on your flash. This will give a blue cast to everything not hit by light from the flash, but the orange gel will cancel out the blue color-cast where the light from the flash hits. It's a good idea to position the camera low shooting up so you mainly end up with an electric blue sky. At night, I sometimes use a blue filter on the flash and shoot tungsten scenes, like the one in Figure 5.16, ending up with an interesting mixed-color look.

◆ **Color combos.** Blue/Orange, Red/Green, and Purple/Yellow are complementary colors and will cancel each other out when used in this way. For this effect to work best, be sure to have similar strength versions of each filter.

You could also use split color filters to apply the effect to limited parts of the scene.

◆ **Control flash power to control distance its light travels.** You can control the distance affected by this effect. Many flashes let you change power settings reducing or extending the distance the light covers. Add additional control by changing your f/stop to increase or decrease the light's effective distance as well. Use less power and a smaller lens opening and the light from the flash may only cover a few feet; crank up the power and open up the lens and the light might carry a hundred feet or more.

◆ **White balance.** Digital cameras with their various white balance options offer a way to vary the effect even more. You can experiment with different white balance options combined with a filter on your flash to get interesting effects. Some cameras even let you dial in specific color temperatures in degrees Kelvin.

**Figure 5.15**
Most add-on flash units allow attaching filter gels directly to the front of the unit.

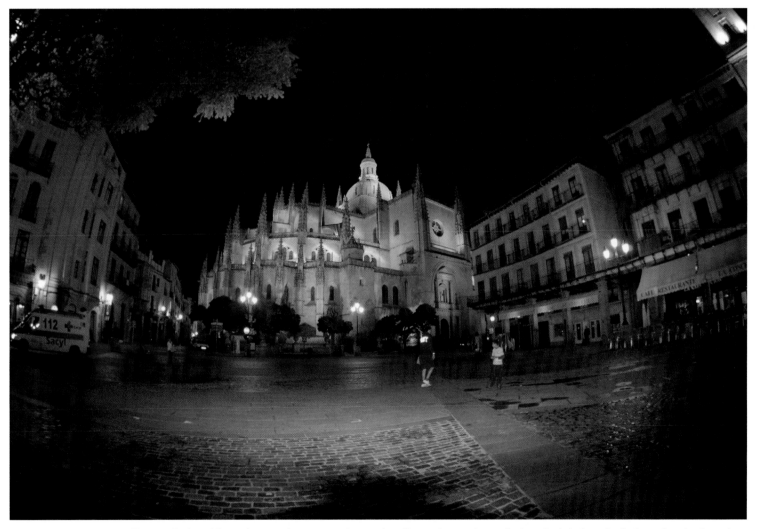

**Figure 5.16** By combining filters on flash and lens, photographers can apply no color effect to the area beyond where the light from the flash reaches, but keep the foreground another color entirely.

# Filter Accessories

There are certain accessories that can be useful if you do a lot of work with filters. These accessories can make your life easier or bail you out in a jam. If you use filters a lot, or carry a lot of filters, these next few items can be a good investment; even better, most of them don't cost much either.

◆ **Carrying cases/boxes.** Most of the time when you buy a filter it comes in its own protective case. That's fine for sticking in your camera bag if you're only carrying a filter or two. If you get to the point where you're carrying a half dozen or more, then a filter case or box starts to make some sense. There are even cases designed as part of modular bag systems so you can attach them to your camera bag instead of having to use a pocket for the case. I like the filter wallet I got for my Cokin system filters. (See Figure 5.17.) It has slots that hold conventional round filters, too, so I can carry all my filters in a single case.

◆ **Stack Caps.** Another option for carrying your filters is a set of stack caps. These consist of two lens-cap-like metal disks, one with a male thread to fit into the front of most filters, and the other with a female thread to fit on the back side of a filter. Stack all your filters together (see Figure 5.18), and you can carry them in a neat pile.

◆ **Step-up, step-down rings.** These are adapters that let you use one size filter on a different size lens. They're cheap (less than $10 each), lightweight, and don't take up much room. The only concern is that sometimes they can bind to a filter and become difficult or impossible to remove.

◆ **Filter wrenches.** These come in sets of two and are used to give greater leverage towards your effort to separate two stuck filters. Rubber bands are good for this purpose too. Fit a rubber band around each filter ring and try twisting. Often the better grip the rubber band gives you is enough. Filter wrenches aren't expensive. (Less than $15 for a pair, but rubber bands cost even less, are easier to find, and take up less space in your camera bag. Wider bands are better than thinner ones.)

**Figure 5.17**
Filter wallets can keep your filter collection neat and tidy.

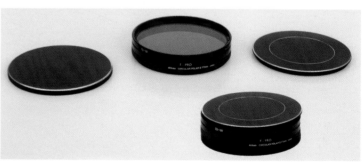

**Figure 5.18** The front cap (rear, right) screws onto the top of the filter stack (rear, center). The other cap (rear, left) screws onto the bottom of the stack. The result is a neat pile of filters (foreground).

Another option for mounting filters on your lenses is not used much today, but is still viable, and can be very, very inexpensive. The *Series system*, a kind of filter holder dating back from before filters in standard screw-in sizes were available, can come in very handy. You can even use this type of adapter to make your own drop-in filters easily and inexpensively.

Before standard thread sizes became universal, lenses didn't necessarily have common systems for mounting filters up front. Some lenses had threads, others used bayonet mounts. Some required push-on mounts that attached to the lens using friction to hold accessories. The solution was the Series system, which used threadless standard filter *sizes* and holders that accepted those filters. The inexpensive filter holder, tailored to each type of lens, had the threads. You'd simply drop the filter you wanted to use into a Series adapter suitable for your particular lens.

You can still buy Series adapters and filters today, and they're easily found in the used/junk bins of most camera stores because they have been largely supplanted by standard filter sizes. When purchased from a junk bin, such adapters and filters can be very, very inexpensive, on the order of a dollar or two.

The Series system works like this: the filter mount comes in two pieces, shown in Figure 5.19. One piece attaches to your lens, using either a screw-in thread that matches your lens's filter thread size, or by a bayonet or push-on mount suitable for your particular (odd-ball, or antique) lens. Several different size ranges are available, called Series VI, VII, VIII, or IX (or, today, 6, 7, 8, or 9) with each Series size suitable for a range of lens diameters. There can be a little overlap; for example, a Series VII ring might fit lenses in the 46mm to 67mm range, with Series VIII fitting lenses with 62mm to 77mm diameters. A standard size retaining ring screws into the inner ring, with enough space between the two for a Series-sized filter.

**Figure 5.19** A Series adapter consists of two parts, and the unthreaded filter fits between them.

The Series system is remarkably flexible. You'd buy an inner ring, say a Series VII size, for each of your lens sizes, a set of Series VII filters, and one outer Series VII retaining ring and use the combination with multiple lenses. Other accessories, such as lens adapters, can also be screwed into Series adapters.

Once you have a Series set that fits your lens, anything circular that can be put between the two rings becomes a filter. A circular piece of window screen can be magically converted into a star filter. An ordinary round piece of glass from an old flashlight can be smeared with petroleum jelly and used as a diffusion filter. (In Hollywood in the 1930s, they used large chicken feathers.) Cut a keyhole shape in a round piece of posterboard, and take faux voyeur pictures. Some of these effects can be done in an image editor, of course, and some cannot, but they are all fun to play with.

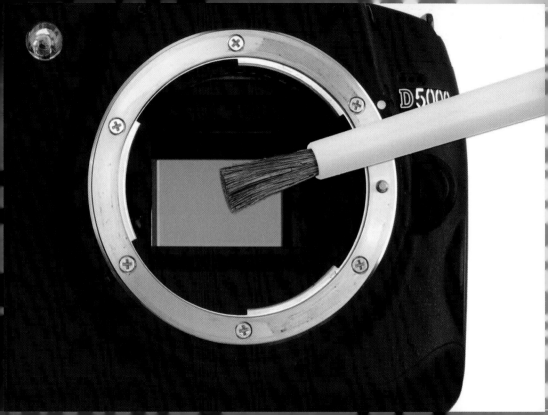

# 6 Keeping Clean

Camera, lenses, filters, tripods, and other gear—it adds up after a while. Soon you find yourself with a pile of gear and concerns of how to best take care of it. Dirt and dust are the bane of photographers because they can cause premature wear of equipment with moving parts, degrade images, and cause lens flare.

Caring for camera bags and tripods is fairly simple; caring for lenses and bodies is a little trickier. Cleaning your lenses and camera are necessary, but delicate operations. Use the wrong cleaning solution or technique and you can seriously damage an expensive piece of equipment. The good news is that it isn't that hard to clean your gear, but you must plan on being careful. We're going to take a good look at how to care for your gear in this chapter.

# Caring for Your Lenses

Camera bodies come and go, especially in the digital age, but lenses are forever. Theoretically. The lenses you buy today might very well be useful to you a decade from now (if you take good care of them), while it's unlikely you'll be using the same digital SLR body in 10 years. I don't recommend mistreating your cameras while treating lenses like prize jewels—both were meant to be used—but there is a lot of truth in the concept that if you take good care of your lenses, they'll take good care of your photo needs for a long time.

In the film era, camera bodies didn't need to be upgraded quite so often. If you wanted more resolution or better high ISO performance, you bought a different or improved film, and kept the body you had. There was pressure to change camera bodies only when a major new feature, like autofocus or a completely different lens mounting system, came along. But even before the digital age, lenses had a longer life than camera bodies. I still own about 15 prime lenses and one zoom that I purchased for use with my film camera, and all of them still work—albeit in manual focus mode—on my latest digital camera. I use one of them, a 55mm macro lens, five or six times a week, and relied on an

aging 85mm f/1.8 lens almost as much until it was finally supplanted with a new 85mm f/1.4 with even better optical characteristics. My old 16mm f/3.5 full-frame fisheye is seeing renewed use now that I'm using full-frame digital SLRs. I'm glad I took good care of my lenses—although that's a relative term, since in those days I never bothered with "protective" filters, and was prone to toss a lens into an open camera bag when swapping one for another. I'm more careful now.

You, too, can keep and use your best lenses for an extended period, replacing them only when you switch to a different brand camera that has a different lens mount, or when a better lens for the job comes along. Here are the keys to long lens life:

◆ **Keep your lens barrels and mounting bayonets clean.** Many lenses don't have internal seals to prevent air from pumping through them as they focus or zoom. Indeed, that's one reason why amateurs who *never* swap lenses (they may own only the one lens) still end up with dust on their sensors. The mere act of focusing may suck in tiny dust particles and propel them back into the mirror chamber. More dust may be introduced to the interior of a camera by clinging to the rear bayonet, electrical contacts, or other surfaces when lenses are changed. Keep the exterior of your lenses clean, and you won't have to worry about premature wear of the moving parts, such as the helical focusing threads, or dust getting inside your camera.

◆ **Keep the front (and rear) glass elements clean.** The front surfaces of lenses, in particular, seem to attract dirt, fingerprints, and other contaminants. As I noted in Chapter 3, unless you're working in dusty or wet environments, you probably don't need a "protective" filter to keep the dirt off the lens, unless you want to use one as a clear lens cap. You'll just have to clean the filter instead (and lenses aren't that difficult to clean properly). But you can at least *be careful* about exposing your lenses to fingerprints and grime. A lens hood can help.

◆ **Avoid environmental extremes.** In the olden days, the lubricants used on the moving parts in lenses, including the focus mechanisms, aperture stops, and the diaphragms themselves could become sluggish in very cold temperatures, and possibly ooze or even outgas vapors at very high temperatures (say, in the trunk of your car). Teflon and other self-slippery substances have pretty much eliminated most dangers from changes in temperature. But, even so, you don't want to take your camera from an air-conditioned car out to photograph a humid lakeside sunset (as I have), because your lenses and entire optical path exposed to air will fog up. To be honest, I have to point out that I have sometimes taken great "misty" pictures anyway, with so much fog that I couldn't see through the viewfinder. But, in general, your lenses (and cameras) will perform better and last longer if you avoid extreme heat, cold, and moisture.

## Cleaning Lenses

High-quality optical glass needs to be treated gently. While there are a variety of tools on the market designed for camera care, most of them need to come in contact with your expensive glass in order to work. This is where the potential problems arise. Imagine a tiny speck of dust on your lens. Now imagine pushing that speck around with a lens cloth or cleaning tool. Just imagine the dust grinding into your expensive glass, leaving tiny almost-imperceptible scratches and rubbing off tiny bits of multi-coating. This is exactly what you're trying to avoid doing.

Generally the best way to approach lens cleaning is by using compressed air or a bulb blower to try and blow as much dust from the lens as possible. It's best to sneak up on the dust from an angle and try to blow it off the lens sideways rather than blast the compressed air straight onto the lens and force the dust into the glass before it bounces off.

Also, if you're using compressed air, do your best to keep the can upright and level and maneuver the lens into position. If you tilt the can of compressed air, you may end up with some of the can's liquid propellant being sprayed onto the lens as well.

Once you've blown off as much dust as you can, it's best to take a lens brush and gently brush the surface of the lens off using a motion designed to lift the dust off the lens surface rather than just brushing across it. At this point you can consider using lens cleaning fluid (alcohol works well) and lens paper or a microfiber cloth to finish the job if necessary. Always stop at the point where your lens looks acceptably clean though. If canned air does the job, skip the other steps; if canned air and a brush get it done, skip the cleaning fluid. The less contact you make with the glass the better.

Let's take a look at some of the lens cleaning options available to you:

◆ **Compressed air.** This is a popular and generally safe tool as long as you're careful to keep the can level. As I noted, the risk with "canned" air is that some of the propellant sprays on your gear. It's not the end of the world, but now you've got to clean the propellant off your glass. And always remember to tilt your lens so the jet of air blows dust off the lens surface rather than into the lens surface.

◆ **Bulb blower.** While not as powerful as canned air, bulb blowers are safer since they can't accidentally spray propellant on your lens. Bulb blowers can also be brought on airplanes while canned air can't. If you have a bulb blower with a brush attached, use it only on lenses, filters, or your camera. The typical blower bulb/brush is suitable only for cleaning lenses, and should not be used for cleaning sensors.

◆ **Lenspen or lens brush.** Lens brushes, like the one shown in Figure 6.1, are handy devices since they fit neatly into your camera bag or shirt pocket without the worry of any liquids to spill. One

**Figure 6.1** Lens brushes can whisk off dust that isn't adhering to your lens.

type includes cleaning options on each end. On one end is a retractable brush, which is used to flick dust off the lens. The other end holds a cleaning surface that flexes to match the surface of the lens. By giving the cap a half-turn twist, it loads the surface with a cleaning compound you use to clean smudges off the lens surface. It's important to be gentle when you're doing this, but if you're careful, you can get good results.

◆ **Lens tissue.** Photographic lens tissue is another inexpensive and reasonable cleaning tool, but be sure to get tissue specifically designed for camera lenses. As a rule of thumb, the softer the tissue is, the better, especially when removing stubborn artifacts, like fingerprints, with a lens cleaning liquid. The advantage to this choice is it's inexpensive and you're throwing away whatever dirt you pick up when you're done with it. The best way to use lens tissue for dust is to roll it up into a tube, tear off one end of the tube, and use the roll as if it were a soft, fuzzy brush.

◆ **Microfiber cloth.** These cleaning cloths have gained a lot of popularity over the past decade or so. They're great for eyeglasses and can be good for cleaning your camera lens too. Once again, gentleness is the order of the day and remember to launder them often. It's a good idea to store the cloth in a plastic bag or the bag it's furnished with (see Figure 6.2) when it's in your camera bag. It might be a good idea to breathe gently on the front element of your lens before using a microfiber cloth to provide a little lubricating moisture to help prevent grinding any dust into the lens/coating surface.

◆ **Cotton balls.** These are my personal favorite (although I also use a Lenspen, microfiber cloth, and compressed air depending on whether I'm in the field or at home). I like cotton balls because they're very soft and inexpensive. I use one for cleaning (apply the fluid to the cotton ball) and another for gently drying the lens surface. I follow up with a squirt or two of compressed air to blow away any loose fibers that may still be on the lens surface.

## CLEANING fREQUENCY

If you're looking for a regular lens cleaning schedule, you're not going to find one here. The reality is that you should only clean your lenses when they need it. If you're not using your gear much and it's safely tucked away in a closed camera bag, there's no reason to think it's getting dirty. On the other hand, if you live in the desert and spend a lot of time shooting, you might have to clean your gear a lot. If so, the idea is to do the minimum you need to get the job done. Start by using some gentle air (bulb blowers work well) and get rid of as much dust as you can. Shine a flashlight on your glass and see how it looks. If it seems pretty clean, you're done. If it doesn't what's the problem? If it's more dust, go to compressed air and see if you can blast it off. If that works, you're done. If there's still dust or spots or fingerprints, you've got more work to do. Use a brush to gently flick remaining dust particles off, then use a Lenspen or cotton ball with some alcohol on it to clean the lens surface. After that you can use another cotton ball to dry it off. Use the blower again to get rid of any fibers from the cotton ball and then you're done.

◆ **Cleaning solution.** Ethanol and isopropanol alcohol are popular choices among photographers. They dissolve grease and other oils and evaporate completely so they don't leave any residue on your lens. A stronger solution is generally better than a weaker one. Distilled water is also okay, but not as useful on oil or grease (think fingerprints). You want something with the fewest additives possible since these can leave residues on your lens. Fogging a lens with your breath provides a similar liquid and is a reasonable alternative provided you didn't just finish eating crackers. Stay away from household glass cleaners; they can contain additives that won't do your equipment any good. Commercial lens cleaning fluids, like the one shown in Figure 6.3, can be useful, but don't really do anything to improve on plain alcohol.

**Figure 6.3** Isopropyl alcohol, frequently sold in small bottles as lens cleaner, can dissolve fingerprints while helping you remove dust and artifacts from your lens.

**Figure 6.2** A microfiber cloth can be used to gently remove more stubborn dust.

# Introduction to Sensor Cleaning

Dirt on sensors is the most vexing part of using a dSLR. There's nothing worse than looking at a series of photos and realizing that every single one of them has a big old out-of-focus fuzzy spot that stands out like a sore thumb in a plain, light-toned area. Certainly, you can remove these artifacts in an image editor, but that's time consuming. Some cameras have a "Dust Delete" feature, which basically takes a picture of the dust and provides information that the vendor's image-editing utility can use to blank the dust out. That's not a preferred solution either. What most of us would prefer would be to stop dust dead in its tracks, before it finds its way onto our images.

Fortunately, most cameras introduced today have automatic sensor cleaning built in. Some can be set to clean every time you start up the camera as well as every time you turn it off. The auto sensor cleaning step can even be invoked manually. These systems are sophisticated, and usually involve a combination of technologies, including an air control system to keep dust away from your sensor, a sensor-shaking vibrating mechanism that jiggles any invading dust off your sensor, and, maybe a tiny sticky strip in front of and below the sensor to capture the particles so they can't recontaminate your camera. But no dust-busting technique is 100-percent effective. At best, they can simply delay how long you can go before you have to clean your sensor the old-fashioned way, with blower bulbs, brushes, or swabs.

## Identifying Sensor Specks

Dust on your sensor may not be obvious, at first. It is most noticeable only in light-colored areas that silhouette the dark specks against a brighter background. At wider f/stops, sensor dust may be so out of focus that it is invisible. You might not see it unless you use a smaller f/stop, from f/11 to f/22 or so. Then, it shows up as blurry, ill-defined specks in your image, as shown in Figure 6.4. Any dirt you see through the viewfinder (at least, when not using your camera's Live View feature) is dust in the viewing system, and won't affect your photographs. You can safely clean that kind of dirt with a blower or soft brush, taking care not to scratch the underside of the focus screen or the mirror (which is front-silvered and delicate).

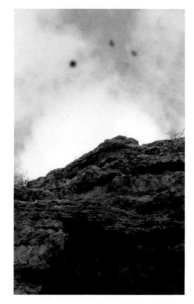

**Figure 6.4** Sensor dust shows up as fuzzy blobs on your image.

Sensor dust is not a hot, dead, or stuck pixel, like the one in Figure 6.5. These can be removed through a process called *pixel mapping*. Some cameras have that feature built in; others require that you send the camera into the manufacturer, who will reprogram it to "ignore" the errant pixel.

**Figure 6.5** A bad pixel is surrounded by improperly interpolated pixels created by the camera's demosaicing algorithm.

## Avoiding Dust

The best way to minimize your sensor cleaning chores is to prevent it from settling on the sensor in the first place. Here are my stock tips for eliminating the problem before it begins.

◆ **Clean environment.** Avoid working in dusty areas if you can do so. Of course only a few of us are so paranoid about sensor dust that we'll totally avoid moderately grimy locations. However, it still makes sense to *store* your camera in a clean environment. One place cameras and lenses pick up a lot of dust is inside a camera bag. Clean your bag from time to time, and you can avoid problems.

◆ **Clean lenses.** There are a few paranoid types who avoid swapping lenses in order to minimize the chance of dust getting inside their cameras. It makes more sense just to use a blower or brush to dust off the rear lens mount of the replacement lens first, so you won't be introducing dust into your camera simply by attaching a new, dusty lens.

◆ **Work fast.** Minimize the time your camera is lens-less and exposed to dust. That means having your replacement lens ready and dusted off, and a place to set down the old lens as soon as it is removed, so you can quickly attach the new lens.

◆ **Let gravity help you.** Face the camera downward when the lens is detached so any dust in the mirror box will tend to fall away from the sensor. Turn your back to any breezes, indoor forced air vents, fans, or other sources of dust to minimize infiltration.

◆ **Protect the lens you just removed.** Once you've attached the new lens, quickly put the end cap on the one you just removed to reduce the dust that might fall on it.

◆ **Clean out the vestibule.** From time to time, remove the lens while in a relatively dust-free environment and use a blower bulb like the one shown later in this chapter. A blower bulb is generally safer than a can of compressed air, or a strong positive/negative airflow, which can tend to drive dust further into nooks and crannies.

◆ **Be prepared.** If you're embarking on an important shooting session, it's a good idea to clean your sensor *now*, rather than come home with hundreds or thousands of images with dust spots caused by flecks that were sitting on your sensor before you even started.

◆ **Clone out existing spots in your image editor.** Photoshop and other editors have a clone tool or healing brush you can use to copy pixels from surrounding areas over the dust spot or dead pixel. A semi-smart filter like Photoshop's Dust & Scratches filter can remove dust and other artifacts by selectively blurring areas that the plug-in decides represent dust spots.

If you do end up with dust on your sensor that can't be removed by your camera's auto-cleaning mechanism (and you will), you'll need to learn how to clean it yourself. The process isn't as terrifying as you might think, and your camera's service center will be using methods that are more or less identical to the techniques you would use yourself. None of them are difficult.

# Simple Sensor Cleaning Procedures

There are several ways to remove dusty and sticky stuff that settles on your dSLR's sensor. All of these must be performed with the shutter locked open. Check your camera manual to see the proper method for locking the mirror up. Usually, the option will be found in your camera's Setup menu. It's best to have a fully charged battery or connect your camera to an AC power source, because you do *not* want the shutter closing and crashing into whatever cleaning tool you are using. Some day, all vendors will follow the example of Pentax, which completely locks its shutter open for sensor cleaning. You can even turn the camera off. The shutter won't close.

## AIR IS A BLAST

Can you just blast some canned air into your camera and blow the dust out that way? It's a dirty secret that many photographers *do* use this risky approach. It just requires an awful lot of care. Remember though, if you cause any damage to your camera this way, you're on your own, the camera maker's warranty won't protect you. There are two main worries to this method. First, you're poking the long red nozzle of the canned air into your camera, with the chance that it can make contact with something it shouldn't. The second worry is that you may spray some of the propellant onto the glass filter that protects the imaging sensor. If this happens, you've made the filter dirtier and now have to find a more invasive way of cleaning it. The best approach is to make sure the can is as level as possible and work in short bursts. You should also do a couple of test fires first to make sure the canned air you're using will cooperate.

There are four common ways of cleaning your sensor. Three of them, air cleaning, brushing, and liquid cleaning, are generally safe. The fourth one, tape cleaning, is a bit off-the-wall and I don't recommend it. I mention it only so you won't discover it on your own and wonder why I didn't at least describe it for you. I'll address the first two methods in this section, and look at more advanced cleaning techniques and liquid cleaning, in the section that follows.

## Air Cleaning

Your first attempts at cleaning your sensor should always involve gentle blasts of air. Many times, you'll be able to dislodge dust spots, which will fall off the sensor and, with luck, out of the mirror box. Attempt one of the other methods only when you've already tried air cleaning and it didn't remove all the dust.

Here are some tips for doing air cleaning:

◆ **Use a clean, powerful air bulb.** Your best bet is bulb cleaners designed for the job. They have one-way air valves in their nether end, so that when you unsqueeze the bulb, air is sucked in there, rather than from the nozzle end, where the negative airflow might cause dust you've just removed to recirculate. Smaller bulbs, like those air bulbs with a brush attached sometimes sold for lens cleaning or weak nasal aspirators may not provide sufficient air or a strong enough blast to do much good.

◆ **Hold the camera upside down.** Then look up into the mirror box as you squirt your air blasts, increasing the odds that gravity will help pull the expelled dust downward, away from the sensor. You may have to use some imagination in positioning yourself. (See Figure 6.6.)

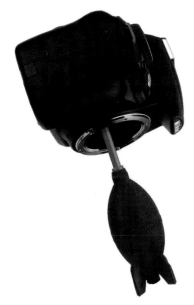

**Figure 6.6** With the shutter locked open, turn the camera upside down and gently blow the dust off with a blower.

◆ **Never use air canisters.** I'm repeating this important warning. The propellant inside these cans can permanently coat your sensor if you tilt the can while spraying. It's not worth taking a chance.

◆ **Avoid air compressors.** Super-strong blasts of air are likely to force dust under the sensor filter and possibly damage some internal parts.

## Brush Cleaning

If your dust is a little more stubborn and can't be dislodged by air alone, you may want to try a brush, charged with static electricity, which can pick off dust spots by electrical attraction. One good, but expensive, option is the Sensor Brush sold at www.visibledust.com. A cheaper version can be purchased at www.copperhillimages.com. You need one like the one shown in Figure 6.7, which can be stroked parallel with the long dimension of your camera's sensor.

Ordinary artist's brushes are much too coarse and stiff and have fibers that are tangled or can come loose and settle on your sensor. A good sensor brush's fibers are resilient and described as "thinner than a human hair." Moreover, the brush has a wooden handle that reduces the risk of static sparks. Some brushes come with grounding straps that bleed off the static electricity before it can attract particles.

Brush cleaning is done with a dry brush by gently swiping the surface of the sensor filter with the tip. The dust particles are attracted to the brush particles and cling to them. You should clean the brush with compressed air before and after each use, and store it in an appropriate airtight container between applications to keep it clean and dust-free. Although these special brushes are expensive, one should last you a long time.

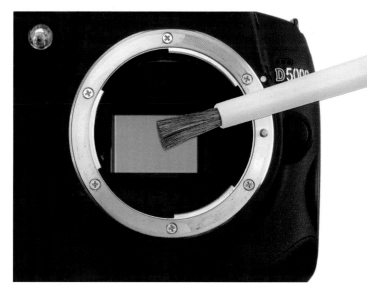

**Figure 6.7** A proper brush is required for dusting off your sensor.

# More Cleaning Tools

If air bursts and brushing don't remove the dust from your sensor, there are more advanced techniques you can use. You'll find that the first two methods will work 90 percent of the time and that you might need to resort to the techniques in this section only every few months or a couple times a year. If the dust is really stubborn, you might want to invest in some equipment that will help you do the job.

◆ **Sensor scopes.** Helps you look inside the camera body and check your imaging sensor to see if dust is a problem. If you want a close-up look at your sensor to make sure the dust has been removed, you can pay $50-$100 for a special sensor "microscope" with an illuminator. Or, you can do like I do when I'm traveling and work with a plain old Carson MiniBrite PO-25 illuminated 3X magnifier, as seen in Figure 6.8. It has a built-in LED and, held a few inches from the lens mount with the lens removed from your camera, provides a sharp, close-up view of the sensor, with enough contrast to reveal any dust that remains. I happen to use both.

◆ **Sensor vacuums.** Sucks the dust off your imaging sensor. Look for models designed for cameras, don't just use a mini-vac designed for computer keyboards. These vacuums should be static free (static discharge around camera electronics is a bad idea).

◆ **Sensor wands or swabs.** These tools are usually shaped like small scrapers and are used to gently (as in GENTLY!!!) squeegee dust off the imaging sensor. I did say gently didn't I? There are a variety of them on the market. Make sure you get ones that are designed for digital camera sensors. Also make sure you carefully read the manufacturer's instructions on how to use the device. Generally, they tell you to push it in one direction only in hopes of sliding dust off the sensor rather than using a back-and-forth motion. Some of these will also work with a liquid cleaning solution. I'll describe the use of swabs in the next section.

◆ **Arctic Butterfly.** This is a brush designed to remove dust from your sensor. What's interesting about it is that you begin by pushing a small button to make the brush spin (safely outside your camera body, do not do this with the brush inside the camera!). This does a couple of things: first it causes any dust on the brush to fly off; second, it builds up a charge to encourage dust particles to stick to it. You then use the tool to gently brush dust off your imaging sensor. This is a popular tool among photographers who have to fly a lot because you don't need to carry compressed air or cleaning liquids (which can be a problem when flying). The Arctic Butterfly costs about $80.

## MAC (Magnifier Assisted Cleaning)

I just made up that acronym, but using a magnifier to view your sensor as you clean it is a good idea. As I mentioned, I rely on two types. I have four Carson MiniBrites, and keep one in each camera bag. So, no matter where I am shooting, I have one of these $8.95 gadgets with me. When I'm not traveling, I use a SensorKlear loupe, like the one shown in Figure 6.9. It's a magnifier with a built-in LED illuminator.

**Figure 6.8**
The Carson MiniBrite is a good value sensor magnifier.

There's an opening on one side that allows you to insert a SensorKlear cleaning wand, a pen-like stylus with a surface treated to capture dust particles. (See Figure 6.10.) Both are available from www.lenspen.com.

When I'm using the MiniBrite, I locate the dust on the sensor with the magnifier, remembering that the position of the dust will be *reversed* from what I might have seen on an image on the camera's LCD (because the camera lens flips the image when making the exposure). Then, I use the

SensorKlear wand or the blower brush to remove the artifact.

The SensorKlear loupe actually allows you to keep your eye on the prize as you do the cleaning. You can peer through the viewer, rotate the opening to the side opposite the position of the dust,

then insert the hinged wand to tap the dust while you're watching. This method allows removing a bunch of dust particles quickly, so it's my preferred procedure when I have the loupe with me. (See Figure 6.11.)

**Figure 6.9** The SensorKlear Loupe can be used for viewing dust on your sensor.

**Figure 6.10** Use this wand to pick up dust.

**Figure 6.11** The loupe and wand allow quickly removing multiple dust particles.

# Liquid Cleaning

Unfortunately, you'll often encounter really stubborn dust spots that can't be removed with a blast of air or flick of a brush. These spots may be combined with some grease or a liquid that causes them to stick to the sensor filter's surface. In such cases, liquid cleaning with a swab may be necessary. During my first clumsy attempts to clean my own sensor, I accidentally got my blower bulb tip too close to the sensor, and some sort of deposit from the tip of the bulb ended up on the sensor. I panicked until I discovered that liquid cleaning did a good job of removing whatever it was that took up residence on my sensor.

Liquid cleaning involves two basic tools: a swab and cleaning solution, like those shown in Figure 6.12. You can make your own swabs out of pieces of plastic (some use fast food restaurant knives, with the tip cut at an angle to the proper size) covered with a soft cloth or Pec-Pad, as shown in Figures 6.13 and 6.14. However, if you've got the bucks to spend, you can't go wrong with good-quality commercial sensor cleaning swabs, such as those sold by Photographic Solutions, Inc. (www.photosol.com/swabproduct.htm).

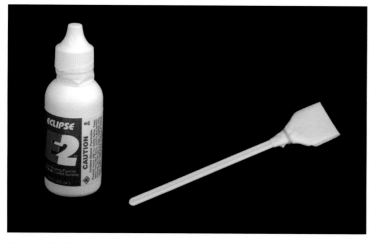

**Figure 6.12** Pure Eclipse solution and special sensor swabs make the best wet sensor cleaning tools.

**Figure 6.13** You can make your own sensor swab from a plastic knife that's been truncated.

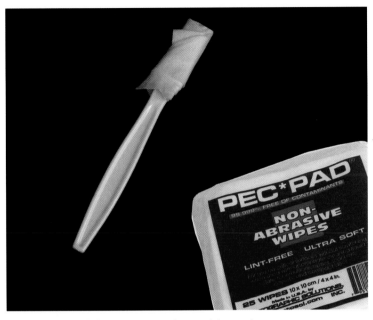

**Figure 6.14** Carefully wrap a Pec-Pad around the swab.

## TAPE CLEANING: A FOOTNOTE

Tape cleaning works by applying a layer of Scotch Brand Magic Tape to the sensor. This is a minimally sticky tape that some of the tape-cleaning proponents claim contains no adhesive. I did check this out with 3M, and can say that Magic Tape certainly *does* contain an adhesive. The question is whether the adhesive comes off when you peel back the tape, taking any dust spots on your sensor with it. The folks who love this method claim there is no residue. There have been reports from those who don't like the method that residue is left behind. This is all anecdotal evidence, so you're pretty much on your own in making the decision whether to try out the tape cleaning method.

You want a sturdy swab that won't bend or break so you can apply gentle pressure to the swab as you wipe the sensor surface. Use the swab with methanol (as pure as you can get it, particularly medical grade; other ingredients can leave a residue), or the Eclipse 2 solution also sold by Photographic Solutions. Eclipse 2 is actually quite a bit purer than even medical-grade methanol. A couple drops of solution should be enough, unless you have a spot that's extremely difficult to remove. In that case, you may need to use extra solution on the swab to help "soak" the dirt off. Note: the E2 version of Eclipse is now recommended for cleaning what are termed "tin oxide" sensors, like those found in most current cameras. If you have some of the older Eclipse solution, it's great for cleaning lenses! Buy the new stuff to be safe.

Once you overcome your nervousness at touching your camera's sensor, the process is easy. You'll wipe continuously with the swab in one direction, then flip it over and wipe in the other direction. You need to completely wipe the entire surface; otherwise, you may end up depositing the dust you collect at the far end of your stroke. Wipe; don't rub.

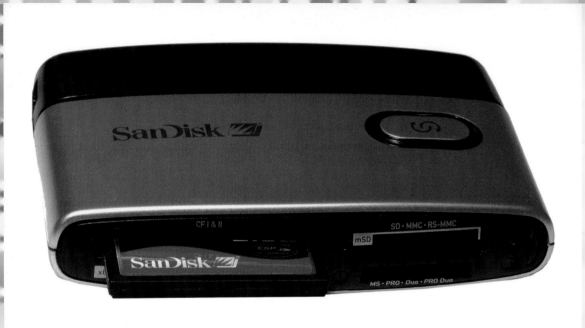

# 7 Memory and Storage Options

Gotta love those super high resolution dSLRs don't you? Some of the latest models give you 15 megapixels of resolution for less than $800. Because of the testing I do, I regularly use different models with lots and lots of resolution, including new 15- and 21-megapixel Canon models, a 14-megapixel Sony camera, and a *really* high-res 24.5-megapixel Nikon camera. In one extreme test, I shot RAW+JPEG, bracketed three shots in continuous shooting bursts, and set the camera so that one copy of each shot was saved to each of the two internal memory cards. That meant that every time I pressed the shutter, the camera stored a duplicate set of images totaling 12 individual files amounting to 250 megabytes. I managed to fill up a 32GB memory card with only 128 "shots." Uh, by any chance do you have an extra memory card I can borrow?

I bought my first dSLR in 2002 and paid almost a dollar a megabyte (yes, that's megabyte) for memory cards back then (I still have a receipt for $93 for a no-name 128MB card I bought for that camera). Over the years I've accumulated cards ranging in size from 32MB to 4GB and larger. Several of my cameras can simultaneously write to a pair of memory cards (Nikon has a couple dual Compact Flash slot cameras, while some Canon models support both Compact Flash and Secure Digital cards in the same camera). I also work with backup cameras that use a different type card than my "main" cameras. That means I need to carry multiple types of cards and card readers to keep viable.

This chapter takes a look at memory card choices as well as external storage solutions, which give you a way to move images from your cards freeing them for use while you're still out in the field.

# Memory Cards

There are a number of different types of memory cards on the market including Compact Flash, Sony Memory Stick, SD (Secure Digital)/SDHC (Secure Digital High Capacity), xD, Smart Media, and micro SD to name most. Of these, only Compact Flash (CF) and Secure Digital High Capacity (SDHC), shown in Figure 7.1, are commonly used in digital SLRs these days. The others have fallen into disuse (although Sony has introduced cameras that use both SDHC and Memory Stick cards), along with an oddball and obsolete variation called MicroDrive (a miniature hard disk), which also used the Compact Flash form factor, but different technology.

Most digital SLRs don't come with a memory card for a good reason: the vendor has no way of knowing what your size and speed requirements are. Why pay for a card that doesn't meet

your needs? You might find that 4GB cards that store images at an average speed (more on these later) is fine for your everyday shooting. Or, you might be a sports photographer who snaps off hundreds of pictures at 5 to 8

frames per second in an afternoon. You want a 32GB high-speed UDMA (ultra direct memory access) card. Because your camera comes with no card at all, you're free to choose the exact media you need.

There are several issues to be concerned with when shopping for memory cards. Here are the most important.

## Cost

For most of us, cost is a serious consideration that affects our decisions about what memory cards we buy. If 64GB super-high-speed cards cost $20, many of us would own a ton of them (at least, those who aren't spooked at the thought of having several thousand of their best shots all stored on a single memory card). We probably wouldn't even bother to erase them. When a card filled up, we'd transfer the images we wanted to work with to our computer, file the card itself away in an archive, and then buy a new card. But, to date, memory cards aren't quite that cheap, so cost remains a consideration.

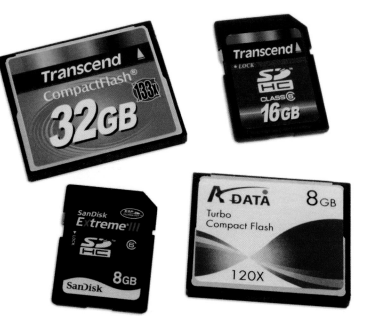

**Figure 7.1** Today, Compact Flash and Secure Digital cards are the predominant media used in digital SLRs.

One weird thing about memory card costs is that the more prices change, the more they stay the same. Only the cost-per-megabyte shifts up or (in the long term) down. For the last few years, the highest capacity memory cards you could buy for common use cost in the neighborhood of $100 for standard media, and $150-$200 for premium (usually that meant high speed) media. As a result, I've paid $100-$150 for a 1GB memory card. A year later, I bought a 4GB card for the same price. I had a brief fling with $100 8GB memory cards, and most recently have standardized on 32GB cards, which can be had for $60 for slow generic cards to $100 and up for the medium and higher speed versions I prefer.

Another weird thing is that when a new, higher capacity becomes standard, the price ratio between that size and the next smallest common size (usually with half the capacity) can be calculated by a formula: High Capacity Cost=Next Smallest/2+10 percent. That is, the bigger card costs about 10 percent more than two smaller cards that total the same capacity. As the technology matures, the cost "penalty" for the larger card shrinks, until it becomes cheaper to buy the big card, rather than two smaller ones (HCC=NS/2-10 percent).

These "rules" mean that the card you buy today will cost a lot less in the future (probably in less than a year), so you should avoid buying a lot more memory than you actually need based on the grounds that it's currently pretty cheap. It will be cheaper later. In addition, count on paying a little more to be on the leading edge of capacity—after a new memory card size has been available for awhile, it will eventually be cheaper to buy a large card rather than several smaller ones.

## Write Speed

Some folks consider the speed of the card as measured when your camera writes to it to be the most important consideration. After all, who wants to wait for the blinking green (or yellow) light to stop flashing before another picture can be taken? Memory cards operate a bit like hard drives in the sense that some of them can write data faster than others. Although cards don't have the rotating platters that hard drives have, they do have electrical properties that limit the speed with which they can accept and store information. Real-world write speeds typically range from about 3MB/second to about 30MB/second, and they depend greatly on the speed of your digital camera. That is, a particular card might be usable at 3MB/second in one camera and at 8MB/second in another that does a better job of writing information quickly. However, the speeds are proportional: A card rated as a better performer works faster in all the dSLRs it is used with, regardless of the actual speed, and regardless of the type and size of the file being written.

However, in most cases, with most cameras, the card's write speed isn't all that crucial. Most cameras can write to most cards faster than you typically shoot. A faster card may be wasted on such cameras. If you're a landscape or portrait photographer whose efforts are deliberate, shooting at the highest possible resolution settings might not be a problem. But if you do a lot of action photography where you're blazing away at 6 to 11 fps and shooting in high-resolution modes, write speed becomes much more important. One consideration in such cases is how large your camera's buffer is. Low-end cameras skimp on certain capabilities to keep the price down; buffer size is frequently one of them. If your camera doesn't have much of a buffer and can take advantage of faster cards, then you might need to choose the faster versions.

Unfortunately, card vendors haven't standardized on one way of describing the speed of their cards. Some use terms like Ultra, Ultra II, Ultra III, Extreme, etc., while others go for the 133X, 200X, 300X designation. The actual megabytes-per-second transfer rates may be hidden in the specs or not provided. If you want to examine some comparisons of memory card speeds with different brands of cards and various camera models, I recommend Rob Galbraith's website (www.robgalbraith.com).

## Camera to Computer Transfer Times

Another aspect of memory card speed is the *read* time, or how quickly your computer or memory card reader can suck data off the card while transferring your images to a hard disk. For most of us, this type of speed is much more important than write speed. If you think your camera's blinking memory card access LED is annoying, wait until you twiddle your thumbs for 30 minutes while transferring 32GB (or even 8 GB) of images using a slow memory card and slow card reader. Slow transfer is particularly a problem in situations where quick turnaround is important, such as photojournalism or event photography.

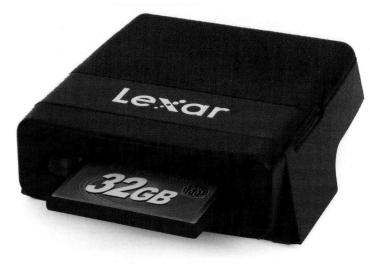

**Figure 7.2** This FireWire card reader can transfer images to your computer at up to 800 megabits (100 megabytes) per second rates, which are actually faster than memory cards support.

Read speeds of various memory cards suffer from the same obfuscation as write speeds. To add to the confusion, the fastest memory cards use something called Ultra Direct Memory Access (UDMA), and a given card may be fully UDMA compatible, or may offer the top UDMA speeds only when reading from the card. Write speed may be somewhat lower. Rob Galbraith's site may be your best source for sorting out the confusion. Another aspect affecting transfer is the speed of your card reader. You'll want a high-speed USB 2.0 or a FireWire reader, like the one shown in Figure 7.2.

## Capacity

A few years ago, the maximum capacity your camera could handle was an actual consideration. Some older models were unable to handle cards with capacities of more than 2GB of storage. Today, with the SDHC specification, larger cards are readily available, but your camera needs to be compatible with that standard. Some older models can be upgraded with a firmware tweak. Others are forever locked into using 2GB and smaller SD cards.

Today, the main consideration in choosing capacity is how much storage do you need—or trust? Do you want fewer, larger cards, or more, lower capacity memory cards? Personally, I opt for a third alternative: lots of the highest capacity cards available. Many of the pros of having larger memory cards revolve around not running out of storage space in the middle of shooting. Professional photographers are so paranoid about having a card fill up at the wrong time that they will often swap out when their current card is 80 to 90 percent full. And who

wants to fill up all the available memory cards and be forced to go copy a few to some other storage option before continuing shooting?

The cons against having large cards usually revolve around the "All your eggs in one basket" myth. I call it a myth because the analogy is deeply flawed. Images are not eggs, and our memory cards differ from baskets in many important respects. No one asserts that, say, 8GB cards are twice as likely to fail as 4GB cards. But, the rationale says, if the larger card fails, you lose twice as many images. Better to use several smaller baskets and avoid that problem.

The fallacies with this thinking are as follows:

◆ **Twice as big, not twice the loss.** The myth assumes that munged media will always be full before it becomes corrupted. Fortunately, memory cards don't magically wait until they are full before they fail. In a typical shooting session, it doesn't matter whether you've shot 3.5GB worth of pictures on a 4GB card or

3.5GB worth of pictures on an 8GB card. If either card fails, you've lost the same number of images. Your risk increases *only* when you start shooting additional photos on the larger card. In the real world, most of us who use larger memory cards don't fill them up very often. We just like having the extra capacity there when we need it. So, unless your memory card has a magic instruction that says "Ooops, I'm full; time to fail!" and you also typically shoot until each of your memory cards is crammed full of images, failure of a larger card really isn't likely to cost you any additional pictures.

◆ **Splitting your risk.** The myth says that by using several smaller cards, you're spreading the risk around so that only some pictures will be lost in case of a failure. What is more important to you, your photographs or the members of your family? When going on vacation, do you insist on splitting your kin up and driving several smaller cars? Why not—the odds of having a traffic accident are *much* higher than having a memory card fail. It could be said that having two cars on the road increases the chance that at least one of them will have an accident or get lost. You don't split your risk in that case. Unless your family is

very large, you take one car and make sure you drive very, very safely. In the same vein, using one large card reduces your chances of losing one, subjecting it to physical harm, or accidentally damaging your camera by inserting and re-inserting multiple cards more frequently.

◆ **Some loss is acceptable.** The eggs/basket myth assumes that it's more acceptable to lose 200 pictures than it is to lose 400 pictures. Hey! I don't want to lose *any* pictures at all, so the fact that I was clever enough to split my shots among several memory cards is little solace. Who wants to tell a bride, "I got some great shots at your wedding and reception. I'm only missing the 50 or so I took during the ceremony itself!"? I'd rather take the steps necessary to make sure all my shots are preserved. That might mean reducing the risk of losing one (by using fewer cards), backing up frequently, copying to a second card in the same camera (possible with certain Canon and Nikon models), or, when feasible, transmitting my pictures, as they are shot, over a network, using the WiFi capabilities offered in some cameras, and now available to many more models thanks to the Eye-Fi card (discussed later in this chapter).

# Portable Storage: You Can Take It with You

Once upon a time memory was so expensive that carrying a portable hard drive was a necessity for many photographers just because it was cost effective. Now memory prices are low enough that the average photographer can usually afford more than enough memory to get through all but the longest shooting situations. I typically carry around five 32GB cards at all times, and I also have five 8GB cards left over from the olden days that I take on trips as backup. That's enough for several days of shooting—at the minimum—and frequently enough for a week.

Of course, I usually travel specifically to take photos, and it would be more than just embarrassing to come home without some of my treasured shots. It would be financially unrewarding. So, even though I've never had a card failure while traveling, and have never lost or damaged a memory card, I always (*always*) back up my shots and keep those backups

safe until I return home and copy my images to multiple hard disk archives.

Indeed, I generally come home with *two* backup copies (who knows when I'm going to make it over to Prague again?). My first line of defense is to set my camera to copy each file to a pair of memory cards within the camera itself. Then, when I return to my hotel for the evening, I copy one of those cards to the hard disk on a netbook, notebook, or personal storage device (PSD). You probably don't own a camera with dual card slots—but you probably do have a netbook or notebook and, if you don't want to lug around either one, can easily rely on a PSD.

Any of these come in handy to provide the peace of mind you get from backups, but they also allow you to stretch the memory cards you do have over longer trips. I travel a lot, so I can justify carrying enough memory cards to cover me on my longest trips.

But, perhaps, you take one vacation a year, and the rest of the time you shoot closer to home, with access to your home or office computer. In your case, two memory cards with enough capacity for a day's shooting is all you really need for much of the year. Why have four or five other cards gathering dust when you'll use them only once a year? Given plummeting memory card prices, you probably don't want to spend $100 on cards you seldom use when next year you can buy twice as much capacity for half the price.

That's where PSDs come in. These days, you'll pay a little more for a personal storage device than you would for a modest library of memory cards, but you can use them for a long time, and many provide a feature that even your camera doesn't offer: the ability to sort and review images on a big screen that measures 4.3 inches or more. PSDs give you extra backup, a convenient viewing option, and a way to give

portable "slide shows" to admiring friends and fellow travelers without dragging your camera out.

PSDs and PSD-like gadgets come in several forms:

- **iPods, iPhones, etc.** You can transfer your photos to the storage in your iPod or iPhone and view the images. However, capacity is limited and transfer is likely to be very slow. Some GPS devices can store images, too. Unless you want to find another use for your iProduct, or have a cool app you want to use with your photos, this is not your best choice.

- **USB hard drives.** Tiny 2.5-inch hard drives have the footprint of a 3 × 5-inch index card and are only a fraction of an inch thick. They aren't standalone devices, however. You'll need a card reader and, usually, a computer, to transfer photos from your memory card to the USB hard drive. Since I generally carry a tiny netbook around with me anyway, I find a $69, 320GB USB hard drive to be a cost-effective backup option. (See Figure 7.3.)

◆ **Simple PSD.** The most basic personal storage devices are nothing more than a hard drive with a card reader built in, some software to automate copying from your memory card, and a small monochrome LCD that displays commands and status. These are very inexpensive, quite small, and probably your best choice if you don't need to view your images after they've been copied, and don't tote a netbook or notebook around with you. (See Figure 7.4.)

◆ **Full-featured PSDs.** Deluxe personal storage devices feature gigantic screens, typically 4.3 inches, which is larger than all current dSLR LCDS as I write this. The

best of them also store and play back movies, MP3s, and other media (like your iPod and iPhone), and have other cool features built in. The only thing I find daunting about these devices is their cost: some of them actually cost more than you'd pay for a notebook computer that can do exactly the same thing, and more, with a larger screen to boot. That extra cash goes for compactness and, to a certain extent, convenience.

Until I got my netbook and USB drive, I always liked the simple PSDs over the alternatives, and I still use them when I am traveling and don't want to carry (or know

I won't find Internet access for) my netbook. They're small and economical enough that I typically carried two of them (shown in Figure 7.4) so I could have multiple backups and excess capacity.

How economical are they? You can find a barebones shell for way under $100, and, usually for as little as $30-$50. Buy one that fits an old laptop drive you have sitting around (from when you upgraded from a 160GB internal drive to a 320GB version), and your PSD can be very cheap indeed. Make sure you get a PSD shell that takes the type of hard drive you have sitting

around—PATA (parallel ATA, also known as IDE/EIDE) or SATA (serial ATA) are not interchangeable. However, most PSD vendors offer portable drives that already have hard drives installed. These cost a little more, but are ready to go. If you're not comfortable installing electronics, these are a good choice (between $100 and $300 depending on how many gigs of storage space you want). I use a company called My Digital Discount (www.mydigitaldiscount.com), which is reliable, uses FedEx delivery, and offers the largest selection of barebones and fully "populated" PSDs. I buy most of my memory cards from this company, too.

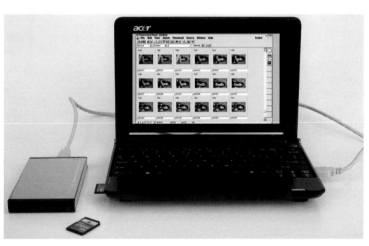

**Figure 7.3** A netbook and a cheap USB hard drive can provide all the on-the-road backup you need.

**Figure 7.4** Personal storage devices fit in your camera bag without taking up too much room, but provide plenty of storage to free up your memory cards.

# Memory Card Readers

While many people capture their images to their computer by transferring them from camera to computer via USB cable, using a card reader saves wear and tear on your camera, and if you have multiple cards to transfer, makes things a lot easier for you. Card readers also don't drain your camera's battery, which a direct connection is quick to do. Memory card readers can also transfer data faster than most dSLRs, a big deal when you're dumping several gigabytes worth of images.

Things to look for in a memory card reader and its supporting software include:

◆ **Card format.** Some memory card readers are designed to read only one card format, such as the Compact Flash-only reader shown earlier in Figure 7.1, or the SD card reader pictured in Figure 7.5. I particularly like the SD card reader when traveling light, because it's not much larger than an SD card. It's an essential tool, because older SD card readers may not be compatible with the newer SDHC specification. If I want to be sure that a computer can read my memory card, I take this reader along.

◆ **Versatility.** On the other hand, even if you use just one card format today, you never know what your needs will be in the future. There are a lot of memory card readers out there, why not choose one that can read a lot of different card formats? (See Figure 7.6.) Even though your current camera might just use one style of card, there's no guarantee your next camera won't use something different.

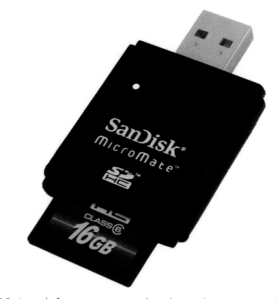

**Figure 7.5** A single format memory card reader can be compact and very portable, not even requiring a connecting cord.

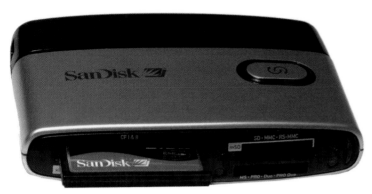

**Figure 7.6** With a multi-format reader, you're ready for any memory card you encounter.

◆ **Computer connection.** Card readers come with USB 2.0 or FireWire interfaces, and a few might be compatible with both. Go with the fastest option available. This will usually be USB 2.0 for an external connection unless your computer offers FireWire. Unless you need the ultimate in speed, I recommend USB 2.0 simply because such readers are easier to move from computer to computer. All computers have USB ports; fewer, other than recent Macs, have FireWire connectors.

◆ **Transfer first or view then transfer?** Depending on your image-viewing software, it might be possible to view your images before transferring them to the computer and delete rejects directly from the card. That's potentially a useful option, especially since it means you'll be transferring fewer images to the computer, saving time. If you're only dealing with one card's worth of images, this approach is a good one, but if you've got multiple cards you might as well transfer them all then work your way through all the images. By the way, you should always reformat the card in your camera rather than just deleting all the images while the card's connected to the computer.

Transferring photos with a card reader is easy. As I mentioned, I always recommend using a card reader attached to your computer to transfer files, because that process is generally a lot faster and doesn't drain the camera's battery. However, you can also use a cable for direct transfer, which may be your only option when you have the cable and a computer, but no card reader (perhaps you're using the computer of a friend or colleague, or at an Internet café).

To transfer images from a memory card to the computer using a card reader do the following:

❶ Turn off the camera.

❷ Slide open the memory card door and remove the card. With a Compact Flash card, you'll usually need to press a button to pop the card out. With an SD card, press the edge of the card in, and it will pop out so you can remove it from the camera.

❸ Insert the card into your memory card reader. Your installed software detects the files on the card and offers to transfer them. This software may have been furnished with your camera, be part of your Windows or Mac operating system, or be a component part of an image-editing program, such as Adobe Photoshop Element's Photo Downloader.

❹ The card can also appear as a mass storage device on your desktop, which you can open and then drag and drop the files to your computer.

# Portable CD and DVD Burners

Sometimes you just gotta burn onsite. It might be for backup purposes or it might be for sharing with others. Photographers who need to generate discs while still out in the field do have an assortment of choices available including laptop computers with CD/DVD burners or using an external burner. The problem is your camera kit starts getting bulky when you have to lug all this extra stuff along. Another problem might be you don't have a laptop computer and don't want to buy one. There must be a better way.

An excellent choice is to use a portable CD or DVD burner that has a built-in memory card reader and doesn't need to be hooked up to a computer to burn a CD or DVD off your memory card. Another option is to use a USB bridge, a device that can connect your camera to a burner that normally has to be hooked up to a computer.

Let's take a closer look at each of these options:

- **CD burners with card reader.** Although CDs, which generally have less capacity than even a 1GB memory card, are on the way out, there are still several different options on the market. Be careful to make sure your CD burner will work with your home computer system. Some of these models use a writing scheme that may not work with the Mac OS or earlier versions of Windows software. One of the hassles with portable CD burners is some of them are unable to handle memory cards that contain more than a CD's worth of images, so if you try to load a 1GB card, you end up wasting a CD because the burn fails. Some portable CD burners can handle larger cards, some can't; find out before you buy which category yours comes under. Portable CD burners can be had for about $100 these days.

- **Portable DVD burners with card reader.** These offer even more storage, more than four and a half gigs worth. Units such as the EZDigiMagic (about $359) can handle a variety of memory cards and runs off of four AA batteries, meaning you won't even need to look for a power source (just make sure you have fresh batteries). (See Figure 7.7.)

- **Portable Blu-ray DVD burners.** Delkin makes a 4x Blu-ray drive. While Blu-ray is cutting-edge new, it's also cutting-edge capacity. A Blu-ray BD-R disc can store 25GB worth of data, and other formats can store up to 50GB. The burner itself isn't too hard on the wallet at $339.95, but the BD-R discs cost about $27 a piece. Burning one of these takes about 23 minutes according to Delkin, a reasonable amount of time for burning 25GB worth of data, but a long time to stand around waiting for a burn to end. One other thing, Delkin claims these are archival quality discs that can preserve data safely for more than 200 years. When you consider how transient the data can be on a regular CD or DVD this can certainly justify BD-R's higher price tag.

◆ **USB bridge to portable burner.** If you have an external CD or DVD burner that you use with your home computer, it might be possible to use that with a separate memory card reader (or your camera) and a USB bridge. This device is designed to act as a "middleman" between two peripheral devices making a computer unnecessary. They can be tricky to use and you should test one thoroughly before you actually need to use it on a shoot. The advantage is they're relatively cheap. (Less than $40.)

**Figure 7.7** Portable CD and DVD burners save you the hassle of lugging a laptop into the field while still giving you the ability to burn discs.

## RIGHT CHOICE

What's the right choice to make for your storage needs? Simply buying more memory cards has become a pretty good answer. As memory prices have dropped, you can toss a lot of capacity into your camera bag for not a lot of money and not too much space. Portable hard drives offer good value too, particularly if they offer a reasonably quick display capability. (It's nice to be able to check images on a larger screen to see if lights are properly positioned and the effects of filters are what you want.) The problem is some of the LCD viewer models take a long time to render images. (Standing there waiting for what seems like an eternity for an image to load is anything but convenient.) Portable CD and DVD burners have their advantages, but are not as easy a choice as the other two options just discussed. First off, they need a stable surface to burn on. Failures (which are incredibly rare for cards, and highly unusual for portable hard drives) are a bit more common when burning CDs and DVDs. Portable burners are bigger and heavier than even a pile of memory cards or a portable hard drive. My own advice is only go for this option if you know you need to produce CDs or DVDs onsite for sharing with others or if you're selling them as a part of your photography business. I would also recommend plenty of extra discs and, if it's part of a business, having at least two burners.

# Look Ma, No Cords! WiFi Memory Cards

I have a box in my storage room. It's filled with cables, USB cables, serial cables, FireWire cables, modem cables, Ethernet cables, and who knows what else. When you've been buying and using computer equipment for three decades (remember the TRS-80 Model I?) and digital camera equipment for 10 or more, you accumulate a lot of cables. It's a very big box. Wouldn't it be nice if you could eliminate some of those cables?

Turns out you can. At least you can if your camera takes the right kind of media. Then something by the name of the Eye-Fi WiFi card might be your answer. It's certainly going to be mine. This remarkable card has the capability of transmitting your images, as they are shot, over a network to your laptop or computer, assuming a network and a computer are available. A company called Eye-Fi (www.eye.fi [no .com]) markets a clever Secure Digital card with wireless capabilities built in.

Although the Eye-Fi card (see Figure 7.8) is intended only for cameras that use SD cards, I know several photographers who have used them in other cameras, thanks to an SD-to-CF card

adapter. I haven't tested this configuration, but, given the low cost of the Eye-Fi cards, they are worth a try. The cards are good for about 45 feet indoors and 90 feet outdoors. As usual, your results may vary depending on obstructions between your camera and WiFi router. If you have an Eye-Fi Connected camera (like the Nikon D60, D90, and D5000), the camera recognizes when an Eye-Fi card is inserted. The camera allows you to change power settings for the card, and provides an LCD screen notification when photos and videos are uploaded wirelessly.

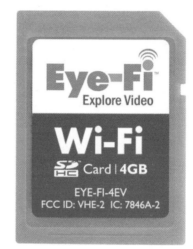

**Figure 7.8** The Eye-Fi WiFi card makes it possible for you to transfer images from your digital camera to your computer or the web wirelessly.

Let's take a closer look at each of these options:

◆ **Eye-Fi Home.** This is the basic 2GB card. It connects to a designated folder on your computer and transfers your images via your home WiFi network. The basic Eye-Fi Home (about $50) can be used to transmit your photos from your camera to a computer on your home network (or any other network you set up somewhere, say, at a family reunion).

◆ **Eye-Fi Share/Share Video.** There are 2- and 4GB versions of this card, at about $60 and $80 respectively. These are basically exactly the same (Share Video is 4GB instead of 2GB in capacity), but include software to allow you to upload your images from your camera through your computer network directly to websites such as Flickr, facebook, Shutterfly, Nikon's My Picturetown, and digital printing services that include Walmart Digital Photo Center, and Kodak Gallery.

◆ **Eye-Fi Explore.** This card is also available in 2- and 4GB versions and does everything the other versions do, plus offers geotagging. The Explore card adds geographic location labels to your photo (so you'll know where you took it), and frees you from your own computer network by allowing uploads from more than 10,000 WiFi hotspots around the USA. Very cool, and the ultimate in picture backup. If you've ever looked at a photo you've shot and tried to remember where you were when you shot it, this card might be worth considering. The company claims that about 70 percent of the populated areas of the United States are covered by WiFi with more areas being included every year, so you should have coverage most of the time. Of course if wilderness photography is your thing, this might not be your geotagging answer (we'll look at other options in the next chapter).

◆ **Eye-Fi Pro.** As I was writing this book, Eye-Fi introduced Eye-Fi Pro, a $149 4GB SDHC card which adds support for RAW files and direct wireless connection to a computer without the need for a network or Internet link. At the same time, the company introduced a Selective Transfer feature for all its SDHC cards, which allows you to choose which images are transferred over the wireless conection using the "protect" or "lock" marking capability found in all digital cameras.

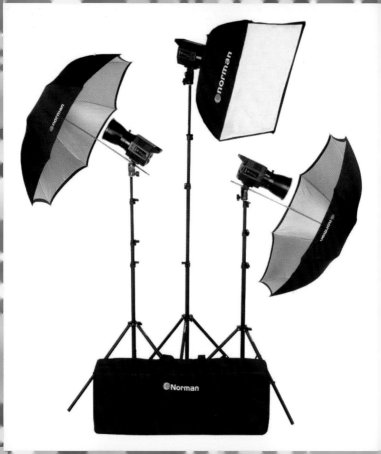

# Don't Fear the Shadows

If I had to pick one thing the average photographer could do to improve his photography it would be to improve the quality of his use of light. How you apply illumination—both the light that's available as well as light that you add to a scene is, more than anything else, the difference between good photography and great photography; between keeper images and rejects.

In this chapter we're going to explore different lighting tools. We'll start up at the high end and delve into pro lighting kits and systems and all the various options available. Later in the chapter we're going to take a different approach, namely how to get good quality lighting when you're on the run and can't carry a kit along with you.

The reality is there are different approaches to photography. Some of us crave the control the studio can provide us, while others are trying to do the best we can in the heat of the moment whether it be shooting for the local newspaper or just trying to get good pictures of our kids' birthday party. Either way, light makes all the difference.

# Lighting Basics

If you've ever been in a photographer's studio you've seen that control over lighting can blossom into a very big deal. Studio lights are large, they can be expensive ($200 and up per light), and they call for all sorts of accessories such as umbrellas, light stands, and other gear. The huge assortment of professional and amateur quality lighting on the market makes it difficult to single out specific products. Instead, we'll look at categories, and I'll try to provide some insight into what to look for.

The irony, of course, is that when it comes to lighting, the studio photographer is often trying to make the most natural looking photograph possible even though he or she is using artificial light and lots of it. Lighting is a complicated subject (much more complicated than we can explore completely in a book on camera gear). I'll try to show you what's important and give you some hints on how to use it in this chapter, but be prepared to go on further to learn more about this topic. You might want to check out another book in this series (*David Busch's Quick Snap Guide to Lighting*), also from Course Technology/PTR, that can help you build your skills in this important area.

## LIGHTING SPECS

There are basically two forms of studio lighting, flash-based and continuous illumination. Electronic flash studio lighting is usually measured in terms of watt seconds, which are a measure of electrical power the unit draws and *not* a standard of output, making it difficult to compare units from different vendors. Vendor A's apples may be considerably more powerful than Vendor B's oranges, even though they are rated in watt seconds. Effective watt seconds (which is always a lower number) can be a more useful specification.

When considering a flash-based system some other concerns include recycling time (how long before you can fire the flash at full power again), whether or not the system has a built-in slave (a light-sensitive device that triggers the unit when a flash goes off), and rated duty cycle (how many times can you re-fire within a short period of time without risk of damaging your unit).

Putting a lighting kit together can be a real challenge because there are so many choices, so many accessories, and so many costs involved. One of the first things to consider is how powerful you need your lights to be and how you're going to use them. If your lights are never going to leave your studio, one type of kit will do the job, but if you're going to occasionally have to set up on location, other choices make more sense.

◆ **AC Packs and flash heads.**
The basic approach to studio lighting is a two-piece unit with separate flash head and AC power pack. Often the power pack can supply power to more than one flash head, making it a versatile device. Because flash heads and power packs are separate units, it's cheaper to replace a part of the lighting kit this way. Flash heads that are powered via an AC pack also tend to be lighter since they don't have to incorporate their own power supplies. The problem is that you have more stuff to carry this way and those power packs are heavy. Flash heads can run from just a couple of hundred dollars each to a couple of thousand dollars each (and you usually want from three to four for a basic studio setup). Their power output is measured in watt seconds. Low-end units might only put out a few hundred watt seconds worth of light compared to the several thousand a high-end unit is capable of. Usually you combine several higher power flash heads (as main lights) with a low power flash head or two for use as hair or background lights.

A basic 2-light kit with AC power pack runs about $700 at the low end, and the prices only go up from there. AC packs and flash heads are better choices if your kit is never going to leave the studio. Still, I've done location shoots with them; it's a little more cumbersome, but it's certainly not impossible. Just about all flash heads offer variable power control and most offer some kind of modeling light too. (A modeling light is a continuous light source at lower output that helps the photographer determine how shadows are going to fall.)

◆ **Monolights.** Monolights are self-contained units that incorporate the flash head and power pack in the same unit. These are versatile and convenient, but aren't capable of quite as much power at the high end. At the low end a light that can pump out 150-watt seconds of power can be as cheap as $100, but might be a little weak to use as the main light for a scene. Triple that cost and you can get a unit capable of 900 watt seconds, more than enough for portraiture, even if the light is diffused (muffled and softened) with a softbox or umbrella. If you're working in a larger studio and are trying to light large items such as automobiles, such a unit would be horribly underpowered (in fact monolights might not be the answer at all since it takes a lot of light to properly illuminate such a subject). (See Figure 8.1.)

Monolights also offer variable power control and, like the AC pack/heads previously discussed, also usually have a modeling light of some kind to let you preview the lighting effect you're going to get. Recycling time can be a concern if you have to shoot quickly, so be sure to check this capability when you're researching a particular light. Keep in mind that less expensive systems may sacrifice reliability, consistency (light output that doesn't vary), or both.

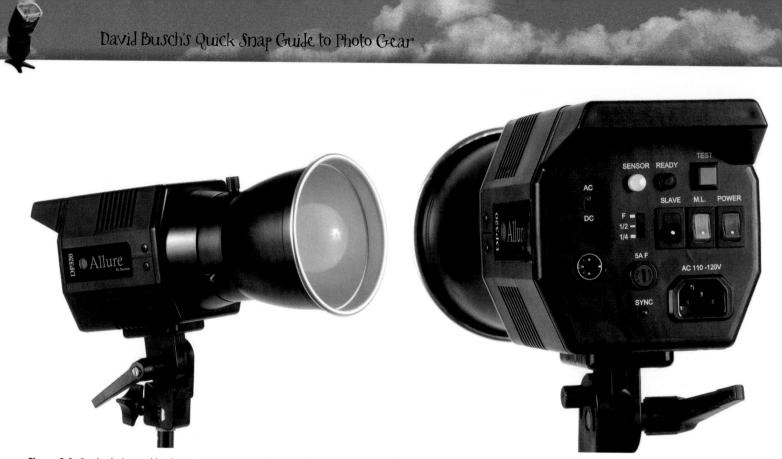

**Figure 8.1** Studio lighting, like these Norman DP-320 monolights, gives you complete control over the lighting for your images. Once you get the hang of using it, your photos will look more professional.

◆ **Continuous output lights.**
Simply put, these lights stay on the whole time you're shooting. Varieties include tungsten, fluorescent, and even LED units. Even a set of work lights from your local hardware big box store falls into this category. This can be really affordable lighting (except for the LED units which are fairly expensive), and with some considerations, can also serve as a novice or hobbyist's entry into studio lighting without the expense of the previous two lighting choices. One of the big hassles with continuous output lights is heat. They produce a lot of it. They can also be hard on the subject's eyes if you're photographing human beings or animals.

◆ **Flat-panel lighting.** Just as the name implies this is a flat light source. While not as powerful as some of the other light sources listed so far, flat-panel lights produce a soft, diffuse light that can be very flattering for a subject. A modest flat-panel light costs about $300 and can be a good choice for tabletop macro photography. The same light provides a flattering illumination for a headshot or a head and shoulders shot. You can use a reflector on the subject's other side to bounce some light back and fill in the shadows a little bit.

◆ **Ring lights.** A ring light is a circular flash unit that mounts on the front of the lens and bathes your subject in soft, diffuse light that comes from multiple directions, producing a relatively shadow-free illumination. Ring lights are especially useful in macro and fashion photography. (See Figure 8.2 for an illustration of an Alien Bees ring light.)

◆ **Buying a lighting kit.** It's often tempting to buy a prepackaged lighting kit (many of which come with lights, power pack, light stands, and other accessories). This can be an easier approach, but make sure you know what you're buying and that you're buying from a reputable company. There are a lot of very cheap, very crappy lighting kits for sale on online auction sites that are overpriced at just about any price. If you're on a really tight budget, try the work lights at your local hardware store instead.

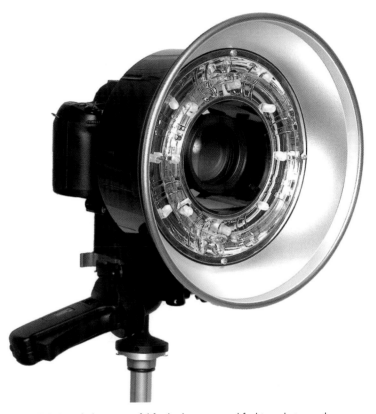

**Figure 8.2** Ring lights are useful for both macro and fashion photography.

# Modifying Light

Once you've got your lighting kit it's time to think about how you're going to modify it to avoid that direct lighting look, which is harsh and unflattering for portraits. Photographers use different tools to create the light quality they want. These tools fall into a number of different categories, each with its own strengths and weaknesses.

Light can be softened, directed, narrowed, bounced, shaped, colored, and blocked and each of those techniques has it uses. A variety of tools exist to help photographers modify light. When you're planning a home photo studio, figuring out how to modify your light is an important consideration. Some tools can pull double duty serving several different functions. Others can be homemade if you're on a tight budget.

Let's start with a quick overview of some of the most common tools photographers use to modify light.

◆ **Umbrellas.** One of the most commonly used—and least expensive—light modifiers are umbrellas. (See left and right in Figure 8.3.) These handy tools come in a variety of sizes, shapes, and colors. Some are even designed to work in multiple configurations. The primary job of the umbrella is to reflect light and curve it out and around your subject providing a more three-dimensional light. The umbrella is mounted on the studio light (which has a slot for the umbrella shaft to fit through). The light is then angled upward and turned away from the subject (usually, but not always, at a 45-degree angle). The light is then fired into the umbrella where it is reflected back at the subject. Some umbrellas are known as shoot-through umbrellas. With these the light is pointed at the subject and used as a lighting diffuser instead of a reflector to soften the light. Occasionally a dual-purpose version is sold that can be used either way, because it has a removable outer cover that keeps light from spilling through until it is taken off.

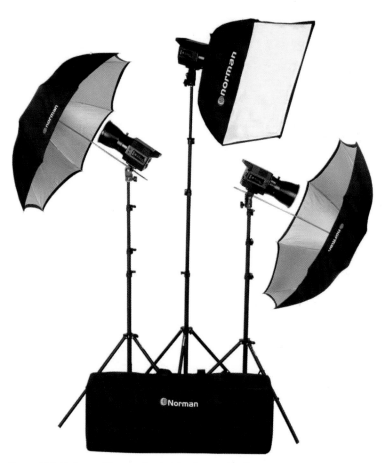

**Figure 8.3** Light modifiers such as umbrellas and softboxes play an important role in determining the quality of your studio lighting.

◆ **Softboxes.** These are also shoot-through devices. They're mounted on the light, which is then pointed at the subject. The light from the strobe spreads out as it leaves the flash head and then travels through the diffusion material, which softens the light even more. A big softbox on a powerful light can be used as a single main light coupled with a background light to serve as the principle light source for a two-light setup. (Center, top, in Figure 8.3.) The chief drawback of a softbox is that it absorbs a lot of light, so you'll need a more powerful flash unit to produce a given exposure, when compared with direct lighting or umbrella lighting.

◆ **Strip boxes.** Kind of like narrow softboxes, these produce a thin strip of illumination, either vertical or, when rotated, horizontal. I love strip lights because they give you more control over what parts of your subjects are illuminated. When aimed from the side, for example, you can focus your lighting on the front of your subject, the back, or even the middle part closest to the strip box. (See Figure 8.4.) A softbox at the same position, in comparison, would "wrap" around the entire subject—excellent for some subjects, but not preferred if you want to apply some creative direction to the illumination.

◆ **Barn doors/snoots.** These are light modifiers that have four small flaps that can be swung in and out to shape the light. While shaping the light, barn doors do nothing to diffuse it, making it a good choice for when you need a harsher light (which is useful for showing detail or producing dramatic effects). Barn doors can allow you to control where the light falls when using a light to illuminate the background, and you may be able to put one to work on a hair light—although a cone-shaped snoot is probably a better tool for that.

◆ **Reflectors.** Sometimes you only want to use one main light and kick some of that light back to fill in the shadow areas of your subject. Reflectors can be high-end expensive accessories (usually featuring a gold side and a silver side) or something as simple as a large piece of Styrofoam packing material that can reflect light. Either will get the job done, but one is more expensive (and durable) than the other.

◆ **Gobos.** Short for "go betweens," these are flat panels that are used to block light so it doesn't spill into areas where you don't want it. These are frequently large, flat pieces that clip onto light stands or the light sources themselves, like standalone barn doors.

◆ **Scrims.** Perhaps a bit more common for video than still photography, scrims are patterns. Place one of these on a light and it will cast a light pattern.

◆ **Filter holder.** Stick a colored gel in front of a light and you get that color projected onto your subject.

◆ **Beauty dish.** This is a bowl-like reflector with a hole in the center (similar to a ring light). The flash head is positioned through the hole and the reflector produces a soft, wrap-around light. These are frequently used for tight headshots because the closer it is to the subject the softer the light falloff is.

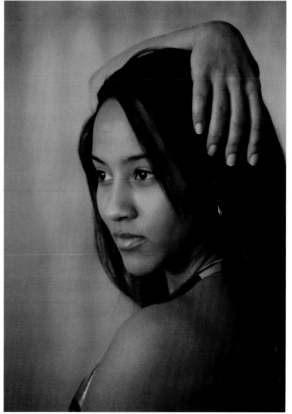

**Figure 8.4**
A strip light allows you to position your illumination more precisely.

# Other Studio Lighting Tools

So far, we've introduced you to lights and light modifiers, but haven't yet told you about the supports required to hold these items as you use them in a studio or on location. Light stands are the common solution, but if you've designed a permanent studio where you don't plan on doing remote shoots (or plan on having a second set of lights for location shooting) then it's also possible to mount your lights from the ceiling using a railing system which will let you maneuver the lights around the studio.

It's important to make sure you don't skimp on support for your lights since watching your expensive lighting come crashing to the floor can ruin more than just your day. Your lighting support should also be easy to use and versatile enough to meet a variety of needs.

Light stands come in different sizes and can raise your lights to varying heights. But light stands aren't the only tool for positioning lights. There are several others including booms and railing systems.

Here are your alternatives:

◆ **Light stands.** They come in a wide range of sizes. A shorter stand may be useful to support a background light, while the taller ones are useful to hold the main light and any light you use to fill in the shadows (cleverly known as a *fill* light). A tall light stand is also needed for a hair light, which is generally positioned above and behind your subject. Make sure whichever light stands you buy are capable of supporting the weight you plan on putting on it (as shown in Figure 8.5). There are portable units that can collapse to very small heights. They're great for use out in the field when used with shoe mount flashes, but aren't necessarily up to supporting a big studio light. Background stands can be as cheap as $20 or as much as $150 depending on their height and the weight they can support.

◆ **Booms.** A boom is a specialized form of light stand designed with a horizontal arm that allows you to position a light behind or above your subject while keeping the light stand out of the picture. Figure 8.6 shows a Table Top Studio (www.tabletopstudio.com) kit with a boom light hovering over the lighting tent. (Tents are discussed in the next section.) A boom kit can run a little less than $200, but usually needs something known as a "grip," a sandbag designed to be a counterweight to make sure the boom doesn't tilt over from the weight of the studio light.

◆ **Sandbags.** Sandbags (grips) are also used to weight light stands, keeping them steady.

◆ **Caster sets.** Wheels for your boom or other light supports help position them more easily.

◆ **Grip heads and clamps.** These tools are useful for holding reflectors, gobos, and other devices from a boom arm or stand.

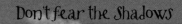

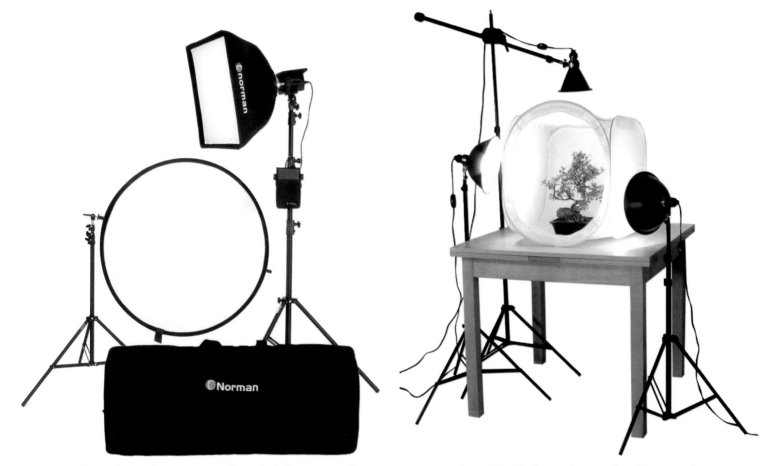

**Figure 8.5** Light stands are a key component of a studio lighting setup and should be carefully chosen to provide both versatility and support for your lights.

**Figure 8.6** A boom light, like the one shown in this Table Top Studio setup, helps position lights above or behind your subject.

# Light Tents and Other Tools

If you want to set up a studio for macro photography there are some accessories that will help you improve your photography. Depending on what you're photographing, controlling light and reflections can be a real problem. Whether it be jewelry or plastic clamshells, reflections can ruin your shot. It's also important to be able to position items properly for best effect.

Let's look at what's out there:

◆ **Light tents.** When you're dealing with highly reflective surfaces (such as plastic clamshell packaging), it can be very hard to control reflections. Light tents (like the EZ Cube model shown in Figure 8.7; www.ezcube.com) position the subject inside the tent. A camera is placed at an opening designed to admit just the lens and the tent is completely sealed everywhere else. Your lights are positioned outside the tent and their light is diffused as it penetrates the white fabric walls of the tent. The result is a very soft, even lighting that produces minimal reflections. Light tents come in a variety of shapes

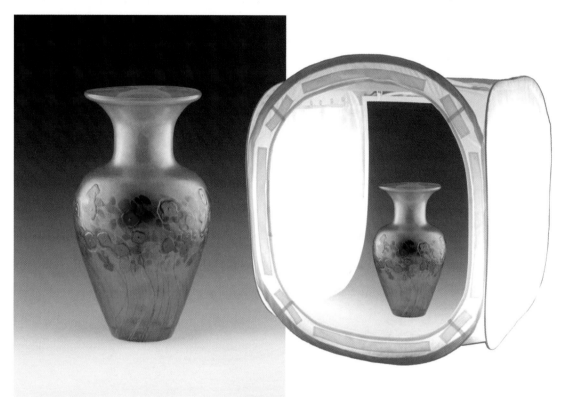

**Figure 8.7** Lighting tents are helpful when you need to photograph small, highly reflective subjects such as clamshell-packaged products.

and sizes. Small ones can cost as little as $50 while bigger, higher-quality tents might hit $300 or more.

There are some things you should be aware of if you're considering buying a light tent. Make sure the one you're getting is big enough to hold what you need to photograph and provide some extra "head" room for your subject. Also, get a good pair of white cotton gloves for handling it and make sure to keep the area you're working in clean (including cleaning objects before putting them in the light tent). Once you start getting dirt on the tent surfaces, getting rid of it can be hard. If you're on a tight budget and want to experiment with a light tent, it's fairly easy to build your own (in fact the internet is filled with sites explaining how). Basically, you just take a cardboard box, cut off one end (what ends up being the bottom, cut large square holes in each side and the top, then cover the holes with white tissue paper. Get a length of thin white poster board and thin black poster board (these are your backdrops) and tape whichever one you need in place in the top rear of the box. Cut a hole in the front of the box to shoot through and you're pretty much ready to go.

◆ **Kits.** Thanks to the popularity of online auction and classified sites, all sorts of tabletop close-up and macro lighting kits are available. Depending on the type of item you need to photograph, you have a couple of options. The first is a copy stand like approach where the camera is mounted on a column and oriented so that it is pointing at a flat surface below. The camera can be raised and lowered usually via a cranking mechanism. A pair of lights suspended on parallel arms rake the surface at 45-degree angles to provide even cross lighting for detail. This is a very good setup if you have to photograph flat or relatively flat objects. It's not quite as useful for three-dimensional items. Usually for those the photographer uses a tabletop kit that includes a light tent and two to three lights (the third one on a boom arm illuminating the top of the item). The camera is positioned on a tripod and shoots into the lighting tent. Cheap kits can be found for less than $100 while higher-end sets can cost a thousand dollars or more.

◆ **Jewelry setups.** Photographing jewelry can be particularly challenging because of all the reflective surfaces and angles they take. In fact, at least one jewelry photographer I know works by photographing individual facets and then composites the final image in Photoshop. Others use either a white or clear acrylic platform or a black version (which raises the jewelry off the background surface).

The jewelry and stand is placed inside a light tent where it is photographed. Sometimes a necklace display stand is used instead when photographing necklaces. The Black Ice Jewelry photography kit available from Table Top Studio (see Figure 8.8) is a $325 solution you might want to consider if you do a lot of this type of work.

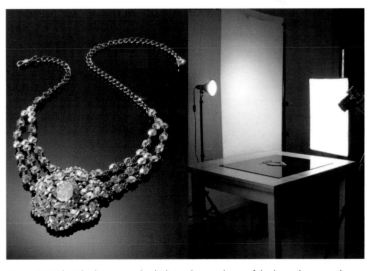

**Figure 8.8** The Black Ice Jewelry lighting kit can be useful when photographing this difficult subject.

# Backgrounds and Other Studio Gear

While these don't exactly qualify as lighting, backgrounds, posing stools, and other tools do fall under the list of things a photographer will consider when planning his or her own studio set up. If you're putting together an all-purpose photo studio, especially one in your home, the list of things to consider includes what kind of background and support system you're going to use, type of background support material, whether or not you need a posing table, posing stool, blocks, and props. You'll probably also need a set of clamps and additional supports if you plan on using seamless paper on a posing table.

Your preparation gets a bit easier if you're planning on specializing in one type of photography or another. For instance, if you're going to specialize in product photography, a posing stool isn't necessary, unless you're going to use human models with the products. I once had an Upstate New York truck clutch manufacturer ask me for a "glamour" photo of one of their products. I couldn't figure out how to glamorize such a mundane industrial product, until I ended up asking a model to pose behind the table, prop up the component, and smile. I used a soft spotlight, and gave the client a photo that I called "Miss Clutch." They loved it; the model, who had posed for serious photographers like wedding/portrait legend Monte Zucker, did not care for my title. But although she hadn't signed a release, I showed her our marriage license, so she didn't divorce me.

If you're interested in more serious people pictures, say, family portraits, you'll need multiple posing stools and wider stretches of seamless paper or some other background material. For many photographers, particularly ones setting up their first studio, the easiest choice is seamless background paper. It's inexpensive ($21.95 a roll on up depending on width and length; it's even cheaper if you buy the half-rolls in a narrower width) and comes in many colors and sizes. Find a local camera store/photographer supply outlet for these rolls, as they can be expensive to ship. Either buy a set of background stands with a crossbar ($100 and up) or, for a permanent studio, install a wall-mounted hanging system ($300 on up depending on how many rolls of paper it can hold).

Let's look at some of the other options for studio gear:

◆ **Muslin, canvas, and velour backgrounds.** While these are more expensive than seamless paper, they're also much more durable and offer interesting textures that paper can't. Since they're frequently hand-painted, they tend to offer a more distinctive look too. A 5 × 8 muslin background can cost as little as $49, while a 5 × 7 canvas backdrop starts out at about twice that amount. It's possible to get photographic backgrounds in these materials that can depict various sports and location scenes. Such backdrops are worthwhile for student and athlete portraits and can also be popular for holiday-related photography. (See Figure 8.9.)

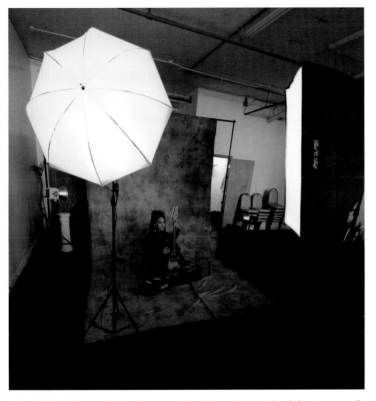

**Figure 8.9** Backgrounds in a bag provide a large (8 × 12) backdrop in a small, lightweight (6 pounds) carrying package. These backdrops resists wrinkling and are easy to work with.

◆ **Portable/collapsible backgrounds.** If you do location or event photography and need to set up a portable studio, the portability of your backdrop system can be an issue. It's certainly possible to break down a conventional studio backdrop system and carry it in a pickup truck, station wagon, or van and then reassemble it on site even without the help of an assistant. Still, there are any number of reasons why you might not want to do that. If so, a "Background in a Bag" might be a choice worth considering. These are complete background systems designed to fit into a relatively small carrying bag. The largest version is an 8 × 12 background built around a velour backdrop. The velour can be folded and stuffed into the carrying bag (see Figure 8.9) along with the crossbar (which separates into sections) and stands and carried quite easily. Since the velour doesn't wrinkle, it survives the packing and even storage without complaint. The company (PhotekUSA) also offers a smaller version known as a "People Popper" that can be used for individual portraiture. These are dual-sided backgrounds (hand-painted on one side, solid color on the other, except for the black-and-

white backgrounds). The package (backdrop and stands) weighs about six pounds and costs from $126 (6 × 7 size) to $192 (8 × 12 size).

◆ **Posing stools, tables, and benches.** Arranging people properly is one of the keys to multiple person portraiture. Usually you start with a one- or two-person base and build the portrait from there. Having pneumatic posing stools that can be raised or lowered as needed makes your life a lot easier. Two-person benches are another choice (combined with a box or cushion to increase one person's head position over another). Posing tables are useful for an individual to pose on (using it as an arm or elbow rest) and are also handy for baby portraits. Pneumatic posing stools cost about $150. It's about $50 more for a pneumatic posing table.

◆ **Posing boxes.** Usually sold as a set of nesting boxes of different sizes, these are helpful as foot rests if you have someone raised up on a posing stool. They're also useful for when you're building a group portrait and need something for someone to stand on to make them taller.

# Portability—Taking the Show on the Road

So far we've been covering studio-based photography while mentioning the need to take equipment on location. Not all photographers can be called studio-based though. Some spend most of their time working on location trying to recreate studio settings, while others, photojournalists and street photographers, have to work fast and light and rely mainly on small portable on-camera flash units. Note that portable electronic flash units are more costly than the kind you can use in a home studio. You can find some great Alien Bees AC-powered units for about $225-$380, while even the lowest-cost portable units will run you $270-$900.

Those are two different sets of needs. A swimsuit or glamour photographer working on location at some island beach has a very different set of logistics to deal with than an automotive photographer shooting a car on some scenic overlook. A wedding photographer may have a studio for bridal portraiture, but can't rely on studio lights during the wedding ceremony or on a bridal safari. For Figure 8.10, I was lucky enough to get permission to shoot in a mansion that served as the clubhouse for a yacht club, but I knew that many of the electrical outlets were tucked behind leather sofas and antique furnishings. So, my battery-pack studio lights made my portrait-shooting efforts a whole lot easier.

**Figure 8.10** Portable lights were essential for this location shoot, because the mansion's electrical outlets weren't conveniently accessible.

Choosing the right strobes and accessories can make your job a lot easier or a lot more frustrating. Understanding how to build a powerful, versatile, and lightweight portable lighting system is a real challenge, one that can make or break your photography. There are a number of issues you have to deal with.

Here are some units to consider.

◆ **Norman battery portable lighting systems.** Norman offers several different portable, battery-powered lighting systems ranging from 200 to 400 watt seconds and in price from $1,200 to $1,400. They put out a lot of light and recycle quickly (about 1.5 seconds on full power) so you won't miss shots waiting for the strobe to be ready to fire again. (See Figure 8.11.)

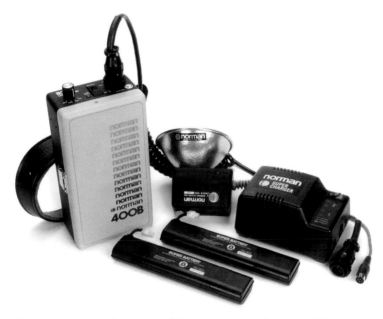

**Figure 8.11** Norman battery portable systems are popular with wedding photographers because they provide a lot of light in a small portable package.

◆ **Lumedyne LumeKit.** Lumedyne also offers a series of portable flash heads with batteries. These also range from 200 to 400 watt second units and prices run from $1,200 to $2,000 for a complete one-light kit.

◆ **JTL Mobilite series.** This is a budget-priced system that offers 200 to 600 watt second units that range in price from $270 to just under $900. Depending on which model you're using, you can get from 100 to 180 flashes from a single battery charge. The units have a built-in modeling lamp, variable output control (1/4 increments), and a two- to four-second recycling time.

◆ **Dynalite.** The company offers location kits that include an AC powerpack. It also offers a battery powerful enough to power the separate flash heads in case you're working somewhere without electrical outlets. The 1,000 watt second power pack can provide up to 200 flashes per charge with a 1.5-second recycle time.

# Special-Purpose Strobes

Not everyone has the need, the budget, or the back, for portable studio power. Fortunately, the capabilities of modern on-camera flash units have reached impressive heights the past few years. With some creativity and the right accessories, a photographer can do remarkable things with just a couple of portable flash units and some other odds and ends.

There are many choices when it comes to picking an on-camera flash. Manufacturers such as Canon and Nikon offer a powerful array of dedicated flash units designed to make the most of the camera-flash relationship. Third-party manufacturers such as Metz, Quantum, and Sunpak (to name a few) work hard to compete with the camera makers and offer some pretty sophisticated gear themselves.

On-camera flashes come in several different types. The most basic is the shoe mount flash, which, as you might imagine, fits into the hot shoe mount on the top of the camera. (See Figure 8.12.) They can also be used off-camera, on either a bracket connected by a cable, as shown in Figure 8.20 later in this chapter, or a light stand and triggered remotely (usually by your camera's built-in flash). Handle mount flashes (once known as "Potato Mashers" because of their bulbish head) are less common and often more expensive, but also much more powerful. "Dedicated" flash systems are designed to communicate with the camera and take advantage of programming and technology that lets the camera read the light coming through the lens to get the most precise exposure.

So how do you decide which is the right flash or flashes for you? Keep in mind that one of the quickest and easiest ways to improve your photography is by improving the quality of your lighting. Many pros carry multiple strobes with their basic camera outfit because of the versatility and ease of control modern wireless flash controllers (more on these later in this chapter) provide.

◆ **Manufacturer choices.** Your camera maker will offer a range of dedicated strobes designed to work with your camera. If you plan on staying with the same camera line or want the greatest compatibility between camera and strobe, the camera maker's strobe is the best choice. They tend to be a bit more expensive than other options. The difference between the top of the line and budget versions can be several hundred dollars in price. (Canon prices, for example, range from $125 for a low-end dedicated flash to almost $400 for its best shoe mount flash. Nikon's units cost about the same.) Often you're paying more for greater power and versatility (bounce/ swivel heads) and the ability to remotely control the flash unit.

**Figure 8.12** Your camera manufacturer offers at least two or three different external flashes. The advantage: they can "talk" to each other as your camera calculates the right exposure.

◆ **Third-party dedicated flash units.** Third-party equipment makers also offer dedicated flash units designed to work with specific camera systems. In fact, certain dedicated units can actually provide the same communication and control that the camera maker's strobes can. For example, I have a three-strobe setup for my camera system that uses two Canon flashes and one third-party flash. My off-camera controller (a device I'll talk about soon) can communicate with and fire and control all three strobes simultaneously. Sometimes you need to buy a particular strobe for your camera and sometimes you buy the strobe and a specific

foot that's designed to communicate with your camera.

◆ **Third-party dumb flash units.** Actually, these units aren't all that "dumb"; it's just that they don't talk to your camera. Most of them still offer some kind of automatic setting that makes them easy to use (although not as easy as a dedicated flash). They do tend to be less expensive though and can make good "slaved" flashes (more on photo slaves in a few pages).

There are some other flash units of interest for specialized purposes. These are all lifesavers if you need them, and provide

interesting options if they're available in your lighting toolbox.

◆ **Ring lights.** Just as it sounds, these are ring-shaped lights. (See Figure 8.2, earlier in this chapter.) They attach to your camera's lens and are used primarily for macro photography. (Ring lights are also useful for photographing people, but often the ones designed for macro work are too underpowered to be used for people photography. Generally you need a studio ring light for that.) Because they bathe the subject in light from 360 degrees on one plane, ring lights produce an even, if somewhat flat, lighting. They can be very nice for relatively flat-surface subjects (coins, stamps, papers, etc.).

◆ **Flat-panel lights.** Interfit Photographic makes a flat-panel flash designed for dSLR photography (see Figure 8.13 for an example). This is an interesting piece of equipment. Flat-panel lights provide a very soft diffuse light so you can use this flash without any light modifiers and still get a very soft light. Relatively inexpensive (about $100), the E Flash also has a built in photo slave so it's easy to fire as a remote (as long as you're the only photographer using flash). The drawback is this as basic a flash as you can get. In fact, you have to either use a flash meter or calculate

your lens opening the old-fashioned way, by using guide number calculations. (Its guide number is 35 at 100 ISO, which gives you an f/stop of f/5.6 at 6 feet. Oh well, it's digital, do a test photo and compensate.) The E flash is a hot shoe mount flash that connects to your camera through PC cable. It is removable (just turn a lever) and can actually hold a second flat-panel flash to double the light output. Another company, Novoflex, makes a similar flat-panel light called the Flash Art Flat Panel. It has a guide number of 12 at ISO 100 and costs $745. Unlike the E Flash, the Flash Art is capable of operating as a dedicated flash unit thanks to dedicated flash shoes for specific cameras (extra cost, about $99).

◆ **Underwater strobes.** Earlier in this book we talked about underwater camera housings and I mentioned that the deeper underwater the greater the problem of light falloff and the loss of different color wavelengths. Underwater strobes are the most effective way of dealing with these problems, especially as you head deeper into the water. Several companies produce underwater strobes including Sea&Sea, Bonica, Epoque, Fantasea, and Ikelite. Pricing ranges from about $300 to more than $1,600 for these strobes.

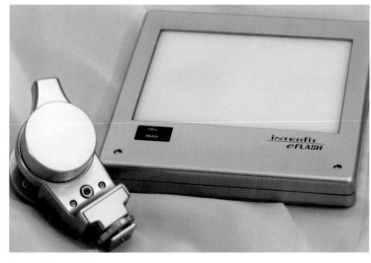

**Figure 8.13** An E Flash flat-panel on-camera flash unit.

# Light Modifiers: Diffusers and Bouncers

Shoe mount flash units are convenient sources of light with their small size, power, and portability, but their quality of light when pointed directly at the subject is still a bit harsh and unflattering. The good news is that there is a very wide range of options for the photographer who wants to improve the quality of his or her lighting. There are established companies such as Lumiquest and Sto-fen and a whole cottage industry of small companies cranking out all sorts of tools to modify light. Light modifiers fall into a number of categories. Some are designed to diffuse light, while others bounce it. Still others narrow it, while yet another group magnifies it.

I'm going to describe the diffusers first. A diffuser spreads and softens the light as it leaves the flash. These devices are mounted on the head of the flash, usually with Velcro, but sometimes with spring clamps. (See Figure 8.14.) If you have a flash that can't tilt up to bounce, a diffuser might be your best choice for modifying light. Diffusers improve your light, usually at the cost of about an f/stop or more worth of light loss.

◆ **Lumiquest.** The company makes a variety of diffusing tools including one to mount on the pop-up flash of a dSLR. The Softbox III ($36) is a reasonably large (by dSLR standards anyway) softbox that mounts on the end of the flash via Velcro. Lumiquest also offers three smaller versions of a softbox ($18 on up), plus several light modifiers that also serve to diffuse light, the Big Bounce and the Ultra Soft. While it sounds like the Big Bounce is a bounce unit, it actually sends the light through a diffuser.

The company also has several bounce products including the Ultra Bounce ($14) that fits on the head of your flash and provides a bare bulb effect. The company also offers several other bounce devices that mount on the head of the flash by Velcro. The flash head is tilted vertically and the bounce tool catches the light and kicks it forward (these are bounce tools that can be used outside). Costs range from $23 to $36 depending on which unit you want.

◆ **Harbor Digital Design.** The company's product, the Ultimate Light Box System, can be used as a combination diffuser when its diffusion filters are added. ($105 plus the cost for the filters.) (See Figure 8.15.)

◆ **Gary Fong.** Offers several different diffusers including the WhaleTail Studio ($130, the unit by itself is a little cheaper). The company has some smaller options (the Reporter and the Lightsphere) that cost a bit less.

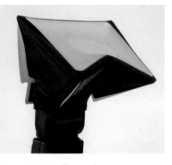

**Figure 8.14** Diffusers fasten onto external flashes with Velcro or clamps.

**Figure 8.15** This "light box" attachment for electronic flash units can be used with diffusers, filters, and other accessories.

- **Sunpak.** Makes a flash-mounted diffuser, which also softens and spreads the light ($40).

- **Westcott.** Collapsible softbox called the Micro Apollo that attaches to the head of the flash via spring clips ($36).

- **Sto-Fen Omni-Bounce.** Sto-fen's product is the Omni-Bounce. This is an opaque white shell that mounts to the end of the flash, which is generally tilted at a 45-degree angle (although if you have a TTL flash unit it can also be used pointed straight on as a diffuser). The interesting thing is that the Omni-Bounce does more than just soften light through the bounce effect; it also simulates a bare light bulb effect. This improves the quality of light because it can travel around the room in a 360-degree pattern bouncing off surfaces and reflecting back to your shot. You don't get the same effect outdoors, but with the flash head pointed at your subject, there's at least some diffusion. The Omni-Bounce will reduce the maximum effective distance of your flash by a factor of 2.5x.

Many camera vendors include a version of the Sto-Fen Omni-bounce with their proprietary electronic flash units. However, the company (www.stofen.com) produces its own line of diffusers that you can purchase as replacements, or to fit onto flash units that don't come with a diffuser. (See Figure 8.16.)

- **PRESSlite VerteX.** This is an unusual and versatile device that resembles a rectangle with a pair of white cards on it (one side of the cards is a diffusion material, the other is a mirrored surface [both of which are removeable]). The rectangle (a hybrid elastic band with rubber like bumpers according to the company) is mounted on the end of your flash and the two cards are maneuvered as needed so you can direct the light from one flash in different directions (simulating multiple light sources). You can also position them so they serve as one big reflector card if that's the approach you need. (See Figure 8.17 for an example of the product in use.) The VerteX costs about $50.

**Figure 8.16** Sto-Fen Omni-Bounce diffusers are popular both as original equipment and after-market accessories.

**Figure 8.17**
The VerteX is an unusual new flash modifier that can be used as both a reflector and a diffuser.

## THE WHITE CARD TRICK

Newspaper photographers have long made a habit of carrying a small stack of index cards and rubber bands in their camera bags. Put the rubber band around the flash head and slide the index card under the rubber band. Tilt the flash head to almost 90 degrees. The light from the flash bounces off the ceiling and kicks forward at the same time to throw some light directly on the subject (filling in the eye sockets). Another variation of this is the spoon trick. Use a white plastic spoon and place it under the rubber band instead of the index card. Some photographers preferred this approach since the curvature of the spoon would cause the light to curve outward the same way it does with an umbrella. Sometimes they'd cut aluminum squares and Velcro them to the back of the flash, even choosing copper-colored aluminum to provide a warming effect to the light. If you've ever walked by a newspaper building and seen a photographer rummaging around the dumpster, now you know why; they were looking for light modifiers!

# Other Light Modifiers

So far we've been looking at ways to diffuse, or spread and soften, the light from a small flash, but suppose that's not what we need to do. Sometimes you want to restrict the light from a flash so it only illuminates a certain spot. It might be that you want to create a spotlight effect or you might need a hair light for a portrait. You might even be trying to create any number of special effects that call for narrow patches of light or perhaps a tightly focused bit of colored light that doesn't spill over into other areas of the photo.

## Snoots

Snoots are the first of the light modifiers designed to do this kind of work and they're pretty useful for it. We'll look at some other options later. Some form of light modifier that can narrow your flash output is a good idea for your camera bag. You may not need it often, but when you do, it can have nice results. There are a number of choices if you're looking for a small, portable snoot to carry in your camera bag. You considerations should include cost, ease of use, and effectiveness.

## DO-IT-YOURSELF OPTION

On a budget? Just like do it yourself projects? If so, it's not that hard to create a snoot-like light modifier. Take a small, empty box. Open both ends and cover it in Gaffer's tape, duct tape, or electrical tape. Put some Velcro on the inside flaps of one end and on the end of your flash (opposite sides of the Velcro of course). You can now mount your cracker box snoot on your flash. Is it as effective as the ones above?—maybe not, but it is cheap and it will shape your light.

- **Zoot Snoot.** I know, the name's really cute. Well so is the snoot. The Zoot Snoot is a neoprene tube that fits over the end of your flash and can be rolled to shorten it if you want to widen the light pattern. It's black on the outside and white on the inside and can be reversed to change the light falloff it produces. A buttonhole at one end of the snoot means you can easily carabineer it to your camera bag making it easy to carry and get to. A rarity for a light modifier, the Zoot Snoot is machine washable. ($23, one size fits many flashes, but not all. Fit fine on my Sigma EF-500 Super and Canon 550EX, but a bit big on my Canon 420 EX.)

- **Honl Speed Snoot/Reflector.** Elegant and simple. This light modifier is simply a square of black material on one side and silver on the other (the inside). Strategically placed Velcro lets you form a tube out of it turning it into a snoot, which attaches to your flash via Velcro on the flash head. Need a reflector instead? You can just Velcro the material to three sides of the flash head. It's stiff enough to stand up without any support and turns into a nifty reflector. You can fold it up when you're not using it and stow it in your camera bag

($29.95, should fit just about any shoe or handle mount flash.) See Figure 8.11 for an example.

- **Lumiquest.** Collapsible and foldable snoot. This one Velcros on to your flash head and folds flat when you don't need it. Not as well constructed as the first two, but with a modicum of care, should still hold up. ($28.95, and may not fit larger handle mount flashes, but should fit most shoe mount flash units.)

**Figure 8.18** Barn doors can allow directing the light into a narrow strip or wide area.

## Grids, Gobos, and Barn Doors

Grids, long a staple of studio photography, are a relatively new portable flash option. Their entry into the portable flash world has everything to do with creative photographers developing their own tools to modify light and then deciding to bring their concept to market. These devices are small, lightweight, and inexpensive. They don't take up much space in a camera bag, but can serve to restrict light to a very narrow angle.

Another useful light modifier is a barn door attachment for your flash head. (See Figure 8.18.) This will also serve to narrow your light, but unlike grids, which create a circular light pattern, will allow for a narrower strip of light effect.

Such tools have many uses. If you're trying to create studio portrait lighting you can create a simple three-light setup with a main light, fill light, and hair light using a grid on your hair light. If you're going for something more creative, you can stick a colored

gel on your flash, pop on a grid, and create a color glow on your subject's face without having it spill onto your model's hair (hide the flash behind a laptop's LCD computer screen and make it look like the model is being bathed in the glow of light from the computer).

**Figure 8.19** Grids such as the Saxon grid used here create a much narrower light pattern which is useful as a hair light or to provide a small dramatic spotlight effect.

◆ **HonlPhoto 1/4 or 1/8 Speed Grid (purchase separately).** These are small rectangular grids that Velcro onto your flash head. Simple and easy to use, this grid is a handy and effective accessory. ($29.95 plus $9.95 for the accessory speed strap to attach it to the flash. The speed strap works with other Honl products too.) The 1/8

grid produces a narrower circle of light than the 1/4 grid. You could easily place a colored gel between the flash lens and the grid to add a color effect to your light.

◆ **Saxon Portable Flash Grids.** Low cost and effective. The company offers several different grid options including a stackable grid that lets you restrict the light pattern more and more as you add extra grid panels. This is another grid that would be easy to add a colored gel to. (A basic grid is $6.99, the multi-stage one costs $27.48.)

◆ **Saxon Pop-up Flash Grids.** Saxon also makes a grid attachment that mounts to your camera's pop-up flash to restrict its angle of coverage. (These run from $.99 to $2.49.) (See Figure 8.19.)

◆ **Adorama 4 Leaf Barn Doors for Budget Flash.** Adorama is a New York City camera store that carries many of the products discussed in this book. It also occasionally develops its own products and this light modifier is one example. The inexpensive ($9.95) barn door attachments work on most flashes.

◆ **Honl Speed Gobo/Bounce Card.** This is a single rectangle that uses the Honl Speed Strap to attach it to the flash head. Add a second one and you have an effective barn doors set up.

# Off-Camera Lighting

Hot shoe mounted flashes are convenient. Sadly, that doesn't mean they're at their best when used in that location. While the flash and camera can communicate with each other allowing for more sophisticated lighting control and metering accuracy, that doesn't necessarily mean you can get the best quality light that way. On-camera flash tends to produce harsh light and direct, distinct shadows. The light modifiers mentioned on the preceding pages will definitely improve the quality of your lighting, but getting the flash away from the camera will help a lot too.

Mounting a flash on the accessory shoe elevates it, when compared to your camera's built-in flash, and can help reduce red-eye. But, unfortunately, the higher position of a shoe-mounted flash may not totally eliminate this bane. Red-eye pops up because the angle of the light from the camera mounted flash strikes the subject's eyes and bounces back into the camera lens. Red-eye is more pronounced in children and younger adults because their eyes have more pigment in them. While using a shoe-mounted flash can help, the best way to avoid

red-eye is by getting your flash off the camera.

The first step is to consider a flash bracket and off-camera shoe cord if you're using a dedicated flash or a PC cable if you're using a non-dedicated flash. (Many digital SLRs require an adapter that slips into the hot shoe to provide

a PC connection.) (See Figure 8.20.) Your camera vendor may provide a special connector cable to link an off-camera flash with the hot shoe that includes all the conductors needed to maintain automatic operation and communication between the flash unit and the camera. "PC" cables are "dumb" links, allowing no

**Figure 8.20** Flash brackets get your flash away from your camera body reducing the chance of red-eye and improving the quality of your light.

## PC NOT POLITICALLY CORRECT

"PC", by the way, has nothing to do with personal computers or being politically correct. In fact, the letters PC stand for "Prontor-Compur" shutterworks, two companies in Germany that devised the cord as a means of triggering studio strobes. In doing so, they invented one of the worst connectors ever dreamed up: unreliable, easy to pull loose, and prone to breakage. When the PC connector was the main way to connect electronic flash units, one huge seller was a "PC conditioner" that did nothing more than reshape the easily bent connector tip. Today, basic PC cords cost about $10 (sometimes less) and can be purchased in various lengths. More expensive cords may be sturdier, and less prone to the afflictions of the PC cord.

information sharing between flash and camera; their only function is to trip the flash when the camera's shutter opens.

Dedicated flash off-camera shoe cords are more expensive with third-party versions running about $40 and camera maker units costing $60 or more. The off-camera shoe cords let the camera and flash communicate as if the camera was still in the hot shoe so you're able to maintain all of the system's sophisticated lighting control. All you get with a PC cable is the light being triggered on time (and PC cables often malfunction so you should plan on having at least one back up cable in your bag at all times).

Once you've got the cables to get your camera away from the hot shoe, how do you hold it in place? One option is to hold the flash in one hand and the camera in the other. This does work, but it's tricky (you may point the flash in the wrong direction, plus it's tiring). A better approach is to add a flash bracket to your camera.

These give you an additional grip and provide a shoe mount to slide your flash into. They also raise the flash up and to the side reducing the chances of red-eye.

Many companies make flash brackets, and just like potato chips, haven't been able to stop with just one. One thing to consider when buying a flash bracket is whether or not it offers a way to flip the flash into a more appropriate position when you hold the camera vertically. If it doesn't, and you shoot verticals, the flash will not be as effective. Here's a list of companies and some comments on their offerings.

◆ **Stroboframe.** Offers eight different units ranging in price from $87.99 to $159.99. (Usually the more expensive brackets are designed to hold bigger, heavier cameras or to get the flash farther away from the camera.) The company also makes a bracket designed to flip the camera from horizontal to vertical while on a tripod. This makes it easier to re-orient the camera when you're using a lens that doesn't have a tripod collar.

◆ **Custom brackets.** This company offers three different lines of flash brackets ranging from heavy duty pro versions to lighter weight affordable models. This company's approach is that rather than flipping the flash when you want to shoot verticals, it's easier to flip the camera (on it's own rotational mechanism). One of the interesting

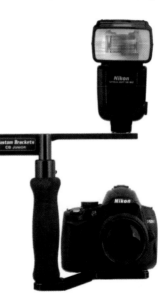

**Figure 8.21** This Custom Brackets CB Junior is an inexpensive flash bracket.

things about its approach is that you can design your own custom bracket at the company's website. Depending on how you configure your bracket, you can spend between $250 and $400 or more. The company also has a much less expensive line for shooters on a budget with prices beginning around $50. See Figure 8.21 for an example.

◆ **Demb Flash Bracket.** A small, lightweight flash bracket that only weighs seven ounces and will let you orient your flash horizontally or vertically. Costs $89.95.

◆ **Kirk Photo.** Kirk offers one flash bracket with a flash arm that can be easily raised and lowered to put the flash at just the height you want it. Among its other models is one that folds for easy storage and another designed to mount to the lens collar of big telephoto lenses (a super telephoto and lens hood is big enough to block some of the light coming from the flash if it's mounted above the camera). Kirk flash brackets range from $180 to about $260 but accessories such as mounting plates may add extra to the cost.

# Wireless Flash

Of course the ultimate in off-camera flash is to remove the whole physical connection between the camera and the flash unit. Once you can do this, your possibilities become very exciting. It isn't particularly hard to do either. Depending on your circumstances and your budget, there are a lot of options available to you for putting some distance between you and your flash or flashes.

There's a bit of a pecking order to the tools available for triggering flashes remotely. At the high end are the dedicated flash units that can be fired by preflashes emitted by a camera's built-in flash or an external dedicated flash. Simply set up your remote flash to trigger when the camera flash issues a command, then set your camera flash to "command" any remote flash units. Many

flash units use a preflash that causes the main and remote units to fire a monitor signal, which the camera can use to calculate exposure for all the combined flash units, then, another flash triggers all the remote units when your camera shutter opens. This happens in a fraction of a second, and you may not even be aware of the multiple bursts that are emitted when you press the shutter release down all the way. Your camera/flash manufacturer may have designed the flash units to operate in "groups" and "channels" so that each group of one or more flash units can be controlled independently, and those on a particular channel won't interfere (or trigger) other flash units (including those from other photographers at the scene) using a different channel.

At the low end is the photoelectric slave. There are two basic types these days, the old-fashioned kind and the digital kind. You have to be careful which dSLRs you use each with. If your camera is one of those that issues a preflash prior to exposure, the preflash will trigger a traditional (old-fashioned) slave unit, and the remote flashes will fire before the shutter opens. Cameras that emit a preflash need to use the digital slave, originally designed for point-and-shoot cameras, which fires a very brief preflash to set white balance for the flash burst that's going to follow. If your camera does not emit a preflash, you need to use a traditional slave, because when your camera fires the flash, it's firing the main burst, and a digital slave will ignore that. When you buy a slave trigger, make absolutely sure it's compatible with your type of dSLR camera.

Of course in order to trigger a photoelectric slave you still need a flash to fire somewhere. This means you either have to use your camera's pop-up flash or have a shoe mount strobe in your hot shoe. You also have to be positioned so the slave can see your flash's light (more of a limitation than it sounds). If I'm using this technique, I grab my camera (which has a pop-up flash) and stick a neutral density gel over the flash head. The photoelectric slave still sees the flash trigger, but the ND gel reduces the light output so it doesn't affect the image. If your flash has a Manual mode, you may be able to dial down the output of the flash to 1/128th power or so, and it will trigger most slave units that aren't too far away, without contributing significantly to the exposure.

Photoelectric slaves (see Figure 8.22 for an example) range in price from $15 to a little over $100. Figure you'll need one for every remote flash you plan on triggering, plus a couple of spares (sorry, but photoelectric slaves are small, delicate devices that break easily). Also, one of the problems with photoelectric slaves is that any flash (not just yours) will trigger them. If you're at an event with lots of other people taking photos, there's a good chance some of them will be triggering your slaves too. In addition to photoelectric slaves, you can also get flash units that have photo slaves built in.

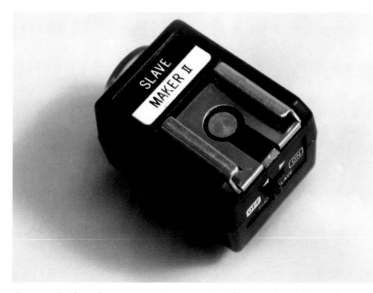

**Figure 8.22** Photoelectric slaves rely on the light from another flash to tell them where to fire. They are effective at modest distances, but are triggered by any flash, not just that of the photographer who owns them.

Let's look at some of your choices.

◆ **Basic slaves.** There are dozens of choices when it comes to basic slaves. Some of the considerations include how far away the slave can be triggered from and how it connects to your flash unit. Some are hot shoe style mounts while others connect via PC connection (a problem if your flash doesn't connect by PC cord), and others connect via a plug that looks like it would go into a household electrical outlet. Making sure a slave is compatible with the flash you plan on using it with is important. Metz, Wein, and Bowens are just a few of the companies that make photoelectric slaves.

◆ **Mini slave flashes.** There are some mini flashes with built-in photoelectric slaves. These can be useful if you keep in mind that many of them don't put out a lot of light. Still, they can make a nice accent or backlight and there are one or two that put out enough light to be useful for fill flash purposes if you don't put it too far away from your subject. Prices run from $18 to $50 for conventional units. Digital versions are more expensive, but you don't want them anyway. The biggest advantages to these are that they don't take up much space in your camera bag, but power and reliability issues are sometimes a problem. Morris, Smith-Victor, and SP Studio Systems all offer some kind of mini slave strobes.

◆ **Strobes with built-in slaves.** Some normal-sized hot shoe mount strobes also come with built-in slaves. They can be used as regular hot shoe mounted flashes, or positioned within line of sight of another flash and when set to slave mode, will fire when another flash goes off. These units provide a lot more power and cost a good deal more than the mini slave flashes. If your budget allows, they're a better choice too.

# Infrared Flash Controllers

Here's where off-camera flash starts to get really interesting. Wireless infrared controllers don't just tell your flash when to fire, but may also be able to give them very specific instructions on just what to do.

There are two basic approaches to infrared flash controllers. The first is the dumb controller. This is just another wireless trigger that doesn't do any more than trigger any remote flash that can be fired by infrared signals and can see the signal. These units run from $31 to $100 or more and may require specific strobes to team up with (or you may have to buy a receiver for each of your flashes to get it to work with the

transmitter—about $80 each). The advantage to them is that while everybody else at the party is firing away with their popup flashes, your slaved flashes are ignoring all those bursts of light and are sitting around patiently awaiting your signal to fire. Underwhelmed? So am I, but if you're on a budget, they do a better job than a photoelectric slave and cost less than the next option.

At the high end of the infrared trigger range is the camera maker's wireless flash controller. For instance, Canon offers the ST-E2 controller ($219.95). (See Figure 8.23.) Besides firing my Canon and Sigma dedicated

flashes, it will also set power ratios between multiple flashes and provide full E-TTL exposure control over them. The controller isn't cheap though and to use it, I have to have dedicated flashes that can communicate with the ST-E2 (also pricey). Still, it gives really good results—most of the time. It's also possible to use a dedicated strobe such as a Canon EOS 550EX or 580EX to fire and control other system dedicated flashes, although this means you're tying up an even more expensive piece of gear to use as a flash controller. Nikon has a similar unit, the Nikon SU-800 Remote Commander.

Let's take a look at some of the plusses and minuses of infrared controllers.

◆ **Selectivity.** Greatly reduced chance of another photographer's flash setting your strobes off. Dumb infrared systems aren't very heavily used (because of the next type of system) so you're not likely to run into another photographer who's using them and the camera maker's versions usually offer several different channels they can be set to so if another photographer shows up with one you can just make sure you're using a different channel.

◆ **Cost.** While infrared systems are more expensive than photoelectric slaves, they're less expensive than radio signal-based systems (see next section for radio system costs).

◆ **Effectiveness.** Infrared systems are very effective indoors as long as all your gear is in the same room or within line of sight. Infrared won't travel through walls (although it will bounce off of them). If you need to trigger a flash in another room, radio transmission is your only choice.

◆ **Ease of use.** Infrared systems can be very easy to use. The camera maker's system usually just requires carrying a small controller.

◆ **Range (Indoors).** Infrared systems tend to be more effective indoors and can generally reach distances of about 40 feet or more.

◆ **Range (Outdoors).** Infrared systems are not as effective outdoors. Their maximum range is about 30 feet and their effectiveness can really suffer on bright days.

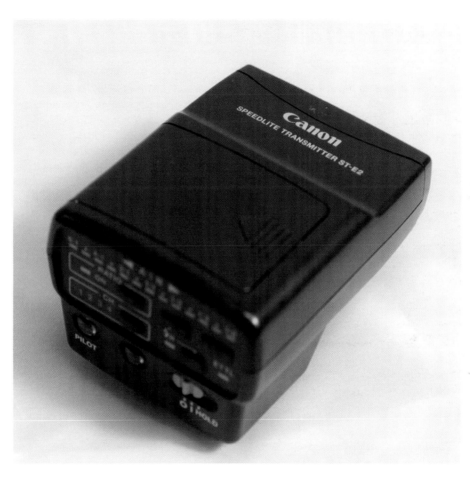

**Figure 8.23**
Canon's ST-E2 infrared flash controller works with both Canon and third-party EOS system dedicated strobes to provide off-camera remote E-TTL lighting.

# Radio Signal Based Flash Controllers

At the high end, remote flash triggers that rely on radio signals represent the favorite option of many pros. As they've caught on in popularity during the past few years, more and more companies are offering radio signal based flash controllers. Prices vary greatly and so does quality. You can find cheap systems at online auctions for $30 or $40, but these systems usually don't have much of a track record.

Better systems are good for well over a thousand feet (some manufacturer's claim 1,600 feet) and walls or obstructions don't block the signals. These systems also offer multiple channels so if other photographers are using the same gear (not unusual with Pocket Wizards or Radio Slaves) you can just agree to change channels and go on shooting.

There are also useful accessories that let these devices pull double duty. As noted earlier in this book you can get a cable that lets you connect a Pocket Wizard or Radio Slave remote to your camera and lets you trigger your camera (and flashes) remotely via another Pocket Wizard transmitter (see Figure 8.24 for an example). PWs (as they're known) come in a number of different models. The earlier versions offered either a transmitter or a receiver. Later models incorporate both for greater versatility.

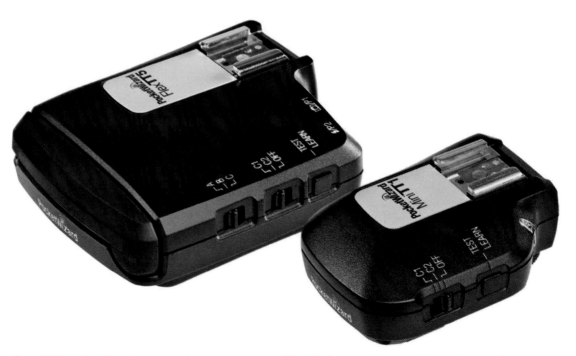

**Figure 8.24** Pocket Wizards can provide remote triggering of both flash units and cameras from a distance of up to 1,600 feet.

Wireless off-camera flash offers you the greatest versatility and the chance for remarkable creativity. While you may not get full TTL exposure with these systems, you'll generally get much greater range and reliability (bright sun doesn't affect them).

Lets take a look at some of your options:

- **Morris 4-Channel Radio Transmitter.** A relatively new radio signal wireless controller. Less expensive than other choices, a transmitter and receiver kit goes for about $160. Extra receivers are an additional $89.

- **Quantum Radio Slave.** Can be used to trigger either flash units or cameras remotely. Comes in separate transmitter and receiver models, each capable of using any of 4 channels. The Radio Slave is reasonably small, light, and effective and has a range of about 350 feet (obstacles not a problem). Cost $177 each for both transmitter and receiver.

- **Pocket Wizards.** There are a variety of Pocket Wizard models available ranging from a basic transceiver for $159.95 to the Multimax model ($295), which can control and independently fire different cameras and strobes from one unit. Power Wizard has also come up with an E-TTL transmitter and receiver system for Canon dSLR cameras and flash units that can control light output and exposure from up to 1,200 feet away. The transmitter costs $199 and the transceiver another $219. (See Figures 8.24 and 8.25.)

- **Bowens Multi-functional Transceiver Pulsar Radio Slave.** The company offers a twin pack for $239.90. Each unit can serve as transmitter or receiver and the pair can work at a distance of up to 333 feet.

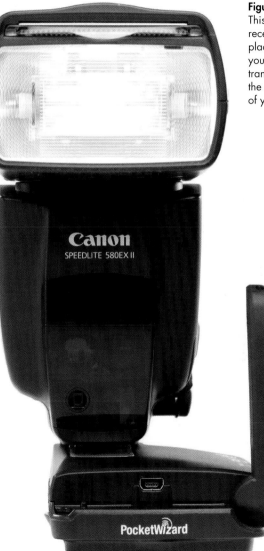

**Figure 8.25**
This Pocket Wizard receiver provides a place to mount your strobe. The transmitter fits in the accessory shoe of your camera.

# Portable Power—You Can Take It with You

Now that you're really getting creative with flash, you might start wondering if your batteries can hold out through all your experimentation.

Maybe they can, maybe they can't. But small, disposable batteries aren't your only option. When you really need power, accessory power packs can be a lifesaver. Not only do they pack a lot of juice, but they can also power your flash during fast motor drive bursts so you can get off seven or eight flash bursts or more and keep pace even with a pro motor drive (at least for a little while).

A good power pack can keep you going for several hundred full power flashes. A great power pack can power your flash and your camera. While these units are much more expensive than AA batteries, they're incredibly useful if you shoot a lot of flash, and they are rechargeable. With some models you can even power more than one flash unit simultaneously. Most rely on lead-acid cells so there's no worry about memory effect. Once a battery cell dies (which depends on use), it is possible to get the battery cell replaced or reconditioned.

When it comes to buying a battery pack, keep in mind that you also have to purchase a cable that goes from the power pack to your camera's battery compartment so this adds to the cost of your purchase.

Lets take a look at some of your options:

- **Quantum batteries.** The Quantum battery is a small rechargeable unit good for several hundred flashes on a single charge (see Figure 8.26). There are several different versions of the battery and you'll have to do some checking to see which version and cable you need for your flash. These are workhorse units and I'd hate to have to do the math to figure out how many wedding photos have been lit with flashes powered by these batteries. (Cost around $200 plus another $50 or so for the cable.) A smaller version, known as the compact, can be had for $119.95 (plus cost of connecting cable). This version screws into your camera's tripod socket and rides underneath while you work. It's capable of about 150 flashes. There's also the Turbo version for about $400, which can power both flash and camera (cords are another $90 or so, each). I've gotten two years of heavy use out of a basic Quantum battery.

◆ **Sunpak.** The company makes several different battery packs that can work with both high- and low-voltage flash units. An added benefit of this system is that you can swap out battery clusters and keep shooting. ($249.95 for the battery, extra battery clusters are about $70. It uses connecting cords for the Quantum Turbo battery to connect to your flash; about $90.)

◆ **Dynalite.** This company makes several battery packs including the Jackrabbit II, a Nickel Metal Hydride battery capable of more than 700 flashes on a single charge with a one-second recycle time. Costs about $400 with camera connecting cables adding another $30 to $40 to your expense.

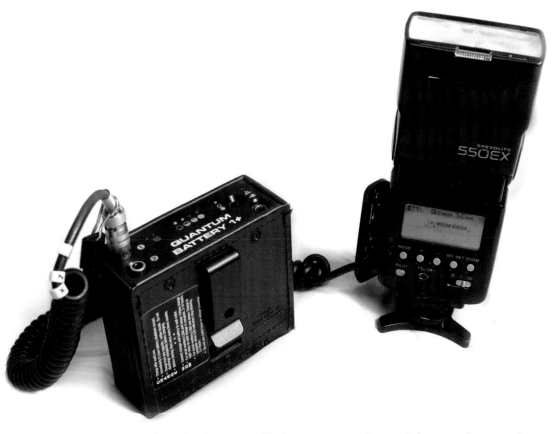

**Figure 8.26** Quantum battery packs work with a variety of flash units. Battery packs provide faster recycle times and hundreds of flashes, plus can be recharged (often in just a couple of hours).

# Add-Ons: Exotic and Mundane

This is the section of the book where I get to talk about some of the weird stuff as well as some of the little odds and ends that can come in handy if they're actually in your camera bag. This is the stuff that doesn't quite fit into other sections of the book, but that doesn't mean these items aren't potentially useful. Many of these gadgets are specialized items that solve particular problems and if you need to solve one of those problems, can be the difference between getting the shot and not getting it.

On the wild and wacky side, there are ways of remotely triggering your camera, recording GPS data on your image files, and ways to take your camera underwater safely. While these aren't things the normal person worries about very often, they're the kind of things creative photographers sometimes need to do to create memorable images.

On the more mundane end are things like eyepiece extenders, vertical grips, and LCD screen protectors. Not the most exciting of accessories, but these add-ons can make your photographic experience easier. They can also help you protect your expensive camera and make it easier to use. Let's start with the more interesting stuff first.

# Taking Pictures by Remote Control

Sometimes you want to trip your shutter without being anywhere near your camera. It's not out of laziness; sometimes you just don't want to be anywhere near what you're photographing because it's scared of you (small birds and animals) or you're scared of it (big animals, ex wives). While you can set the self-timer and run, that only gets you one shot with most cameras and doesn't really work when you're trying to get birds lurking in some dense foliage (see Figure 9.1). You can set up your camera and use a remote trigger and cable, while hiding in a blind. This will do the trick, but now you're stringing the cable a fair distance and have to worry about different parts maintaining a good connection.

A wireless triggering system is simpler to rig and easier to use, and you may not have to pay a very high price for that convenience either. Cheaper systems are available for specific camera lines for less than $100 (sometimes a lot less) and often rely on infrared light to signal the camera to fire. While pro versions will cost a good deal more, the good news is a pro wireless triggering system can also be used for firing a flash wirelessly too. The systems that provide the greatest range use radio waves that are stronger than infrared, not prone to failure in bright sunshine, and transmit through obstacles. The cheap ones are good for about 150 feet or so, while the pro setups can be good for well over a thousand feet. A cable-based approach can only manage about 100 feet at best.

**Figure 9.1** Remote control shot of a waterfowl.

Let's take a look at the possibilities.

◆ **At the cheap end.** There are several low-cost camera remote systems available these days. They may only be able to work with cameras in a particular subfamily (for instance just Canon's 10D, 20D, 30D, 40D, and 50D cameras). These devices can cost from $30 on up. An extension cable adds to the cost. Phottix (www.phottix.com) makes one for Nikon, Canon, and most other camera systems. (See Figure 9.2.)

◆ **Pro versions.** Higher-end remote transmitters can trigger their receiver from distances of more than a thousand feet and send their signals through walls and around corners. They can also be used to fire remote flashes as well. Pocket Wizard makes a variety of transmitters and receivers (including units that can do both). You need two units plus a cord to plug into the camera's digital connection. Setting up the pair would run you from $300 to close to $600 (the company offers several different units, hence the price range). The accessory cable for the camera

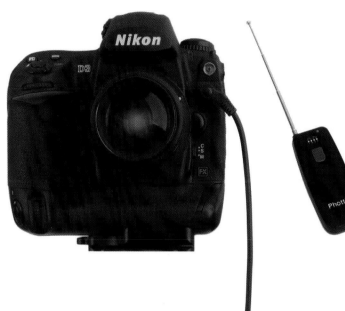

would add from $20 to $60 or more. You'd need another cord to hook up the receiver with the strobe (more on this in the section on working with flash units). While this sounds like a lot of $$$ for a remote capability, keep in mind that the Pocket Wizards are very valuable if you need to fire a slaved flash in an environment where a lot of other photographers are using flash. (More on this in the lighting section [Chapter 8] of this book.)

◆ **Infrared remotes.** At the low end of the price range ($29.99) are infrared remotes. These will trigger the camera but may not have the range of radio signal based devices. Higher-end versions

such as the Argraph twin1 R3 can cost upwards of $100 but offer more features and greater range (more than 300 feet). These are line-of-sight remotes, meaning you can't have anything blocking the signal for them to work. Different cameras will call for different options as some cameras have a built-in receiver and will only need the addition of a transmitter; others will require both a transmitter and a receiver. These remotes are usually camera line specific. For example, Canon dSLRs can use one model, but you'd need a different device, like the one shown in Figure 9.3, for use with Nikon cameras with built-in receivers.

**Figure 9.2** Wireless remotes let you keep some distance between you and your camera while still being able to keep shooting.

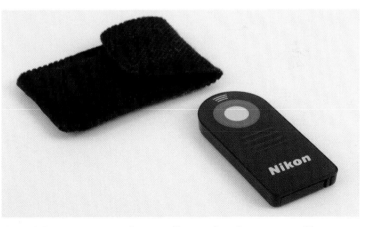

**Figure 9.3** Your camera vendor may offer an infrared remote control for use with your camera.

# Putting Things on Auto—Time-Lapse Remotes and Intervalometers

Sometimes you need a series of photographs taken over a long period of time at regular intervals. Time-lapse photography, nature photography, and stop-motion animation are just a few forms of photography that take advantage of this technique. It can also be useful for creating multiple exposure sequences at precise intervals.

Fortunately, there's a tool for photographers who need to create such sequences, or who need to capture a subject when it moves to a certain place (like a coyote coming down a trail at night). That tool is known as an intervalometer and there are some choices available for the average photographer that are worth considering.

Both camera makers and third-party equipment manufacturers offer some options for this kind of thing. A lot of it depends on how sophisticated a device you need.

◆ **Remote cable release with intervalometer.** Camera makers such as Canon and Nikon frequently offer choices when it comes to remote cable releases. On the inexpensive end they offer a basic cable release that just trips the shutter and locks it open if need be (about $45). On the high end they offer a unit such as the Canon TC-80N3, which can be set to fire the camera at regular intervals from one second to 99 hours, 59 minutes, and 59 seconds, or anywhere in between making it a perfect device for sequences that need to be captured at regular intervals. Remote cable releases that offer this function cost about $150.

◆ **Mumford Time Machine.** This is a programmable device that can be used to trigger the camera at regular intervals or set it to fire in response to another action such as a sound, light, or motion. The company also offers an accessory table that can be used for time-lapse movies that pan across a scene. The device is also useful for high-speed time-lapse photography. Depending on how it's configured, the Time Machine (see Figure 9.4) runs between $325 and $400 or slightly more. It can produce stunning results, as shown in Figure 9.5, produced using the Time Machine's ability to trigger a camera based on motion sensing.

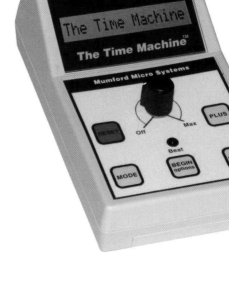

**Figure 9.4**
Mumford Time Machine.

◆ **Zigview.** This is one of those devices that will get mentioned in more than one section of the book. The Zigview is an electronic viewfinder that mounts on to the eyepiece of the camera and then provides a larger LCD view (see Figure 9.6 for a typical macro setup with the S2 model). Its uses as a viewer are discussed in the screen accessories section of this chapter. It's an additional feature of the Zigview that gets it mentioned here, namely the ability to trigger the shutter release based on your settings. The Zigview can be set to work as an intervalometer, a remote cable release, or—and this is really cool—a nine area motion sensor that triggers the camera when variations in the brightness level indicate that there is movement in the image. Zigview electronic finders that offer this capability (the R and the S2 models) range in price from $279 (plus additional cost for an adapter to fit your camera's eyepiece) to $399. While that may sound like a lot, the combination of increased viewer size and remote triggering capability does make a useful tool.

**Figure 9.5** An intervalometer can trigger your camera to fire at specific intervals making it useful for time-lapse and stop-motion photography.

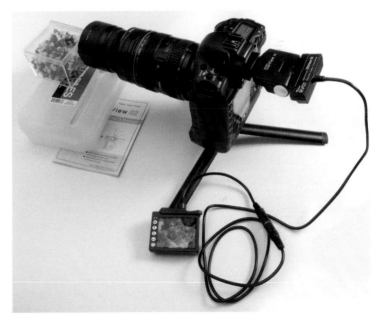

**Figure 9.6** Although shown here being used for a macro shot of some stick pins, this Zigview unit has a motion detector that can be very useful for capturing animals in the wild or husbands making late night snack runs to the fridge.

# GPS—Or, Where Did I Take This Picture?

I love the Global Positioning System (GPS)—and not only when I'm driving around in my car. When you consider how often a freelance photographer has to make it to a new shooting location, having a tool designed to help you find your way can save you time and money. As a hiker/backpacker/boater, I've also had great success with a handheld GPS unit that let me load my own topographical maps for whatever location I was visiting. A few years ago, I used it boating on Lake Powell where it kept me appraised of exactly where I was (no small feat considering the lake is a maze of side canyons and islands—without GPS I'd have been hopelessly lost).

So I can make a pretty good argument for GPS as a tool for getting to a place for making images. But there's a new use for GPS receivers—"geo-tagging." GPS receivers that have been designed to work with dSLRs keep track of your location and enter geo-tags on your image files so you can always tell exactly where an image was created. Bear in mind that GPS acquisition can be slow with some of these units, especially when initializing them for the first time. GPS signals tend to be lost when blocked by overhead structures such as overpasses and when you go inside (or into caves or some slot canyons) and so how quickly a device can reacquire enough satellites for reliable data is a bigger concern.

As you might expect, there are different options and approaches to recording and connecting GPS information (geo-tags) to images. Some systems add the information directly to the image file while the image is being created, while others are designed to merge data with the image files once you're back at your computer and have captured images and data to your hard drive. While the latter is not as elegant or as safe (what happens if you lose the GPS or it gets damaged before the transfer takes place?) sometimes it may be the only way you can add the ability to a camera. Also, some systems are manufacturer specific while others will function on a wide range of dSLRs.

The Nikon D90 gained a lot of credibility as a tool for serious photographers when it debuted with a GPS port that accepts the new Nikon GP-1 Global Positioning System device. The unit makes it easy to tag your images with the same kind of longitude, latitude, altitude, and time stamp information that is supplied by the GPS unit you use in your car. (Don't have a GPS? Photographers who get lost in the boonies as easily as I do *must* have one of these!) The geo-tagging information is stored in the metadata space within your image files, and can be accessed by Nikon View NX, or by online photo services such as mypicture-town.com and Flickr. Having this information available makes it easier to track where your pictures are taken. That can be

essential, as I learned from a trip out West this Spring, where I found the red rocks, canyons, and arroyos of Nevada, Utah, Arizona, and Colorado all pretty much look alike to my untrained eye.

Like all GPS units, the Nikon GP-1 obtains its data by triangulating signals from satellites orbiting the Earth. It works with the Nikon D90 and D5000, as well as more upscale Nikon cameras, such as the D200, D300, D700, D3, and D3x. It also works with the older Nikon D2x/D2xs and D2H/D2Hs. At about $225, it's not cheap, but those who need geo-tagging—especially for professional mapping or location applications—will find it to be a bargain.

The GP-1 slips onto the accessory shoe on top of the Nikon D90 or D5000. It connects to the GPS port on the camera using the Nikon GP1-CA90 cable, which plugs into the connector marked CAMERA on the GP-1. If you

want to use the unit with one of the other supported cameras, you'll need to buy the GP1-CA10 cable as well—it attaches to the 10-pin port on the front of the D200/D300/D700/D3/D3x. The device also has a port labeled with a remote control icon, so you can plug in the Nikon MC-DC2 remote cable release, which would otherwise attach to the GPS port when you're not using the geo-tagging unit.

A third connector connects the GP-1 to your computer using a USB cable. Once attached, the device is very easy to use. The first step is to allow the GP-1 to acquire signals from at least three satellites. If you've used a GPS in your car, you'll know that satellite acquisition works best outdoors under a clear sky and out of the "shadow" of tall buildings, and this unit is no exception. It takes about 40-60 seconds for the GP-1 to "connect." A red blinking LED means that GPS data is not being recorded; a green blinking

LED signifies that the unit has acquired three satellites and is recording data. When the LED is solid green, the unit has connected to four or more satellites, and is recording data with optimum accuracy. Once the unit is up and running, you can view

GPS information using photo information screens available on the color LCD. The GPS screen, which appears only when a photo has been taken using the GPS unit, looks something like Figure 9.7, captured from a Nikon D5000 screen.

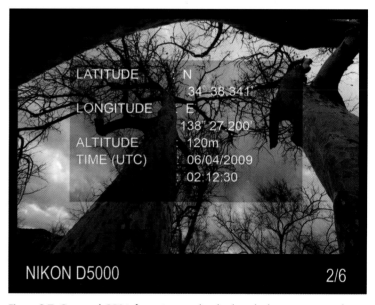

LATITUDE : N
          34° 38.341'
LONGITUDE : E
          138° 27.200'
ALTITUDE : 120m
TIME (UTC) : 06/04/2009
           02:12:30

NIKON D5000                                    2/6

**Figure 9.7** Captured GPS information can be displayed when you review the image.

Let's take a look at some of the choices you have:

◆ **GiSTEQ GPS Digital PhotoTrackr series.** These are relatively inexpensive independent units that rely on the "we'll get together later" approach to merging images and GPS data. (See Figure 9.8.) The least expensive, the DPL700, costs less than $100, relies on just a single AA battery (manufacturer estimates 32 hours of coverage from one battery), and is sensitive enough that it can pick up a signal while still inside your backpack or camera bag. Depending on which version you buy, you may have to upgrade its software to handle RAW files. The devices have a 250K internal memory, which the manufacturer estimates is enough for 40 days of normal usage. The PhotoTrackr units match up image and GPS coordinates by matching the time stamps of the image file and the GPS data, so it's important to make sure both devices are properly set up. You can add waypoints by the push of a button and the software is Windows XP, Windows Vista, and Mac OSX supported. The GPS data includes date and time the image was created (something your camera does already), provides the GPS coordinates and the approximate address of the photo, and its description. Users should remember that not every place in the world has detailed map coverage, so if you're using this in particularly remote places, you won't get as much information as you will in other areas.

**Figure 9.8**
GiSTEQ GPS Digital Photo-Trackr CD1111 series are relatively inexpensive independent units.

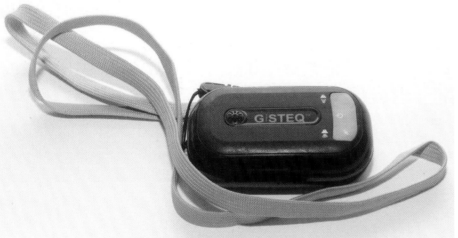

◆ **Nikon GP-1.** Camera maker specific unit, which works on Nikon D3X, D3, D2XS, D2X, D2HS, D200, D300, D700, and D90 cameras. The GP-1 costs a bit over $200 and records latitude, longitude, altitude, and time information. Much smaller than the PhotoTrackr units, this geo-tagger can be hot shoe mounted or attached to the camera strap and draws its power from the camera so you don't have to worry about its battery life. As I mentioned previously, the device uses a simple blinking light method to let you know how strong a connection it's getting with the GPS satellite network (red blinking = no GPS data recorded, green blinking = GPS data recorded using three satellites, green solid = four or more satellites detected). Keep in mind that since the device is powered by the camera, if you turn the camera off, the GP-1 will lose its GPS connection and will have to reacquire it once the camera's turned back on.

◆ **Promote Systems GPS (Nikon and Fuji cameras only).** This is another hot shoe mount unit and is also camera powered and embeds the geo-tag information directly to the image file (see Figure 9.9). At $149 it's cheaper than the Nikon unit and powers up and down with the camera's exposure meter. This device maintains a memory function to remember where it is when it powers down, so it tends to reacquire a GPS connection quickly. It's compatible with many Nikon and Fuji dSLRs but check the manufacturer's website to see which ones.

◆ **JOBO photoGPS.** This is a hot shoe mount unit that records GPS data every time the camera's shutter trips. The photographer then merges geo-tags and images back at his or her home computer. The good news is that it's not camera specific and it costs less than

$200. It's also Mac and PC compatible. Once the images and geo-tags are combined, the user can connect to the JOBO photoGPS server via the Internet and download additional GPS information such as the location of historical information and nearby points of interest. The device has 128MB of built-in memory, good for about 1,000 locations. It supports JPEG and RAW.

◆ **Other choices.** There are other units on the market, but in researching them I've read about enough problems to think they should not be included here. Keep in mind, this is very young technology. As is often the case with such new technology, devices often promise more than they can deliver. Try and buy from a store that has a good return policy and test the unit out first before going on the trip of a lifetime.

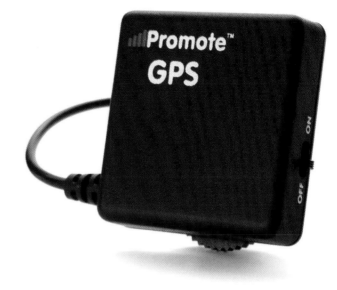

**Figure 9.9** The Promote Systems GPS for Nikon and Fuji dSLRs embeds geo-tags in the camera's image file as the image is created. Such devices help photographers know exactly where an image was created, and depending on the system, may provide additional information such as historical data and nearby points of interest.

# Underwater Housings

Underwater photography is both challenging and rewarding. Once you slip below the water's surface a wide range of opportunities and problems greet you. Most pressing of course is how to keep your valuable camera equipment safe and dry.

The nature of your underwater efforts helps frame the problem. It's one thing if you just want to grab some shots while snorkeling. If you're operating a camera just a foot or two under the surface, the main problems facing underwater photography—water pressure and loss of certain color wavelengths—are minimized. Even light falloff is inconsequential at that depth, so all you really have to worry about is safety, protecting your camera from moisture.

It's a whole 'nother story when you put on scuba gear or try to take your camera deeper than five or 10 feet. As you descend deeper into the water the pressures that build up on whatever's protecting your camera increase drastically and the consequences of even a tiny leak become magnified under the greater pressure. The amount of light penetrating the water decreases significantly the farther down you go and certain color wavelengths also become weaker, meaning your photos take on a pronounced bluish cast.

This is expensive gear, but there are good reasons for it. Once you're at depth, you can't just make a quick run to the surface if something goes wrong (at least not if you're diving to a depth that requires decompression stops on the way back up). Equipment failures when you're diving past snorkeling depths risk your equipment and can blow your shoot.

Right now we're going to take a look at protecting your camera and keeping it safe and operational while it's underwater. In Chapter 8 we covered how a flash unit can solve the other problems.

Let's take a look at what options exist for underwater photography:

- **Ewa-Marine.** Ewa-Marine has been making underwater camera housings for a long time now. The company offers a soft, baglike housing. These housings offer certain advantages over the hard housing approach. They pack smaller for travel, cost less, and can be a little more adaptable when it comes to using different lenses. For instance, the company makes an extra-large body housing that can handle a professional dSLR with up to a 300mm lens, making it a good choice for photography from a small boat or kayak as well as for use underwater. This unit (the U-BZ) costs under $350. A similar model (for use with shorter lenses) costs a bit less.

- **Ikelite.** Ikelite is another company that has specialized in underwater housings (see Figure 9.10). This company offers a variety of units including polycarbonate models designed for specific cameras. These are more expensive ($1,600 or more suggested U.S. retail price) but are fully functional to a depth of 200 feet. The company also offers strobes specifically designed to attach to and work with the housing. (See Figure 9.11.) Ikelite also offers a variety of accessories to work with its housings.

◆ **Sea&Sea.** Sea&Sea offers both its own underwater digital camera and an assortment of hard camera housings. Its flagship model uses an aluminum body designed to withstand severe shooting environments. The housing can handle even a pro dSLR as big as the Canon EOS 1D Mark III and still provide use of almost all the camera's controls. It has a depth rating of 200 feet. Specific housings are designed for specific cameras so I can only give a broad sense of pricing. A top of the line dSLR housing for a pro dSLR at Canon or Nikon's top end can cost as much as $4,000 and you may still need a couple of accessories to complete the unit. As you drop down to smaller dSLRs the prices lower too, but not that much. A housing for a Canon 40D or Nikon D300 still runs almost $3,000. These are high prices, but this is an all or nothing situation. At a depth of 200 feet, any malfunction is likely to result in a wrecked camera and a missed opportunity.

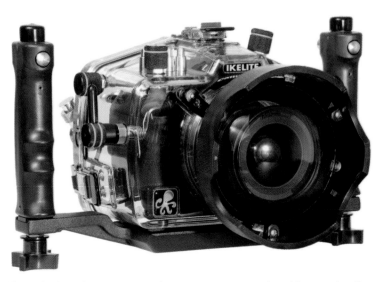

**Figure 9.10** Underwater camera housings require strength and functionality. If problems arise when you're at depth, you're in a tough spot. There's no such thing as rushing to the surface when you're deep enough to require decompression stops on your return. If the housing's controls won't operate your camera, you're not much better off either.

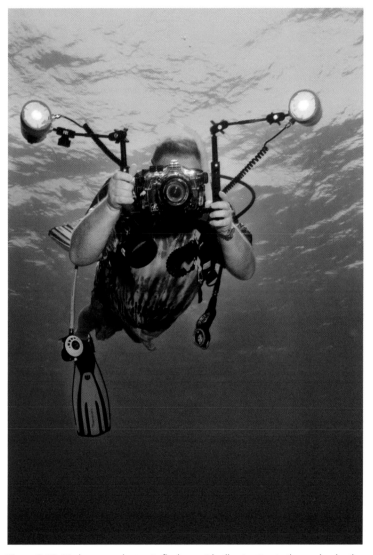

**Figure 9.11** Underwater electronic flash provide illumination in the murky depths.

# Improving Your View

Let's face it. Your connection with your camera gets pretty intimate, particularly when it comes to bringing your eye up to the viewfinder. It sounds like a simple thing, unless of course you wear eyeglasses or need to achieve critical focus or need a stronger diopter power than what's built into the camera viewfinder. Eyepiece accessories can improve the quality of your photographic experience in many ways and at least a few of these may merit inclusion in your camera bag.

Let's take a look at some of the choices you have:

◆ **Eyepiece extender.** These are inexpensive accessories (less than $20) that bring the eye farther from the camera. (See Figure 9.12.) This can make the photographer more comfortable and help keep your nose off the back of camera. They also reduce magnification by about 30 percent.

◆ **Anti-fog eyepiece.** Oh how I wish I had one of these when I lived on Guam. Usually you had to plan to leave for a shoot a half hour earlier than prudence would normally dictate simply to let your camera adjust to the humidity in time for the shoot. Even now I sometimes have to shoot swim meets and deal with high indoor humidity. An anti-fog eyepiece doesn't solve the problem completely, but it certainly helps.

◆ **Eyepiece magnifier.** Sometimes you need to achieve critical focus (particularly with macrophotography). This is one of those times where even professional quality autofocus may not be enough. Eyepiece magnifiers help you zoom in so you can focus as precisely as possible. (See Figure 9.13.)

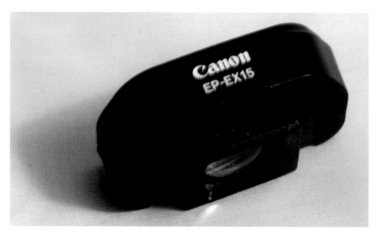

**Figure 9.12** Eyepiece extenders let you back off from the camera.

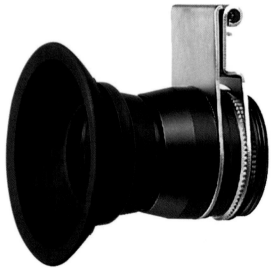

**Figure 9.13** An LCD loupe with diopter correction makes it easy to check your LCD screen even on the brightest of days.

◆ **Eyepiece cup.** This is a rubber eyecup designed to block intermittent light from bothering you while you're looking through the viewfinder. These cost anywhere from $10 to $30 depending on the quality of the eyepiece and whether you're buying the manufacturer's version or a larger heavy-duty option such as the one Hoodman offers.

◆ **Correction diopters.** While most dSLRs already have diopter correction built in, it's not always enough. If your eyesight needs more help than your camera's diopter correction can deliver, then one of these might be the answer for you. They usually aren't very expensive (less than $20).

◆ **Right-angle finders.** Right-angle finders are useful accessories (see Figure 9.14). They're great for times when you've got the camera mounted on a tripod and it's low enough that bending down to look through the viewfinder would be uncomfortable. They're also useful for ground-level photography where you'd rather not lie flat on the ground. Camera makers usually offer some kind of right-angle finder for their cameras and there's a third-party manufacturer or two as well. Prices can run from $70 for a third-party version to more than $200 for a camera maker's version. Some offer magnification choices too.

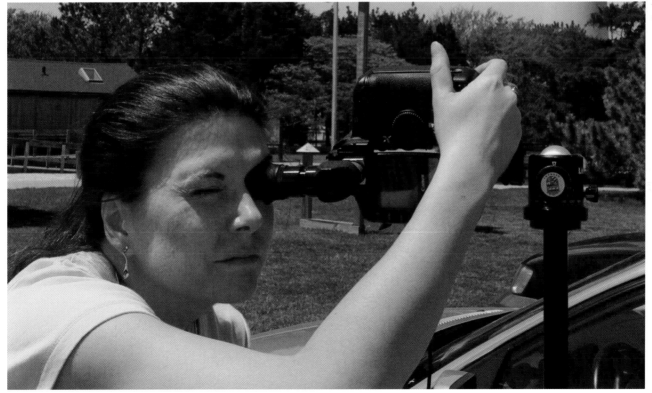

**Figure 9.14**
Right-angle finders let you stand in one position to evaluate the image in the viewfinder, but take a picture with the camera pointing left, right, up, or down.

# Screen Accessories

Your camera's LCD screen is one of the things that makes digital photography special. Used properly, it can be an incredibly valuable tool in helping improve your photography. The immediate feedback it provides is vital in helping correct problems while you're still onsite and in a position to do so. Of course, to take full advantage of it, you need to keep it free of smears, scratches, and fingerprints. You also want to be able to get a good look at the image it shows, even when you're working in bright sunlight.

Among your choices:

◆ **Screen protectors.** LCD screen protectors can be purchased individually or in multipacks. Pricing starts around $4 per individual protector and around $8 for a three pack. These are simple disposable screen protectors. More permanent versions are also available, but at a higher price. Hoodman (www.hoodmanusa.com) and Giottos (www.giottos.com) both offer such versions and their prices run around $20 apiece or more. I like the tempered glass versions offered by GGS. You'll have to hunt on eBay or use Google to find a supplier for GGS products; there seems to be no official US importer (see Figure 9.15.)

◆ **Screen protector and mirror.** Flipbac makes a combination screen protector and viewing mirror. If one of their models fits your camera, you can take advantage of this dual-purpose device. Once mounted, the mirror is flipped up to protect the LCD screen. When you're ready to use it, you flip the mirror down exposing the LCD and at the same time projecting its image onto the lowered mirror. It's an interesting idea but needs a camera that provides LiveView imaging, so it won't be as effective on cameras that only use the LCD screen to show the image you just captured. This device is offered on a reasonable range of dSLRs but you should check to make sure yours is one of them before buying it.

◆ **LCD hoods.** If you're shooting outdoors on a bright, sunny day, making out the image on your LCD screen can be a real challenge. Fortunately there are some pretty useful accessories designed to help you with this problem. LCD hoods (some with magnifiers or diopter correction) can help you make the most of having an LCD screen. Hoodman makes a variety of such hoods, including a combination hood and loupe that has a built in +/– 3.0 diopter. You turn the focusing ring on the eyepiece and set the correction strength for your eyes. The hood and loupe comes with a neck cord so you can keep it handy. It costs about $80.

◆ **Flip-up hoods.** Hoodman also makes flip-up hoods that fit on the back of your camera as does Delkin, another accessory maker. These hoods fold flat when not in use and then pop up to shade the LCD screen so you can review the image. The Hoodman hoods are a bit less expensive at $30 and take up less space in your camera bag than the hood and loupe model. Delkin offers two different versions, a minimalist stick-on version for $9.95, and a "pro" version that snaps on and off and has buttons to correspond with your camera's layout. (Meaning you have to buy one specifically designed for your camera.) They don't have any form of diopter correction though.

**Figure 9.15**
LCD protectors protect your screen from scratches.

# Vertical Grips

I love vertical grips. In fact, if one of my cameras can accept a vertical grip I buy it when I buy the camera.

Vertical grips offer several important advantages. First, many of them make it easier to use your camera in vertical orientation because they have a shutter button conveniently placed at the base of the grip. This means you don't have bend your wrist over to reach the normal shutter button. When you have long sessions shooting in vertical orientation (in my case, that's portraits, fashion, and basketball photography), a vertical grip is much more comfortable to use.

These grips typically contain one or two batteries, providing extra juice for your camera. You can shoot longer before having to change batteries. In some cases, the extra battery in the grip adds capabilities to the camera. The Nikon D300, for example, fires

off continuous bursts at 5 frames per second without its optional vertical grip. With the MB-D10 grip installed (see Figure 9.16), the camera's top speed is boosted to a speedy 8 fps. Vertical grips also balance the camera better, offer more weight (which can add enough inertia to reduce camera shake), and provide a more secure grip on the camera when you're carrying it one handed.

Camera vendors who supply these grips for their own cameras frequently keep the same camera base configuration when they upgrade models, so a single grip can be used on several cameras. For example, the Canon BG-E2 grip can be used with several models in the Digital Rebel/Rebel line. The Nikon MB-D80 fits both the older Nikon D80 and newer D90, while the company's MB-D10 fits the Nikon D300 and its full-frame counterpart, the Nikon D700.

Of course, top of the line pro cameras such as the Canon EOS 1D and 1Ds series and Nikon D3 series come with a vertical grip as part of the camera. This is because such cameras are designed for the abuse working pros deliver and camera makers can build stronger cameras if they can design the body out of a single piece of metal rather than connecting separate pieces the way they'd have to if building a separate camera/grip combination. For cameras that are sealed to provide some measure of protection against the weather, such a connection would be another place where moisture, sand, or dust could get in, another reason to avoid that kind of construction. These cameras also frequently offer a high frames-per-second rate shooting capability, which also requires the additional battery power accessory grips can provide.

Mid-range cameras and lower models on the other hand, aren't built to the same standards.

Camera makers know that not every buyer wants the power grip or can afford the extra cost, so it's better to design the camera to accept an optional grip and leave the decision up to the buyer whether to add one or not. The owner can always decide to add the grip later on if they want to.

It used to be only camera makers who offered accessory grips, but that's not the case anymore. Let's see what's out there:

- **Manufacturer's grip.** The power grips offered by the manufacturer are usually the safest and most expensive options available. On the one hand, they offer security that they will work as well with the camera as any vertical grip on the market can. On the other hand, their cost is usually upwards of $150 and may approach $300 for some cameras. (See Figure 9.16.)

- **Third-party grip makers.** It's now possible to buy a vertical grip from one of several third-party manufacturers. (Often in such cases there's only one or two companies making the item, but more selling it as the manufacturer will label it for

another seller.) These units tend to be considerably cheaper (under $100) but the reviews I'm seeing for them aren't good. Users are reporting problems with fit and connection with these units no matter what name they're sold under. My advice if you're considering one of these would be to take your camera to a camera store that sells the grip and actually test the grip you want to buy in your camera. Once you get one that fits and works properly in your camera, buy that specific grip. It might cost you a few dollars more, but the added cost will be worth it. Many users have been pleased with the Opteka grips (www.opteka.com).

◆ **Satechi LCD Timer Vertical Battery Grip.** I'm singling this one out because it's quite different than the other vertical grips on the market. This unit has a built-in intervalometer and a small LCD screen that provides a variety of useful information. It's somewhere between the manufacturer's grip and the other third-party grips when it comes to price (about $129) but offers functionality that few other vertical grips do. If you need both a power grip and an intervalometer, this can be a cost-effective way of getting both. A separate battery powers the LCD screen, so using it won't drain your regular camera batteries.

**Figure 9.16**
Vertical grips help provide better balance for your camera, extra battery power, and a more ergonomic grip for you to hold.

# Electronic Viewfinders

A long time ago I worked with a Canon F1 film camera. One of the neat things about it was I could remove the pentaprism and use the ground glass focusing screen as a waist-level viewfinder. It was also great for ground-level shots where I didn't want to lay flat on the ground. Over the years I've moved on to other cameras that offered all sorts of improvements over the old F1, but I've always missed that one ability it had that no other camera I've worked with since could offer. Modern electronic cameras just don't have the modularity that mechanical film cameras boasted.

Certainly, right-angle finders are nice, but you've got to get your eye next to them. A true waist- or ground-level finder lets you position your camera down low (or up high) without your eye having to tag along. (See Figure 9.17.)

There is a product on the market now that offers this capability. It's called the "Zigview" and it's an interesting device. The Zigview (there are several different models) is an electronic viewfinder that mounts onto your camera's viewfinder. (In fact, I've written about it earlier in this chapter when I discussed how it can be used as an intervalometer or as a motion sensor that can trigger your camera.)

**Figure 9.17**
Electronic viewfinders offer a variety of functions that can be of great help to your photography. One of the niftiest is having the ability to mount your camera on a monopod or tripod and hold it up high while still being able to see what the camera sees.

Here's a look at what the different models can do:

- **Zigview B.** The B model is the lowest priced in the Zigview line and costs $229.95. Eyepiece adapters (which are necessary for your camera) cost from $14.95 to $29.95 and there are other accessories you might consider necessary as well that add to the price. The B model has a 2-inch color TFT LCD and can be rotated in 360 degrees. It also offers real-time zooming and panning. It has its own rechargeable battery so you don't have to worry about draining your camera's battery while using it.

- **Zigview R.** This is similar to the B model, but adds a shutter release, intervalometer, and motion detector while adding $50 to the base unit price.

- **Zigview S2.** This is the one that's on my Christmas list. It does everything the other two do but is newer technology and has a video out jack so its signal can be sent to an external monitor. In other words, with the addition of a 70 foot cable (extra cost) you can be inside the house seeing exactly what your camera sees and able to trip the shutter at just the right time. This is a handy thing for nature photography as well as many other types of remote photography. The

unit (pictured earlier in Figure 9.6) comes with a basic cable so you can remove the monitor from the Zigview and hold it in your hand. You could put your camera on a monopod and hold it above a crowd while still seeing what the camera sees and triggering it as needed or lower it to ground level to get a shot of a small insect or flower without having to bend down. For Figure 9.17, I wanted a higher angle for my shot of a horse-drawn carriage than was possible from the street-level position where I was standing. So, I mounted the camera on my trusty Gitzo Traveler tripod, raised the whole she-bang up about five feet overhead, and was still able to frame my image. For Figure 9.18, I was able to shoot the statue from waist level without crouching down, making it possible to replace a background full of bystanders with the less-distracting building behind the statue. The $399 price tag includes the transceiver cord for removing the monitor along with several other accessories. The Zigview works with many Canon, Nikon, Pentax/Sigma, Minolta/Sony, and Fuji cameras, but you'll need to check with the manufacturer to see whether or not your camera's one of them and which version you need.

**Figure 9.18** Obtaining an extra-high or extra-low view is one of the advantages of a versatile electronic viewfinder.

# Memory Card Safes and Wallets

If you recall my "don't put all your eggs in one basket" discussion in Chapter 7, my advice was to go ahead and use large memory cards—but watch them very carefully. For maximum safety, as your memory card collection starts to grow (and it always does), you'll need something to carry them in. Fortunately, photographic accessory makers have come up with a variety of cases, wallets, and pouches designed to carry memory cards. You can even find camera bags with built-in memory card holders. You can find memory card wallets that are part of modular systems that clip on to camera bags, card cases that are waterproof and dust

proof, and even ones that fit on a key chain and hold just a card or two for emergencies.

◆ **Original equipment.** I have a fondness for the plastic cases that the memory cards come in. Most of my camera bags have a zippered compartment that can hold five or six cards in those cases. They're transparent, so I'm able to slip an "Exposed" or "Unexposed" note inside, and view the status of each card instantly (flipping the note over when a card has been filled or emptied, as appropriate). I also like the small zippered pouches provided by SanDisk (see Figure 9.19), which hold three or four cards securely. (Although I don't necessarily put SanDisk cards in them.)

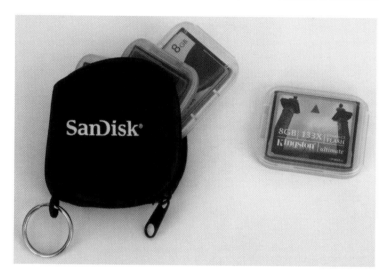

**Figure 9.19** Memory card wallets and safes protect your memory cards and keep them organized.

◆ **Card wallets.** These are great for everyday use. Usually they offer individual pockets for the cards and Velcro closures. They hold your cards securely and provide some protection against dust. (See Figure 9.20.)

◆ **Card safes.** These offer more protection for your memory cards and may even seal tight against water. Some models will even float if dropped in the water. They may not offer the capacity of a card wallet, but do keep your cards safer. I even have one that fits on my key chain and holds two compact flash cards so I always have some spares around.

◆ **Combo wallets.** You can also find wallets that will hold both memory cards and extra batteries. While this sounds like a good idea, there's always the risk of a battery leaking and damaging your memory cards.

◆ **Organization.** When you're using a memory card wallet to store your cards, it's important to develop a system for keeping track of whether you've already used a card. Some wallets use a flag system so users can differentiate between empty and full cards. If your wallet or safe doesn't offer that feature, then position your cards all facing the same way and then as you replace an empty card with a full one, flip it the opposite way of the empty cards.

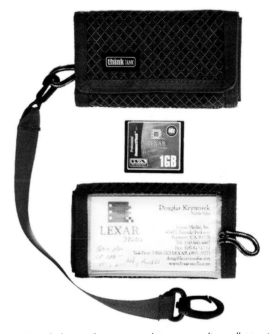

**Figure 9.20** Include your business card in your media wallet to simplify returning lost cards to you.

# Batteries and Battery Chargers

Once upon a time, cameras worked even when they didn't have any batteries in them. I used mechanical cameras for many years, including old Nikon F and F2 models that lacked a built-in light meter. I used a half-dozen different bodies, and figured my handheld Sekonic meter would provide the exposure for any of them. Why pay extra for a metering prism attachment? By the mid-1980s, cameras were all-electronic, through-the-lens meters weren't an option, and without power, any modern camera became little more than an expensive paperweight. It takes batteries to power your camera and batteries to power your flash.

An external flash is fairly easy to feed, since most (but not all) use over-the-counter AA and AAA batteries. You have some decisions to make regarding battery type and whether to go with disposable batteries or rechargeable ones, but those decisions aren't that difficult and there's not

a big downside if you don't make the best possible choice.

How about your camera? Most dSLRs rely on proprietary batteries that require specific battery chargers. (It's true that there are some dSLRs, like several Pentax models, that also can accept AA

batteries.) (See Figure 9.21.) If your camera accepts a vertical grip (described earlier in this chapter), one of the power options for that grip may be AA batteries, as you can see in Figure 9.22. Depending on your shooting load, buying extra proprietary batteries—and even an

extra battery charger—can be a good idea.

There's another dilemma the equipment buyer faces when it comes to proprietary batteries and chargers: whether to buy the manufacturer's offerings or third-party versions. It can be a tough call, since the third-party ones tend to be so much cheaper, but this decision is a more important one than your AA battery choice.

Third-party batteries seem to be a marginally better choice than the chargers. Some proprietary batteries are so popular (often used as batteries for both still and video cameras) that there are tons of choices. For other cameras though (think top of the line pro cameras) weatherproofing efforts require greater engineering and sealing efforts. If you have one of these cameras (which cost thousands of dollars), saving $60 on a third-party battery (and may not provide the same quality weather seal) might not be a good idea.

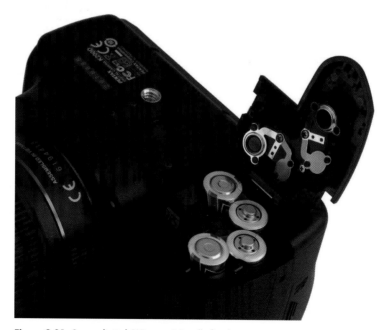

**Figure 9.21** Some digital SLRs use AA cells for their main power source.

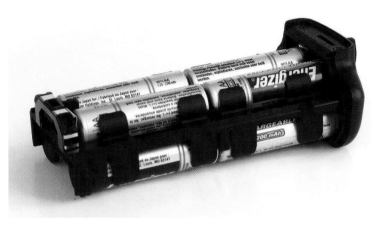

**Figure 9.22** AA batteries may also be an option for your camera's add-on vertical grip.

Okay, so buying batteries for your camera and flash isn't rocket science. It's hardly a no-brainer either. Casual photographers can get through a day with just a battery or two, but casual photographers really don't buy books on camera equipment, so I'm guessing you're much more serious about your photography. If so, you'll be glad you prepared that much harder. If you're working a whole day's shoot, battery power becomes significant. And if you're shooting sunrise at the North Rim of the Grand Canyon or Sunrise Point at Bryce Canyon, you and your gear, including the batteries in your camera and other equipment, are going to be cold. Will your batteries be able to function in cold weather? Will your fill flash poop out before your ideas do?

What are your choices and what should be your concerns, if any? Let's take a look.

◆ **Alkaline batteries.** A good, basic battery choice. These can be better in your flash unit than in your camera though since, surprisingly, dSLRs put an even heavier drain on batteries, because so many things in the camera—from exposure meter to LCD, to autofocus, to image-stabilization features—all drain juice.

◆ **Rechargeable alkalines.** Yes, there's a rechargeable version of most size alkaline batteries, but it generally doesn't last as long as other rechargeable batteries, plus loses capacity every time it's recharged. These batteries don't do well in cold weather, either.

◆ **Lithium.** Pricey, but they provide lots of power. The Pentax dSLRs that use AA batteries are furnished with, and thrive on, lithium batteries. These cells are also more difficult to get rid of (you're supposed to give them to your county's hazardous waste facility). But, they hold up well in cold weather.

◆ **Carbon Zinc.** Your basic, old-fashioned battery. Generally not a particularly good choice for photography because it doesn't provide enough power or last very long. These batteries don't do well in cold weather either. In general, an overall poor choice for all types of photography.

◆ **NiMH.** Nickel-metal hydride batteries are a good choice for rechargeable use, and they provide lots of power. The main downside is this type of battery drains when not in use, losing as much as 25 percent of its charge each month.

◆ **Lithium Ion.** These rechargeable batteries are the cells furnished with most digital cameras these days, and you can buy them for use in electronic flash. They cost more, but provide more power, long life, and don't lose power quickly when not in use.

◆ **NiCad.** A workhorse rechargeable, NiCads have been relegated to a subordinate position in the rechargeable category to NiMH and Li-ion batteries, which provide more power and don't suffer from the memory effect. (If you drain a NiCad partially, recharge it, and repeat a few times, the cell starts acting as if the partial charge was its regular charge. It may no longer accept a full charge.) NiCads are still useful batteries though. They're easy to find, cost less than NiMH and Li-ion, and if cared for properly, do their job for a long time. NiCads also have to be disposed of at your county hazardous waste facility, another flaw compared to NiMH. Also, these batteries don't do well in cold weather.

# Battery Chargers

What kind of battery charger should you buy?

It's not as easy a question as you might think. If your camera came with a rechargeable battery, it probably also was furnished with a charger, like the Canon model shown in Figure 9.23. Yet, the charger pictured, which plugs directly into a wall socket, is only one of several that Canon offers for that battery. Optional chargers include one that has a cord, a dual charger that can rejuvenate

two batteries at once, and one that can draw juice from your car's battery through the auto accessory socket.

While it might seem like any old charger that can recharge your batteries will do the trick, higher-end chargers can do so much more for you. A good battery charger can charge your batteries at different rates, refresh your batteries (charge and discharge them completely as much as necessary to bring them back to full

**Figure 9.23**
Your camera vendor may offer several different options for charging your dSLR's battery.

capacity avoiding the memory effect), and offer a test mode to identify bad cells. They also protect your batteries against overcharging and will offer a "trickle" mode to maintain full power once the battery is completely charged.

Some chargers can even determine when an alkaline battery is inserted and refuse to charge them, avoiding damage to both the battery and the charger. Others give you a choice between longer recharge times to prolong battery life versus fast charges to get the battery back in your camera or flash as quick as possible. Keep in mind, bad battery chargers can overcharge (and damage) your batteries or undercharge them (making them less effective).

At one time I owned a well-known 15-minute charger offered by a battery company, and used it exclusively with the batteries that came with it. So, I wasn't worried that the cells were too

hot to touch after the charge cycle (even with the charger's built-in fan blasting at full strength). However, I noticed that even the recommended batteries lasted only a few months before they failed—undoubtedly the result of the fast charging. I strongly suspect that this particular charger was marketed as a way for the company to sell more batteries! I still use their batteries, but not their charger.

Things to look for in a charger:

◆ **Size/weight.** If you travel, you'll want a charger that can be packed away and carried about without taking up space you'd rather devote to something more important—like a lens. There are AA chargers that collapse when the batteries are removed, making them especially portable.

◆ **Corded/cordless.** A charger that plugs directly into the wall and doesn't require a cord is particularly compact and portable, but may not be convenient if the only electrical outlet is tucked away behind some furniture. You can plug in the cord of a two-piece

charger and snake the cable around to a convenient location. Then, plug in the charger only when needed. It won't draw any electricity when not connected to the cord.

- **Intelligence.** Smart battery chargers offer different charge options, including reconditioning, fast (and safe) charging, and the ability to charge several different cells of different voltages, sizes, and capacities simultaneously.

- **Multi-voltage compatibility.** Most chargers will operate both at home and internationally, so you shouldn't settle for one that doesn't. A car battery adapter is a good option, but, if you power many pieces of equipment from your vehicle, you might want a voltage inverter that converts 12VDC to 110VAC, for use with many different pieces of equipment.

There are other nice features to look for too. Some chargers can independently charge from one to eight batteries at a time and provide an LCD display to show each battery's charging level. For the world traveler, many models can be used anywhere without the need of a special power supply (relying on having a switching adapter already built in). I generally don't carry a voltage converter with me when I am traveling overseas anymore. Every charger I own works well on 110/220 volt, 50/60 cycle current.

Let's take a look at what's out there.

- **Maha MH-C9000 WizardOne Charger/Analyzer.** This is a versatile charger than can handle from one to four NiMH batteries. It has an LCD screen that displays more information on your batteries than you ever thought you needed (but only one battery at a time so checking all four can take a while). It also has a "Break-in" mode and a "Cycle" mode that allows you to charge and discharge batteries while storing the capacity for up to 15 cycles. (Costs about $50.)

- **La Crosse Technology BC-900 AlphaPower Battery Charger.** Lets you pick the charge current (fast or slow) and can also recondition your NiMH batteries. Includes four AA and four AAA batteries plus C and D cell adapters. Charging cells charge independently (with LCD screen information that displays all four batteries at once) so you can pull off individual batteries as they finish charging. (Costs about $40.)

- **Maha Powerex MH-C801D Eight Cell 1-Hr PRO AA/AAA Charger.** This charger (shown in Figure 9.24) charges up to eight batteries at a time in any combination in one hour in its normal (fast) mode setting while providing the charging status of each battery. It also offers a "soft" charge mode that delivers the highest possible battery life and allows compatibility with older batteries that can't be quick charged. This charger can also be used to recondition batteries. (Costs about $65.)

- **Sony BCG-34HRMF4 Battery Charger with LCD Display.** This is another battery charger with LCD indicator. It comes with four AA batteries and has a refresh function, plus automatic cutoff to prevent batteries from overheating. While this unit doesn't offer quite the features of the previous chargers, it's probably the most portable of any of the units mentioned so far. (Costs about $30.)

- **Silicon Solar Inc. Solar Battery Charger.** I once did a weekend hiking trip to Havasu Falls out in the Western reaches of the Grand Canyon. Since we weren't going to be anywhere near a power outlet the entire time, we had to carefully ration our camera batteries the whole time. Solar chargers have come a long way since then and are available for AA and AAA batteries in fairly inexpensive form. This charger can handle AA, AAA, C, and D batteries and only costs about $25 (batteries extra). It can charge two AA batteries in three to four hours, so battery rationing may still be necessary.

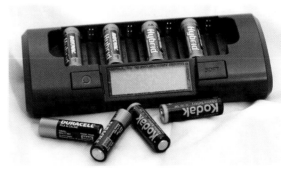

**Figure 9.24**
Modern battery chargers offer a variety of functions and can quick charge, soft charge, or recondition your batteries.

225

# Camera Straps

Yeah, I know your camera came with one, but what if you don't like it? Or you wear it out? Or it hurts your neck? I find that the neckstraps furnished with cameras have little to recommend them, unless you find the name of your camera manufacturer emblazoned in "Steal me!" style a benefit. I usually keep them in their original shrink-wrap, and if I end up selling that camera someday, a factory-fresh strap is one of the selling points.

As you've probably learned by now, most basic camera straps are little more than a sewn strip of canvas. They'll do the job, but they won't necessarily do it well. They abrade easily too. Camera straps are the kind of thing you worry about once, then forget about for a long, long time. Still, the difference between a good camera strap and a bad one is measured in pain and security. If you use your camera enough, with enough heavy lenses (and remember, pro camera bodies

and lenses are a lot heavier than consumer versions), you'll appreciate a camera strap that is kind to your neck and shoulders.

When you're considering a replacement strap, your first concern should be security, followed by comfort, followed by durability. Toss in a little versatility (being able to add a memory card holder or switch parts of the strap easily) and you're good to go.

So what choices do you have if you want to get a better camera strap?

◆ **UPstrap.** Built around a patented 3/8-inch thick rubber pad to prevent slipping, these camera straps are heavy duty. According to the manufacturer, you can place the strap on your shoulder instead of your cross shoulder and not have to worry about it slipping off. (Costs from $34 to $42 for dSLR models, point-and-shoot versions a bit less.) I use them myself, and know photographers who refuse to use anything else. (See Figure 9.25.)

◆ **OP/TECH.** The company makes a variety of wide neoprene and fabric camera straps to better distribute the weight of the camera on your neck and shoulders. Depending on the particular strap you choose, they can provide support for big pro rigs or smaller straps for little point-and-shoot cameras. They even have some wrist strap camera grips, which secure the camera to your wrist rather than around your neck. One design, the Reporter Strap, can even carry two cameras at once. OP/TECH straps feature a clasp connection that makes it easy to remove the strap and connect a different strap or use as a short loop for carrying your camera (just connect the remaining clasps). (See Figure 9.26.) The OP/TECH straps are all non-slip too. (Prices range from $20 to $25.)

◆ **Zing Action Strap** This is a handgrip camera strap that can be used with a regular camera strap (sold separately) for photographers who prefer not to use a camera strap at all. It does include a safety leash to prevent the camera from being dropped accidentally. There can be some issues in connecting this grip to cameras with power

extensions or smallish dSLRs so check it out at a camera store before buying. (Costs about $12.)

◆ **Tamrac.** The company offers a variety of camera straps including some with a pair of memory card cases already attached (one card can fit in each case). Tamrac straps cost from $17 to $30.

◆ **LowePro.** The company offers a variety of camera straps including the Transporter ($24.99), which can carry multiple cameras, and has a memory pouch attached to the strap. The company's Voyager camera straps ($29.99) are designed for adventure photographers and are wider than regular camera straps, plus made of neoprene for greater comfort.

◆ **Tenba Skooba: Superbungee Camera Strap.** Features a "sport-tuned suspension system." According to the manufacturer, the strap uses a "high-density, floating bungee/shock cord ring which acts as a shock absorber." The neck strap pad also has "a flexible grid of individual, air-filled cells, to further enhance carrying comfort." It's supposed to be slip proof too. (Costs about $20.)

◆ **Black Rapid RS Strap.** This is a different kind of camera strap that offers a different approach to wearing your camera. The RS straps position the camera on your hip where you can just reach down and grab it. The strap then helps guide the camera up to your face in a quick, fluid motion. There are a couple of things I like about this design. The first is that it positions the weight of your camera in a more comfortable position. Second, it makes carrying and using a second camera while using a big rig on a monopod easier. In the past, when I've needed to shoot this way, I kept a second camera in a chest-style pouch worn at my hip, so I could quickly reach down and grab the second camera. As you might imagine, this is a tricky proposition. The RS strap works much better for this. You can also combine a pair of these straps (with accessory couplers) for wearing a pair of cameras. (Costs $54 or $116 for a two-camera rig.)

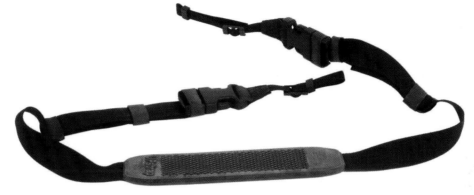

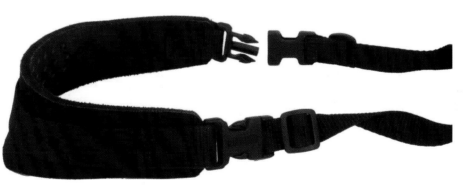

**Figure 9.25**
Spending a few extra dollars on just the right camera strap can do wonders for your neck and shoulders. Some things to consider are wider straps to better distribute the weight load of your camera and lens, plus cushioning where the strap rests on your neck.

**Figure 9.26**
Quick connectors make removing the strap easy.

# Light and Measuring Aids

Digital photography has made photography easier in many ways. Savvy photographers can glean a lot of information from the feedback the camera's LCD screen provides. From being able to see the image itself and judge its exposure and color to being able to read the histogram, this information is incredibly valuable.

Even so, as important as it is, such feedback alone doesn't guarantee the results you need. For critical exposure and for color accuracy, there are certain accessories that help you achieve the quality you need. It sounds kind of old fashioned to be carrying a handheld light meter or color meter, but there's nothing old fashioned about the modern versions of these tools.

Color meters can provide precise color information, and gray cards and tools such as the Expo disc can help photographers make sure they get the most accurate color possible. As I've noted earlier, while Photoshop can fix a lot of problems, it's still easier to get it right in the camera than it is to fix it later. Plus, if you're running or thinking about running an event photography business (which produces a high volume of images), having to spend a lot of time working in Photoshop is time that can be better spent doing other things.

◆ **Light meters.** While your camera comes with a built-in light meter, it's not as accurate as a handheld unit, many of which can also double as flash meters. Light meters are particularly important when you have unusual conditions. (See Figure 9.27 for a typical spot meter.) Remember, camera light

**Figure 9.27** Light meters can help you measure exposure more precisely.

meters are calibrated to 18 percent gray. If you're shooting a lighter or darker scene, you camera meter can be thrown off. With a hand-held light meter you can measure the light falling on the scene rather than the light reflected off the scene, a more accurate method under such conditions. Light meters can cost from about $100 to more than $700. The difference in price reflects things such as digital versus analog technology, and additional capabilities such as being able to measure flash output, and control wireless remotes such as Pocket Wizards.

◆ **Spot meters.** These are light meters with a very narrow field of view so you can take readings from a distance. You use this to take several light meter readings of the scene to determine the best overall exposure. Zone System proponents in particular find spot meters useful (the Zone System is a very precise exposure control system made famous by Ansel Adams) but landscape photographers in general like them. Spot meters generally cost between $300 and $500 but often you can find a handheld light meter that has a spot meter attachment ($100 or more as an add-on accessory) so you don't have to buy both.

◆ **Color meters.** Similar to a light meter, but it measures color temperature instead (generally in degrees Kelvin). As long as your camera can accept input in degrees Kelvin, it provides for very accurate color. Color meters cost from $1,000 to $1,400.

◆ **Flash meters.** Usually better quality light meters can also trigger flash units (either via PC cord or Pocket Wizard) and read their light output, but if you don't need a multi-purpose light meter or yours doesn't have a flash meter capability, you might consider a flash meter. Flash meters run about $100.

◆ **Gray cards.** Since camera light meters are theoretically calibrated to 18-percent gray (it's actually closer to 13-14 percent gray), using a gray card to help achieve correct exposure and color works fairly well. You hold the gray card under the light your subject is under and activate the camera's light meter. This gives you the best exposure as long as you've got the card under the same light as your subject. You might want to use about one-half stop *more* exposure, because your camera is probably calibrated for a slightly lighter tone. You can also use the gray card to set your white balance under the camera's custom white balance feature (the method varies from camera to camera so check

your owner's manual to see how). These run from $5 to $50, but the more expensive versions are usually made from plastic or resin rather than cardboard and may include a color chart or some other color correction tool.

◆ **Expo Disc.** The Expo Disc is a white diffuser-like dome that fits over your camera lens. (See Figure 9.28.) You point it at your subject area and create an exposure. You then load the image into your custom white balance setting and as long as your lighting conditions

don't change, you can then work from that white balance. If your lighting conditions change (or you move to an area with different lighting conditions, such as indoors from the outside or vice versa) then you need to create another Expo Disc exposure. If you're shooting at this location on a repeat basis, you can always use the Expo Disc exposure all over again, but you should be sure the lighting conditions haven't actually changed. Expo Disc prices are based on filter size for your camera and cost from $70 to $170.

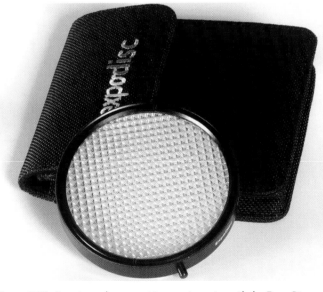

**Figure 9.28** Creating color correct images is easier with the Expo Disc, which can be used to create custom white balance reference images.

# Dealing with Weather

Before the Navy sent me to Antarctica, I was stationed on Guam for two years. (I know, I know, I must have ticked somebody off somewhere.) Guam is a tropical island in the South Pacific. It only has two seasons—a dry season and a rainy season. During the dry season it only rains four hours a day. During the rainy season it only stops raining for four hours a day (at least that's how I remember my time on the island). When you have to shoot under those conditions, you develop a few tricks for keeping your gear dry. Oh yeah, did I also mention the island is fairly

humid (fairly as in ranging from 72% humidity to 86% humidity under normal conditions)? It takes a little planning to deal with such conditions.

Even if you're not shooting under such extreme conditions, you should consider your various equipment protection options, including camera "raincoats" (like the one in use in Figure 9.29), blinds, and other aids.

There are some other things to consider as well when making such a purchase. First off, how comfortable are you going to be

using one of these protective aids? Remember, if you're working with a camera raincoat, you've got to get your hands in and out from time to time. How difficult is that going to be? What happens if you want to change lenses? It doesn't do you a lot of good to have a camera raincoat if you can't change lenses without taking the thing apart. How hard is it to use with

the camera on a tripod or a monopod? How well does it work vertically? Do you have to attach strips of Velcro to your camera body and lens? Also, plan on wearing a polypro glove liner when working with these. It doesn't do much good to have a good rain cover if you stick your wet hand inside and grab your nice dry camera with it.

## RAIN COVERS FOR THE FRUGAL

If you're on a really tight budget and don't shoot in the rain much, there is a do-it-yourself option. You can make your own disposable camera rain cover with either a plastic trash bag or a turkey-roasting bag. Cut a small hole in the bottom and stretch it over your lens shade, then tape it in place with artist's or Gaffer's tape. Pull it over the back of the camera and tape it to the bottom of the camera and then make a small hole in back so you can look through the viewfinder and see the LCD screen—or, just keep it over the back for protection and stick your head under the bag for protection.

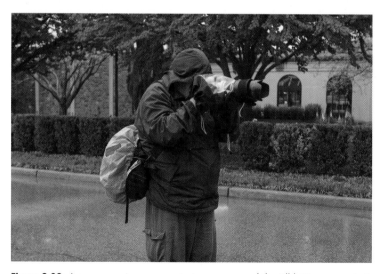

**Figure 9.29** A camera rain cover protects your gear while still letting you get at your camera controls.

Let's take a look at what's out there.

- **FotoSharp.** This company offers a variety of camera rain covers designed to work with lenses of different physical lengths. Prices range from $20 to $40. Some have tripod covers, some don't. They can also be used as sunshades to keep the camera cool under the hot sun.

- **Tenba.** Offers several different rain covers ranging in price from $40 to $70. Collapse into a small carrying pouch.

- **Aqua Tech.** Offers a range of covers designed for different focal length lenses. A bit more expensive, but these covers look to provide greater protection. Prices run from $65 for a cover to protect your flash without stealing light to $230 for a camouflage cover to protect a camera with a huge telephoto lens.

- **Kata.** Makes a variety of camera and video rain gear, starting at $35 and running up to about $70. What's nice is this company offers a basic rain cover that can take an extension attachment for longer lenses, so rather than buying multiple covers, you can just add the

extension to your kit. The covers have a simple cinch pull system to fix the cover around the lens. The cover also has a sleeve you stick your hand in so you can operate the controls from inside the cover. (See Figure 9.29 for an example of this cover on a camera.)

- **OP/TECH.** Offers four rain covers ranging in price from $6 to $80. The really cheap ones are really cheap, but the pricier ones are worth considering if you mainly shoot horizontally. The covers do provide some working area behind the camera too, but this is a cover that's designed to be used on a tripod.

## Camera Protection

Once upon a time, cameras came with a leather case that screwed into the camera's tripod socket and then wrapped up and over the camera. Camera makers called them "Ever-ready Covers," while working pros jokingly called them "never-ready's." The reality was by the time you got them off your camera whatever you wanted to take a picture of was long gone.

Two companies offer more useful camera protection. Camera Armor makes a form-fitting elastomeric silicone body armor custom designed for your specific camera model. The four-part system is designed to protect your camera from dust, impact, abrasion, and fingerprints. (It is not waterproof, but it shouldn't trap condensation inside either.) Camera Armor works on the same principle as some of the form-fitting cases that wrap around iPods or small point-and-shoot cameras. Another company, Delkin, offers the Snug-it Pro, although it doesn't offer it for as many cameras as Camera Armor does. Here are some things to think about:

- **Do you shoot in dusty conditions?** Dust and electronics don't mix very well. Getting dust in your camera can be a big problem, so anything that can help prevent that is worth considering.

- **Are you rough on your gear?** How rough are you on you gear? If you're driving around with your camera on the passenger seat next to you ready for action, then this might be a good idea. If you run with your camera or work in close quarters, something like this might be worth considering.

- **Just have your camera and not much else?** If all you have is your camera, some memory cards, and a battery or two, it might be worthwhile to protect your camera with one of these skins and use a small fanny pack to carry those odds and ends instead of getting a camera bag.

- **Probella instead?** I worked on a shoot once on a brutally hot and sunny day. One of my colleagues, worried about his fair complexion (and an approaching rain storm), came up with the bright idea of lashing a golf umbrella to his monopod. The Probella is a similar idea except the umbrella's a little bit smaller and it mounts to your camera instead of being lashed to a monopod. These gizmos provide some protection from the sun and from the rain and cost $29.95.

# Camera Blinds

Camera blinds aren't so much for equipment protection as they are for helping you remain inconspicuous while photographing birds and animals in their natural habitat. Most animals believe in keeping a safe distance from human beings (for good reason). Camera blinds help hide you from the wildlife and give the animals a chance to get closer to you. Oh yeah, and they can keep you dry if it rains.

When considering a camera blind there are several things to keep in mind. One of the most important issues is what kind of lens or lenses you plan on using in it. Some camera blinds are designed to work with the really big lenses nature photographers prefer. If you're not starting out with such powerful optics, then your choices are a bit simpler. You just have to worry about how easy the blind is to set up, carry, and use.

Blinds vary in size too. Some are designed to fit just one person comfortably, while others can accommodate two or more people. Since you may have to carry the blind quite a distance to reach your shooting location (while carrying your camera equipment too), it's a good idea to consider how much the blind weighs and how easy it is to carry. You should also consider whether or not you could set up a folding chair inside it since you may be spending a lot of time inside it. Other considerations include how easy it is to add twigs, branches, and grasses to it to help it blend in better with its surroundings. (See Figure 9.30 for an example.)

Photo blinds come in a variety of shapes and sizes. Let's look at some of them.

◆ **Visual Departures Camouflex All Seasons Camouflage Camera Blind.** This is a circular blind that when collapsed is the size of a small circular reflector. It's lightweight (about 15 ounces) and fits a pouch that's only 12 inches in diameter. Made of waterproof polyester netting, it stands 58 inches tall and has a 6 × 8 viewing flap. You can use a tripod inside this blind. (Costs $84.95.)

◆ **Petrol PFT-CF Camera Person Flex Tent—Camouflage Green.** Pops up quickly and protects the photographer from the elements. Also folds up quickly as well. Weighs four pounds and has a pop-open window to shoot through. Stands 81 inches high. (Costs $79.50.)

◆ **Kwik Camo Blinds for Nature Photography.** This is an unusual looking blind that is kind of form fitting around the photographer. You can even use a flash with it. These blinds (there is a heavy and a light version) are very light, weighing only a few ounces (3 ounces for the light version, 6.5 ounces for the heavy one). (Costs $99.99.)

◆ **Ameristep Doghouse Blind.** This is a two-person model that's 60 inches square and 68 inches tall. It packs down to 24 inches in diameter and two inches thick and weighs 14 pounds. It has four windows and three portholes with window tie-downs and mesh, which offers better visibility than when the windows are sealed. It also features a shadow liner so movement inside the blind is less apparent to wildlife. (Costs $99.95.)

◆ **The Rue Ultimate Photo Blind.** This is a versatile and high-end photo blind. Designed with nature photographers in mind, it not only features portholes for big lenses at just the right height for a photographer sitting in a folding chair or on a stool, but Velcro slits to permit photos to be taken at ground level and six screened viewing windows on five sides. The easy-to-assemble blind is completely free standing and water repellent. (Costs $315.)

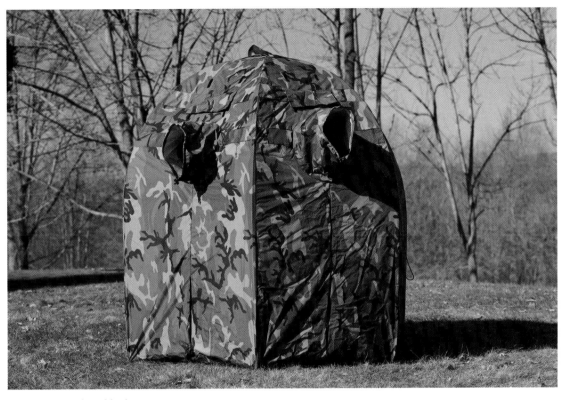

**Figure 9.30** A photo blind as set up.

# Other Bad-Weather Aids

Photography in inclement weather introduces all sorts of complications for both the photographer and the equipment. Both need to be cared for in order for the shoot to be successful. When considering bad weather photography, divide your planning into two categories: your equipment, yourself. Ask what you need to do to keep each functioning and remember, bad weather can include heat just as much as cold.

We've covered rain and snow gear already in this chapter, but there are still some little things that should be in your inventory for certain conditions, and there are also some things you should plan on doing for yourself too. When it's cold: Your body burns more calories when it's cold than when it's hot outside. Pack some high-energy, high-calorie, high-fat snacks (fat provides more calories per gram than protein or carbohydrate, plus it's harder for the body to break down, meaning your system generates more heat metabolizing it). For your camera: cold weather drains your batteries faster. Carry extra camera batteries and keep them inside your parka or pile. If it's cold and wet, have more changes of gloves and have some kind of towel for wiping things down.

◆ **Desiccant packs.** You know those little packets that come with every electronic device you buy? They're just what you need to help with humid conditions. Instead of throwing them out, collect them and store them in an airtight container. You can then use them in your camera bag and any storage cases you use to keep down the humidity. If you don't collect them, it is possible to buy larger desiccant packs (camera stores frequently stock them).

◆ **PacTowel.** This is a small, super-absorbent towel backpackers frequently carry for extended trips. While it's not as comfy as that luxurious fluffy towel you might have at home, it does a good job of keeping your hands dry during wet conditions.

◆ **Chemical heat packs.** There's a pretty good assortment of sizes and shapes available. When working under cold conditions I usually carry packs for my hands, toes (they're shaped to fit inside a shoe or boot), and even a larger pack that I can put in the chest pouch of my anorak. With the larger pack I can always press it against my chest for a quick burst of warmth that feels oh so good. At least one set of my shooting gloves has a pouch where I can insert a small heat pack to help keep my fingers warm too. You can also use these heat packs to re-warm batteries that have drained because of the cold rather than from use.

◆ **Plastic zip bags.** Plastic zip bags are handy for keeping things dry and organized in your camera bag. Sometimes you have little odds and ends (the adapters that convert 1/4-inch tripod screws to the 3/8-inch European version, double bubble levels, coins for tightening or undoing those large thread screws sometimes found on camera gear, etc.). These bags are perfect for keeping those little items under control. Also, if you need to keep something dry under extremely wet conditions, triple bagging it in these will do the job.

◆ **Brightly colored scarf or other material.** One of the interesting things about going out right after a snowstorm passes is that the world becomes exceptionally monochromatic. With everything covered in snow and heavy overcast still the rule, it seems like you're shooting in black-and-white mode. Under such conditions you sometimes want to add a splash of color. If you're carrying some kind of brightly colored cloth or object, it can add an interesting visual aspect to your image.

◆ **Baseball cap or hiking cap.** Shooting in hot weather and strong sun presents its own hazards, sunburn being one of them. A baseball cap keeps the sun out of your eyes until it's time to shoot, when it can easily be reversed. Or, by keeping it reversed, it can help shade the back of your neck to keep that area from being burned (get a light-colored cap to reflect heat). It's also possible to buy a billed cap that has a long stretch of fabric draped off the back to protect your neck. These caps are great for hiking, but can be a hassle when you're shooting (you have to turn them sideways—which is a bit weird—or take them off).

◆ **Energy snacks.** As I mentioned, your body burns more calories when it's cold than it does when it's warm. If you're going to spend the day outdoors in extreme cold conditions you need to consume extra calories. Energy bars and those little packets you see runners squeezing into their mouths aren't bad, but keep in mind, these kinds of aids are all about getting carbs into the system. For extreme cold, fat is more important. Pemmican— a mixture of fat and protein—is what the old polar explorers used (and commercial snack versions are available at many grocery stores, plus outdoor stores such as REI, EMS, L.L. Bean, and Cabela's stock it). Chocolate bars are also good sources of fat, but perhaps not as nutritionally sound as other choices.

# Glossary

**ambient lighting** Diffuse nondirectional lighting that doesn't appear to come from a specific source but, rather, bounces off walls, ceilings, and other objects in the scene when a picture is taken.

**angle of view** The area of a scene that a lens can capture, determined by the focal length of the lens. Lenses with a shorter focal length have a wider angle of view than lenses with a longer focal length.

**autofocus** A camera setting that allows the camera to choose the correct focus distance for you, usually based on the contrast of an image (the image will be at maximum contrast when in sharp focus) or a mechanism such as an infrared sensor that measures the actual distance to the subject.

Cameras can be set for *single autofocus* (the lens is not focused until the shutter release is partially depressed) or *continuous autofocus* (the lens refocuses constantly as you frame and reframe the image).

**averaging meter** A light-measuring device that calculates exposure based on the overall brightness of the entire image area. Averaging tends to produce the best exposure when a scene is evenly lit or contains equal amounts of bright and dark areas that contain detail. Most digital cameras use much more sophisticated exposure measuring systems based in center-weighting, spot-reading, or calculating exposure from a matrix of many different picture areas. See also *spot meter*.

**B (bulb)** A camera setting for making long exposures. Press down the shutter button and the shutter remains open until the shutter button is released. Bulb exposures can also be made using a camera's electronic remote control, or a cable release cord that fits to the camera.

**backlighting** A lighting effect produced when the main light source is located behind the subject. Backlighting can be used to create a silhouette effect, or to illuminate translucent objects. See also *front lighting, fill lighting,* and *ambient lighting.* Backlighting is also a technology for illuminating an LCD display from the rear, making it easier to view under high ambient lighting conditions.

**ballhead** A type of tripod head that swivels around on a ball mechanism that allows positioning the camera or other equipment attached to the ballhead at multiple angles. When locked down, the ballhead holds the position chosen.

**barrel distortion** A defect found in some wide-angle prime and zoom lenses that causes straight lines at the top or side edges of an image to bow outward into a barrel shape.

**bellows** A telescoping device that attaches to the camera lens mount at one end, and accepts a lens on the other, allowing the lens to be moved back and forth to focus closer or farther away.

**blooming** An image distortion caused when a photosite in an image sensor has absorbed all the photons it can handle, so that additional photons reaching that pixel overflow to affect surrounding pixels producing unwanted brightness and overexposure around the edges of objects.

**blur** In photography, to soften an image or part of an image by throwing it out of focus, or by allowing it to become soft due to subject or camera motion. In image editing, blurring is the softening of an area by reducing the contrast between pixels that form the edges.

**bokeh** A buzzword used to describe the aesthetic qualities of the out-of-focus parts of an image, with some lenses producing "good" bokeh and others offering "bad" bokeh. *Boke* is a Japanese word for "blur," and the h was added to keep English speakers from rhyming it with *broke*.

Out-of-focus points of light become discs, called the *circle of confusion*. Some lenses produce a uniformly illuminated disc. Others, most notably *mirror* or *catadioptic* lenses, produce a disk that has a bright edge and a dark center, producing a "doughnut" effect, which is the worst from a bokeh standpoint. Lenses that generate a bright center that fades to a darker edge are favored, because their bokeh allows the circle of confusion to blend more smoothly with the surroundings. The bokeh characteristics of a lens are most important when you are using selective focus (say, when shooting a portrait) to deemphasize the background, or when shallow depth-of-field is a given because you're working with a macro lens, long telephoto, or with a wide-open aperture.

**bounce lighting** Light bounced off a reflector, including ceiling and walls, to provide a soft, natural-looking light.

**bracketing** Taking a series of photographs of the same subject at different settings to help ensure that one setting will be the correct one. Many digital cameras will automatically snap off a series of bracketed exposures for you. Other settings, such as color and white balance, can also be "bracketed" with some models. Digital SLRs may even allow you to choose the order in which bracketed settings are applied.

**brightness** The amount of light and dark shades in an image, usually represented as a percentage from 0 percent (black) to 100 percent (white).

**burn** A darkroom technique, mimicked in image editing that involves exposing part of a print for a longer period, making it darker than it would be with a straight exposure.

**burst mode** The digital camera's equivalent of the film camera's "motor drive," used to take multiple shots within a short period of time.

**camera shake** Movement of the camera, aggravated by slower shutter speeds, which produces a blurred image. Some of the latest digital cameras have *image-stabilization* features that correct for camera shake, while a few high-end interchangeable lenses have a similar vibration correction or reduction feature. See also *image stabilization*.

**cast** An undesirable tinge of color in an image.

**center column** The pole in the middle of a tripod that the camera is fastened to, and which can be raised and lowered to provide additional or less elevation.

**center-weighted meter** A light-measuring device that emphasizes the area in the middle of the frame when calculating the correct exposure for an image. See also *averaging meter* and *spot meter*.

**circle of confusion**  A term applied to the fuzzy discs produced when a point of light is out of focus. The circle of confusion is not a fixed size. The viewing distance and amount of enlargement of the image determine whether we see a particular spot on the image as a point or as a disc.

**Cokin**  The trade name for a system of attaching filters to the front of a camera lens using a removeable frame, and for the square, rectangular, or circular filters that fit into the frame.

**color correction**  Changing the relative amounts of color in an image to produce a desired effect, typically a more accurate representation of those colors. Color correction can fix faulty color balance in the original image, or compensate for the deficiencies of the inks used to reproduce the image.

**contrast**  The range between the lightest and darkest tones in an image. A high-contrast image is one in which the shades fall at the extremes of the range between white and black. In a low-contrast image, the tones are closer together.

**crop**  To trim an image or page by adjusting its boundaries.

**dedicated flash**  An electronic flash unit designed to work with the automatic exposure features of a specific camera.

**density**  The ability of an object to stop or absorb light. The less light reflected or transmitted by an object, the higher its density.

**depth-of-field**  A distance range in a photograph in which all included portions of an image are at least acceptably sharp. With many dSLRs, you can see the available depth-of-field at the taking aperture by pressing the depth-of-field preview button, or estimate the range by viewing the depth-of-field scale found on some lenses.

**desaturate**  To reduce the purity or vividness of a color, making a color appear to be washed out or diluted.

**diaphragm**  An adjustable component, similar to the iris in the human eye, which can open and close to provide specific-sized lens openings, or f/stops and controlling the light striking the sensor. See also *f/stop* and *iris*.

**diffraction**  The loss of sharpness due to light scattering as an image passes through smaller and smaller f/stop openings. Diffraction is dependent only on the actual f/stop used, and the wavelength of the light.

**diffuse lighting**  Soft, low-contrast lighting.

**diffusion**  Softening of detail in an image by randomly distributing gray tones in an area of an image to produce a fuzzy effect. Diffusion can be added when the picture is taken, often through the use of diffusion filters, or in post-processing with an image editor. Diffusion can be beneficial to disguise defects in an image and is particularly useful for portraits of women.

**Exif**  Exchangeable Image File Format. Developed to standardize the exchange of image data between hardware devices and software. A variation on JPEG, Exif is used by most digital cameras, and includes information such as the date and time a photo was taken, the camera settings, resolution, amount of compression, and other data.

**existing light**  In photography, the illumination that is already present in a scene. Existing light can include daylight or the artificial lighting currently being used, but is not considered to be electronic flash or additional lamps set up by the photographer.

**exposure** The amount of light allowed to reach the film or sensor, determined by the intensity of the light, the amount admitted by the iris of the lens, the length of time determined by the shutter speed, and the sensitivity of the sensor in ISO values.

**exposure program** An automatic setting in a digital camera that provides the optimum combination of shutter speed and f/stop at a given level of illumination. For example a "sports" exposure program would use a faster, action-stopping shutter speed and larger lens opening instead of the smaller, depth-of-field-enhancing lens opening and slower shutter speed that might be favored by a "close-up" program at exactly the same light level.

**extension tube** A cylindrical attachment that fits between the camera and a lens, allowing the lens to focus closer.

**fill lighting** In photography, lighting used to illuminate shadows. Reflectors or additional incandescent lighting or electronic flash can be used to brighten shadows. One common technique outdoors is to use the camera's flash as a fill.

**filter** In photography, a device that fits over the lens, changing the light in some way. In image editing, a feature that changes the pixels in an image to produce blurring, sharpening, and other special effects.

**flash sync** The timing mechanism that ensures that an internal or external electronic flash fires at the correct time during the exposure cycle. A dSLR's flash sync speed is the highest shutter speed that can be used with flash. See also *front-curtain sync* and *rear-curtain sync*.

**flat** An image with low contrast.

**focal length** The distance between the film and the optical center of the lens when the lens is focused on infinity, usually measured in millimeters.

**focusing rail** A geared device that can be fastened to a tripod or other support, then attached to a camera, and the distance between the camera and the subject being photographed varied by moving the camera carriage along the rail.

**framing** In photography, composing your image in the viewfinder. In composition, using elements of an image to form a sort of picture frame around an important subject.

**fringing** A chromatic aberration that produces fringes of color around the edges of subjects, caused by a lens' inability to focus the various wavelengths of light onto the same spot. *Purple fringing* is especially troublesome with backlit images.

**front-curtain sync** The default kind of electronic flash synchronization technique, originally associated with focal plane shutters, which consists of a traveling set of curtains, including a front curtain (which opens to reveal the film or sensor) and a rear curtain (which follows at a distance determined by shutter speed to conceal the film or sensor at the conclusion of the exposure).

For a flash picture to be taken, the entire sensor must be exposed at one time to the brief flash exposure, so the image is exposed after the front curtain has reached the other side of the focal plane, but before the rear curtain begins to move.

Front-curtain sync causes the flash to fire at the *beginning* of this period when the shutter is completely open, in the instant that the first curtain of the focal plane shutter finishes its movement across the film or sensor plane. With slow shutter speeds, this feature can create a blur effect from the ambient light, showing as patterns that follow a moving subject with subject shown sharply frozen at the beginning of the blur trail (think of an image of The Flash running backwards). See also *rear-curtain sync*.

**front lighting** Illumination that comes from the direction of the camera. See also *backlighting* and *side lighting*.

**f/stop** The relative size of the lens aperture, which helps determine both exposure and depth-of-field. The larger the f/stop number, the smaller the f/stop itself. It helps to think of f/stops as denominators of fractions, so that f/2 is larger than f/4, which is larger than f/8, just as 1/2, 1/4, and 1/8 represent ever-smaller fractions. In photography, a given f/stop number is multiplied by 1.4 to arrive at the next number that admits exactly half as much light. So, f/1.4 is twice as large as f/2.0 (1.4 × 1.4), which is twice as large as f/2.8 (2 × 1.4), which is twice as large as f/4 (2.8 × 1.4). The f/stops which follow are f/5.6, f/8, f/11, f/16, f/22, f/32, and so on. See also *diaphragm*.

**GPS** Global Positioning System, a satellite based navigation system based on 24 satellites in Earth orbit that provide signals that can be used by cameras, auto navigation systems, and separate GPS devices to determine the location of the sensing device.

**graduated filter** A lens attachment with variable density or color from one edge to another. A graduated neutral density filter, for example, can be oriented so the neutral density portion is concentrated at the top of the lens' view with the less dense or clear portion at the bottom, thus reducing the amount of light from a very bright sky while not interfering with the exposure of the landscape in the foreground. Graduated filters can also be split into several color sections to provide a color gradient between portions of the image.

**gray card** A piece of cardboard or other material with a standardized 18-percent reflectance. Gray cards can be used as a reference for determining correct exposure.

**highlights** The brightest parts of an image containing detail.

**histogram** A kind of chart showing the relationship of tones in an image using a series of 256 vertical "bars," one for each brightness level. A histogram chart typically looks like a curve with one or more slopes and peaks, depending on how many highlight, midtone, and shadow tones are present in the image.

**hyperfocal distance** A point of focus where everything from half that distance to infinity appears to be acceptably sharp. For example, if your lens has a hyperfocal distance of four feet, everything from two feet to infinity would be sharp. The hyperfocal distance varies by the lens and the aperture in use. If you know you'll be making a "grab" shot without warning, sometimes it is useful to turn off your camera's automatic focus and set the lens to infinity, or, better yet, the hyperfocal distance. Then, you can snap off a quick picture without having to wait for the lag that occurs with most digital cameras as their autofocus locks in.

**image stabilization** A technology, also called vibration reduction and anti-shake, that compensates for camera shake, usually by adjusting the position of the camera sensor or lens elements in response to movements of the camera.

**incident light** Light falling on a surface.

**infinity** A distance so great that any object at that distance will be reproduced sharply if the lens is focused at the infinity position.

**interchangeable lens** Lens designed to be readily attached to and detached from a camera; a feature found in more sophisticated digital cameras.

**International Organization for Standardization (ISO)** A governing body that provides standards such as those used to represent film speed, or the equivalent sensitivity of a digital camera's sensor. Digital camera sensitivity is expressed in ISO settings.

**interpolation** A technique digital cameras, scanners, and image editors use to create new pixels required whenever you resize or change the resolution of an image based on the values of surrounding pixels. Devices such as scanners and digital cameras can also use interpolation to create pixels in addition to those actually captured, thereby increasing the apparent resolution or color information in an image.

**intervalometer** A device used to trigger an event, such as the taking of a photograph, at preset times.

**invert** In image editing, to change an image into its negative; black becomes white, white becomes black, dark gray becomes light gray, and so forth. Colors are also changed to the complementary color; green becomes magenta, blue turns to yellow, and red is changed to cyan.

**iris** A set of thin overlapping metal leaves in a camera lens, also called a diaphragm, that pivots outwards to form a circular opening of variable size to control the amount of light that can pass through a lens.

**Kelvin (K)** A unit of measurement based on the absolute temperature scale in which absolute zero is zero; used to describe the color of continuous spectrum light sources, such as tungsten illumination (3200 to 3400K) and daylight (5500 to 6000K).

**latitude** The range of camera exposures that produces acceptable images with a particular digital sensor or film.

**lens** One or more elements of optical glass or similar material designed to collect and focus rays of light to form a sharp image on the film, paper, sensor, or a screen.

**lens aperture** The lens opening, or iris, that admits light to the film or sensor. The size of the lens aperture is usually measured in f/stops. See also *f/stop* and *iris*.

**lens flare** A feature of conventional photography that is both a bane and creative outlet. It is an effect produced by the reflection of light internally among elements of an optical lens. Bright light sources within or just outside the field of view cause lens flare. Flare can be reduced by the use of coatings on the lens elements or with the use of lens hoods. Photographers sometimes use the effect as a creative technique, and Photoshop includes a filter that lets you add lens flare at your whim.

**lens hood** A device that shades the lens, protecting it from extraneous light outside the actual picture area that can reduce the contrast of the image, or allow lens flare.

**lighting ratio** The proportional relationship between the amount of light falling on the subject from the main light and other lights, expressed in a ratio, such as 3:1.

**macro lens** A lens that provides continuous focusing from infinity to extreme close-ups, often to a reproduction ratio of 1:2 (half life-size) or 1:1 (life-size).

**magnification ratio** A relationship that represents the amount of enlargement provided by the macro setting of the zoom lens, macro lens, or with other close-up devices.

**matrix metering** A system of exposure calculation that looks at many different segments of an image to determine the brightest and darkest portions.

**maximum aperture** The largest lens opening or f/stop available with a particular lens, or with a zoom lens at a particular magnification.

**midtones** Parts of an image with tones of an intermediate value, usually in the 25 to 75 percent range. Many image-editing features allow you to manipulate midtones independently from the highlights and shadows.

**monochrome** Having a single color, plus white. Grayscale images are monochrome (shades of gray and white only).

**monolight** An electronic flash unit that incorporates flash and power supply in the same housing, and which is usually mounted on a light stand to operate, rather than on a camera.

**monopod** A single-legged camera support.

**neutral density filter** A gray camera filter reduces the amount of light entering the camera without affecting the colors.

**noise** In an image, pixels with randomly distributed color values. Noise in digital photographs tends to be the product of low-light conditions and long exposures, particularly when you have set your camera to a higher ISO rating than normal.

**noise reduction** A technology used to cut down on the amount of random information in a digital picture, usually caused by long exposures at increased sensitivity ratings. Noise reduction involves the camera automatically taking a second blank/dark exposure at the same settings that contain only noise, and then using the blank photo's information to cancel out the noise in the original picture. With most cameras, the process is very quick, but does double the amount of time required to take the photo. Noise reduction can also be performed within image editors and standalone noise reduction applications.

**overexposure** A condition in which too much light reaches the film or sensor, producing a dense negative or a very bright/light print, slide, or digital image.

**panning** Moving the camera so that the image of a moving object remains in the same relative position in the viewfinder as you take a picture. The eventual effect creates a strong sense of movement.

**panorama** A broad view, usually scenic. Photoshop's new Photomerge feature helps you create panoramas from several photos. Many digital cameras have a panorama assist mode that makes it easier to shoot several photos that can be stitched together later.

**perspective** The rendition of apparent space in a photograph, such as how far the foreground and background appear to be separated from each other. Perspective is determined by the distance of the camera to the subject. Objects that are close appear large, while distant objects appear to be far away.

**pixel** The smallest element of a screen display that can be assigned a color. The term is a contraction of "picture element."

**polarizing filter** A filter that forces light, which normally vibrates in all directions, to vibrate only in a single plane, reducing or removing the specular reflections from the surface of objects and emphasizing the blue of skies in color images.

**prime** A camera lens with a single fixed focal length, as opposed to a zoom lens.

**quick release** A two-part mechanism that allows a camera to be attached to or removed from a tripod, monopod, or other component rapidly.

**RAW** An image file format offered by many digital cameras that includes all the unprocessed information captured by the camera. RAW files are very large, and must be processed by a special program supplied by camera makers, image editors, or third parties, after being downloaded from the camera.

**rear-curtain sync** An optional kind of electronic flash synchronization technique, originally associated with focal plane shutters, which consist of a traveling set of curtains, including a front curtain (which opens to reveal the film or sensor) and a rear curtain (which follows at a distance determined by shutter speed to conceal the film or sensor at the conclusion of the exposure).

For a flash picture to be taken, the entire sensor must be exposed at one time to the brief flash exposure, so the image is exposed after the front curtain has reached the other side of the focal plane, but before the rear curtain begins to move.

Rear-curtain sync causes the flash to fire at the *end* of the exposure, an instant before the second or rear curtain of the focal plane shutter begins to move. With slow shutter speeds, this feature can create a blur effect from the ambient light, showing as patterns that follow a moving subject with sub-ject shown sharply frozen at the end of the blur trail. If you were shooting a photo of The Flash, the superhero would appear sharp, with a ghostly trail behind him.

**red eye** An effect from flash photography that appears to make a person's eyes glow red, or an animal's yellow or green. It's caused by light bouncing from the retina of the eye, and is most pronounced in dim illumination (when the irises are wide open) and when the electronic flash is close to the lens and therefore prone to reflect directly back. Image editors can fix red eye through cloning other pixels over the offending red or orange ones.

**red-eye reduction** A way of reducing or eliminating the red-eye phenomenon. Some cameras offer a red-eye reduction mode that uses a preflash that causes the irises of the subjects' eyes to close down just prior to a second, stronger flash used to take the picture.

**reflector** Any device used to reflect light onto a subject to improve balance of exposure (contrast). Another way is to use fill-in flash.

**reproduction ratio** Used in macrophotography to indicate the magnification of a subject.

**resolution** In image editing, the number of pixels per inch used to determine the size of the image when printed. That is, an 8 × 10-inch image that is saved with 300 pixels per inch resolution will print in an 8 × 10-inch size on a 300 dpi printer, or 4 × 5-inches on a 600 dpi printer. In digital photography, resolution is the number of pixels a camera or scanner can capture.

**saturation** The purity of color; the amount by which a pure color is diluted with white or gray.

**selective focus** Choosing a lens opening that produces a shallow depth-of-field. Usually this is used to isolate a subject by causing most other elements in the scene to be blurred.

**sensitivity** A measure of the degree of response of a film or sensor to light.

**shadow** The darkest part of an image with detail, represented on a digital image by pixels with low numeric values or on a halftone by the smallest or absence of dots.

**sharpening** Increasing the apparent sharpness of an image by boosting the contrast between adjacent pixels that form an edge.

**shutter** In a conventional film camera, the shutter is a mechanism consisting of blades, a curtain, plate, or some other movable cover that controls the time during which light reaches the film. Digital cameras can use actual shutters, or simulate the action of a shutter electronically. Quite a few use a combination, employing a mechanical shutter for slow speeds and an electronic version for higher speeds.

**shutter-preferred** An exposure mode in which you set the shutter speed and the camera determines the appropriate f/stop.

**side lighting** Light striking the subject from the side relative to the position of the camera; produces shadows and highlights to create modeling on the subject.

**single lens reflex (SLR) camera** A type of camera that allows you to see through the camera's lens as you look in the camera's viewfinder. Other camera functions, such as light metering and flash control, also operate through the camera's lens.

**slave unit** An accessory flash unit that supplements the main flash, usually triggered electronically when the slave senses the light output by the main unit, or through radio waves.

**slow sync** An electronic flash synchronizing method that uses a slow shutter speed so that ambient light is recorded by the camera in addition to the electronic flash illumination, so that the background receives more exposure for a more realistic effect.

**softbox** An enclosure, often square or rectangular in shape, that can hold a light source and provides diffuse illumination through one translucent side.

**soft focus** An effect produced by use of a special lens or filter that creates soft outlines.

**soft lighting** Lighting that is low or moderate in contrast, such as on an overcast day.

**specular highlight** Bright spots in an image caused by reflection of light sources.

**spot meter** An exposure system that concentrates on a small area in the image. See also *averaging meter*.

**teleconverter** An optical device that fits between a camera and lens and multiplies the magnification of the lens by a given factor, such as 1.4X, 1.7X, or 2X.

**telephoto** A lens or lens setting that magnifies an image.

**tent** An enclosure, usually cubical, with translucent sides that is used to provide diffuse illumination for any object placed inside. The camera lens is inserted through a slit or opening in the tent to photograph the object within.

**time exposure** A picture taken by leaving the shutter open for a long period, usually more than one second. The camera is generally locked down with a tripod to prevent blur during the long exposure. See also *bulb*.

**tint** A color with white added to it. In graphic arts, often refers to the percentage of one color added to another.

**tolerance** The range of color or tonal values that will be selected with a tool like the Photoshop's Magic Wand, or filled with paint when using a tool like the Paint Bucket.

**transparency** A positive photographic image on film, viewed or projected by light shining through film.

**tripod** A three-legged supporting stand used to hold the camera steady. Especially useful when using slow shutter speeds and/or telephoto lenses.

**TTL** Through-the-lens. A system of providing viewing through the actual lens taking the picture (as with a camera with an electronic viewfinder, LCD display, or single lens reflex viewing), or calculation of exposure, flash exposure, or focus based on the view through the lens.

**tungsten light** Usually warm light from ordinary room lamps and ceiling fixtures, as opposed to fluorescent illumination.

**underexposure** A condition in which too little light reaches the film or sensor, producing a thin negative, dark slide, muddy-looking print, or dark digital image.

**vignetting** Darkening of corners in an image, often produced by using a lens hood that is too small for the field of view, or generated artificially using image-editing techniques.

**white balance** The adjustment of a digital camera to the color temperature of the light source. Interior illumination is relatively red; outdoors light is relatively blue. Digital cameras often set correct white balance automatically, or let you do it through menus. Image editors can often do some color correction of images that were exposed using the wrong white-balance setting.

**wide-angle lens** A lens that has a shorter focal length and a wider field of view than a normal lens for a particular film or digital image format.

**WiFi** A system for communicating between a camera, computer, or other device using a wireless network, in order to upload photographs from the camera to the computer, or (with a computer) to access other computers on the network or the Internet.

# Index

# We've got your shot covered.

## Selections from Bestselling Camera Guide Author David Busch

David Busch's Pentax K200D
Guide to Digital SLR Photography
1-59863-802-5 • $29.99

David Busch's Nikon D300 Guide
to Digital SLR Photography
1-59863-534-4 • $29.99

David Busch's Nikon D60 Guide
to Digital SLR Photography
1-59863-577-8 • $29.99

David Busch's Canon EOS 50D
Guide to Digital SLR Photography
1-59863-904-8 • $29.99

David Busch's Canon EOS Rebel
XS/1000D Guide to Digital SLR
Photography
1-59863-903-X • $29.99

Canon EOS 40D Guide to
Digital SLR Photography
1-59863-510-7 • $29.99

David Busch's Canon EOS Rebel
XSi/450D Guide to Digital SLR
Photography
1-59863-578-6 • $29.99

David Busch's Sony α DSLR-
A350/A300/A200 Guide to
Digital SLR Photography
1-59863-801-7 • $29.99

## The 50 Greatest Photo Opportunities

The 50 Greatest Photo
Opportunities in New York City
1-59863-799-1 • $29.99

The 50 Greatest Photo
Opportunities in San Francisco
1-59863-800-9 • $29.99

David Busch's Quick Snap
Guide to Lighting
1-59863-548-4 • $29.99

David Busch's Quick Snap Guide
to Using Digital SLR Lenses
1-59863-455-0 • $29.99

## Other Great Titles

Picture Yourself Getting the Most
Out of Your Digital SLR Camera
1-59863-529-8 • $24.99

The Official Photodex
Guide to ProShow
1-59863-408-9 • $34.99

301 Inkjet Tips
and Techniques
1-59863-204-3 • $49.99

More Than One Way
to Skin a Cat
1-59863-472-0 • $34.99

Mastering
Digital Black and White
1-59863-375-9 • $39.99

The Digital Photographer's
Software Guide
1-59863-543-3 • $29.99

**www.courseptr.com** or call **1.800.354.9706**